A Paris Life, *A Baltimore Treasure*

A Paris Life,
A Baltimore Treasure

The Remarkable Lives of George A. Lucas
and His Art Collection

Stanley Mazaroff

JOHNS HOPKINS UNIVERSITY PRESS *Baltimore*

Johns Hopkins University Press
2715 North Charles Street
Baltimore, Maryland 21218-4363
www.press.jhu.edu

Library of Congress Cataloging-in-Publication Data

Names: Mazaroff, Stanley, author.
Title: A Paris life, a Baltimore treasure : the remarkable lives of George A. Lucas and his art
 collection / Stanley Mazaroff.
Description: Baltimore : Johns Hopkins University Press, 2018. | Includes bibliographical
 references and index.
Identifiers: LCCN 2017018079| ISBN 9781421424446 (hardcover : alk. paper) | ISBN
 9781421424453 (electronic) | ISBN 1421424444 (hardcover : alk. paper) | ISBN
 1421424452 (electronic)
Subjects: LCSH: Lucas, George A., 1824–1909. | Lucas, George A., 1824–1909—Art
 collections. | Art—Collectors and collecting—France—Paris—Biography. | Americans—
 France—Paris—Biography. | Baltimore (Md.)—Biography. | Paris (France)—Biography.
Classification: LCC N5220.L76 M39 2018 | DDC 709.2 [B] —dc23
 LC record available at https://lccn.loc.gov/2017018079

A catalog record for this book is available from the British Library.

*Special discounts are available for bulk purchases of this book. For more information, please contact
Special Sales at 410-516-6936 or specialsales@press.jhu.edu.*

Johns Hopkins University Press uses environmentally friendly book materials, including recy-
cled text paper that is composed of at least 30 percent post-consumer waste, whenever possible.

To Nancy

CONTENTS

FIGURES

This book could not have been written without the groundbreaking and tireless scholarship of Lilian Randall, who in 1965 discovered George Lucas's handwritten diaries in two musty old shoeboxes. She spent years studying, interpreting, and publishing the diaries, virtually returning Lucas to life. Nor could this book have been written without the encouragement of Bill Johnston and Jay Fisher, two of the country's finest scholars of French nineteenth-century art, who generously shared their knowledge and ideas with me. I am also indebted to Doreen Bolger, who served as director of the Baltimore Museum of Art, and Fred Lazarus, who served as president of the Maryland Institute College of Art, for allowing me to study all of the BMA's and MICA's archival records pertaining to the history of the Lucas collection, including all records involving the litigation over the collection's ownership.

I would like to acknowledge the assistance provided by the present and former curators and professional staffs of the Baltimore Museum of Art, the Walters Art Museum, the Maryland Institute, and the Maryland Historical Society. Among the staff at the BMA, I want to thank Rena Hoisington, Sona Johnston, Katy Rothkopf, Oliver Shell, Emily Rafferty, and Meagan Gross. At the Walters, I want to thank Gary Vikan, Jo Briggs, Diane Bockrath, Joy Heyrman, Joan Elizabeth Reid, Betsy Tomlinson, and Ruth Bowler. At the Maryland Institute, I want to thank Doug Frost, and Kathy Cowan. And at the Maryland Historical Society, I thank James Singewald. I also want to express special thanks to Hiram "Woody" Woodward, for providing me with his copy of the catalogue of the initial exhibition of the Lucas collection at the Maryland Institute in 1911 and sparking my interest in writing this book, and to Nicole Simpson, Margaret Klitzke, and Joanna Karlgaard for sharing their very special and scholarly knowledge about the Lucas collection of prints and their significance.

I also want to acknowledge and thank the many leaders of the BMA, the Walters, and the Maryland Institute and other public and civic leaders who shared with me their memories and documents involving the battles that were fought in and out of court over the Lucas collection. They include Tim Armbruster, Connie Caplan, Janet Dunn, Jay Fisher, Laura Freedlander, Neal Friedlander, Frances Glendenning, Andy Graham,

Roy Hoffberger, Judge Joseph H. H. Kaplan, Fred Lazarus, Harry Lord, Anne Perkins, Sheila Riggs, Ben Rosenberg, Harry Shapiro, Robert Shelton, Dena Testa, and Calman "Buddy" Zamoiski.

I also want to thank Winston Tabb, Sylvia Eggleston Wehr, Greg Britton, and Earle Havens for their support and encouragement, and Elizabeth Demers, senior acquisitions editor of Johns Hopkins University Press; Julia Ridley Smith, copyeditor; Deborah Bors, senior production editor; Julie McCarthy, managing editor; Lauren Straley, editorial assistant; Tom Broughton-Willett, indexer; and Morgan Shahan, acquisitions associate, for their superb work in reviewing and improving the book and bringing it to publication.

Finally, I want to thank my wife, Nancy Dorman, for carefully reading every chapter of the book, serving as my most constructive and loving critic, and lending her encouragement and support from beginning to end.

A Paris Life, *A Baltimore Treasure*

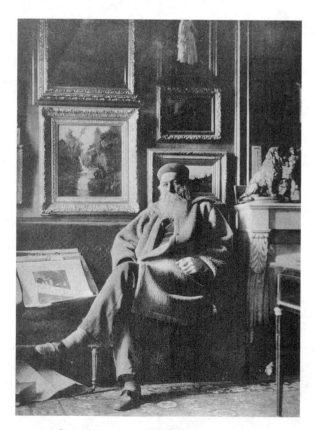

FIGURE 1. Dornac, *George A. Lucas and His Collection*, 1904. The Walters Art Museum Archives.

Prologue

Rarely has such a brilliant period in the history of art been so meticulously documented by a contemporary collector. . . . Dispersal of any part of this unique assemblage which comprises an acclaimed artistic and scholarly resource would be a loss to art lovers everywhere.

J. CARTER BROWN, Director, National Gallery of Art,
November 1991

On February 24, 1904, in his Parisian apartment overflowing with paintings, prints, and sculpture, George Aloysius Lucas looked into the eye of the camera and posed for his last portrait (fig. 1). Just shy of his eightieth birthday, Lucas recognized that it was a time for retrospection, a time for summing up. He leaned back and allowed his art to surround him, as if to suggest that he and his art were inseparable and revealed not simply what Lucas collected but more profoundly who he was. At a time when Paris was the center of the art world, when its artists competed for the patronage of wealthy Gilded Age Americans, and when those Americans sought to be introduced to the most gifted Parisian artists, Lucas was the quintessential go-between. He was an American expatriate who was literally at home with his art in Paris. And there was, as Lucas knew, no one else quite like him.

Born into a wealthy and prominent Baltimore family, endowed with a comfortable inheritance of $1,500 per year, fluent in French, and polished by acquired tastes for art, opera, fine food, and vintage wine, Lucas left his family home at the age of thirty-three and departed for Paris as if it were the promised land. Arriving there in 1857, he had no regular job

or plan to find one. He was neither trained nor claimed to be an artist, an art dealer, or an art critic. His talent lay not in making art but in making art his business. With unbridled confidence, Lucas ventured into the related fields of French culture and commerce as an apprentice and, within four years, emerged as a master. By the early 1860s, Lucas had established himself among American collectors not only as a connoisseur of French art but, more importantly, as the French connection.

Lucas had the good fortune to arrive in Paris at a critical intersection in cultural history, when French art and American interest in its acquisition first met. Paris in the middle of the nineteenth century had entered an era of unprecedented prosperity and artistic productivity as it raced ahead on the road to modernity. It was at this same juncture in time when wealthy American collectors acquired an unquenchable taste for French art that would last for generations. What Lucas found upon his arrival in Paris in 1857 was a world of paintings, drawings, engravings, and sculpture so sumptuous and accessible that it must have seemed as if the muses had set a table of art in his honor. Spread before Lucas was an art collector's dreamlike world of opportunity, where practically all styles of art—whether neoclassical, romantic, or realistic—were available. Depictions of modern Parisian life and Barbizon landscapes competed in the marketplace against classical nudes floating on clouds and heroic images of emperors on horseback. Paintings by the most celebrated living French artists could be purchased at the city's vibrant auction house or at the nearby neighborhood of elegant new galleries, and thousands of new works of art crowded the walls at the annual Salons each spring. Photography had emerged both as a form of art and a widespread means of documenting it. A passion for etching had been revived, lithographs were a dollar a dozen, and art was reproduced as never before. Art was not simply something to look at; it was something to think, read, write, and argue passionately about. A lively free market for art had emerged where bargains could be made. And, in this cultural labyrinth of changing directions, a young, cultivated, and ambitious American entrepreneur like Lucas could find his place, create his own collection, and make a name for himself.

It was in this milieu that Lucas created a unique transatlantic business in which he personally served as the conduit for bringing together the interests of American collectors and French artists. It was no easy task. There was no economic model for him to follow nor book of existing clients for him to acquire. As an American agent for the collection of French art, Lucas was the pioneer. To succeed, Lucas was faced with the Janus-like challenge of appearing to be American and French at the same time. He needed to cultivate and preserve ties with wealthy American collectors, while meeting and befriending the most celebrated French artists, dealers, and bourgeois businessmen who made the wheels of the French art market turn.

Lucas once described himself as "a wanderer upon the earth," but if Charles Baudelaire had followed his footsteps in Paris, he most certainly would have labeled Lucas as a quintessential *flâneur*. Nearly every day for years, Lucas would walk the streets of Paris, from morning to night, feeling the pulse of the cultural life of the city,

exploring the art galleries along the rue Lafitte on the right bank and studying the paintings at the Luxembourg Museum on the left, leaving a trail from one artist's studio to another, from dealer to dealer, and from exhibition to exhibition. He absorbed everything there was to see, learned everything there was to learn, and became as intimately familiar with the streets of Paris and the city's way stations of culture as with the lines on the palms of his hands.[1]

Lucas became acquainted with the most important art dealers, framers, photographers, restorers, engravers, publishers, booksellers, bookbinders, bankers, craters, and shippers in Paris. He learned what everything cost and where to find it. And he gradually developed a network of players in the Parisian art world that was unmatched by anything offered by any other American living in Paris. More importantly, he became a friend to many of the most celebrated midcentury Parisian artists. He not only frequented their studios but also studied their art, acquired their catalogues, saved their letters, preserved their palettes, collected their art in great quantities, and encouraged a select group of wealthy American clients to do the same. He befriended Cabanel and Corot, breakfasted with Fantin-Latour, dined with Daubigny, and even shared his home briefly with James McNeill Whistler. As a result of his savoir faire and network of contacts, Lucas reached the enviable position, as Whistler once observed, of having an "entree everywhere" in the Parisian world of art.[2]

At the end of each day, Lucas would open his leather-bound diary and faithfully record the mundane, unembellished details of what he had done that day—the studios and galleries he visited, the artists he met, the art he acquired, the clients he served, and the money he spent. His diary, in a sense, became his nightly prayer rug, and the world of art he discovered each day, his religion. Each entry alone provides little more than a bone-dry, cryptic summary of Lucas's daily life, but taken together, the eighteen thousand entries contained in the fifty-one diaries that he left behind provide a unique picture of what it was like to be the premier American art agent in Paris during one of the most glorious periods of French cultural history.[3]

During his second year in Paris, while still learning his trade, Lucas received unexpected but welcome direction from a small circle of prosperous friends and family in Baltimore who shared his interest in French art. In January 1859, his older brother William wrote requesting information about one of the most celebrated midcentury French artists, Ernest Meissonier. Commanding the highest prices of any artist in France, Meissonier was in a different league than the hungry artists Lucas knew. In 1855, Napoleon III had purchased one of his paintings, *The Brawl*, for 25,000 F as a gift for Queen Victoria and Prince Albert, and Meissonier had been awarded the medal of honor at the Universal Exposition in Paris.[4]

On February 4, 1859, Lucas traveled by train to Meissonier's hometown of Poissy, about fifteen miles from the center of Paris. Without any invitation or prior arrangement, he boldly knocked on the front door of the famous painter's mansion and requested to be admitted. We can only speculate whether Lucas's handsome six-foot frame, beautifully tailored clothes, gentlemanly demeanor, or personal charm helped

him gain entrance, but Meissonier's wife invited him in. Although her husband was not home, she provided Lucas with what he was after—the price of Meissonier's paintings and the standards he used for determining the price. She also showed Lucas a copy of the famous painting purchased by Napoleon III. Emboldened by his success and with an unwavering belief in his own importance, Lucas began visiting the most prominent artists in Paris at their homes or studios and negotiating the purchase of paintings directly with them.[5]

Lucas wrote to his mother and brother William in Baltimore about his successful meeting with Mrs. Meissonier. This report likely shaped Lucas's reputation as an entrepreneurial connoisseur who could open the gates of the Parisian art world for budding American collectors. Before the end of that year, his venture began to pay dividends. His first major client was William T. Walters, one of America's earliest great collectors of French art. Walters retained Lucas in November 1859 and continued to be guided by him for the next thirty years. In 1867, Lucas began to serve as an art agent for Samuel P. Avery, another prodigious collector, who acquired hundreds of French paintings and prints for resale at his influential New York gallery and later gave the magnificent gift of 17,775 etchings and lithographs to the New York Public Library. Among other wealthy American collectors who subsequently retained Lucas were John Taylor Johnston, a founder and the first president of the Metropolitan Museum of Art; William Wilson Corcoran, the founder of the Corcoran Art Museum; and William Henry Vanderbilt, whose private collection was considered by many to be the finest in America. Just as Lucas's taste was shaped by the art he found in Paris in the middle of the nineteenth century, he, in turn, was instrumental in shaping the tastes of his clients and in creating the engine that eventually carried, by the crateload, mid-nineteenth-century French art across the Atlantic and into the private salons and newly minted museums of the United States.[6]

The key to Lucas's success was his ability to become embedded in French culture. The way he dressed, where he resided in Paris, the country home he bought on the banks of the Seine, the expensive Empire-style furnishings that he purchased for his homes, the paintings that covered his walls, the way he artfully camouflaged his relationship with his mistress so as not to transgress the social conventions of the time, where he dined, how he entertained his clients, the way he admired Napoleon III, and, in general, how he comported himself in public—in short, everything about how he lived—made Lucas indistinguishable in taste, appearance, and manner from the well-off bourgeoisie with whom he associated and did business.[7] As evidenced by a handsome photograph of Lucas at the age of forty-five—dressed impeccably in an elegantly tailored double-breasted overcoat, dark suit, and white shirt—Lucas would have felt at home in any gathering of Parisian high society where appearance mattered and conspicuous consumption ruled (fig. 2). Indeed, one might imagine him stepping out of the crowd of uniformly dressed, bearded gentlemen depicted by Édouard Manet in *Music in the Tuileries* and striding into the studio of Antony Adam-Salomon, where his photograph was taken.[8]

A Paris Life, A Baltimore Treasure

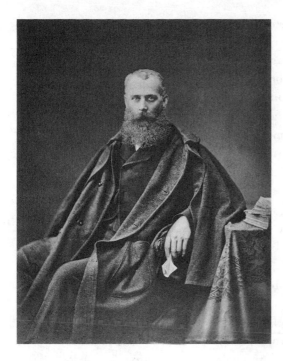

FIGURE 2. Antony Adam-Salomon, *George A. Lucas*, 1869. The Walters Art Museum Archives.

Adam-Salomon's portrait of Lucas was intended not merely to record his good looks but to emphasize his character. His formal upright posture, as well as his serious and straightforward demeanor, contributed to a commanding presence that filled the picture plane and created the impression that he was seated directly across and within immediate reach of the viewer. The dark conservative clothes, open book by his side, and unsealed record in his hand all served to signify that Lucas had nothing to hide in the performance of his business and was a trustworthy, intelligent, elegant, and sophisticated gentleman of the highest caliber. Lucas prized this image of himself, referring to it as an "artistic portrait." He purchased six copies and gave one each to Walters and Avery, two of his most enduring friends and clients.[9]

Based on their years of experience in dealing with Lucas, Walters and Avery would attest in their words and deeds to what the photograph portrayed. Both established healthy bank accounts in Paris for the acquisition of art and actually gave Lucas the keys, a gesture of unmistakable trust. Walters would later refer to Lucas's "sterling truth."[10] While his trustworthiness was paramount to his clients, his warmth and generosity was what counted most to his large circle of friends. Generous, fun loving, and adventuresome, Lucas was also intellectually curious, painstakingly studious, and indefatigable in his love of art.

The income Lucas derived from his work enabled him to live well. (He charged his clients a standard commission of 5 percent of the purchase price of the art he acquired for them.) He moved into a fashionable six-room apartment at 41 rue de l'Arc-de-Triomphe, close to the famous monument, and rented a second adjacent apartment on the same floor for his mistress Octavie-Josephine Marchand (whom he simply

called M) and her young son, Eugène. He paid for a servant to live upstairs in his building and, when needed, to attend to his meals and housekeeping. Lucas generously looked after and supported his friends and their families in times of need. He purchased a lovely country home on the banks of the Seine in the small village of Boissise-la-Bertrand, within five kilometers of the artists' colony in Barbizon. He enlarged the grounds, redesigned the house, and stocked it with barrels of fine Bordeaux. And for the pleasure and convenience of his circle of friends and artists, Lucas added to his country home a small studio in which they could paint.

It was there, in August 1886, that Whistler sketched a small, full-length portrait of Lucas at the age of sixty-two. Dressed comfortably in a loose-fitting jacket and baggy pants, Lucas holds a walking stick in one hand and a straw hat in the other, as if he were about to stroll along the banks of the Seine and into the Fontainebleau forest. Set against an earthy brown background, the painting evoked the relaxed environment and relative freedom of his country life and suggested that while Paris was his place of work, Boissise-la-Bertrand had become his garden of pleasure (plate 1).[11]

Capitalizing on the advice and service that he had provided to Avery and Johnston, two of the founding trustees of the Metropolitan Museum of Art, Lucas began to court the museum with the goal of expanding his business. Beginning in 1879, he oversaw the packing and shipment of art acquired by the Metropolitan in Paris.[12] But more importantly, he began to favor the museum with a series of gifts, including a bronze bust by Auguste Rodin and another bronze bust by David d'Angers. Lucas's efforts produced the desired results. In its *Bulletin,* the Metropolitan referred to Lucas as an "eminent collector and generous friend," and in November 1889, the trustees conferred upon him the title "Honorary Fellow for Life."[13] In reporting the honors bestowed by the museum upon Lucas, the *New York Sun* wrote, "Mr. Lucas's life is spent in the artistic fraternity of the French capital. He knows everybody who is worth knowing: his great services to French art have won the recognition of the government and secured to him a well-earned reputation as one of the most cultivated and accomplished art students of our time."[14]

While undoubtedly pleased by the praise and honorary title, Lucas wanted to perpetuate the notion that although an ocean away, he was in spirit always present at the Metropolitan and ready to serve its interests. To convey this message, Lucas decided to present the Metropolitan with an unashamedly self-serving gift. It was a large bronze bust of himself. He commissioned the well-known French sculptor Augustin Jean Moreau-Vauthier to sculpt what Lucas called "my portrait bust" at the cost of 300 F (fig. 3). In February 1891, after the bronze bust was briefly shown at the annual Salon, Lucas shipped it to the Metropolitan Museum of Art. Without identifying himself as the donor, he simply indicated on the shipping instructions that the bust was "a gift from a friend." It was accepted and accessioned that way into the permanent collection of the Metropolitan, where it remains today.[15]

Lucas's success as an agent for American collectors enabled him to accumulate his own massive collection of art. It grew and grew as if it had a life of its own, gradually

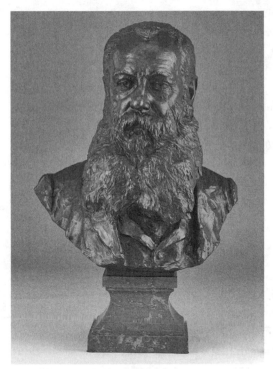

FIGURE 3. Augustin Jean Moreau-Vauthier, *George A. Lucas*, 1890. The George A. Lucas Collection, Baltimore Museum of Art, BMA 2006.48.

inhabiting all of the walls and empty spaces in his city and country homes. His collection even extended from his Parisian apartment into the adjacent apartment of his mistress, filling carton upon carton with thousands of prints, photographs, and portfolios of information about the artists, turning her kitchen into a veritable cabinet of wonders, covering her walls with dozens of paintings, and wrapping Lucas and M together in an endless ribbon of art.[16]

Lucas's collection ultimately included over 18,000 works of art by over 500 different artists.[17] There were approximately 15,000 prints, 300 oil paintings, over 300 watercolors and drawings, 140 bronzes and other pieces of sculpture, and an elegant collection of blue and white Chinese vases and other porcelain.[18] His collection, however, was not limited to what the artists created but extended to the objects and ephemera that evidenced their way of life. He acquired more than seventy palettes, many of which were inscribed with personal notes to him. ("I have given it [my palette] to my good friend George Lucas, the accomplished connoisseur of objects of art," wrote the artist Antoine Emile Plassan.) He scrupulously preserved their letters and acquired practically every book and catalogue he could find by them or about them, amassing an art library of around fifteen hundred volumes. Sometimes he incorporated pictures of art into books about the artists and bound the words and pictures together, thereby creating his own unique and visually alluring biographies. He glued newspaper clippings about the artists to the back of their artwork. Along with handsome silver gelatin photographs of prominent artists in their studios, he kept

photographic portraits of almost all the artists he met or whose art he acquired, as if to preserve their memory in his own pantheon of heroes. He was obsessed not only with establishing a collection of art but with capturing for future generations an archive of the culture that French artists had collectively created and that shaped his own life.

Lucas's art collection was defined by his encyclopedic accumulation of nineteenth-century French etchings and a strong preference for Barbizon landscapes. It also contained a large number of unpretentious still-life paintings and portraits of people from different walks of life: a Moroccan odalisque, an Italian male model, a French dandy, a bourgeois woman admiring her new hat, a peasant woman peeling vegetables, a young girl. Many of these were preparatory sketches for larger, more complex paintings. In practical terms, Lucas's collection was shaped by what he could afford or, in many cases, what he was given by artists free of charge as tokens of appreciation for introducing them to his wealthy clients. Most of his paintings were small appealing objects, measured in inches rather than feet, that easily could be held in one hand and fit in among the other paintings covering his walls. He did not seek to acquire large history paintings, genre scenes, or other pictures that contained multiple figures and conveyed ethical or moral messages. Among the three hundred oil paintings in his collection, only one painting won an award at the annual Salons. While wealthy, Lucas did not have the money or inclination to compete with millionaires like Walters and Vanderbilt in the acquisition of grand works of art. He never claimed that his collection was full of masterpieces, but he loved his art almost as much as he loved himself.

The names of the important midcentury artists were all inscribed presumably by the artists' own hands on the paintings and other art that comfortably resided in Lucas's apartment and country home: Antoine-Louis Barye, Léon Bonnat, François Bonvin, Eugène Boudin, William Adolphe Bouguereau, Félix Bracquemond, Jules Breton, Alexandre Cabanel, Mary Cassatt, Jean-Baptiste-Camille Corot, Gustave Courbet, Thomas Couture, Charles-François Daubigny, Honoré Daumier, Alexandre-Gabriel Decamps, Eugène Delacroix, Narcisse-Virgile Diaz de la Peña, Jules Dupré, Henri Fantin-Latour, Édouard Frère, Jean-Léon Gérôme, Norbert Goeneutte, Charles Émile Jacque, Johan Barthold Jongkind, Jules-Joseph Lefebvre, Théophile-Victor Lemmens, Jean-François Millet, Adolphe Joseph Thomas Monticelli, Camille Pissarro, Antoine Emile Plassan, Théodore Rousseau, Paul Signac, Alexandre Thiollet, Constant Troyon, Emile van Marcke de Lummen, James McNeill Whistler, and Félix François Georges Philbert Ziem. If names were all that mattered, Lucas would have had a collection of mid-nineteenth-century French paintings that would have been the envy of the cultural world of that time. Yet it was not only the quality of the artworks that mattered to Lucas but the stories and history that they collectively told.

The jewels of his collection were his exquisite prints by Whistler and Manet, his iconic drawings and watercolors by Daumier, a preparatory drawing of *The Gleaners* by Millet, landscapes by Corot and Pissarro, and the remarkable bronzes by Lucas's

favorite artist, Antoine-Louis Barye. These were the works that drew the most attention from Parisian art aficionados. In 1884, his drawing by Daumier, *The Grand Staircase of the Palace of Justice* (plate 2), was borrowed by the École des Beaux-Arts for an exhibition of *Dessins de l'école modern* (Drawings of the modern school). A century later it would be considered the most valuable work in the Lucas collection.[19] The 1889 *Exposition Barye,* also held at the École des Beaux-Arts, featured 167 sculptures from Lucas's collection. His dozens of prints by Manet and Whistler drew experts to his apartment to closely examine them. He placed them in custom-made portfolios stored in small cabinets in his living room and turned away several offers to purchase some of these etchings. Lucas recognized that the quantity and unusual diversity of his collection was a hallmark of its identity. He believed—as did the beneficiaries of his collection a century later—that the collection as a whole was greater than the sum of its parts, and he vowed to keep it together with the hope that it would be cherished in the future as much as he had cherished it during his lifetime.[20]

As Lucas approached eighty, he was concerned not only about his own longevity but about his collection's fate. Most of his immediate family had died years earlier, and in November 1903, his mistress M, with whom he had spent most of his adult life, became seriously ill and required the daily care of a doctor. Many of Lucas's best clients also had died or were near death.[21] And the more recent deaths of several of the artists with whom he dealt, including Whistler, Pissarro, Plassan, and Gérôme, made Lucas keenly aware of the fragility of life and his own mortality.

To add to his anxiety, on February 11, 1904, Lucas learned that the center of Baltimore had been devastated by a horrible fire that destroyed more than fifteen hundred buildings, including the house where he was born, the structure that served as the home of his family's very successful stationery and publishing business, and the building that housed the Maryland Institute, a venerable school of art and design that his father had helped to found a generation earlier (figs. 4 and 5). The terrible news, as reported in the *Baltimore Sun,* was that, "to all appearances Baltimore's business section is doomed. . . . There is little doubt that many men, formerly prosperous, will be ruined by the events of the last twenty-four hours." H. L. Mencken, then a reporter for the *Baltimore Herald,* wrote more succinctly, "Heart of Baltimore Wrecked."[22]

On the day that Lucas received this bad news, he was visited by two distinguished scholars, Elizabeth and Joseph Pennell, who wanted to see his Whistlers. Preoccupied with the tragic events in Baltimore, he showed his visitors a map of the city to illustrate the extent of the devastation. According to the Pennells, Lucas for a while "could talk of nothing else."[23] Three days later, to make matters worse, he suffered, in his words, "violent pains" in his back that hindered his ability to walk.[24]

On the heels of these distressing events, Lucas retained the photographer Paul Cardon (known as Dornac) to come to his home and preserve for posterity a picture of him and his art. Dornac had gained fame by photographing Rousseau, Breton, Gérôme, Fantin-Latour, Redon, and Whistler, as well as other illustrious figures of

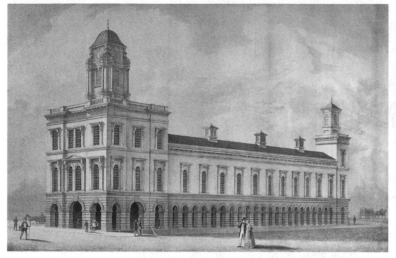

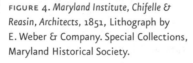

FIGURE 4. *Maryland Institute, Chifelle &
Reasin, Architects*, 1851, Lithograph by
E. Weber & Company. Special Collections,
Maryland Historical Society.

FIGURE 5. Ruins of the Old Maryland Insti-
tute, 1904. MICA Archives, Decker Library,
Maryland Institute College of Art.

fin-de-siècle France, such as Alexander Dumas, Louise Pasteur, and Émile Zola. He
had made their portraits in the intimacy of their homes or studios, where they were
surrounded by paintings or other personal objects that symbolized their lifelong
achievements. Dornac's photographs were themselves valued as precious works of art
worthy of collecting; Lucas purchased in 1903 Dornac's photograph of Whistler in
his studio.[25]

Lucas wanted to use Dornac's camera as his time machine, a way of communicat-
ing his presence, wrapped in the aura of French art, into the future. Better than a
tombstone or marble shrine, the photograph, Lucas hoped, would enable future gen-
erations to appreciate the spirit of his times and the art that sparked his life. There
was, however, a more immediate and pressing reason for hiring Dornac. Lucas wanted
to give his entire collection something that it had never had before: publicity. Aside
from his sculptures by Barye and several works of art by Daumier and Whistler, most
of his eighteen thousand works of art had never been displayed outside his home.
Moreover, not a single scholarly article about his collection had ever been published.
Anxious to find a future home for his relatively unknown collection, Lucas retained
Dornac to create a flattering photograph of his art that might attract the attention of
some museum, institution, or well-heeled collector interested in acquiring it. It was
Lucas's artful way not only of immortalizing himself but also of saving his beloved
collection.

Despite the impression of intimacy created by Dornac's photograph of Lucas re-
laxing comfortably on a sofa in his living room, there was nothing impromptu or ex-
temporaneous about it. It had been as carefully staged as any set at the Garnier Opera,

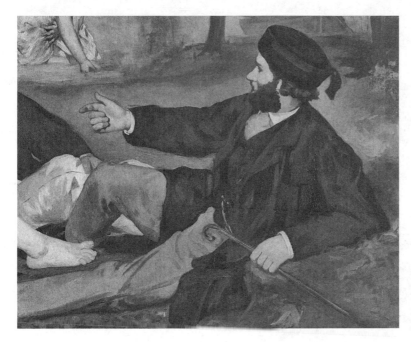

FIGURE 6. Édouard Manet, *Le Déjeuner sur l'herbe* (Luncheon on the Grass, *detail*), 1863. Musee d'Orsay. RMN-Grand Palais / Art Resource, NY.

showing Lucas closely surrounded by the paintings, prints, and sculpture that served as testament to his accomplishments and that had shaped his life. At the center, Lucas wears a long gray moleskin robe de chambre and a dark beret, which had become synonymous with the bohemian style of many Parisian artists at that time. The beret, the folds of his robe, his clenched left hand, his bended knee, his full beard, and the relaxed lean of his body make Lucas appear as if he were an older cousin of the reclining figure in Manet's famed *Le Déjeuner sur l'herbe* (compare fig. 1 and fig. 6). In this manner, Lucas was pictured as a work of art and the embodiment of his own collection.

The works of art that appear in Dornac's photograph demonstrate the rich diversity of Lucas's collection. To illustrate the quality and quantity of Lucas's prints, an open portfolio of etchings was placed on the sofa next to him. The etchings appear to cascade onto his carpeted floor, as if to suggest that they are part of an endless stream of thousands more. The most visible of these etchings is a haunting image of a poor old man with a gray beard and a dark robe, his daughter standing close by his side (fig. 7). It was based on a painting by Théodule Ribot, a highly regarded realist who twice had received medals at the annual Salons and awarded the Légion d'Honneur.[26] Lucas likely displayed this particular etching in Dornac's photograph because its striking chiaroscuro was reminiscent of the masterful etchings of Rembrandt, suggesting that within Lucas's large collection of etchings resided many pictures of masterful quality.

On the other side of Lucas are two small bronzes by Barye, *Seated Lion* (fig. 8) and *Tiger on the March*. The *Lion* occupied the nearby mantle of Lucas's fireplace,

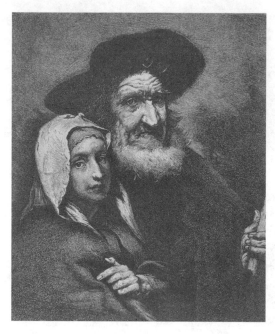

FIGURE 7. Alphonse Charles Masson, After Augustin Théodule Ribot, *An Old Beggar and His Young Daughter*, c. 1887. The George A. Lucas Collection, Baltimore Museum of Art, BMA 1996.48.9022.

while the *Tiger* paced the floor in front of it.[27] Lucas was well aware that among all of the objects in his vast collection, the one that would resonate the most among art lovers in Baltimore was *Seated Lion*. In 1884, at the request of William Walters, Lucas had commissioned a large and magnificent cast of *Seated Lion* and had it shipped to Baltimore. In 1885, the *Seated Lion* was publicly unveiled in Baltimore's Mount Vernon Place and given by Walters to the citizens of Baltimore (fig. 9).

To illustrate the strength of his collection of paintings, Lucas posed in front of a group of works by or attributed to five of France's most celebrated painters: Breton, Cabanel, Courbet, Daubigny, and Fantin-Latour.[28] The subject matter of these paintings—landscapes, figures of people, and a portrait of Lucas himself—typified the art that he collected. But what really glued these paintings together was not their quality but the famous names of the artists and the underlying stories that they told about Lucas's connections to them.

Among the five paintings, the only one that can be clearly seen in Dornac's photograph is *The Waterfall*, attributed to Courbet (fig. 10). Given its centrality and how it is illuminated, the painting appears among the five to be the most important. Although Lucas might not have known it at that time, it would also turn out to be the most troublesome.

Lucas had earned his stripes as the premier agent for American collectors by becoming personally acquainted with the most celebrated mid-nineteenth-century Parisian artists. While his clients depended on his knowledge, trustworthiness, and savoir faire, what they found most comforting was his personal connections to the artists, his presence in their studios, his watchful eye over the completion of their art,

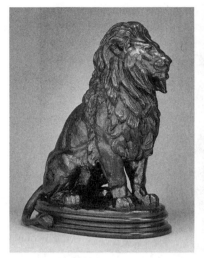

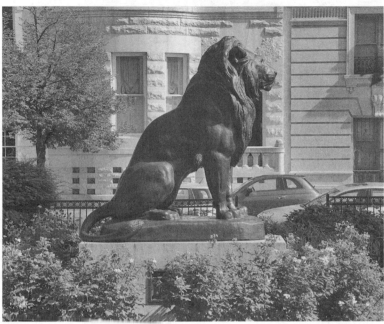

FIGURE 8. Antoine-Louis Barye, *Seated Lion*, 1879 or 1883. The George A. Lucas Collection, Baltimore Museum of Art, BMA 1996.46.2.

FIGURE 9. Antoine-Louis Barye, *Seated Lion* in Mount Vernon Place, Baltimore, Maryland. Photograph by author.

and, in essence, his assurance that the work that passed through his hands carried his imprimatur that it was precisely what it purported to be.

These safeguards did not apply to the work of Courbet, whom Lucas never met. Nor had he purchased any of his art for himself or his clients prior to Courbet's death in 1877. However, Lucas certainly knew of Courbet, one of the greatest and most controversial French artists of the nineteenth-century. In his famous work *The Artist's Studio,* Courbet portrayed himself as the master of his own universe, sitting at the easel in the middle of his atelier painting a magnificent landscape of high cliffs and falling waters, a sexually alluring nude model standing admiringly by his side (fig. 11).[29]

Courbet's name was not mentioned in Lucas's diary until May 1882, when he attended a sale of his art at the Hôtel Drouot. By then, purchasing a Courbet had become a risky endeavor. Toward the end of the artist's life, especially after 1871 when he fled from France to Switzerland to avoid imprisonment for allegedly participating as a member of the Commune in the destruction of the Vendôme column, Courbet's studio produced a multitude of paintings that he might never have seen or touched. To minimize the risk of purchasing a Courbet landscape of questionable authenticity (he purportedly painted over five hundred), Lucas acquired photographs of Courbet's earlier paintings and a verified copy of his signature, naively believing that these artificial tools would enable him to identify and distinguish a good Courbet from a bad.[30]

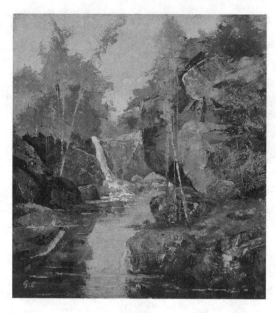

FIGURE 10. Unknown Artist, After Gustave Courbet, *Waterfall*, n.d. The George A. Lucas Collection, Baltimore Museum of Art, BMA 1996.45.269.

Before obtaining his own Courbet, Lucas had purchased two Courbet landscapes. The first was a painting of a doe forced down in the snow by a pack of hounds (*Biche forcée sur la neige*). The original painting had been exhibited at the Salon of 1857 and shown again with considerable fanfare at the Paris Exposition of 1889. In November 1889, Lucas examined what he mistakenly believed was the same painting at a dealer's showroom, and in December of that year, he purchased it for William Walters at a cost of 6,000 F. Eighty years later, it was reattributed to an unknown follower of Courbet.[31]

The second landscape, entitled *The Stream of the Black Well*, was purchased in June 1903 for Henry Walters. By then the price of Courbet's art had steeply declined, and Lucas was able to acquire this painting for the relatively modest sum of 1,000 F. He bought it from Alfred Prunaire, a Parisian engraver who at that time had accumulated and was offering to sell a large number of Courbet paintings.[32] Strapped for cash, Prunaire was not only selling these paintings but also using them as collateral to obtain personal loans.

In 1902, Prunaire visited Lucas at his Parisian home, obtained a loan of 500 F, and left behind as collateral "a landscape study" attributed to Courbet. He repaid the loan the next year and retrieved his painting, but nine months later, in December, he redeposited the landscape with Lucas as collateral for another loan. On January 12, 1904, Prunaire returned again and asked Lucas to "advance" to him another 700 F. But this time Lucas refused, and because Prunaire had defaulted on his obligation to repay the existing loan, Lucas kept the painting. In this peculiar manner, *The Waterfall* permanently entered Lucas's collection, and it was prominently featured a few months later in Dornac's photograph of Lucas and his art.[33] Because *The Waterfall* was reminiscent of the waterfall in Courbet's famous painting *The Artist's Studio*,

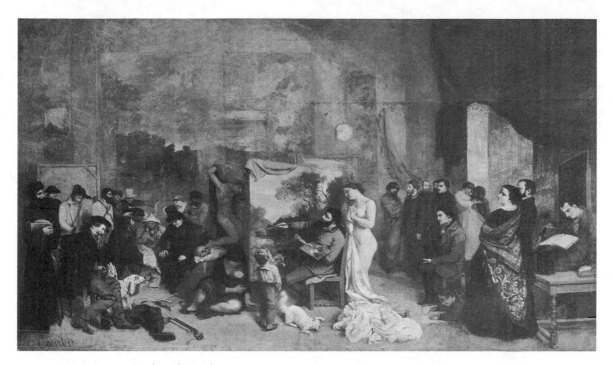

FIGURE 11. Gustave Courbet, *The Artist's Studio*, 1855. Musee d'Orsay. Scala / Art Resource, NY.

Lucas apparently believed that these paintings could be linked together, adding to his painting's importance. He obviously was unaware that his prized possession was a fake.[34]

The small painting by Fantin-Latour immediately above Lucas's head in Dornac's photograph has always been difficult to decipher (fig. 12). It is a muddy, seemingly unfinished sketch of three unidentifiable figures—two seated women and a standing man—who together form a triangle. They are depicted in a brushy woodland under a sky as cloudy as the painting itself. The uncertain subject matter of the painting conveys an air of romance, allowing one to imagine, perhaps, a composer with a sheet of operatic music in his hand deciding which of his two lovers seated before him will be chosen to sing the leading soprano's role. Whatever one might read into the painting, it is far different in style and temperament from the smooth, realistic still-life paintings of fruits and flowers and the group portraits for which Fantin-Latour would become renowned. It also contrasted with the well-defined paintings that dominated Lucas's collection. In keeping with the hazy nature of its subject, the painting was not given any descriptive title.[35] It was simply referred to by Lucas as *Study in Oil*. Despite the roughness of its surface and opaqueness of its subject-matter, the painting had a particular personal meaning to Lucas, related to his entangled life as both art agent and art collector, that can only be traced through his diary entries.

Like many others in his collection, this painting was not one that Lucas bought.

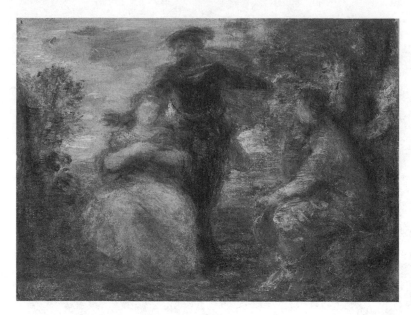

Instead, it fell into his possession as a result of a string of dealings with Fantin-Latour, Whistler, and Avery. In 1862, Lucas was introduced to Fantin-Latour over dinner in Paris by their mutual friend Whistler. Around that time, Fantin-Latour was painting small, seemingly unfinished scenes of unidentifiable people like the one that Lucas latter obtained. In 1863, one of these paintings, entitled *La Féerie* (Fantasy), was rejected by the Salon and harshly criticized as having neither substance nor form.[36] This early blow to Fantin-Latour's career, together with his participation that year in the Salon des Refusés, likely reinforced Lucas's initial opinion that his paintings, especially his sketchy scenes, were not worthy of acquisition. (Indeed, Lucas never purchased any of his paintings for his own collection.)

In February 1873, Lucas purchased for Avery at the cost of 500 F a now-famous portrait of Whistler by Fantin-Latour.[37] Before shipping the portrait to its new owner, Lucas had it photographed and took the photograph to Fantin-Latour, who gave Lucas "a sketch in exchange."[38] While that "sketch" was almost certainly the hazy picture that later found a place on Lucas's wall, he initially disliked the painting and carried it from gallery to gallery in an effort to sell it. But, as he discovered, no one wanted it.[39]

By the turn of the twentieth century, his attitude about Fantin-Latour's work had changed. There was a burgeoning interest in Fantin-Latour's lithographs in America, and Avery asked Lucas to obtain as many as possible for himself and for resale to Avery's New York customers. Between 1888 and 1902, Lucas acquired over 160 lithographs by Fantin-Latour for Avery, whose avid interest influenced Lucas to acquire 84 of the artist's lithographs for himself.[40] As a result, by the turn of the twentieth century, Fantin-Latour's art had found a place in Lucas's art business and his own

A Paris Life, A Baltimore Treasure

collection. And the once-undesirable sketch of three figures in a park had become for Lucas an insignia of his own good fortune and success.

A third painting shown in Dornac's photograph—a lovely sketch by Breton of a young girl dressed in a celebratory white gown and holding a red Bible close to her heart—also came to Lucas in a roundabout way. When Lucas arrived in Paris in 1857, Breton was already a star, having received medals for his idealized paintings of rural life at the Salons of 1855 and 1857. Shortly thereafter, his fame further increased when one of his paintings was purchased by Napoleon III and another was accepted into the Luxembourg Museum. In May 1863, Lucas purchased two Breton drawings for his client William Walters. As a result, a friendship arose between Lucas and Breton that would last for more than thirty years.[41] In 1866, Lucas asked Breton to give him a work of art as a token of their friendship, and Breton agreed. "Met Breton who promised to send me my sketch," is how Lucas recorded this commitment in his diary.[42]

It was not until fifteen years later that the promise was finally satisfied. In 1881, Lucas commissioned Breton to paint a large canvas, entitled *The Communicants,* for Avery.[43] *The Communicants* depicts a young peasant girl receiving a parting kiss from her mother before leaving her family and joining a procession of uniformly dressed young people, marching to their communion at the nearby village church as if beckoned by its steeple, which can be seen in the background (plate 3). It was a visually beautiful illustration of the rural piety and high principles often encapsulated in Breton's work.[44] When the painting was completed in 1884, Lucas received from Breton the gift he had been waiting for—a small preparatory sketch of the girl in this painting (plate 4). On March 15, 1884, Lucas recorded in his diary: "got my J. Breton sketch of Communicante."[45] It was an arrangement that worked well for all concerned. Breton was paid 50,000 F; Avery got his painting, which he later resold for a profit; and Lucas finally received, free of charge, his lovely sketch to display on his wall.[46]

Among the five paintings shown in Dornac's photograph, the only one that Lucas purchased was by Daubigny. An unpretentious landscape that captures the natural beauty and simplicity of rural life, *Through the Fields* depicts the diminutive figure of a woman calmly walking alone along a path through an open field under a blue but gently clouded sky (plate 6). The attractiveness of the painting rests on its easy spontaneity, its avoidance of any slick and pretentious finish, and its use of perspective in a manner that invites the viewer to enter the picture, walk along the same road as the figure, and become closer to nature.[47]

Lucas met Daubigny in 1864 and shortly thereafter began to acquire dozens of his paintings and over four hundred of his prints. Like other wheelers and dealers in the frenzied Parisian art market, Lucas purchased some of Daubigny's paintings with the intent of reselling them to other dealers and earning a profit. Among the many paintings that went through his hands, the only one that he kept for himself was the one pictured in Dornac's photograph. Lucas appears to have purchased this painting

on March 20, 1868, at an auction at the Hôtel Drouot for the modest sum of 300 F (about $60). Because Lucas actually selected, purchased, and kept this particular painting, it—more than the other paintings shown in Dornac's photograph—likely serves as the best measure of his taste.[48]

Among the five paintings in the photograph, however, the one that Lucas loved the most was his own portrait by Cabanel (plate 7). If Lucas had a favorite painter, it was certainly Cabanel. He likely fell in love with the artist's luscious, over-the-top *The Birth of Venus,* which was the *cause célèbre* of the 1863 Salon.[49] Thereafter, he referred to Cabanel by name no less than 165 times in his diaries. Lucas knew him not only by reputation but also as an active proponent of his art. He frequented Cabanel's studio, studied his paintings, and in 1872 began to encourage his American clients, especially Walters and Avery, to purchase the artist's work.

In the summer of 1872 and again in early 1873, Lucas accompanied Avery to Cabanel's studio, where Avery purchased four paintings for 39,000 F. Lucas had the distinction of delivering to Cabanel two checks that covered most of the price of these paintings. In May 1873, Lucas also accompanied Walters to Cabanel's studio to look at his pictures and to decide which to buy. At that point, Lucas undoubtedly had proven to Cabanel that he was the fountain from which a lucrative stream of American dollars could flow.[50]

As a token of his appreciation, Cabanel agreed to paint Lucas's portrait. Under ordinary circumstances, it would have cost thousands of francs. But for Lucas, it was free. On June 8, 1873, one week after introducing the artist to Walters, Lucas spent the entire day in the studio posing for his portrait. Among the sixteen portraits that Lucas commissioned of himself, Cabanel's was the one he cherished the most.[51] Cabanel at that time was at the pinnacle of an illustrious career, during which he served as the guardian and greatest exponent of the academic and romantic painting favored in the Paris salons. He also had gained fame as a portraitist whose beautiful compositions were believed to capture the fine inner qualities, social status, and personalities of his sitters. Over the years, forty portraits by Cabanel appeared in the Paris salons, the most famous of which was his portrait of Napoleon III, which won a medal of honor at the Salon of 1865. As Lucas knew, Cabanel's portraits were in constant demand by Europe's aristocracy and America's Gilded Age millionaires, and having his own portrait in this pantheon of wealth and privilege represented the quintessential banner of his own success.[52]

In Cabanel's painting, Lucas appears exceptionally handsome and virile, with chiseled features, deep-set blue eyes, high cheekbones, and a healthily ruddy complexion complemented by aristocratic streaks of silver along the temples of his neatly trimmed hair and in his luminous full beard. In harmony with his elegant bearing are his stylish clothes: a perfectly tailored, dark gray suit with a black velvet collar, and a matching dark gray vest and light gray tie. Captured in the portrait is a fastidious attention to detail, as well as a serious air of confidence, experience, and sophistication, which, taken together, epitomized the image that Lucas wanted to present to the public. Like

the advice and guidance that he provided to his wealthy clients, there was nothing risky or nonchalant about his appearance. Not a hair was out of place; not a mark was on his face; no ruffle or blemish of any kind disturbed his composure.

Lucas was also undoubtedly delighted with the manner in which Cabanel signed and dated his portrait. Instead of signing inconspicuously at the bottom, Cabanel fixed his name in the upper right-hand quadrant, within inches of Lucas's head. The signature's placement suggested that Lucas the connoisseur and Cabanel the artist not only were closely connected but also had reached the same elevated heights in the firmament of Parisian art. This status was reaffirmed by the deferential manner in which Cabanel referred to Lucas in their correspondence. His letters concluded with sentences like "Please accept my dear sir the assurances of my most distinguished sentiments" and "Please receive my dear sir my best compliments."[53] Lucas, of course, saved these letters, recognizing that they would underscore his status with the leading artists of his day. Through his portrait by Cabanel and its display in his house, Lucas became a part of his own collection. And, as he fully realized, saving his collection for future generations was tantamount to saving a cherished image of himself.

In March 1904, Lucas sent copies of Dornac's photograph to a select group of persons and institutions in the United States whom he believed might have an interest in acquiring his collection or influencing others to do so. Among the recipients were Samuel Putnam Avery and Henry Walters, both of whom were connected to the Metropolitan Museum of Art; Lucas's niece Bertha Lucas; and the Grolier Club of New York and the New York Public Library, two institutions that avidly collected prints. Lucas made it clear that the photograph was about not just him but the art that surrounded him. On the back of the copy that he sent to the library, Lucas inscribed in pencil the names of the famous artists.

J. Breton / Study for the Communicants
Portrait GAL / by / Cabanel
Fantin-Latour . . . Courbet / d'apres nature hors ligne
Daubigny / a bijou[54]

Lucas also arranged for the photograph to be reproduced and displayed by the printer Alfred Prunaire, but this effort to publicize his collection generated little interest.[55] The only expression of interest in acquiring his art came from the French painter and sculptor Louis Robert Carrier Belleuse, who sought to purchase Lucas's bronzes by Barye. Intent on keeping his entire collection together, Lucas responded, "None of my Barye bronzes ever for sale."[56]

In retrospect, it is easy to understand why Lucas's collection attracted little attention from any potential buyers. It was not well known, and the overall quality of the paintings was not at a level that could entice any museum to consider their acquisition. The many lovely small sketches and studies by famous artists that dotted his collection of paintings were in a different league than the monumental masterpieces of French art by those same artists that were displayed in the Louvre, the Luxembourg,

and the newer art museums in Paris. Nor could Lucas's collection compete with the magnificent private collections owned by wealthy and powerful French bankers, businessmen, and entrepreneurs, such as the Rothschilds, Pourtalès-Gorgier, and Alfred Chauchard, who maintained elaborate galleries within their mansions and chateaus, and in many cases donated their collections to the Louvre or the state.[57]

The most promising home for Lucas's collection was in the United States, but he could find no museum that had any interest in acquiring it. The Metropolitan Museum's declination of a gift of seventeen thousand prints owned by Samuel Avery, an important trustee of that museum, foreclosed any possibility that Lucas's similar collection of prints would find a home there.[58] The Corcoran Museum in Washington, for which he had obtained French paintings and sculpture years earlier, had refocused its collection on American art, and the aesthetics of Lucas's collection and the Corcoran's collection no longer were aligned. The two major institutes in New York that collected prints, the Grolier Club and the New York Public Library, also expressed no interest in acquiring Lucas's collection.

The best prospect was the museum that his close friend and client Henry Walters was planning to construct to house his and his father's encyclopedic collection. The Walters Art Museum would open in 1909. Lucas tried to influence Walters to acquire his art for his new museum, but his friend had little interest at that time in nineteenth-century French prints, and Lucas's collection of paintings could not compare in quality or grandiosity with the masterpieces that he had helped the Walters family acquire. The disheartening truth was that at the turn of the twentieth century, there was no museum or collector of wealth and substance on either side of the Atlantic that had any interest in acquiring Lucas's gigantic collection of art.

In the absence of such interest, Lucas intended to leave his art to his mistress and her son, along with an endowment that would enable them to manage and preserve it. However, in July 1904—five months after Dornac photographed him—another option was presented to him. It was to leave the collection to the Maryland Institute in Baltimore following its reconstruction. Lucas, however, was reluctant to do this, and by the time the institute reopened in 1907, he still had not made up his mind.

As he struggled to decide what should be done to preserve his collection, he could not have foreseen the additional troubles that lay ahead. First, there was another fire—this time in his own apartment—and its tragic consequences. Next, there was the ensuing battle with Eugène over the ownership of the art that had been housed in M's apartment. Then, there were the obstacles that the collection would encounter upon reaching the United States. These included the inability of the Maryland Institute, despite its best efforts, to find the space and resources to care for the massive collection; the sale or mysterious disappearance of small parts of the collection; the dramatic fall in popularity of the mid-nineteenth-century artists, such as Bouguereau and Cabanel, whom Lucas had adored; the painful discovery that at least two paintings attributed to Courbet and Manet were not what they pretended to be; the belittlement of his paintings by art critics in Baltimore; and the placement

of most of his collection in storage where, for years on end, it remained in obscurity, unseen and largely forgotten.

Perhaps the greatest challenge that the collection faced was the failure to appreciate it for what it was—a collection whose importance did not rest on the merits of its individual works of art but on its value as a whole. Together, its paintings, prints, sculpture, art books, personal diary, and thousands of informative pieces of ephemera provided a unique panorama of French mid-nineteenth-century art and culture. It was a highly unusual collection that provided more of a feast for the mind than for the eyes. And in the United States, there was no other collection quite like it.

As Lucas contemplated his collection's fate, he also could not have envisioned the chain of unusual events that would save it from oblivion. Nearly a century later, his art collection would rise from relative obscurity, captivate public attention, enflame the passions of Baltimore's large and vibrant cultural community, pit friends against friends, and spark a battle that itself would become an integral chapter in his collection's remarkable history. It was a battle that was fought in a Baltimore courtroom, in the court of public opinion, and in the boardrooms of the city's great museums. The struggle engaged community leaders, the mayor, and the state's governor. It was not a simplistic battle between right and wrong or over issues that were black and white but a much more nuanced and complicated struggle that pitted the legitimate interest in preserving the collection intact for the pride, education, and culture of Baltimore against the equally legitimate interest in selling the collection for the noble purpose of allowing the country's oldest and one the finest schools of art to grow and thrive. There were no villains on either side of this battle—only intelligent, strong-willed, civic-minded leaders and their advisors, who approached the issue from conflicting points of view and had good reasons to fight for the interests they served.

As is revealed in the following pages, Lucas could not have imagined how that battle would end—with the community leaders and government officials wisely coming together, placing their competing claims aside, protecting the public interest, and saving his collection. Nor could he have imagined how the massive collection of art that once no one wanted and that relatively few ever saw would be enshrined as a cultural treasure that now carries his name.

The Cultivation of Lucas

The portraits of Fielding Lucas Jr. (fig. 13) and his wife Eliza Carrell (fig. 14) displayed in the family's Baltimore mansion served as elegant announcements of their wealth and culture. The paintings were completed in 1808 and 1810 by the famous portraitist Thomas Sully, whose subjects represented a who's who of American society in the early nineteenth century.[1] The portrait of Fielding Lucas with his hand placed affectionately on the sculpted head of a lion and that of Eliza with her hands holding an open book were evidence that painting, sculpture, and literature were not simply idle pleasures but integral features of the family's identity.

George Lucas had the good fortune to be raised in a household and city where culture mattered. The most influential person in his life was his father, Fielding, whose interest in art became the compass by which he directed his business and philanthropic activities. After arriving in Baltimore around the turn of the nineteenth century, Fielding became the owner of a stationery, art supply, and publishing business located in the heart of Baltimore's retail business district. Under his direction, the company grew into one of the largest and most prominent concerns of its kind in North America. It sold an array of art supplies and published beautifully detailed maps of Baltimore, world atlases, children's picture books, schoolbooks of all kinds, classical literature, and, most significantly, books about art. The common denominator of the books Fielding published was their appeal to the reader's intellect and love of learning. Proud of his books, Fielding used the phrase "Valuable Works" to describe them.[2]

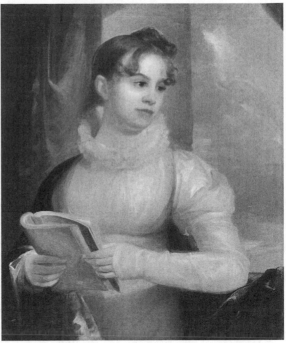

FIGURE 13. Thomas Sully, *Fielding Lucas, Jr.*, 1808. The Baltimore Museum of Art: Group of Friends Purchase Fund, BMA 1935.29.1.

FIGURE 14. Thomas Sully, *Mrs. Fielding Lucas, Jr. (1788–1863), née Eliza M. Carrell*, 1810. The Baltimore Museum of Art: Gift of Mr. and Mrs. Alan E. Behrend, Baltimore, in Memory of Jesse G. Kaufman, BMA 2001.443.

His stationery and bookstore was located at 138 Baltimore Street (then known as Market Street) in one of the most interesting and stylish buildings on the busy commercial street. To reflect his cosmopolitan taste and personal commitment to enhancing the beauty of the city, Fielding in 1816 retained John Mills, the prominent architect who had been selected to design Baltimore's Washington Monument, to rebuild the facade of his four-story book and stationery store (fig. 15).[3] Modeled after a prominent bookstore in London, the inviting entrance to Fielding's store was flanked by bow windows that displayed the books and products available for purchase. Even more interesting was the artfully designed, large oculus in the first floor's ceiling which revealed the second floor, provided an illusion of spaciousness, and invited customers to explore the products upstairs.[4] The elegant yet practical design of Fielding's store conveyed that good art, good books, and good business could fit neatly together, a lesson that became inscribed in the consciousness of Fielding's son George.

The success and growth of Fielding Lucas's stationery and publishing business was emblematic of the burgeoning growth of the city in which it was located. At the turn of the nineteenth century, when Fielding arrived in the city, Baltimore was a small

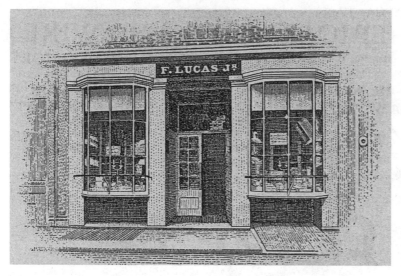

FIGURE 15. Fielding Lucas's Stationery Store on 138 Market Street (Renamed Baltimore Street), c. 1816. Pictured in "The Oldest Stationery Store in America," *Baltimore*, April 1931.

provincial town with a population of only 27,000 people. By 1810, the population had nearly doubled to 47,000. In 1816, the city's boundaries were extended to encompass the rolling hills to the north and to capture more of the vital inner harbor to the east and west. By the 1820s, Baltimore had become the fastest-growing city in the country as its population spiraled upward. Due in large measure to its large deepwater harbor, its ship-building industry, its commercial banks, and the establishment of the Baltimore and Ohio Railroad (the first public railroad in the United States), Baltimore became one of the nation's principal centers of commerce and trade—the midway point between the North and the South and the entranceway into the West. By 1850, Baltimore's population reached 169,000, exceeding that of Boston and Philadelphia. The city had evolved into a beautiful midcentury metropolis, whose center was punctuated with exquisite churches and monuments and surrounded by gentle hills embracing well-maintained estates and elegant homes that were the envy of the nation.[5]

As the city grew, so did its citizens' interest in art and architecture. At first, the most popular art form was drawing. By the early nineteenth century, drawing, like baseball later, had become for many the national pastime. It was taught in school, by artists in their studios or private drawing rooms, and through a profusion of popular how-to-draw books. Its popularity was based on the theory, advanced by Charles Willson Peale, that "any man of intelligence could become an artist."[6] His son Rembrandt Peale, who resided off and on in Baltimore between 1796 and 1824 and was a dominant force in shaping the city's culture, equated drawing with writing and advocated that both should be taught together. In his own drawing book, called *Manual of Drawing and Writing for the Use of Schools and Families,* Peale wrote, "Drawing, the simplest of languages, is understood by all. . . . Every one that can learn to write is capable of learning to draw; and everyone should learn how to draw that can find

A Paris Life, A Baltimore Treasure

advantage in writing." To encourage everyone to draw and, of course, to buy his book, Peale placed one word in bold letters on the book's cover page: "Try."[7]

By 1830, over twenty manuals on drawing were available in Baltimore, but none could compare in beauty or quality to the three published by Fielding Lucas.[8] These featured picturesque landscapes and emphasized the underlying importance of drawing in their creation. One was fittingly entitled *The Art of Drawing Landscapes,* and the other, *A Practical Treatise on Perspective Adopted For Those Who Draw from Nature.* Both were published in 1820 and richly illustrated with prints by the acclaimed English engraver John Hill.[9]

Fielding Lucas's most famous publication, however, was the *Progressive Drawing Book,* published in 1827 (plate 5). Its seductive title page drew the reader in with a picture of a palette, paintbrushes, and a framed painting of a river flowing from its mountainous source through the wild countryside. The picture implicitly carried the message that you—the person who acquired this book—could paint like this, too. The book provided detailed instructions about drawing, painting, and perspective which were borrowed from a treatise written by the English watercolorist John Varley. The *Progressive Drawing Book* also featured hand-colored aquatints of American landscapes by John H. B. Latrobe, who initially worked for and then became a life-long friend of Fielding Lucas.[10] Because of the beauty and quality of Latrobe's illustrations, the *Progressive Drawing Book* carried the hefty price of $12, roughly $300 today. Many considered *The Progressive Drawing Book* the finest art manual printed in the United States during the first half of the nineteenth century; according to one connoisseur, it belonged in "every gentleman's library."[11]

Fielding or Eliza Lucas doubtless showed these three art books and their picturesque landscapes to their son George during his formative years. They would have served as the foundation of his art education, fixing in George's young mind a life-long affection for drawings, prints, and landscape paintings and giving him a remarkable head start in the field of art appreciation and collecting, where his name ultimately would be remembered long after his father's.

There are no extant diaries or other documents written by or specifically about George Lucas during his childhood and teenage years in Baltimore.[12] However, the shape of his early life can be imagined based on our knowledge of the art, culture, power, and wealth that surrounded him. George Lucas was born in Baltimore on May 29, 1824. He was raised among six brothers and two sisters in the family mansion located at the northeast corner of Saratoga and St. Paul Streets in the center of the city's most beautiful and culturally vibrant neighborhood.[13] In retrospect, there was no more conducive place and time for instilling in young George an appreciation for fine art. As he matured, he witnessed firsthand Baltimore's cultural awakening. Beyond the paintings on the walls and the art books on the shelves of the house where he was raised, George was nurtured by the art that he saw in the city's earliest galleries, the monuments and magnificent buildings that arose on the streets around him, the French language and culture that was at the core of his formal education,

and the institutions of fine art and education that were promoted by his father and shaped the character of the city. The image of Baltimore as one of the nation's earliest centers of culture was engraved on his mind and contributed to his decision many years later to bequeath his collection to the city where he was born and raised.

From the activities of his father, George Lucas learned about the vital role of businessmen, art collectors, and philanthropists in creating an environment where culture could flourish. In one of the earliest books about the history of Baltimore, published one hundred years ago, the author focused on a circle of businessmen and community leaders who promoted Baltimore's early growth and interest in art. He referred to them as "merchant princes" and compared them to the Medici of Florence.[14] Fielding Lucas was one of these princes. He not only owned and managed a beautifully designed and highly profitable art-supply and book-publishing business, he had his own diverse collection of fine art.[15] More importantly, he played a leading role in the governance of the city, serving as both president of the city council and president of Baltimore's school board. At the same time, he was instrumental in establishing several of the city's cultural landmarks, including the Washington Monument, the Maryland Historical Society, and the Maryland Institute for the Mechanical Arts (now known as the Maryland Institute College of Art or MICA).

Many years later, in 1935, Sully's portrait of Fielding Lucas was given to the Baltimore Museum of Art (BMA). It was an important event, publicized by the BMA in the *Baltimore Sun* and elsewhere. Having moved just a few years earlier into its permanent neoclassical home designed by John Russell Pope, the BMA employed Fielding's portrait and references to his generosity as a reminder to the museum's first generation of donors of the importance of private support. The *Sun* article showed the portrait, praised Fielding's remarkable career, and identified him in its headline as "A Baltimore Pioneer in the Arts."[16] No one could have then imagined that Fielding Lucas's portrait one day would be joined in the BMA collection by a portrait of another pioneer in the field of art, his son George, and the eighteen thousand works of art that he had acquired.

◆ ◆ ◆

Around the turn of the nineteenth century, Baltimore became a magnet for artists and architects who hoped to display their talents and tie their fortunes to the city's growing economy. The widespread interest in drawing and the notion that anyone could become an artist motivated local and itinerate artists to open small painting and drawing rooms in their homes or in neighborhood bars and coffee houses where they taught drawing, painted portraits, and marketed their own art. Charles Peale Polk, the nephew of Charles Willson Peale, came to Baltimore in 1791. Using his home, located at Frederick and Water Streets, as a drawing school and show room, he became one of the city's favorite portrait painters. Francis Guy arrived in Baltimore in 1795 and taught himself to paint; soon he was specializing in landscapes of the beautiful

grounds and properties owned by the wealthy. But the most influential and well-known artist who arrived in the city around that time was Rembrandt Peale.[17]

In June 1796, Rembrandt Peale and his brother Raphaelle came to Baltimore for the purpose of opening the city's first museum. They moved into the house that had been Polk's residence and studio, and on October 25, 1796, placed an advertisement in the *Federal Gazette and Baltimore Daily Advertiser.*

> The Public are respectfully informed that Raphaelle and Rembrandt Peale, late of Philadelphia, have collected a number of articles of Natural and Artificial production [and] together with their paintings, they have opened rooms at their house in Frederick Street next door to the s.w. corner of Water Street (adjoining the house where Mr. C.P Polk formerly kept his exhibition room) under the title of Baltimore Museum. . . . The collection contains at present fifty-four portraits of illustrious persons: men who have distinguished themselves in the American revolution both as statesmen and warriors . . . [and] a variety of miscellaneous portraits and pictures, besides upwards of two hundred preserved birds, beasts, amphibious animals, fishes & Indian dresses and ornaments.[18]

The advertisement concluded with the enticement, "The rooms are always open—Admission one quarter of a dollar each time—children half price."

This initial venture by the Peale brothers to open a museum in Baltimore lasted only one year. But in June 1804, Rembrandt Peale returned to try again. With the assistance of the city's first mayor, James Calhoun, he was able to lease space in the elegant two-story City Assembly Room located on the corner of Fayette and Holliday Streets. The main attraction this time was the large mammoth that in 1801 had been exhumed by Peale's father and previously shown to enthusiastic and inquisitive audiences in Philadelphia and abroad. To attract a similar audience in Baltimore, Peale again advertised in the *Federal Gazette,* this time trumpeting the mammoth as "the most extraordinary natural curiosity the world has ever seen." The strangeness and scientific qualities of the mammoth overshadowed what was intended as modern art—a novel machine called a physiognotrace, which was capable of tracing the profiles of the gallery's visitors. Despite the hype, the new exhibition flopped, and the operation was closed within a month.[19]

Ten years later, in 1814, Rembrandt Peale returned to Baltimore yet again with a much more ambitious and culturally enriching agenda. It featured fine art as well as natural history and had the lofty objective of elevating the taste while educating the public. With the financial support of the Baltimore business community, Peale constructed the first permanent museum in the United States (fig. 16). Calling it the "Baltimore Museum and Gallery of Paintings," he described it as "an elegant rendezvous for taste, curiosity and leisure."[20] He credited the people of Baltimore as having the "liberality" and "spirit for improvement" that attracted him to the city, and he remarked that "in making a choice of Baltimore for his permanent residence, he was

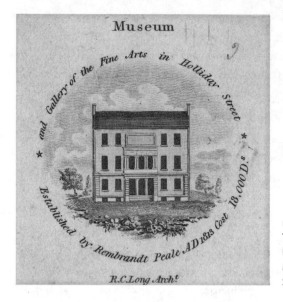

FIGURE 16. *The Peale Museum.* Detail from *The Plan of the City of Baltimore,* 1823. Engraved by J. Cone. Baltimore City Life Museum Collection, Maryland Historical Society.

influenced not only about the amount of its population but by the acknowledged spirit and liberality of a principal portion of its inhabitants. The rising generation, surrounded by the most extraordinary operations of individual and collective industry, have incorporated in their natures a spirit for improvement which must raise Baltimore to the foremost rank amongst cities."[21]

Although Peale continued to exhibit the bones of the mammoth and other oddities, his museum featured on its second floor a spacious picture gallery designed exclusively for fine art. The gallery initially displayed forty to fifty portraits of American heroes, painted by Peale and his father, but it evolved into a space that featured some of America's finest contemporary painters, including Benjamin West and John Vanderlyn, whose nude painting of *Ariadne Asleep on the Island of Naxos* reportedly drew nearly one thousand visitors. While still charging an admission fee of twenty-five cents, the new Peale Museum—as it was then called—convinced Baltimoreans that fine art was an elevated form of entertainment well worth the price of admission.[22]

After operating his museum for eight years, Rembrandt Peale resigned and left the museum to his younger brother, Rubens. Under Rubens's direction, the Peale Museum continued to display all sorts of curiosities, including wolves, rattlesnakes, bears, and other wild animals that often caused the space to look more like a menagerie than a museum. On a higher level, he also initiated the idea of sponsoring large annual exhibitions of contemporary and allegedly old master paintings that were owned by local collectors.[23] This idea was subsequently adopted by a succession of Baltimore art institutions—including the Maryland Academy for the Fine Arts, the Maryland Institute, the Picture Gallery of the Maryland Historical Society, and the Peabody Art Gallery—whose exhibitions enabled Baltimore's upper crust, including

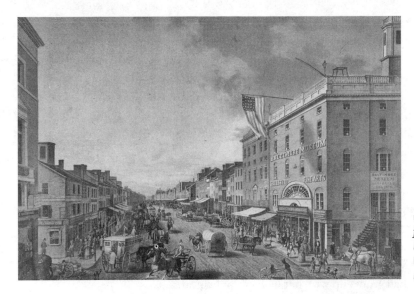

FIGURE 17. *Baltimore Street Looking West from Calvert Street (Showing Baltimore Museum)*, c. 1850. Lithograph printed by E. Sasche & Co. Large Prints Collection, Maryland Historical Society.

the Lucas family, to show off their art and involvement in culture as a symbol of their prosperity.[24]

In January 1830, the Peale Museum moved from Holliday Street to a large four-story red-brick building that had recently been constructed at the corner of Baltimore and Calvert Streets in the heart of Baltimore's busy commercial district just a block away from Lucas's store (fig. 17). No one could suggest that the museum was hard to find. Prominently displayed on the facade was a large white sign proudly announcing that the building housed the "Baltimore Museum & Gallery of Fine Arts." An enormous US flag was extended from the top of the museum over the downtown sidewalk, as if to suggest that Baltimore's love of art had become interwoven with the love of America.

The Peale Museum and Gallery of Fine Arts—as it was then called—was located on the building's two upper stories, where it displayed portraits and landscapes, offered cutout profiles to its visitors, and tried to marry music with art and elevate the taste of the community by sponsoring concerts. On January 6, 1830, shortly after moving to this location, the Peale Museum advertised that it had "engaged a celebrated performer on the violin . . . who will perform to the lovers of fine music a great treat." Hoping to capitalize on its new location and a variety of new cultural events, the museum proposed year-long memberships, offering to admit an entire family for $10 per annum and "a gentlemen and lady" for just $5.[25]

Although the museum closed in 1833, the influence of the Peales on Baltimore's culture was perpetuated by another member of the illustrious family, Sarah Miriam Peale. A younger cousin of Rembrandt and Rubens, Sarah Peale came from Philadelphia in 1818 to study painting under Rembrandt's guidance. Using a space in the Peale Museum as her studio, she displayed her paintings at the annual exhibitions

orchestrated by Rubens, and achieved a measure of fame in 1824 by convincing the Marquis de Lafayette during his triumphal tour of America to allow her to paint his portrait. In 1825, Sarah Peale became a permanent resident of Baltimore, and during the next two decades, she painted more portraits of its upper-class citizens and other dignitaries than any other artist. Today, she is remembered as the "first professional woman artist in the United States."[26]

After the Peale Museum closed, Sarah Peale established her own studio on the corner of Fayette and Holliday Streets, just four blocks away from the Lucas home. It is unclear how long she and Fielding Lucas were acquainted, but it is believed that sometime between 1835 and 1840, Lucas commissioned her to paint his portrait.[27] This portrait joined the earlier ones by Thomas Sully and reinforced in the Lucas household the importance of fine art, especially portraiture. Many years later, after moving to Paris and becoming absorbed in French art, George Lucas acquired his own painting by Sarah Peale—a copy of her self-portrait that served to remind him of the art that he had grown up with but had left far behind.[28]

While the museums operated by members of the Peale family were for many years the principal cultural attraction in the city, the greatest private art collection in Baltimore—and arguably anywhere in the country—during the first half of the nineteenth century belonged to Robert Gilmor Jr. A wealthy and cosmopolitan collector and patron of the arts, Gilmor had enjoyed a European education and cultivation in Paris, especially at the Louvre—which Gilmor described as "my academy." This experience had shaped his exquisite and discriminating taste for fine art. At his Baltimore townhouse on Water Street and at Beech Hill, his family's summer estate located in the western outskirts of the city, Gilmor amassed a large and encyclopedic collection of art and a library of hundreds of books. His art collection featured Flemish and Italian old masters, a celebrated landscape by Claude Lorrain, a painting entitled *The Finding of Moses* and attributed to Nicolas Poussin, rare illuminated manuscripts, Roman sculpture, a copy of Gilbert Stuart's famous portrait of George Washington, portraits of Gilmor and his wife by Sir Thomas Lawrence, and another portrait of Gilmor by Sully (fig. 18). He also owned a wide selection of contemporary American paintings, including landscapes by Thomas Cole, Thomas Doughty, and Francis Guy and genre scenes by Washington Allston and William Sidney Mount.[29]

Along with the Peale Museum, Gilmor's art collection provided the growing city of Baltimore with the cachet that attracted famous visitors. Both sites were on the itinerary of the Marquis de Lafayette during his visit in 1824. Lafayette's private secretary, Auguste Levasseur, described the Peale Museum and Gilmor's collection as "beautiful" and suggested that they contributed to the overriding impression that Baltimore's inhabitants had "a pronounced taste for the fine arts."[30]

A glimpse of Gilmor's collection was provided in 1834 by the American sculptor Horatio Greenough, who had been invited to Gilmor's home to sculpt a bust of his wife. "I work in Mr. Gilmor's library finished in Gothic style receiving the light through a painted window," he wrote: "The air of art is all around me. Exquisite pic-

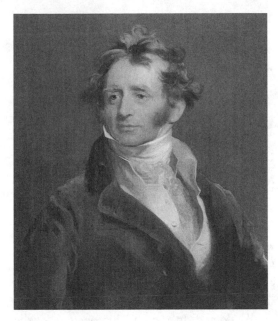

tures of Italian and Flemish masters fill the compartments between the bookcase: books of prints load the side tables; little antique bronzes, heads, and medals crowd each other on the mantle-piece."[31]

Although Gilmor and George Lucas were a generation or two apart (Gilmor was fifty years old in 1824 when George was born), Gilmor's accomplishments and his collection were well known to George. For over twenty years, Fielding Lucas and Robert Gilmor were friends and associates. They shared an avid interest in art—Gilmor as the city's preeminent collector and Lucas as the preeminent publisher of books about art—as well as an interest in using their wealth and knowledge about art for the benefit of the public. Lucas and Gilmor served together on the Board of Managers of the Washington Monument for over ten years and were two of the founders of the Maryland Historical Society.[32]

Fielding Lucas venerated Gilmor, and as a public expression of his friendship and admiration, he dedicated his *Progressive Drawing Book* "To Robert Gilmor, Esq." The book's first page read, in part, "The dedication which is the result of private friendship ... is made to acknowledge talent, taste and information, [which] can be regarded only as the tribute which those qualities are entitled to receive."

Gilmor hoped that his collection would encourage other Baltimoreans to follow in his footsteps. In 1837, while reflecting upon the strengths and weaknesses of his collection and what he paid for his art, he wrote, "if mine only stimulates my countrymen to cultivate a taste for the Fine Arts I shall be well compensated for my expense in making it even such as it is."[33] To this end, Gilmor made sure that his collection was well known. He carefully documented his acquisitions and published a catalogue in 1823; he opened his home and showed his collection to friends, artists, and other

patrons of the arts; and he loaned dozens of his works for display at exhibitions at the Peale Museum and the Maryland Historical Society. In general, Gilmor became the city's most venerated connoisseur and promoter of fine art and the model for the nineteenth-century collectors, including George Lucas, who followed him.[34]

<p style="text-align:center">◆ ◆ ◆</p>

While the Peale Museum and the Gilmor collection set an early standard for fine art in Baltimore, new construction was converting the once-rustic town into an architectural showcase. During the first quarter of the nineteenth century, one new structure after another arose in the center of the city.[35] Their beauty and ingenuity were due in large measure to three of the country's most distinguished architects—Benjamin Latrobe, Maximilian Godefroy, and Robert Mills—who converged on Baltimore and designed scores of buildings that still rank high among the city's celebrated structures.[36]

In 1806, construction began on Latrobe's magnificent St. Mary's Basilica, the first Roman Catholic Cathedral in the United States (fig. 19). Hailed as Latrobe's most important work in America, the basilica was designed in the form of a spacious Latin cross with a great, coffered, Pantheon-like dome.[37] In 1808, within one mile of the basilica, the French architect Godefroy designed St. Mary's Chapel, a small Gothic church located on the recently established campus of St. Mary's College, where George Lucas as well as his brothers went to school (fig. 20). In 1809, at the corner of Calvert and Lexington Streets, a block from the Lucas home, a large decorative new courthouse was constructed, featuring tall Ionic pilasters, arched windows, and an eye-catching cupola encircled by a colonnade that symbolized the building's public importance.

In 1815, on the wooded summit of the tallest hill near the northern edge of the city, the cornerstone was laid for Baltimore's Washington Monument, the first monument to George Washington erected in the country (fig. 21). In recognition of Fielding Lucas's role in the creation of this monument, a small book published by him and bearing his name was enshrined in the cornerstone. Designed by Robert Mills in the form of a Roman celebratory monument, Baltimore's Washington Monument would tower over the city and serve as its principal landmark; the grounds around it would be transformed into Mount Vernon Place, one of the most elegant urban settings in the country.

Also in 1815, construction began on the complex, thirty-nine-foot-tall Battle Monument, at the top of which stood a marble statue of Lady Baltimore wearing a crown of victory and holding a laurel wreath of peace (fig. 22). Designed by Godefroy, the monument commemorated the heroism of the thirty-nine Baltimoreans who died in the War of 1812. Located on Calvert Street one block south of the courthouse, the square and grounds around the monument served as a promenade and fashionable meeting place for the city's residents.

And in 1824, the year George Lucas was born, Baltimore's first athenaeum was constructed (fig. 23). Only a stone's throw from the Lucas home, it was designed as a

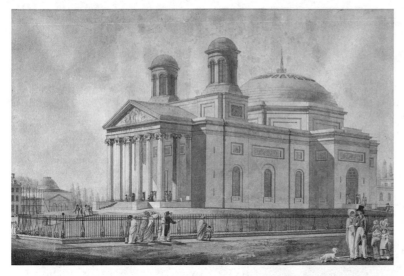

FIGURE 19. Benjamin Henry Latrobe, *Basilica Cathedral, Baltimore,* 1805. Museum Department, Maryland Historical Society.

FIGURE 20. Maximilian Godefroy, *Front of the Chapel of St. Mary's Seminary at Baltimore,* 1807. Museum Department, Maryland Historical Society.

neoclassical building with rows of semicircular arched windows. In 1825, the athenaeum became the home of the newly established Maryland Institute, where the teaching of mechanical skills was combined with the teaching of science and philosophy. To satisfy the broader community's taste for culture, the Maryland Institute initiated a series of lectures on art, music, history, and literature. Its drawing room remained open in the evenings, and models were employed to aid in the instruction. After helping to found the Maryland Institute, Fielding Lucas donated his money and time to assure its success, serving as its vice president and chairman of its board of managers. Although George Lucas did not attend the Maryland Institute, his father's important connection to this school was never forgotten.[38]

FIGURE 21. Robert Cary Long Jr., *Washington Monument and Howard's Park*, c. 1829. Museum Department, Maryland Historical Society.

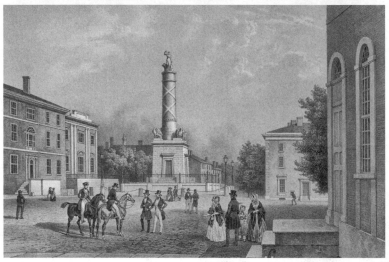

FIGURE 22. Aug. Kollner, *Battle Monument, Baltimore*, 1848. Lithograph by Deroy. Special Collections, Maryland Historical Society.

On October 14, 1827, President John Quincy Adams visited Baltimore and was given the grand tour. He visited Latrobe's basilica, St. Mary's College, the Washington Monument, and the Battle Monument. That evening, following a reception, President Adams made a toast to Baltimore that is enshrined in the lore of the city's history. "The monumental city," is how he referred to Baltimore: "May the days of her safety be as prosperous and happy, as the days of her dangers have been trying."[39]

By the 1830s, the city skyline, punctuated with tall church steeples, monumental columns, and spacious domes, began to capture the imagination of artists who envisioned Baltimore as a descendant of the old world's most beautiful cities. In a drawing by William H. Bartlett published in the 1830s, Baltimore was pictured as a new ver-

A Paris Life, A Baltimore Treasure

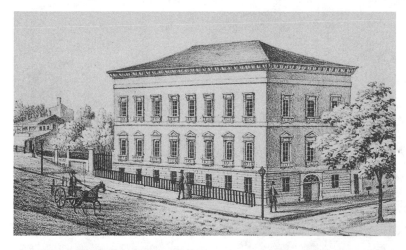

FIGURE 23. *Athenaeum, St. Paul Street and Saratoga Street, Baltimore,* c. 1850. Small Prints Collection, Maryland Historical Society.

FIGURE 24. *View of Baltimore,* 1839. Lithograph by William H. Bartlett. Hambleton Print Collection, Maryland Historical Society.

sion of the ancient seaside city of Constantinople, with the metropolis set on a gentle hill sloping down to the smooth waters of its inner harbor, and with the domes of its basilica and the Baltimore Exchange, as well as the skyscraping Washington Monument, dominating the landscape (fig. 24).[40]

FIGURE 25. *Barnum's City Hotel. Fayette and Calvert Streets, Baltimore, 1850.* Lithograph by E. Sachse & Company. Hambleton Print Collection. Maryland Historical Society.

In 1832, the English novelist Frances Trollope wrote a description that mirrored the lines of Bartlett's drawing. She wrote, "Baltimore is, I think, one of the handsomest cities to approach in the Union. The noble column erected to the memory of Washington, and the Catholic Cathedral, with its beautiful dome, being built on a commanding eminence, are seen at a great distance. As you draw near, many other domes and towers become visible, and as you enter Baltimore-street, you feel that you are arrived in a handsome and populous city."[41] Baltimore by the early 1830s had become a major tourist attraction. Its popularity was reflected in the construction of the spacious and luxurious Barnum's City Hotel (fig. 25). Occupying an entire block near the Battle Monument on Calvert Street, the hotel claimed to have the capacity to house over four hundred guests. In March 1842, Charles Dickens stayed there, met with the American author Washington Allston over mint juleps, and reportedly praised the hotel as one of the most luxurious in America.[42]

Anticipating the continued flow of visitors, Fielding Lucas published in 1832 the first guidebook to the city, *Picture of Baltimore*.[43] Its 249 pages provided a brief history of Baltimore and featured dozens of illustrations drawn by John Latrobe of the city's principle buildings, a map showing their locations, and directions to find them. Besides the major monuments and buildings, there were dozens of other places to visit, and as the guidebook suggested, "three days may be very well spent in Baltimore" to see them all.[44]

George Lucas was eight years old when his father's guidebook of Baltimore was published. The classical buildings and monuments praised by President Monroe, written about by Trollope, and charted in his father's book were all around him. Whichever way he walked upon leaving his home at the corner of St. Paul and Saratoga Streets, he would have seen the beautiful buildings that made Baltimore one of the country's leading tourist attractions. Just a few blocks north of his house were St. Mary's Basilica and the Washington Monument. St. Paul's soaring steeple was only one block west, the athenaeum one short block south, and the courthouse, the Battle

Monument, and Barnum's Hotel two to three blocks southeast. The Baltimore Museum of Fine Art, his father's office on Baltimore Street, the Baltimore Exchange, and the old Peale Museum were a few more blocks away. Further afield but still within easy walking distance was the campus of St. Mary's College and St. Mary's Chapel. One can easily imagine George being led by his father on his own personal tour of these extraordinary buildings and climbing the 228 steps to the top of the Washington Monument to look out over the domes and soaring steeples of the monumental city that Fielding Lucas had shaped and then described in his books and maps.

This was the city that George Lucas liked to remember. It was a city rich in culture and steeped in a tradition of art and architecture. After moving to Paris, he retained among his works of art a large map of Baltimore, likely published by his father, that showed the magnificent buildings and monuments that served as his unusual playground and contributed to his early cultivation.[45]

◆ ◆ ◆

While George Lucas inherited an appreciation of art and architecture from his father, his interest in French art and his fluency in the French language were the products of the unusual camaraderie that evolved during the eighteenth and early nineteenth centuries between waves of eminent French visitors and immigrants, and the upper-crust residents of Baltimore. The link was initially forged in 1755 during the French and Indian War, when approximately nine hundred French Acadians were expelled by the British from their homes in Nova Scotia and sought refuge in Maryland. A small group of these Acadians settled in Baltimore and established a Catholic parish on Charles Street near the harbor in an area that became known as "French Town."[46]

The connection between Baltimore and France grew closer during America's War of Independence. In April and September 1781, French troops under Lafayette's command were stationed in Baltimore on their way to the triumphant battle of Yorktown that concluded the war. They were admired by the leading citizens of Baltimore, who allowed the French officers to reside in their homes and contributed money for their support. In November 1781, after the war was over, Lafayette and many of his troops returned to Baltimore. As one historian phrased it, their "social life had never been better." They were wined and dined and honored at galas and balls. The French officers admired the beautiful young women they met while in the city. "I must say," wrote one French officer, "the women of Baltimore have more charm than the rest of the fair sex in America. . . . Many are to be seen with slender figures perfect in form . . . They arrange their hair with infinite taste and attach great importance to French fashions."[47]

Following America's victory over the English, Lafayette became a national hero in Baltimore and throughout the United States. In 1824 (the year of George Lucas's birth), Lafayette, at the invitation of President Monroe, visited the United States and spent five days in Baltimore, where he was treated as royally as if he were a king. He

entered the city through a triumphal Roman arch erected in his honor and was welcomed by a beautiful assembly of "24 girls clad in white ... [who] placed wreaths around his neck, and crowned him with laurels [while] ... the sound of cannon mixed with the acclamations of the multitude." Lafayette adored Baltimore, and the feeling was mutual. He and his heirs were made honorary citizens of Maryland, several streets in Baltimore were renamed after Lafayette, and plans were made to erect an equestrian statue in his honor which would be placed near and symbolically connected to the Washington Monument.

His secretary Levasseur (and presumably Lafayette himself) reciprocated by showering praise on the place, which he called "one of the prettiest cities in the Union." Of its residents, he wrote, "The inhabitants of Baltimore appear in general to have a pronounced taste for the fine arts," and he perceptively observed that the city's Washington Monument resembled the "Place de la Vendôme in Paris." Further equating Baltimore to Paris, he continued, "It is difficult to do justice to the elegance and refinement of the inhabitants of this city, in which one finds the agreeable conjunction of American freedom and French grace."[48]

Among the variables that influenced Lucas to leave his hometown at the age of thirty-three and reside for the rest of his life in Paris, it is hard to say how much weight should be given to Baltimore's affection for Lafayette and its residents' warm feelings toward France. Clues can be found, however, in Lucas's diary, in which he referred to Lafayette no less than twenty-five times. In 1825, a portrait of Lafayette (fig. 26) by the acclaimed Parisian artist Ary Scheffer was acquired by the US House of Representatives and mounted in its chambers. In 1870, after settling in Paris, Lucas acquired an engraving of this portrait. He subsequently obtained a second engraving, a bronze bust of Lafayette, a medallion that carried Lafayette's portrait, and documents related to him. Whether viewed as art or amulets, Lafayette's image must have occupied practically every room of Lucas's home. Even when Lucas was approaching the age of eighty, he would still scamper across Paris to see the latest sculpture or picture of his hero.[49]

If Lucas ever deified anyone, it was not any painter, dealer, or collector, but the French general who constructed the bridge of friendship between Lucas's native country and France. Hoping to associate his own name with Lafayette's, in 1893, Lucas presented a gift of Lafayette memorabilia to the Metropolitan Museum of Art. The strategy worked. In the museum's *Annual Report of the Trustees,* Lucas's and Lafayette's names were permanently linked together. "George A. Lucas," the report stated, had donated a "bronze gilt statue of Lafayette ... [and] bronze gilt medallion of Lafayette."[50]

There was another connection between France and Baltimore. At the turn of the nineteenth century, a new and highly influential group of French-speaking immigrants had arrived in the city. Prompted by the selection of Baltimore as the first Catholic Diocese in the United States and John Carroll as its first bishop, a small group of priests from the French Society of Saint-Sulpice came in July 1791 for the

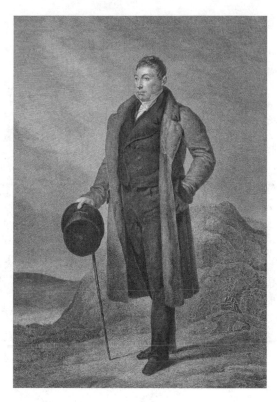

FIGURE 26. Jean Marie Leroux, After Ary Scheffer, *Lafayette*, 1824. The Baltimore Museum of Art: Garrett Collection, BMA 1984.81.1518.

purpose of recruiting and training young men to enter the priesthood. At the northwestern edge of the city, they founded St. Mary's Seminary, the first seminary in the United States. Due to the small number of students who were ordained, however, a decision was made in 1804 to convert the seminary into a college and to open it to all male students regardless of religion. In the following year, the Maryland legislature authorized St. Mary's College to grant degrees in the fields of arts and sciences and the liberal arts. It quickly became the principal institute of higher learning in Baltimore.[51]

St. Mary's College was located on seven beautifully maintained acres near the corner of Paca and Franklin Streets (fig. 27). Initially, almost all of the officials, professors, and teachers were from France. Godefroy taught a course on graphic arts and, inspired by French architecture, designed the school's beautiful Gothic chapel. A small symmetrical French garden composed of well-trimmed evergreen trees and closely clipped boxwood hedges provided a sense of formality. The students, who were called "scholars," were required to dress uniformly in stylish blue coats with gilt buttons, black velvet capes, and brown or blue cloth pantaloons, as if in unison they had left a French military academy, sailed across the ocean, and entered a French colony called Baltimore.

The curriculum at St. Mary's College was modeled after the academic programs of French colleges. It emphasized the reading and appreciation of classical literature.

FIGURE 27. St. Mary's College, Baltimore, c. 1851. Archives, St. Mary's Seminary and University.

Students read Ovid, Cicero, and Virgil in Latin; Socrates, Plato, and Homer in Greek; and Rousseau in French. The college maintained a library of over fourteen thousand volumes, most of which were in these foreign languages. The appreciation of art was a key component of the college's educational program; one commencement address was titled "The Art of Painting." Naturally, the study and mastery of French were required of all students. Even during their leisure time outside the classroom and on the grounds of the college, the students were encouraged to converse in French. Thus, the campus of St. Mary's College was as close in culture and appearance to being a part of Paris as anything in Baltimore. And it became the place where the well-heeled sons of Baltimore's establishment, including the sons of Fielding Lucas, went to school.[52]

The influence of the French on Baltimore was reinforced by one of St. Mary's most famous students—Jèrôme-Napoleon Bonaparte, son of Emperor Napoleon's brother Jèrôme Bonaparte and his beautiful and wealthy Baltimore wife Elizabeth "Betsy" Patterson. In October 1803, Jèrôme Bonaparte, then a nineteen-year-old officer in the French navy, had come to Baltimore to join French friends and partake in the city's lively social life. He met eighteen-year-old Betsy Patterson, they were married on Christmas Eve of that year, and eighteen months later Jèrôme-Napoleon was born. Although Jèrôme returned to France and his marriage to Betsy was annulled

A Paris Life, A Baltimore Treasure

at the insistence of his brother, Betsy and her son remained in Baltimore. Jèrôme-Napoleon graduated from St. Mary's College in 1817, and as a reflection of his continuing prestige among the upper crust in Baltimore, in 1857 he became the first president of the city's elite Maryland Club. Ascending to much higher ranks, his son Charles Joseph Bonaparte later became secretary of the navy and then US attorney general under President Theodore Roosevelt.

The records of St. Mary's College indicate that most, if not all, of Fielding Lucas's sons attended college there. The oldest son Edward was enrolled around 1820; John Carrell, in 1822; Henry, in 1834; and William Fielding around 1838. Following in the footsteps of his older brothers, George enrolled in 1840 and remained there for four school years (1840–44). During this period, most of his professors were French, and the courses he took were rich in the humanities. Lucas studied French, Greek, Latin, Spanish, moral philosophy, political economy, history, natural history, mathematics, and, of course, drawing and painting. He excelled in languages and math.[53]

By the time of his graduation from St. Mary's College in 1844, Lucas had become fluent in French, well read in the classics, and as knowledgeable about art as any young American man could be. Only twenty years old, he left Baltimore and embarked on a thirteen-year odyssey along the eastern coast of the United States that, despite his excellent education, was as emotionally rough and uncertain as his earlier life had been refined and secure.

The Wandering Road to Paris

Although a champion of the arts, Fielding Lucas had other ideas about a career for his son George. He wanted him to enroll as a cadet at the United States Military Academy at West Point. The attraction of West Point in the 1840s did not rest solely on the patriotic desire to serve the country in combat. West Point had evolved into one of the country's most revered schools of higher learning, where cadets were required to become not only proficient in the use of muskets, mortars, sabers, and rapiers but also knowledgeable in mathematics, engineering, and French and skillful in drawing and painting.[1]

Modeled after the engineering program of the Parisian L'École Polytechnique, West Point in the early 1800s initially retained French professors and artists to teach French and drawing. In 1833, the academy strengthened the quality of its art courses by hiring Robert Weir to serve as professor of drawing. Well known for his paintings of historical events, Weir saw his reputation firmly established in 1844 when his work *The Embarkation of the Pilgrims* was permanently installed in the Rotunda of the US Capitol. Under the program developed for the Military Academy by Weir, cadets were required during their second year to spend two hours each day sketching or painting landscapes and human figures and studying the use of perspective, color, shading, and shadows. To encourage cadets to sharpen their artistic skills, Weir displayed his own paintings at the academy and set aside a room for the exhibition of the best student work. While aesthetics played a role, the primary reason for teaching cadets to draw and paint was the more vital need for command-

ers to be able to accurately convey battlefield information by the means of these skills during times of war.

Fielding Lucas was well aware of the benefits of a West Point education. His life-long friend John H. B. Latrobe had attended West Point between 1818 and 1821 before becoming employed as an artist in Fielding's book-publishing company.[2] By 1840, Latrobe had embarked on an illustrious career as an artist, legal scholar, inventor, and public servant—as close to the proverbial "Renaissance man" as Baltimoreans would ever know. Believing that West Point had been an important stepping-stone in Latrobe's remarkable career, Fielding Lucas wanted his son George to follow the same path.

In 1842, when George was eighteen and still enrolled at St. Mary's College, Fielding undertook the task of obtaining his admission to West Point. It was not easy. West Point admitted around fifty applicants each year—one cadet from each congressional district—and an applicant needed the recommendation and political support of his congressmen. Although Fielding obtained the necessary political endorsements in 1842, there was no opening available at that time. The next year, George joined his father's effort and took the initiative of going to Washington to meet face to face with Secretary of War James Madison Porter for the purpose of "pressing my application for appointment to West Point."[3] These efforts paid off. In March 1844, George was offered a space in the upcoming class. With the written consent of his father, he signed and formally accepted a conditional appointment to West Point and bound himself to serve the United States for "eight years unless sooner discharged."[4]

Six months later, George Lucas found himself at West Point sharing with another cadet a claustrophobic ten-by-ten-foot room, furnished with a bucket and two uncomfortable iron beds. He bemoaned the rough turn that his life had taken and wondered whether he was equal to the task. Referring to the "bright side" of West Point that others had told him about, Lucas forlornly reported in a letter to his close friend George Whistler (the older half-brother of the painter James McNeill Whistler) that he was experiencing "the other side." Lucas frowned upon the intelligence of many of the cadets (he estimated that there were 254 cadets enrolled at that time), referring to some as uneducated and to others as "loafers . . . who had no sort of principle to guide them." He also turned up his nose at the inability of some of the cadets to speak French. Finally, he expressed exasperation that drawing, his favorite subject, was not taught in the first year.[5]

Whatever interest Lucas had once had in pursuing a career as a military officer, this goal was dashed by the mounting evidence that he was out of place. Except for in French, at which he excelled, Lucas's grades while at West Point were poor; in math, for example, he was forty-third in a class of fifty-seven cadets. Moreover, between July 1844 (when he enrolled) and the middle of June 1846, Lucas was disciplined fifty-eight times for a variety of infractions. In jeopardy of being dismissed, he resigned on June 15, 1846. His military records reveal that West Point would "not permit

him to return."[6] In light of the intellectual and academic interests of the Lucas family, George's performance at West Point must have been a bitter disappointment to both him and his father.

After his unsettling departure from West Point, George Lucas led for several years a secretive, unhappy life. Despite his family's wealth and his own education, he was depressed and at loose ends, abandoning one employment opportunity after another, suffering from recurring headaches, and harboring an unsettling premonition of his own impending death. On November 7, 1852, he described himself in his diary as "a wanderer upon the earth; now here, now there." And he ominously predicted that he would "pass from this earth to another and better at the age of 30."[7]

With the goal of obtaining some form of psychological relief, in November 1852, he arranged to meet with an old friend (the wife of his physician) who, in his judgment, "always felt & expressed such deep feeling for my welfare and happiness." While hoping to obtain some comfort from this meeting, he was faced with the dilemma of whether to reveal to her the dark secrets of his past. Silently debating the issue with himself in the confines of his diary, Lucas wrote: "What shall I say to her in answer to questions which she will surely ask? Tell her all, or maintain a dull and stupid silence. Accuse myself or accuse others. What? Time will tell. Accuse neither others, nor yourself. Tell what you have suffered, and receive from a warm hearted pure being, consolation such as only she can give. That will be balm indeed."[8]

Whatever comfort he obtained from the doctor's wife did not allay his troubles. Moreover, Lucas's emotional problems were compounded by a variety of physical infirmities, the most serious of which were "bilious headaches" that recurred throughout his life. He became preoccupied with his health, recording in his diary each time he had a headache or felt ill due to some other ailment, such as rheumatism, a boil, or an abscess. In an effort to divert his attention from these physical and mental discomforts, Lucas turned to art. For instance, after becoming ill on the morning of November 26, 1852, Lucas purchased two drawings that afternoon. Likewise, within a few days after suffering another headache on January 2, 1853, Lucas met with an artist and commissioned a portrait of himself. Art, it seemed, had become the remedy for what ailed him.[9]

In January 1853, Lucas also decided to visit West Point, hoping to confront the demons that haunted him. However, the visit did more to reopen than to heal his emotional wounds. Referring to his earlier "sufferings" at West Point, Lucas wondered when it would end and "be forgotten," and he privately resolved, "I will not suffer so again."[10]

Despite his apparently painful life at West Point, Lucas did not leave there empty-handed. From the courses he took on engineering, he had gained the knowledge and skill to become a civil engineer. In July 1851, he obtained employment with a railroad headquartered in New Haven, Connecticut. But he found little that was satisfying in his occupation or in his life in that city, and in April 1853, Lucas resigned. He spent his last day reading gravestones in the town's cemetery, and that night he

exclaimed in his diary that he had "left N.H. forever!!!" He moved to Elizabeth, New Jersey, to accept a similar mundane engineering job with a different railroad, but the result was the same: "Left Elizabeth forever after residing there for nearly 5 months. Leave without the slightest regret. Have found no acquaintances & have been in not a single house to visit. Jersey is a vile place."[11]

As he approached the age of thirty, Lucas continued to struggle emotionally to find a place or occupation that would give meaning to his life. Despondent over his unsettled career, he became even more depressed when his beloved older brother, Fielding Lucas II, died suddenly. Among his family, his brother Fielding II ("Field") was George's closest friend. He revered him as the "noblest" and "finest" member of the family and characterized him as "the bright spot in my life." On June 8, 1853, the day of Field's funeral, George mourned, "I had looked forward to the future for many a pleasant association with one so near & dear & one was nearer like me in many things, habits, and feelings . . . Peace be to your ashes my dearest brother."[12]

Except for his relationship with Field, George by 1853 had become estranged from his family. He rarely saw or communicated with his father, and he had little affection for any of his other brothers.[13] On the last day of 1853, Lucas wrote in his diary, "Thus ends the year that has been an eventful one for me. Changes, changes. Death and ramblings. Thus, to the end of time. . . . Death has deprived me of my favorite brother, one to whom I looked up, and to whose future life entwined with mine. . . . The loss is severe for there is no brother to fill this gap. The bright spot in my life which I saw dimly in the distance is now forever dull—dull—dull."[14]

• • •

In 1854, Lucas gradually emerged from his depression. What brightened his mood and energized his mind were three related strokes of good fortune. First, he found a job as a civil engineer that enabled him to reside in New York City. Second, he had sufficient money that enabled him to live there grandly. Third, he discovered that French contemporary art—the field of aesthetics that he loved the most—was on display and readily available for acquisition there.

During the first half of the nineteenth century, there was little interest in the United States in acquiring or displaying contemporary French paintings, prints, or sculpture. The small but rare collection of French art in Robert Gilmor's collection was an exception to the rule. The art ordinarily on display at the country's earliest repositories of visual culture, such as the Boston Athenæum or Wadsworth Atheneum, provided viewers with an uplifting tour of cultural history, beginning with plaster casts modeled after Venus de Milo and Apollo Belvedere and other icons of classical sculpture, followed by paintings attributed, often mistakenly, to Italian or Dutch old masters, portraits of distinguished Americans, and an array of sentimental paintings by popular American artists such as Washington Allston.[15]

By the 1830s, America's taste for art was gravitating toward paintings that idealized the American landscape or visualized important events in the country's young

history with the overall goal of creating a body of art that expressed, if not celebrated, the patriotic spirit and manifest destiny of a new nation. The popularity of such art was evidenced in 1848 at an exhibition sponsored by the American Art Union in New York, where crowds that reportedly numbered in the tens of thousands thronged to see breathtaking landscapes by Thomas Cole, Frederic Church, Asher Durand, John Kensett, and other Hudson River artists, as well as genre scenes by William Sidney Mount, George Caleb Bingham, and Richard C. Woodville. Likewise in 1850, the Wadsworth Atheneum, the country's earliest public museum, displayed 142 paintings, with the highlight being five landscapes by Thomas Cole. Whether in New York, Boston, or any other major city in the United States during the first half of the nineteenth century, the focus was on American art, and there was hardly a French painting in sight.[16]

This changed around midcentury, when the market for French paintings in America began to firmly take hold. In 1848, Adolphe Goupil, the owner of one of the oldest and most influential art galleries and publishing houses in Paris, opened a branch of his gallery in the heart of New York's flourishing business district.[17] Goupil's gallery began to display paintings by celebrated French artists, including Thomas Couture, Paul Delaroche, Ary Scheffer, and Horace Vernet. To market French art to the American public, Goupil established the International Art Union, an organization that provided its paying members with the opportunity to purchase French prints and to possibly win through a lottery a well-known French painting. The American Art Union resisted this competition, claiming in its *Bulletin* that the art offered by Goupil and the International Art Union were, "bad quality . . . impure in sentiment . . . and would stain the rising fountain of American art."[18] This effort to denigrate the art shown by Goupil failed. American collectors enthusiastically embraced French art, sales at Goupil grew exponentially, and the gallery quickly became the US center for the acquisition of high-quality contemporary French prints and paintings.[19]

The taste for French art arose almost simultaneously in Boston but from a different source—the influence of young American artists who left the country at midcentury to study in France and returned as advocates of its art. In 1847, Charles Perkins, the youngest son of a wealthy and influential Boston family, traveled to Paris to study painting under Scheffer. Scheffer at that time was one of the most preeminent Romantic artists in Paris, and his images of literary and religious figures won the patronage of King Louis-Philippe. Perkins, along with his older brother Edward Newton Perkins (a trustee of the Boston Athenæum), encouraged other collectors to acquire Scheffer's art, resulting in the display at the Boston Athenæum of five of his paintings.[20]

In the same year that Perkins went to Paris to study under Scheffer, another wealthy young New England artist, William Morris Hunt, traveled to Paris to study under Thomas Couture. In 1852, Hunt moved to the village of Barbizon on the western edge of the unspoiled Fontainebleau forest to join the colony of now-famous

landscapists. He entered the atelier of Jean-François Millet, became a devoted advocate of Barbizon landscapes, and upon returning to the United States in 1855, urged New England collectors to purchase Millet's paintings. This led to the acquisition by the Boston Athenæum between 1854 and 1860 of six of Millet's rustic paintings of peasants in the countryside and placed Boston at the forefront of America's interest in Barbizon art.[21]

In December 1852, while on a trip to Boston, George Lucas visited the Boston Athenæum, expecting to see a traditional display of ancient Greek and Roman art. What caught his eye instead was Scheffer's *Eberhart, Comte de Württemberg, Mourning over the Body of His Son*. It was a purely sentimental picture, based on a play by Friedrich Schiller and painted in the neoclassical style prevalent at that time. Lucas adored it. He thought that Scheffer was "the most eloquent of modern painters" and that "his paintings deserved to be displayed more prominently."[22] Lucas's apparent knowledge of French art and his ability to assess the relative merit of French artists at a time when they were barely known in America revealed how far ahead he was in relation to other early American collectors in this field.

The interest in French art that emerged in New York and Boston in the 1850s allowed Lucas to transform his affinity for French art into a passion for collecting it. Beginning in January 1853, he began to frequent the Goupil gallery in New York and to acquire a modest collection of etchings, engravings, and other works on paper.[23] It was an inconspicuous beginning of a relationship that would blossom following his move to Paris, where he would visit the Goupil gallery over five hundred times and become one of its most important American clients.

Because of the savoir vivre Lucas acquired by his entry into New York's budding art market and the pleasure he derived from it, a small circle of his friends, primarily George Whistler and Frank Frick, asked him to begin acquiring art for them. On February 7, 1854, Lucas began shopping for his friends at Goupil; two days later he returned to the gallery to purchase engravings of *Crossing Ferry* at a cost of $11.25 for Frick and *Blue Lights* at a cost of $15 for Whistler. Lucas then arranged for the pictures to be framed at Williams & Stevens, the popular publisher and framer of fine prints.[24] At Whistler's request, Lucas also made all of the arrangements to have a portrait of his friend's deceased mother painted by the popular portraitist Giuseppe Fagnani.[25] (Lucas also had commissioned Fagnani to paint his portrait, the first of fifteen portraits of Lucas commissioned during his lifetime.) With these small steps, Lucas planted the kernels that would grow into his lifelong occupation as an agent for the acquisition of art.[26]

On March 12, 1854, Fielding Lucas died. In failing health, he had had the foresight the year before to hand over the management of his company to his three oldest sons (Edward, William, and Henry), who collectively changed the name of the business to "Lucas Brothers." For whatever reason, George was not provided with any role in the company's management or any financial share of his family's business. Instead, his father provided him with something far more valuable—a license to lead

his own life. It was given in the form of an annuity, set forth in his father's will, which promised to generate between $1,200 and $2,000 each year for the rest of George's life. Although not a fortune, it was an amount strikingly similar to his annual income as a civil engineer. Most importantly, it provided him with the means to declare his independence.[27]

With this additional income, Lucas moved in August 1854 into New York's fashionable St. Denis Hotel, designed by James Renwick and opened with considerable fanfare the year before. He began to dine regularly at Delmonico's, a legendary restaurant widely considered then to be the best and most expensive in New York. He frequented the Dusseldorf Gallery, which the *New York Times* would characterize as the gallery where intellectuals browsed for its "pure aesthetic pleasures."[28] He became a regular patron of the opera and the theater, attending a production of Verdi's *Il Trovatore* one night and Goldsmith's *She Stoops to Conquer* the next. He purchased his claret by the case. He bought gifts for the women in his life—a necklace for one, earrings for another—and discreetly noted in his diary only the initials of his lovers and the locations of their assignations. "Called to see Ms. E.C., 71 London Terrace," read one note. "In evening to 4th Ave, to see A.K.," read another. He became, in a phrase, a man-about-town, guided by the epicurean philosophy that living well was the best revenge.[29]

While enjoying the sensual pleasures available to him in New York, Lucas sharpened his mind by reading the lectures on art that had been delivered by Sir Joshua Reynolds to students at the Royal Academy in London between 1769 and 1779, as well as the more recent lectures on architecture and painting given by John Ruskin in Edinburgh in November 1853.[30] Although Reynolds and Ruskin advanced significantly different and often conflicting theories—Reynolds was the advocate of ideal beauty and Ruskin the advocate of reality as the source of beauty—Lucas accepted the fundamental ideas of both.

What Lucas found in Reynolds's lectures was a set of aesthetic principles that emphasized the importance of tradition and the search for ideal beauty. Reynolds preached that the creation of great art was an intellectual exercise that began with the study of the old masters. The goal, according to Reynolds, was not to copy the old masters but to create new art that added to their luster. With regard to the painting of landscapes—a subject of particular interest to Lucas—Reynolds contended that artists should try not to literally replicate nature but to correct all of her imperfections and thereby create images of ideal beauty. He argued, "This idea of the perfect state of nature, which the artist calls the Ideal Beauty, is the great leading principle, by which works of genius are conducted." And he concluded that art, like poetry, was ennobled by sublime images of heroic virtue, philosophical wisdom, and intellectual dignity, as exemplified by the classical landscape paintings of Nicolas Poussin and Claude Lorrain.[31]

Reynolds's lectures, especially those aspects that focused on the creation of ideal landscapes, resonated with Lucas. The art books published by his father expressly re-

ferred to Claude as the supreme master whom succeeding landscapists should follow. Moreover, Reynolds's lectures pertaining to the pursuit of ideal beauty had captured the interest of elite members of America's intelligentsia, whose interest in the visual pleasures of art was combined with an interest in its history and aesthetic theory. Oliver Wendell Holmes Sr., one of the great American thinkers of the nineteenth century, published in the *North American Review* an art review in which he borrowed Reynolds's ideas and urged artists to adopt Claude Lorrain as their model.[32]

Ruskin, in contrast, dismissed the notion that landscapes should be based on visionary ideals. Instead, he contended that morality and religion provided the quintessential basis for great art. In the 1850s, Ruskin's theory had the exhilarating sound of church bells to America's strongly religious public, and he became enormously popular. In his lectures at Edinburgh, Ruskin presented a history of landscape painting, beginning with biblical images of nature, going on to the landscapes depicted in the paintings of Giotto and Raphael, and finally discussing the landscapes of Claude Lorrain. While conceding that Claude was still considered the greatest landscape painter, Ruskin frowned upon his landscapes emblazoned with setting suns, characterizing them as theatrical and deceptive appearances of nature. He argued that it was time to do away with the illusions of the past in favor of a more perfect form of landscape painting, based on accurate observations of nature, that was "pure, wholesome, simple and modern," as illustrated by the landscapes of Joseph Mallord William Turner.[33]

Neither Reynolds nor Ruskin referred specifically in their lectures to the styles of paintings then popular in France. Nevertheless, when Lucas sailed from Baltimore, he carried their ideas with him. He embraced Reynolds's ideas for the simple reason that he was, at heart, a traditionalist. Lucas had grown up with the art and ideas of the past: the neoclassical architecture that characterized Baltimore during his formative years, the old master paintings by Claude Lorrain and Nicolas Poussin that he saw in Gilmor's collection, the adulation of a hero—Lafayette—of a prior generation, the classical literature written in Greek and Latin that he read and studied, the old-fashioned uniform that he wore year after year while attending St. Mary's College. He was emotionally attached to the past. The conservative ideas advanced by Reynolds resonated with his core values, and they served as the intellectual touchstone that caused him to follow the academic conventions of the Salons and to favor such artists as Ingres, Cabanel, Bouguereau, and others who, like Reynolds before them, sought to capture visions of ideal beauty.

The ideas of Ruskin caught Lucas's attention for a different reason. They contextualized landscape painting within the higher plain of morality. Ruskin's thesis that landscapes should be pure, wholesome, and simple, as if divinely created, constituted a prescription that Lucas would follow in advising his clients and developing his own collection. And the application of such ideas likely led him to embrace the art of Millet, Rousseau, Daubigny, and Pissarro, as well as to buy a house in the countryside and live among them.[34]

On September 20, 1856, Lucas resigned from his last job as a civil engineer and left New York. What exactly precipitated his decision to close this chapter of his life is unknown. He returned to his family's home in Baltimore and for several months pondered his future.[35] There was, however, no anchor to hold him in Baltimore. His father was dead, as was his favorite brother. He had been excluded from the family stationery and publishing business, and there is no evidence that his brothers were willing to reopen that door. He had no job nor any interest in returning to work as a civil engineer. There apparently was no woman in his life. Worse yet, from Lucas's perspective, the culture of the city had lost its luster. There was no permanent gallery of paintings in Baltimore that sparked his passion for art and stirred his dreams of acquisition.[36]

Lucas undoubtedly was aware that the energy that had propelled Baltimore's interest and support of the arts during the first three decades of the nineteenth century had run out. For fifteen years, one devastating blow after another had decimated the city's cultural institutions. Due in large measure to an economic depression, the Peale Museum in 1833 closed; it never reopened and no other commercial art gallery emerged to take its place.[37] The large red-brick building on the corner of Calvert and Baltimore Streets still carried the name "Museum," but instead of showing art, it was used for vaudeville productions of minstrel shows.[38] In 1835, a fire destroyed the Baltimore Athenaeum and gutted the Maryland Institute, ending its repertoire of cultural events. In 1838, an attempt to resuscitate the fine arts in Baltimore through the creation of an academy of fine arts quickly died, and for the next ten years, there were no significant art exhibits in the city. In 1848, following the death of Robert Gilmor, no institution in Baltimore had the resources to preserve his great collection, and it was largely dispersed across the country to the highest bidders. Thus, the vision of Baltimore as a national center of culture—the dream of Lucas's father—had largely disappeared. The painful lesson learned was that a city's connection to the fine arts was as fragile as its residents' wealth and willingness to support it.[39]

In 1848, the lovers of fine arts in Baltimore attempted to stage a comeback. That year, the Maryland Historical Society established a picture gallery "for the improvement of the taste of the public." It was designed to fill the void left by the closure of the Peale Museum fifteen years earlier.[40] At exhibitions held in 1848, 1849, 1850, 1853, and 1856, hundreds of works of art were temporarily placed on display, but their large number could not hide their dubious quality or the misguided effort to attribute many of them to Leonardo, Raphael, and other great masters. Although the quality of the art was uneven, these exhibitions, as one historian has noted, "served the purpose of keeping the idea of a gallery alive."[41]

More significantly, the Maryland Institute was reborn. In 1851, a beautiful Italianate structure with a grand hall that could accommodate six thousand people was constructed. The Maryland Institute's spacious hall was used for important public

events, exhibitions, and fairs that focused on science and industry, celebrated ingenuity, and displayed recent inventions vital to Baltimore's industrial economy.[42] Like the Picture Gallery of the Maryland Historical Society, the Maryland Institute also tried to fill the gap in culture caused by the absence of any year-round gallery of fine arts in the city. It mounted a month-long exhibition each year that focused on contemporary American painting, including canvases painted by Alfred Jacob Miller and popular Hudson River school artists.[43]

Notwithstanding the temporary exhibitions held at the Maryland Institute and the Picture Gallery of the Maryland Historical Society, the fine arts in Baltimore in the 1850s was, as art historian William R. Johnston has observed, "faltering at best."[44] Without any work and without the aesthetic pleasures that could happily occupy his leisure time, there was little for Lucas to do except count the days before his departure for Paris.

For students and devotees of French art like Lucas, there was no place like Paris. The road there had already been mapped by a succession of artists and connoisseurs Lucas had known and admired. Lucas was well aware that Gilmor, Baltimore's most famous collector, had briefly resided in Paris. Latrobe, the artist, writer, and brilliant friend of Lucas's father, had also journeyed there; more recently, James McNeill Whistler, the talented younger brother of Lucas's close friend George Whistler, had left the United States in 1855 for Paris to study art. The romantic idea of following in their footsteps must have had a magnetic appeal to Lucas. Given his financial independence, fluency in French, and passion for French art, Paris in the middle of the nineteenth century was the place where Lucas wanted to be.

Lucas and Paris in a Time of Transition

From the windows of his apartment at 13 rue de Ponthieu, overlooking the Rond-Point and the imperial gardens along the Champs-Élysées, George Lucas had a bird's-eye view of the remarkable changes that had been occurring in Paris. When his lifelong friend Frank Frick visited him there on May 13, 1860, Lucas threw open the widows, inhaled "the morning air laden with the fragrance of flowers," and, in response to Frick's request, began to tell him "everything that [had] happened in the last three years." There was a lot to tell. For the next six days, from nine in the morning until nine at night, Lucas related to Frick almost everything he had learned about art and observed about Paris, as he led his friend on a personal tour of the city. Together they strolled along the city's great new boulevards, through its picturesque new parks, from art studio to studio and to an exploration of the Louvre, while eating at fine restaurants and drinking along the way. Lucas was in heaven, and Frick, as he noted in his diary, was in "infinite delight."[1]

◆ ◆ ◆

When Lucas arrived in Paris in 1857, Louis-Napoleon had been in power for seven years (plate 8). In 1850, he was elected president of the Second Republic, but two years later, he seized absolute power, adopted the name of Napoleon III, became the emperor of France, and declared the beginning of the Second Empire. Shortly thereafter, he embarked on a massive project to reconstruct and modernize Paris.[2] Under the direction of Georges-Eugène Haussmann, the fundamental character of Paris

was transformed as it grew from an impoverished medieval city of dark and twisted streets into an urban capital of wealth and splendor. As a result of the reconstruction, broad, tree-lined boulevards crossed and united the city; the Champs-Élysées was extended from the Arc de Triomphe to the resplendent Tuileries Garden; lavish facades of grand new residences lined the streets; the Bois de Boulogne, once a royal hunting preserve, became a splendid and picturesque public park, dotted with follies and abutted with private mansions; new railways carried the wealthy to the Fontaine-bleau Forest and their countryside retreats; temples of culture, such as the Louvre's Cour Napoléon and the lavish Opéra Garnier, were gloriously rebuilt; a profusion of new ornamental gas lamps illuminated the city, turning night into day and shopping into a never-ending excursion; and promenades bustled with elegant restaurants, the-aters, department stores, fashionable shops, and art galleries. All of these elements combined to attract to Paris a new and wealthy generation of bourgeoisie and to sat-isfy their desire for visual and material pleasures. As the population nearly doubled, from 1.25 to almost 2 million, and middle-class wages by some estimates rose by more than 40 percent, the city became a Mecca for bankers, builders, industrialists, and even ambitious young entrepreneurs like Lucas who collectively ushered Paris into its own Gilded Age.[3]

The economic and social changes in Paris were accompanied by seismic shifts in the taste and market for art. During the first half of the nineteenth century, the pro-duction of French art was tightly controlled by the Académie des Beaux-Arts and its annual Salons, which established rigid aesthetic standards that artists were required to follow in order to obtain public acceptance and achieve financial success. Large-scale, carefully modeled, and perfectly finished history paintings that depicted or al-luded to classical scenes of heroic events of the past were considered the highest form of art and were intended to serve the didactic purpose of educating viewers and in-spiring feelings of patriotism and allegiance to the state. Inspired by Jacques-Louis David and later Jean-Auguste-Dominique Ingres, neoclassical artists who painted such illustrations of virtue invariably won the most prestigious medals at the annual Salons and were showered by the state and aristocratic collectors with lucrative com-missions. In contrast, realistic paintings, especially those that revealed the hand of the artist or appeared unfinished, were often criticized as secondary if not frivolous forms of art and, worse yet, debased as illustrations of "ugliness."[4]

The tastes and money of the new wealthy class of bourgeoisie who inhabited Paris in the 1850s and 1860s changed this. Like newly rich capitalists before and after them, the bourgeoisie sought to acquire art as a symbol of their wealth and a badge of their cultivation. But instead of the large-scale neoclassical subjects previously fa-vored by the wealthy, this new generation of bourgeoisie preferred a diverse collec-tion of more affordable and humbler subjects and styles that struck a chord with the reality of their everyday lives and that could decorate and fit comfortably in the par-lors of their fashionable new apartments and homes. It was at this crossroads, as Charles Baudelaire then observed, where the interest in art was directed away from

the heroic figures of the past toward the "special nature of present-day beauty."[5] As a result, the market soared for easel-size canvases that depicted genre scenes of ordinary people at work and play, idyllic scenes of peasants in the countryside, pure landscapes that celebrated the essential beauty of nature, portraits of the well-heeled collectors who were buying the art, and, in general, images that reflected the spontaneity and vitality of Parisian life at the cusp of modernity.[6]

Swayed by this change in taste and seeking to demonstrate the populist sensibilities of his government, Napoleon III opened the Universal Exposition of 1855 to all living French artists regardless of whether they were categorized as neoclassicists, romantics, realists, Barbizon school landscapists, or simply genre painters. Paintings that defied definition, that were admired because they expressed the artist's individualism, and that seemingly combined the aesthetic standards of classicism and romanticism were also welcome to the Exposition and given the ambivalent label of *juste-milieu,* or the middle way. The most visible symbol of this new spirit of inclusiveness was the decision to mount in adjacent galleries of the 1855 Exposition major retrospectives of France's two most celebrated yet antagonistic living artists, whose brushes had become their swords in a battle over the artistic styles and symbols that should govern the country's culture: Ingres, the paragon of neoclassical art cherished by the aristocracy, and Eugène Delacroix, the champion of the left-leaning spirit of proletarian revolution. The juxtaposition of twenty-three neoclassical paintings by Ingres and thirty-six romantic paintings by Delacroix, including his politically charged *Liberty Leading the People,* suggested that in the 1850s every shade of political thought and every style of art had a place in what was characterized as France's new art of eclecticism.[7]

Despite this new flexible approach to the public display of art, it did not satisfy the rebellious, independent-minded leader of the realist movement, Gustave Courbet, who sought not only recognition but artistic independence and absolute freedom from the conventions of the Academy. Displeased by the rejection of three of his paintings by the jury of the Exposition of 1855, Courbet defiantly constructed his own Pavilion of Realism on the grounds of the Exposition, displayed for sale forty of his own paintings, and plastered the city with posters advertising his show. His aim, he declared, was to create the art of his time—in his words, "living art"—as he envisioned it and not as dictated by others. To this end, he displayed in his pavilion his now-famous painting *The Artist's Studio* (see fig. 11). Courbet's unprecedented action unleashed the creativity of Paris's growing legion of artists and encouraged them individually or as groups to look for opportunities to display and market their art outside of the Salon. Moreover, it led to the government's decision in 1863 to permit artists whose paintings had been rejected by the Salon to display their art at an officially sanctioned *Salon des Refusés,* where 604 paintings, most notably, Édouard Manet's *Le Déjeuner sur l'herbe* and James McNeill Whistler's *Symphony in White No. 1,* were presented to the public for the first time. While the art displayed in the *Salon des Refusés* was thoroughly ridiculed—one critic called it "sad and grotesque . . .

the oddest you could see"—the event itself had major repercussions. It established, albeit unintentionally, a competing avant-garde force of artists against the established camp of neoclassicists and served as a harbinger of the Salon's eventual demise and the birth of impressionism.[8]

Like the currents of four onrushing streams, the reconstruction of Paris, the increased wealth of its bourgeois inhabitants, the thirst for new styles and forms of art, and the budding independence of Parisian artists converged in the 1850s and 1860s to generate an art market whose vibrancy far exceeded anything Paris had previously known. The boom in art was not limited to painting. Photography was recognized as a new form of art, and the interest in etching was significantly revived. The small sketches and studies for larger work that once had littered an artist's studio became part of the artist's oeuvre and entered the low end of the marketplace. And the wholesale reproduction of art through photography and lithography made art available and affordable to all levels of bourgeois society. By the early 1860s, the legion of professional painters, sculptors, and printers working in Paris had burgeoned to the astounding number of 4,450 artists. Their production of art, as reflected in the number of paintings selected for display in the official Salons, also grew exponentially. In 1857, there were 3,483 new works of art displayed at the Salon; in 1861, this increased to 4,102; and by 1870, it jumped again to 5,434.[9]

The explosion in the production of art in Paris in this period gave birth to the private art gallery as we now know it. Prior to 1850, there were very few galleries in Paris that focused exclusively on the sale of art. The official Salons, whose imprimatur was essential to a painting's financial value and marketability, held a near monopoly on this business. Although approximately two dozen shops in Paris sold or leased paintings and prints, such art represented only part of a larger inventory of luxury goods and painters' supplies. Due to the expanding demand and availability of art at midcentury, however, the number and nature of these galleries and the number of individual dealers dramatically changed. Instead of selling paintings on an ad hoc basis as independent luxury objects, dealers initiated long-term business relationships with their most prominent artists, which called for the dealer to actively promote an artist's career in return for the artist's permission to reproduce and sell endless copies of his art to the public. By 1861, there were over one hundred art dealers in Paris, with dozens focusing exclusively on the sale of art in its many forms.[10]

The most prominent of these dealers opened fashionable galleries in the upscale neighborhood intersected by the rue Lafitte and the boulevard des Italiens in the 9th arrondissement, where paintings and prints by the most celebrated Parisian artists were usually available for sale. The oldest of these galleries, Goupil & Cie, offered a wide array of fine art reproductions in the form of engravings and photographs as well as original paintings by Cabanel, Gérôme, Hugues Merle, and Ziem. The Durand-Ruel Gallery exhibited paintings by the major Barbizon landscapists, including Corot, Rousseau, Millet, and Diaz and was hailed as the progenitor of modern forms of art. And the luxurious Galerie Georges Petit, which was designed to look like a grand

salon in a magnificent home, carried paintings by Meissonier, Daubigny, and Bouguereau. By 1858, this neighborhood of art galleries, in the view of the art critic Théophile Gautier, had been collectively transformed into "a permanent Salon, an exhibition of paintings that lasts the whole year round."[11]

At the hub of the Parisian art market was the nearby Hôtel Drouot, the official auction house of Paris. Following its opening in 1852, every type and quality of art, from paintings attributed to the old masters to purely decorative kitsch by unknown artists, was brought to auction almost every day. The art came from estates, established dealers, a growing legion of shadowy middlemen, and sometimes the artists themselves. To assist the buyers, the Hôtel Drouot retained a revolving group of alleged experts who appraised and authenticated works of art while implicitly cautioning the bidders that caveat emptor was still the guiding principle. There was hardly a notable artist in Paris whose work did not pass at one time or another through the Hôtel Drouot's showrooms. On May 18, 1861, for instance, twenty-five paintings by Rousseau were auctioned. In February 1865, a collection of prints and paintings by Delacroix were offered for sale. Ten years later, more than twenty paintings by Millet were sold, and in 1875 and 1878, dozens of impressionist paintings by Degas, Monet, Pissarro, Renoir, and Sisley were auctioned at rock-bottom prices.[12] With an everchanging inventory for sale and an often frenzied crowd of potential buyers and speculators, the Hôtel Drouot became the virtual stock market of art, where the reputations of artists and the value of their work rose and fell with the rapidity of the auctioneer's gavel.[13]

While the Hôtel Drouot and nearby private galleries were the primary places for the bourgeoisie to buy art, the place to see and study the finest examples of neoclassical and other academic art was the Luxembourg Museum. Located in the east wing of the Luxembourg Palace and known as the "Palace of Living Art," it was Europe's first contemporary art museum. By 1870, it housed a highly select group of approximately two hundred paintings, prints, and sculpture that previously had been shown in the Salon and then had been purchased by the state for display in this museum. Because the art ordinarily remained in the Luxembourg for the remainder of the artist's lifetime and within a few years thereafter entered the hallowed collection of the Louvre, the acquisition of an artist's work for the Luxembourg represented, in the words of one contemporary critic, "the greatest public honor possible for a living artist."[14]

◆ ◆ ◆

Three paintings completed in Paris around the time of Lucas's arrival in 1857 exemplify the diverse styles of art that were being offered for sale at that time. Although unveiled in France around the same time, the three paintings thematically were worlds apart. The first, a large life-sized painting entitled *The Source,* by Ingres, represented the neoclassical world of the past (fig. 28). The second, an easel-sized painting by Millet entitled *The Gleaners,* depicted the real, often painful world of the present (fig. 29). The third, a small painting by Pierre-Edouard Frère about family values and

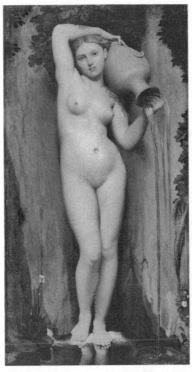

FIGURE 28. Jean-Auguste-Dominique Ingres, *The Source*, 1856. Musee d'Orsay. Erich Lessing/Art Resource, NY.

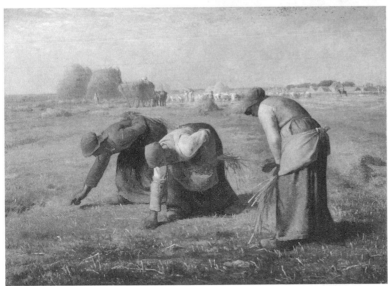

FIGURE 29. Jean-François Millet, *The Gleaners*, 1857. Musee d'Orsay. Scala/Art Resource, NY.

called *The Cold Day,* created a world that was universal and timeless (fig. 30). The first was intended for the eye, the second for the mind, and the third for the heart of the viewer.[15]

As a voyeuristic representation of ideal beauty, *The Source* depicted a curvaceous nude girl standing in contrapposto among water lilies in a shallow stream and pour-

FIGURE 30. Pierre-Édouard Frère, *The Cold Day*, 1858. The Walters Art Museum, WAM 37.29.

ing water from a Roman vessel as if she were the nymph of spring. The visually stunning image was borrowed in large measure from ancient art. The figure of Ingres's nymph apparently was modeled after a fourth-century statue of Venus that once stood in Hadrian's villa, and the vessel from which the water poured was similar to those used in ancient statues of river gods.[16] In the tradition of earlier neoclassical paintings of nudes, the power of this painting was derived from the tension between the nude's desirability and her unavailability. She was alluring but unreal, an erotic object of fantasy that lived only in the neoclassical world that Ingres recreated.

For many years, Ingres was viewed by France's political and cultural establishment as the presiding deity in the country's temple of art. At the Exposition of 1855, he was crowned with the title of grand officer of the legion of honor—an honorific position never before bestowed on another artist, and at the time of his unveiling of *The Source,* he continued to serve as the president of the École des Beaux-Arts. His paintings, especially his nudes, were cherished by Napoleon III, who considered them to reside in the same realm of perfection as paintings by Raphael. Subsequent dreamlike images of nude goddesses, such as Cabanel's eye-catching versions of *The Birth of Venus* (one owned by the Musée d'Orsay and the other by the Metropolitan Museum of Art) were part of Ingres's legacy. Although some critics assailed his art as cold and unimaginative, to those in France who were able to pay the steep price for his paintings and possessed the palatial settings to display them, Ingres remained their champion of academic art. *The Source* was celebrated by the French upper class, and it quickly sold in 1857 to France's minister of the interior for 25,000 F.[17]

Painted in a quite different style was Millet's *The Gleaners*. Shown for the first time at the Salon of 1857, *The Gleaners* pictures three female peasants engaged in the painstaking and monotonous task of bending over to pick up the leftover scraps of wheat that remain on the ground following the completion of a bountiful harvest. To underscore the low status of the gleaners and evoke the social and economic inequities of life in France between the rich and the poor, Millet pictured in the background a *garde champêtre,* or field warden, on horseback, overseeing the completion of the harvest and guarding against any action by the gleaners which would overstep their bounds. Notwithstanding their circumstances, the gleaners in Millet's painting are invested with a monumental, sculptural presence, as if to suggest that they, not their overseer, are the heroes in the composition.

Millet knew this world well. In 1849, he had moved to the village of Barbizon, on the edge of the Fontainebleau forest, where he began to focus his art on the lives of the peasants who lived there. Landscapes were becoming increasingly popular in mid-century France, especially those by Corot and Rousseau that reflected the beauty of nature and the peace and comfort of the bucolic life. Millet's paintings departed from this paradigm by focusing on the hardships of peasant life softened only by the peasants' quiet, visually poetic dignity. Because it dealt with the plight of French peasants, *The Gleaners* initially was condemned as a misguided effort to reignite political passions and to pit the poor against the rich. It damaged Millet's reputation among the conservative and wealthier members of society, as well among the most powerful critics. Reviewing Millet's submission to the Salon of 1859, Baudelaire claimed that the painting was a "disaster" whose figures of peasants revealed "their monotonous ugliness" and "their fatal boorishness which makes me want to hate them."[18] Such attacks devalued Millet's paintings for most of his lifetime and kept them out of the Luxembourg Museum. As a result, Millet, like his subjects, struggled economically. He lived, it was said, as a peasant among peasants, creating images that were an echo of his life. In contrast to the 25,000 F that Ingres received for *The Source,* Millet struggled in 1857 to sell *The Gleaners,* finally settling for the relatively modest amount of 3,000 F.[19]

If, on a political map, Ingres's paintings occupied the right and Millet's the left, the apolitical, sentimental paintings by Frère of domestic scenes featuring children were clearly in the neutral center. *The Cold Day* depicts a young girl and boy and their older sister in the kitchen of their home, huddled together around a small cast-iron stove. The frugal circumstances of their lives are suggested by the few scraps of wood on the floor. The sisters warm their hands, while the younger brother warms and dries his feet, as though he has been trudging dutifully through the snow or rain in search of the sticks needed to keep the fire ablaze. The children, however, do not look haggard. There is no pain in their poverty. Their faces are radiant, and the slender graceful fingers of the older sister suggest that beneath her bundle of clothes she is a lovely and elegant young girl. Although, the children have limited means, their lives have been enriched by an environment where art, education, good manners, and above all devotion to one another matter. Inexpensive art is pinned to their kitchen

wall. The table perfectly set with three glistening bowls and matching glasses is reminiscent of a luminous and beautiful Dutch still-life painting. The children themselves are neatly dressed, and the coat of an unseen but implicitly caring parent hangs on the wall.

The children represent what was considered in nineteenth-century Victorian terms to be the "deserving poor." The underlying message of the painting was not political but moral. It invoked the importance of traditional family values—children sticking together close to home, looking out for one another, and learning through good rearing the lessons that would ennoble their lives. Aside from its message, the painting's appeal rested on its simplicity and sentimentality. Although too sweet for some tastes, it was an image that everyone could understand.[20]

Frère's paintings were awarded medals at the Salons of 1851 and 1852, and at the Salon of 1855, he also received the Légion d'honneur. His fame, however, was derived primarily from the fact that he was John Ruskin's favorite French artist. Ruskin described Frère's paintings as "quite unequalled . . . in sincerity and truth of conception," and he glorified Frère as having "the depth of Wadsworth, the grace of Reynolds and the holiness of Angelico."[21]

Frère resided in the small provincial town of Ecouen, located eight miles north and a short train ride from Paris. Dominated by a beautiful sixteenth-century chateau, the town had a charm accentuated by its narrow alleys, small cottages with thatched roofs, and a population of ubiquitous sheep. However, the town was best known for the colony of artists who resided there. Collectively known as the Ecouen school, the group was led by Frère and included Théophile-Émmanuel Duverger, August Schenck, Paul Signac, Paul-Constant Soyer, Antoine Emile Plassan, and Charles Chaplin. In the style of Frère, this group of artists became well known for small paintings of tender domestic scenes featuring the mothers and children of neighboring peasants. The popularity of this school blossomed in 1854 when Ernest Gambart, one of Europe's most powerful art dealers, entered into a long-term contract with Frère to sell his art. By the late 1850s, the so-called "sympathetic art" produced by Ecouen artists had become fashionable not only in France but in England and the United States as well.[22]

Ecouen paintings were also attractive because of their price. Due to the simplicity of the subject matter and the relatively small scale of the canvases, the Ecouen paintings cost far less than the grand works by Ingres and other neoclassical artists or those by Millet and other Barbizon landscapists. Depending on the number of figures in the image and its size, the price of Ecouen paintings around the time of Lucas's arrival in Paris ranged widely between 100 and 1,500 F.[23]

Despite the differences in the style, subject matter, and cost of these three exemplars of French midcentury art, Lucas became attracted to them all. He purchased for his own collection a small marble sculpture of a nude closely modeled after the figure in Ingres's painting of *The Source*.[24] He also acquired a preparatory drawing by Millet of *The Gleaners*. And he purchased for himself and his clients many examples of

Frère's art. Lucas's taste for mid-nineteenth-century French art was as elastic as the diversity of styles of art shown at the annual Salons. Politically, socially, and philosophically neutral when it came to matters of art, Lucas could salute Napoleon III, praise the neoclassical images of Ingres, offer a toast to left-leaning artists like Millet and Rousseau, and encourage his clients to purchase the sweet, sentimental pictures by Ecouen artists. Because he was not wed to any particular style, Lucas navigated effortlessly across the spectrum of mid-nineteenth-century art to acquire for his American clients whatever satisfied their tastes and fit comfortably within their budgets.

Although his life was an adventure, Lucas's advice about art was decidedly unadventurous. The judges of the annual Salons set the parameters for what was acceptable, and Lucas rarely encouraged his clients to step beyond these lines. He carefully studied and cautiously followed the art market but did not try to make it. He did not encourage his clients to speculate on the acquisition of obscure avant-garde artists. While Lucas attended the Salon des Refusés in 1863 and the later exhibitions of independent and impressionist art, he did not go shopping there. He never acquired a painting by Cézanne, Monet, or Whistler. Nor did he ever purchase for his own collection a painting by Manet until 1906, long after Manet had been accepted into the cultural mainstream, and even then he did so unenthusiastically, telling the dealer that he could "reclaim it if he wishe[d]."[25] Lucas staked his reputation and built his business by his ties to well-established mid-nineteenth-century artists whose names were known to his American clients. What set him apart from other dealers was his personal relationships with these artists and his ability to open their doors, introduce his clients to them, and cautiously acquire for his clients fine examples of their work at reasonable, if not slightly discounted, prices.

◆ ◆ ◆

The year after Lucas arrived in Paris, he began to attend the daily art auctions at the Hôtel Drouot as if this auction house were his classroom and he its student. Between July and December of 1858, Lucas could be found there practically every day. His goal initially was not to buy but to master the process, to learn the prices, to discover what was available, to sharpen his own eye, and above all to learn how to wheel and deal and make a living as a middleman in the business of French art.[26] The knowledge that he gained at the Hôtel Drouot was supplemented by directories (the *Annuaire des Beaux-Arts*) of significant works of art auctioned there each year. The *Annuaire* for 1861, for example, provided Lucas with the prices, sizes, and names of paintings by Rosa Bonheur, Charles-François Daubigny, Eugène Delacroix, Jean-Léon Gérôme, and Ernest Meissonier that were auctioned that year. It also gave the dates of the auctions and the names of the auctioneers, as well as an alphabetized list of the names and addresses of 1,680 artists who lived in or around Paris.[27]

Lucas's education continued at the Louvre, where he would spend entire days. He visited the museum alone or with clients more than 225 times during his life in Paris, never tiring of its encyclopedic and ever-growing collection. When at home, he re-

ferred to the Louvre's three-volume catalogue of its collection. It was among the earliest art reference books that Lucas purchased.[28]

He never missed the spring Salons, of course. To visually grasp and evaluate the enormous number of objects on display, he would return there day after day.[29] At the Salon of 1857—the first that Lucas would have attended—there were 3,483 works of art on display (2,713 paintings, 427 sculptures, and over 300 drawings, engravings, and lithographs). The catalogues for this and subsequent Salons became Lucas's treasured dictionaries. They provided biographical information about the most celebrated artists, including the awards they had won at earlier Salons. By listing the number of works that were on display, the catalogues indicated the current status and popularity of the artists in the minds of the judges. For example, on display at the 1857 Salon were eleven paintings by Bouguereau, nine by Meissonier, seven by Corot, six by Courbet, five by Gérôme, four by Daubigny, three by Rousseau, and one each by Breton and Millet.[30]

Notwithstanding the voluminous amount of art that Lucas saw at the Louvre and the annual Salons, his favorites were housed in the Luxembourg Museum, where masterpieces by such prominent living French artists as Ingres, Bouguereau, Cabanel, Gérôme, and Meissonier was on display. The Luxembourg became for Lucas his sanctum sanctorum, his place not merely to see but to worship the art. Thus, when his wealthy American clients, such as William T. Walters and Samuel P. Avery, arrived in Paris, Lucas would promptly escort them there to refine their tastes. As a practical matter, the list of artists at the Luxembourg served like a scorecard for Lucas and his American clients as they triumphantly acquired paintings by those artists for shipment home.[31]

The final source of Lucas's self-education in nineteenth-century French art was the significant library he assembled. In 1858, he erected shelves in his apartment to hold his collection of art books, which ultimately spiraled to fifteen hundred volumes. The library included catalogues, art criticism, books featuring illustrations of the art created by well-known painters, and dictionaries containing their biographies. To booksellers in Paris, Lucas was both an art lover and a welcome bibliophile, who patronized at one time or another over 125 different Parisian bookstores, buying art-related books for himself and his clients.[32]

◆ ◆ ◆

In July 1858, after learning the ropes of auctioneering at the Hôtel Drouot and studying Salon catalogues, Lucas began to actively bid at the auctions, purchasing dozens of relatively inexpensive works. He initially appears to have been less interested in the quality, subject matter, or maker of the artworks than in the pure experiential pleasure of acquiring art with the hope of promptly selling it. Although cautious at first, beginning in May 1859, Lucas began to acquire art as if it were an obsession. He rarely went to the Hôtel Drouot without returning home with one or more pictures in hand. As documented in his diary, Lucas bid on and purchased works of art at the

Hôtel Drouot on twelve different days in May of that year. He continued on this buying spree in June and July. During the eighteen-month period from July 1858 through December 1859, Lucas purchased ninety-three works of art. Their cost ranged from 5 to 105 F and together totaled 2,300 F.[33]

Most of the art that he purchased during this early period had no lasting value. Thirty-eight works were without any attribution and were distinguished primarily by their sentimentality, as exemplified by his first purchase: an engraving of dogs and pups by an unknown artist. It cost 5 F, roughly $1.[34] Many of the paintings he bought were by undistinguished Flemish artists or poor copies of eighteenth-century French artists, such as the copy of a Delacroix painting that Lucas purchased at the Hotel Drôuot for 35 F on April 1, 1859, and then sought to resell on August 9 of that year. During this stage of his career, Lucas struggled. He was a neophyte lost in a sea of local picture dealers and middlemen, without any American clientele to anchor his practice. On December 7, 1859, Lucas took most of his remaining pictures back to the Hotel Drôuot and tried to auction them to other dealers or collectors. Among the ninety-three works of art he purchased in 1858 and 1859, Lucas sold or otherwise disposed of eighty-three of them. There is no evidence that he turned any profit on the purchase and sale of these paintings, and only a few of the acquisitions made during this period survived and entered his permanent collection.[35]

While the Hotel Drôuot remained the principle center of his activities as an art dealer, Lucas in 1859 began to meet, befriend, and acquire art (sometimes as gifts) from dozens of individual artists. Prior to Frick's visit in May 1860, Lucas had met Auguste Anastasi, Barye, Bonheur, Duverger, Benjamin-Eugène Fichel, Frère, Lemmens, Merle, Isidore Patrois, Plassan, and Signac. He also became reacquainted with James McNeill Whistler. Because of the popularity of the Ecouen artists and the relatively modest price of their art, he was especially attracted to them. In 1859, he began to regularly visit their homes and studios, often joining them for dinner and establishing relationships that would last for a lifetime. Lucas went to Ecouen often during his career and became a major proponent of the art produced there. His early patronage was rewarded in October 1859 by a landscape by Signac—it was the first of many gifts that Lucas received from artists as tokens of appreciation.[36]

◆　◆　◆

While delighting Frick with stories about the artists he had met, the friendships he had made, and what he had learned during his three years in Paris, Lucas also escorted him in May 1860 to the studios and homes of several artists who had become his friends. The group included Anastasi, Barye, Duverger, Lemmens, Signac, and Ziem. Frick found their art to be alluring, causing him on May 15 to facetiously write in his diary, "Lead me not into temptation!" The prayer did not work.

Frick returned to Paris on July 11 of that year and remained there for three more weeks. He became intoxicated with the potent mixture of cognac, coffee, art, and the swirling street life of Paris. "Streets alive with people . . . theaters, cafes, gaslights, ve-

hicles, everything moving . . . until daylight and begins again," he wrote. Led by Lucas, he dove into the robust market for French art. Before he left, Frick acquired with Lucas's guidance seventeen paintings and prints, mostly by Ecouen artists, that ranged in price from 100 to 1,000 F and five excellent bronzes by Barye. The night after he completed his purchases, Frick recorded a different tune in his diary: "Who can resist temptation!"[37]

Observing the joy and satisfaction that Lucas expressed about his life in Paris, Frick noted that the time he spent with his friend in Paris in July and early August 1860 was "one of the happiest . . . of my life and his."[38] Paris had become Lucas's adopted home. It was where he found, according to Frick, "so much pleasure. . . . as a connoisseur of art."[39] When Frick offered Lucas an opportunity to return to Baltimore in December 1861 on a private vessel owned by the president of a Baltimore shipping company, Lucas declined. He informed Frick that he had no intention to leave. Paris had become his home and his paradise, and any notion of his leaving and returning to the United States was never seriously considered again.[40]

Lucas and Whistler

Among the artists whom Lucas befriended during his early years in Paris, his personal relationship with "Jimmy" (as Lucas called him) Whistler was the most unusual and often the most contentious. Lucas's large and precious collection of 152 intaglio prints and lithographs by Whistler (six of which were signed by Whistler and dedicated to Lucas) and the reams of documents about Whistler's life that Lucas acquired might suggest that Lucas was an early and ardent supporter of Whistler's work.[1] But he was not. Like many others, Lucas for many years considered Whistler's art—especially his paintings—to be as wild and rebellious as his personality and an affront to the governing academic standards of mid-nineteenth-century art. The refusal of the judges of the Paris Salon of 1863 to display Whistler's now famous *The White Girl* (plate 9) and Whistler's decision shortly thereafter to display the painting at the Salon des Refusés, where it again was greeted with derision, likely sealed Lucas's opinion that his art was not worth having. For close to thirty years, Lucas repeatedly dismissed opportunities to buy Whistler's paintings and etchings, even though they were offered to him at discount prices. It was not until the late 1880s, when critics began to praise rather than condemn Whistler's art, that Lucas changed his mind and began to voraciously acquire Whistler's etchings with the hunger of a collector intent on making up for twenty-five years of lost time and opportunity.[2]

◆ ◆ ◆

What initially brought the two together was Lucas's close friendship with Jimmy Whistler's older half-brother. George Whistler and Lucas became dear friends in the early 1850s, when they were both employed as civil engineers for railroads located in the same New York–New Jersey region and discovered a common interest in art and high culture. In 1854, George Whistler's fortunes soared when he married Julia De Kay Winans, the daughter of Ross Winans, the wealthy owner of the Winans Locomotive Works, a Baltimore-based company that designed and manufactured engines and machinery for the Baltimore and Ohio Railroad and other US customers. Ross Winans's success led to an invitation from the Russian tsar to construct a railway line between Moscow and Saint Petersburg. Ross Winans's son, Thomas, went to Russia to oversee this project and upon returning to Baltimore with a Russian wife in 1852, he constructed an extravagant Baltimore mansion filled with Tiffany chandeliers and surrounded by boxwood gardens whose paths were dotted with replicas of ancient Greek and Roman sculpture. He named his estate Alexandroffsky after a town in Russia where he worked.[3]

George Whistler's marriage to Julia Winans had significant consequences not only for him but also for his younger brother Jimmy. In 1854, George Whistler returned to Baltimore and became a partner in the Winans railroad business. Shortly thereafter, on June 16, 1854, Jimmy Whistler was expelled from West Point. Without any job or place to live, Jimmy looked to George, who arranged for Jimmy to reside in Alexandroffsky and, in return for his room and board, to use his skills as a graphic artist for the Winans company.[4] Jimmy endeared himself to Thomas Winans, who acquired some of his etchings, drawings, and paintings and became his first patron. With Winans's and his brother's support, Jimmy Whistler lived off and on in Baltimore at Alexandroffsky for approximately one year.[5]

In July 1854, George invited Lucas to dine with him at Alexandroffsky and introduced him to Jimmy.[6] Ten years apart in age and experience (Lucas was thirty and Jimmy, twenty), they had little in common other than having been booted out of West Point. They would not see each other again until three years later, when they both had become American expatriates residing in Paris.

Jimmy Whistler long had harbored the dream to move to Paris and live the carefree life of a bohemian artist. To pave the way, he counted on a small inheritance from his father's estate of $350 per year, which he would receive upon attaining the age of twenty-one. With this in mind, in July 1855, shortly after turning twenty-one, he applied for a passport to France and turned again to his brother George for guidance and legally empowered him to serve as his "true and lawful Attorney with full power to manage and control all of my affairs as if they were his own. . . . and in generally to do whatever I might be able myself to do were I personally present and acting."[7] Leaving his responsibilities in his brother's hands, Whistler left the United States for Paris on September 3, 1855.

◆　◆　◆

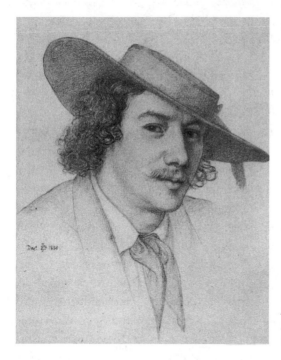

FIGURE 31. Edward John Poynter, *James McNeill Whistler*, c. 1860. Freer Gallery of Art, Smithsonian Institution, Washington, DC: Gift of Charles Lang Freer, F1898.145.

Two years later, when Lucas arrived in Paris, he assumed the thankless task of serving as a surrogate for his friend George Whistler and looking after his young and rebellious half-brother Jimmy. It was not an easy assignment. Not only their ages separated them. In style, temperament, and manners, Lucas and Whistler could not have been further apart. Whistler was a reckless and combative individualist; Lucas, a careful and reserved traditionalist. Sporting long, curly locks and often wearing a distinctive wide-brimmed, low-crowned hat (fig. 31), Whistler styled himself as a flamboyant bohemian; Lucas, always well groomed, presented himself as a conservative, upper-class gentleman. Whistler was notoriously unpredictable; Lucas almost always played by the rules and was dependable. Whistler was a troublemaker who took pleasure in poking his thumb in the eyes of authority; Lucas revered the French aristocracy and took pleasure in quietly caring for his friends and especially his clients. Whistler liberated himself from the didactic canon of art and preached that art existed for its own sake; Lucas, in contrast, felt bound by the traditional canons of art espoused by Reynolds and Ruskin and practiced by the judges of the French salons. During a relationship that lasted for twenty-nine years, each recognized the divergent views and personal strengths and weaknesses of the other. It was what initially glued them together and ultimately what tore them apart.

Not long after Lucas arrived, Whistler began to badger him for money. According to Elizabeth and Joseph Pennell (his earliest biographers), Whistler during his early years in Paris was often drunk, broke, shiftless, and dependent on Lucas's financial support. The rough nature of his dependency is illustrated by an incident that

purportedly occurred late one night in Paris. Whistler became inebriated, left a bar without paying his bill, surreptitiously gained entrance into Lucas's apartment building, and pounded on his door, demanding money. An argument ensued, Lucas refused to give him any money, and the next day, Whistler informed one of his buddies that he planned to challenge Lucas to a duel because of the way he was mistreated.[8]

Whatever the truth of this story, Whistler's conduct did not deter Lucas from continuing to look after him. In January 1858, upon learning that Whistler was ill—likely with rheumatic fever—Lucas rushed to the Maison de Santé Hospital to determine the state of his health. Thereafter, Lucas periodically sought to visit Whistler to see whether he was all right, but he had difficulty keeping track of him, due most likely to the frequency with which he changed his address. According to one account, Whistler moved nine times in a period of three years.[9]

In the spring of 1859, Whistler submitted two paintings to the annual Salon, but the judges rejected both. His lack of success in Paris motivated him to move that summer to London, where he thought his prospects were better. For two and a half years, he and Lucas fell out of touch. In January 1862, they rekindled their relationship when Whistler returned to Paris to attend the opening of his first public exhibition there, a small show at the Martinet Gallery on the boulevard des Italiens of fifteen etchings depicting the Westminster Bridge and warehouses and other scenes along the Thames River.

After the show closed in February 1862 and Whistler returned to London, he began to call upon Lucas for a variety of favors. On April 9, 1862, Lucas received a letter from Whistler's mistress and model Joanna ("Jo") Hiffernan, asking Lucas to fetch an easel and shirt that Whistler had left behind in Paris and to ship these items to him. A couple months later, Whistler wrote requesting him to go to the Martinet Gallery to see whether the gallery was still hanging his etchings and whether any had been lost or damaged. In October, Lucas was requested to select and order frames for two of Whistler's paintings, and in December, Whistler asked Lucas to ship the frames to him.[10]

Whistler's most significant request to Lucas involved his controversial but now famous painting *The White Girl* (plate 9). It is a painting of Joanna Hiffernan dressed in a virginal white gown and standing on the skin of a brown bear, whose open eyes stare straight at the viewer, as if the bear is alive and ready to protect the model's virtue. Unlike familiar salon-type portraits of luxuriously dressed wealthy women, this image of Jo realistically portrays a working-class model, exhausted after a long day's work, with her arms falling by her sides, her uncombed hair loosely falling across her shoulders, her gloves already fallen on the floor, and feeling as weary as the wilted flowers she holds in her hand.[11] Lucas knew Jo and was personally familiar with the painting, having been with Whistler at his home in London on April 1, 1862, when he was preparing *The White Girl* for possible display at an international exhibition sponsored by the Royal Academy. In June, Whistler informed Lucas that the painting had been rejected, and he was thinking of waging an open war against the Academy's judges.[12]

The next year, Whistler again sought Lucas's assistance with regard to this painting. He wrote, "It is my fate to come always to you for kindness which is also my good fortune to always have granted to me." This time, he requested Lucas's assistance in trying to gain the admission of *The White Girl* into the upcoming Salon in Paris. "I have set my heart upon this succeeding," Whistler wrote, and he asked Lucas to "receive it [the painting] for me and see it safely into the Palais de L'Industrie," where the Salon was to be held. He implored, "Therefore I beg above all things that you will meet it and prevent any harm coming to it when they open the case."[13] On March 18, Lucas went to the Palais and obtained an application for Whistler, which he mailed to him on the following day. With Lucas's assistance, the painting was submitted to the Salon, but the judges rejected it.

Whistler continued to turn to Lucas for favors. In March 1867, aware that Lucas planned to visit him in London, Whistler asked him to pick up "a little whisky flask I forgot . . . [and] a small rolled up sketch of Fantins." Later that year, Whistler asked Lucas to pack and ship to him the art that he had exhibited at the Paris Exposition that year and to also find for him in Paris a small studio and a little room in which to sleep. And in January 1873, Whistler asked Lucas to go to the exhibit of his art at the Durand-Ruel Gallery and "fight any battles for me about them with the painter fellows you may find opposed to them."[14]

Because Lucas was so obliging, Whistler recruited him into participating in an unconscionable and duplicitous scheme involving Whistler's newest mistress, Maud Franklin. In January 1879, Maud was eight months pregnant with Whistler's child, and Whistler did not want her around him. Under the pretense that he could not care for her because he needed to be in France, Whistler placed Maud in a hotel room in London, composed letters to her suggesting that he was in Paris, and sent the letters to Lucas for the purpose of having them posted from Paris. Whistler wrote, "I am sorry to give you all this trouble my dear Lucas, but pray help us through this petite affair and all will come right." Lucas, who did not know Maud at that time, faithfully complied with Whistler's directions.[15] Ironically, after soliciting Lucas to help him deceive Maud, Whistler in April 1880 asked him to meet her (for the first time) at a train station in Paris, to find her a place to stay, to take her to the Louvre, and to care for her for a few days.[16] After meeting Maud, Lucas (who was thirty-three years older) treated her as if she were his long-lost daughter. A close familial relationship between them arose that would outlast and be far more endearing than Lucas's friendship with Whistler.

Aside from these personal favors, what Whistler wanted most was for Lucas to buy his art. He recognized, however, that the art he was creating did not fit Lucas's conservative tastes. "I'll be charmed to find myself in your collection," Whistler wrote, but recognizing that Lucas did not care for his art, he added that he thought his friend would never allow his collection to be "shocked with one of my productions."[17] Whistler's perception was correct. Even though some of Whistler's earliest and finest works of art were available to him, Lucas never purchased a single painting by Whistler during his entire life.

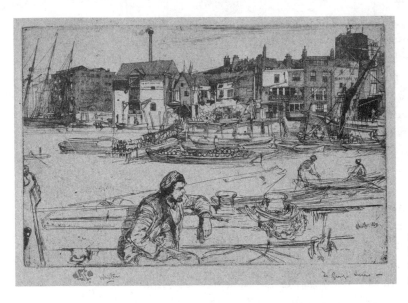

FIGURE 32. James McNeill Whistler, *Black Lion Wharf*, 1859. The George A. Lucas Collection, Baltimore Museum of Art, BMA 1996.48.9088.1.

Whistler also wanted Lucas to recommend his art to his clients. He wrote, "Seriously, you should make the wealthy Americans who come to London come to my Exhibition and buy beautiful pictures—for now there are plenty most portable—small and dainty."[18] Lucas, however, was disinclined to do so. Other than assisting Samuel Avery (whose interest in Whistler predated his association with Lucas) acquire his work, Lucas did not promote Whistler to any of his other clients. The clients with whom Lucas had the longest relationship—William Walters and his son Henry—never purchased a Whistler.[19]

Lucas also was reluctant for many years to purchase any Whistler etchings for his own collection. The few that entered his collection before the 1880s were given to him by the artist as gifts or tokens of his appreciation for the personal services that Lucas had provided. The most famous of these was the masterful *Black Lion Wharf* (fig. 32). It was inscribed "to George Lucas" and likely given to him along with two other etchings on February 1, 1867 (figs. 33 and 34). The power of these etchings, especially *Black Lion Wharf*, rests in the almost photographic detail of the rhythmic line of dilapidated buildings along the Seine, delicately etched in various shades of lightness and darkness reminiscent of Rembrandt.[20] When Baudelaire saw this etching and the others that belonged to Whistler's *Thames Series* at the Galerie Martinet in Paris, he described them glowingly as "subtle and lively as improvisation and inspiration, representing the banks of the Thames; . . . the profound and intricate poetry of a vast capital."[21] Whistler himself was undoubtedly proud of *Black Lion Wharf;* he placed a rendition of this etching on the wall of his mother's room in his celebrated *Arrangement in Grey and Black*, known worldwide as "Whistler's Mother." Years later, in a review of his etchings, Whistler's biographer Joseph Pennell characterized *Black Lion Wharf* as "one of the greatest engraved plates that has been produced in modern times."[22]

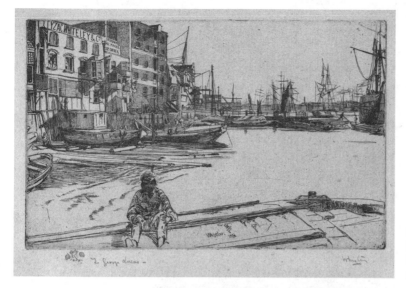

FIGURE 33. James McNeill Whistler, *Eagle Wharf*, 1859. The George A. Lucas Collection, Baltimore Museum of Art, BMA 1996.48.9075.

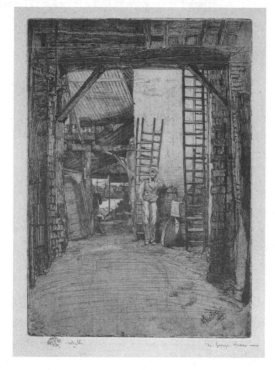

FIGURE 34. James McNeill Whistler, *The Lime-Burner*, 1859. The George A. Lucas Collection, Baltimore Museum of Art, BMA 1996.48.11658.

It is doubtful that Lucas fully appreciated the etchings given to him by Whistler at that time, for they did not inspire him to reach into his pocket and purchase more. In 1879, following Whistler's Pyrrhic victory in his defamation lawsuit against Ruskin (referring to Whistler's now famous painting of *The Falling Rocket,* Ruskin called Whistler a "coxcomb . . . [who asked] two hundred guineas for flinging a pot of paint in the public's face"), Whistler was forced into bankruptcy and required to

liquidate all of his assets, including his home and his art, in order to pay his debts. On May 3, 1879, shortly before the auction of Whistler's art, Maud Franklin implored Lucas to "come over and buy."[23] Lucas again declined the opportunity to purchase Whistler's art, even at substantially discounted prices. It was not until March 1884 that Lucas, following Avery's lead, purchased four etchings by Whistler for approximately 12 F apiece.[24]

Not long thereafter, Whistler asked Lucas to entertain Maud for a few days at his country home in Boissise. Whistler added that he might join her. Lucas responded that he would be pleased to "give him bed and board."[25] Whether Whistler's request was yet another ploy to get rid of Maud is unknown, but shortly thereafter Maud arrived and Whistler did not. It was not until August 1886 that Whistler along with Maud visited Boissise. He stayed for two days, during which he painted a small portrait of Lucas (plate 1). Although they did not know it at the time, the small painting would be the last gesture of their friendship.

On October 21, 1886, Lucas purchased another etching by Whistler and sent it to him for his signature. Whistler, however, refused to sign it. The reason, according to Maud Franklin, was that Whistler thought the etching "damnable." Although Lucas was usually imperturbable, this response angered him. He had provided favor after favor to Whistler, and now, the first time he asked Whistler for a favor, his request was dismissed with an insulting reply. Lucas promptly conveyed to Whistler that he did not want the etching "under these circumstances," and he directed Maud to tell Whistler "not to write to me."[26] This icy exchange marked the end of their friendship.

They apparently met only one time after that. It was by chance at the Durand-Ruel Gallery on October 12, 1892. Having no immediate use for one another, Whistler directed some unkind remarks at Lucas, which Lucas characterized as examples of Whistler's foolishness. Lucas later learned from his friend Mary Cassatt that Whistler had made in her presence similarly ungracious remarks about him. In 1896, she wrote, "I won't make you angry by recounting some of his [Whistler's] speeches. Gratitude seems to have been left out of his composition."[27]

◆ ◆ ◆

Although their friendship ended, Lucas's interest in Whistler—in his life and his art— did not expire. It was revived in the late 1880s, when Lucas became the recipient of a significant number of etchings that had belonged to Maud Franklin. Attracted to Beatrice Godwin, who would later become his wife, Whistler ended his turbulent relationship with Maud in 1888, and she turned to Lucas to overcome what he called her "separation grief." In 1888 and 1889, Lucas often invited Maud to join him at his apartment in Paris for breakfast or dinner and to relax in the comfort of his country home in Boissise for weeks at a time. Having spent most of her adult life with Whistler, posing for many of his works and helping him print his etchings, Maud had accumulated a large body of Whistler's art. She previously had offered Lucas "a few" of

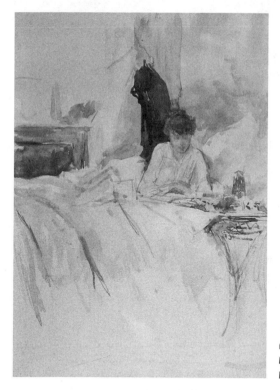

FIGURE 35. James McNeill Whistler, *Maud Reading in Bed*, c. 1879. The Walters Art Museum, WAM 37.318.

his etchings, and after separating from Whistler, she began to share many more with Lucas.[28] On Maud's behalf, Lucas began to sell many to Avery and other clients but kept many for himself.[29] It seems likely that Whistler's watercolor of Maud reading in bed entered Lucas's collection around that time (fig. 35).[30]

Lucas's interest in Whistler was stimulated by a dramatic turn in the artist's popularity in France. In 1882, Whistler's paintings began to obtain the acceptance of the judges of the annual Salons; in 1883, he received a medal at the Salon for his portrait of his mother; in 1889, he was made a chevalier of the French Legion of Honor; and in 1891, the French government purchased *Whistler's Mother* and displayed it in the hallowed Luxembourg Museum. Having emerged victorious, Whistler returned to Paris in 1892 to bask in the glow of his long-awaited stardom.[31] He was made a judge at the annual Salon, acquired a large apartment and studio on the rue du Bac overlooking the Luxembourg Garden, and was greeted by a stream of friends and admirers. Having severed his relationship with Whistler six years earlier, Lucas was not among them.

Whistler's entrance into the French pantheon of famous artists made Lucas, who was always attracted by the sweet smell of success, hunger for more of his art. By this time the price of Whistler's paintings was far beyond Lucas's reach, but his etchings and more recent lithographs continued to be readily available and affordable. In 1895,

Lucas embarked on a ravenous buying spree of Whistler's prints. In October, he purchased "a lot of Whistlers" for 600 F, and in April 1896, he purchased dozens more for approximately 1,000 F.[32] He acquired catalogues of Whistler's prints, requested and received a "package of documents" about the artist from Avery, and surrounded himself with books, pamphlets, and articles by and about Whistler. On the back of his prints, he identified the Salons in which they were shown, and he purchased portraits of Whistler that depicted him at various stages in his life.[33] While Lucas no longer liked Whistler personally, he became obsessed with his art and the objects that helped to tell the story of his life.[34] By the early 1900s, Lucas had accumulated over 150 of his prints and a unique and valuable collection of Whistler ephemera.[35] The amount of information that he had collected led Elizabeth and Joseph Pennell to speculate that Lucas was planning to write a book about Whistler.[36]

In July 1902, Lucas was approached by the well-known Parisian art critic and writer Théodore Duret, who sought his assistance in connection with a biography that Duret planned to write about Whistler. Duret's own life-size portrait had been painted by Whistler and displayed at the Salon in 1885, and he had become a devoted friend and patron of the artist. Wanting to know everything that Lucas knew about Whistler's life, Duret visited him frequently during the course of the next two years to gather information for his book. Upon completing a draft, Duret provided a copy to Lucas to read before its publication. Entitled *Whistler* and published in 1917, the book praised Whistler, calling him the "greatest artist his country ever produced" and stating that his etchings "come from a man without equal in his art." Toward the end of his book, Duret acknowledged the significant role that Lucas played in Whistler's life. He referred to the support that Lucas had provided to Whistler during the early phase of his career and credited Lucas, albeit mistakenly, with being the first American "capable of appreciating him."[37]

While Lucas, perhaps better than anyone, knew Whistler's personality and the mercurial history of his life, it is doubtful whether he ever fully appreciated Whistler's art, especially his paintings. In an effort to entice him to purchase them, Whistler once explained to him that his paintings were "not merely canvases" but expressions of "my theory of art . . . the science of color and 'picture pattern' as I have worked it out for myself during the years."[38] For a collector and art advisor steeped in Ruskin and Reynolds and in love with the mid-nineteenth-century art of the Salon, Whistler's explanation must have sounded like a call from the wild.

In the fall of 1908, toward the end of his life, Lucas took his final action involving Whistler. By then Lucas was weighing whether to leave his large collection of art to the Maryland Institute for the instruction of its students, while hoping that, instead, his friend Henry Walters would resolve to adopt his collection and place it in his new Baltimore museum. Lucas decided to give to Walters his small portrait by Whistler and Whistler's watercolor of Maud. In October 1908, Lucas shipped them without a word of explanation. Upon receiving the paintings, Walters wrote to Lucas, "I am a little taken off my feet by the Whistlers," and asked what he should do with them.

Lucas did not respond. His silence was pregnant with the answer. Lucas wanted these paintings—and indeed all of his paintings, prints, and sculpture—to be preserved by Walters in his new museum. Walters kept the paintings, but when he opened his museum in 1909, they were not to be found. They had been placed in storage, where they remained unexhibited for over fifty years.[39]

The Links to Lucas

In 1857, the gently rising tide of interest in French art among wealthy American collectors turned into a wave. It was generated by the efforts of two charming and skillful European art dealers, Michael Knoedler and Ernest Gambart. Knoedler was a German-born but French-raised dealer who came to the United States in 1852 to manage the New York branch of the Goupil Gallery. Five years later, he purchased the gallery and began to preside over it, as the *New York Times* reported, "with a frank heartiness and genial diligence that are irresistible."[1] Knoedler increased the inventory of French paintings, while featuring several of France's most popular midcentury artists. In 1860, he joined forces with Gambart and mounted the largest exhibition of French art yet seen in this country, firmly establishing his gallery as the primary source of this art in the United States.[2]

Ernest Gambart was a Belgian-born art dealer who owned a highly influential gallery (known as the French Gallery) in London and became England's most successful dealer of contemporary French art. He was fittingly referred to by his biographer as the "Prince of the Victorian Art World."[3] There could be no better measure of Gambart's influence and power than the fact that the queen was on hand to open his first annual exhibition of French paintings in London in the spring of 1854. The exhibition featured such masters as Delacroix, Ingres, Delaroche, Meissonier, Scheffer, and Troyon, but the newest and most popular star in Gambart's galaxy was Rosa Bonheur, whose enormous masterpiece called *The Horse Fair* was creating a sensation on both sides of the Atlantic.[4]

In 1857, Gambart brought *The Horse Fair* to the United States and

sold it to the American collector William P. Wright for 30,000 F, or $7,000, a price that far exceeded the cost of the most celebrated Hudson River school paintings and at the time was the highest amount ever paid for a painting in the United States.[5] It was a transaction that shook the marketplace by suggesting that French art was valued much higher than American art and provided its wealthy American buyers with more prestige and bragging rights. When the painting was exhibited that year at the New York gallery of Williams, Stevens, and Williams, the *New York Times* praised it as "glorious" and proposed that most artists might "suffer a spasm of despair in the presence of that wealth of power, the masterly foreshortening... [and] the ingenious reliefs of coloring."[6] Other reviews were equally ecstatic, with one claiming that Bonheur's painting was "one of the most remarkable paintings ever exhibited on the continent."[7] After its exhibition in New York, the painting embarked on a traveling exhibition to major cities along the East Coast, where crowds of art lovers paid admission just to see it. The painting became, as the art historian Lois Marie Fink has concluded, "an important milestone in directing Americans toward modern French art."[8]

The enthusiastic reception of Bonheur's painting in the United States motivated Gambart to significantly expand his sale of French paintings to American collectors. He joined forces with Knoedler and mounted an ambitious exhibition at the National Academy of Design of 206 French and English paintings (owned by Gambart). The reception from the American press served to guarantee the exhibition's success. On September 10, 1859, a few days before the opening, the *New York Times* proclaimed that it was not to be missed and identified Bonheur, Frère, Gérôme, and Troyon as starring in the lineup of artists whose work was being shown. Its highest praise, however, was reserved for Gérôme's "famous picture," *The Duel After the Masquerade* (plate 10), a dramatic rendering of a tragic event that actually took place during the winter of the previous year in the Bois de Boulogne. Gérôme's painting had been shown in 1857 at the Paris Salon, where it had generated "more admiration than any work by a French artist since the appearance in 1847 of Couture's *Romans during the Decadence.*"[9]

The publicity attracted many wealthy collectors to the New York exhibition of Gambart's art. Chief among them was William T. Walters, an affluent Baltimore businessman who had become an ardent collector of Hudson River school paintings, including work by Asher Durand, John Kensett, and Frederic Church. Walters's passion for art had become legendary. According to one story, the first five dollars he ever earned was spent on a picture. Wishing to explore the possibility of adding French art to his collection, on October 29, 1859, Walters attended the exhibition and, during the course of that remarkable day, purchased ten French paintings. Among them were pictures by Frère, Duverger, and Plassan, three artists whose intimate genre scenes of poor French families were extremely popular at that time. However, Walters's most important acquisition was Gérôme's celebrated *The Duel After the Masquerade*. It cost $2,500, which was more than the other nine paintings combined.[10]

Six months later, Walters returned to New York to purchase from the Knoedler Gallery a charming charcoal drawing by Bonheur. Entitled *The Conversation,* it pictured a shepherd and his dog seated side-by-side on a peaceful hillside amid a score of listening sheep. On June 26, 1860, Walters went again to the Knoedler Gallery and purchased Frère's *The Cold Day* (see fig. 30). His acquisition of three paintings by Frère, the drawing by Bonheur, and the celebrated *Duel* by Gérôme placed him at the vanguard of American collectors of French art. It also instilled within him an insatiable appetite to collect more, which led him to George Lucas.[11]

◆ ◆ ◆

By the end of the 1850s, William Walters was not alone in his desire to acquire French art. The Bonheur painting purchased by Wright and the Gérôme painting purchased by Walters generated among wealthy American collectors a "craze" for French art that threatened to eclipse America's love for its own Hudson River school landscapes.[12] While excellent examples of French art remained available in New York, American collectors began to look to France itself not only as the obvious and most abundant source of its art but also as a place to acquire it at more affordable prices. Having recently moved to Paris and immersed himself in the market for French art, Lucas had the remarkable good fortune of being at the right place at the right time.

Among the small group of American expatriates living in Paris then, Lucas was the only person who held himself out as an agent for American collectors. In 1858, after being in Paris for less than a year, Lucas began to receive requests for his services from a small group of prominent Baltimoreans with whom he was well acquainted. The first came from John H. B. Latrobe, who had been a great friend of his father's and had gained fame as an artist, legal scholar, and generous supporter of the arts. In March 1858, while in Paris, Latrobe sought Lucas's assistance in selecting and acquiring a large number of plaster casts of sculpture from the Louvre and in making the arrangements for their shipment back to Baltimore. The second request came from Solomon B. Davies, whose father had been the mayor of Baltimore in the 1840s around the same time that Lucas's father served as president of the Baltimore City Council. What Davies wanted was not any particular work of art but to be immersed in the cultural and epicurean pleasures of Paris for two weeks in May 1858. To this end, Lucas found him a place to live, escorted him to the Louvre, and wined and dined him every night while he was there. Lucas's old friend Frank Frick, whose wealthy father also served on the Baltimore City Council, had a simpler request. He wanted Lucas to acquire an engraving for him, the same kind of favor that Lucas often had done for Frick when they socialized together a few years earlier in New York. Lucas was not compensated for the assistance he gave to these old friends and acquaintances, but his actions benefited him in a more meaningful way—they planted the seeds that caused his reputation as a helpful friend of American art collectors to quickly grow, especially among the affluent upper-class members of Baltimore society.[13]

On June 18, 1859, Lucas received his first opportunity to provide art-related services to a paying American client. His brother William Lucas sent him twenty English pounds (the equivalent of 500 F) and conveyed a request from William Hamilton Graham to purchase a painting for him. Graham was one of the wealthiest and most cosmopolitan members of Baltimore society. He was the director of Alexander Brown & Company, the first investment-banking firm in the United States and one of the most powerful banks in the country. Graham's interest in acquiring French art might have been related to the expansion of his bank's business to Europe. Without any expertise in French art, he authorized Lucas to select a painting for him. It was a pivotal opportunity in Lucas's early career, and he spent the next three days searching for the type of picture likely to satisfy Graham's taste and budget.[14]

His search led to Ecouen, where on June 28, 1859, he met Frère and Duverger. Lucas settled on a small painting by Duverger that cost 500 F—the exact amount that Graham had provided. Lucas shipped the painting to Graham and notified his brother William that the mission had been accomplished.[15] Graham was delighted with this painting and requested Lucas to acquire another. Pursuant to this request, in September, Lucas purchased a painting by another well-known genre painter, Benjamin-Eugène Fichel, who had medaled at the Salon in 1857. Over the course of the next twenty years, Graham remained one of Lucas's most devoted clients, purchasing dozens of French drawings and paintings (including work by Lemmens, Merle, Signac, Schenck, and Duverger) from him and, more importantly, encouraging other wealthy friends to do the same.[16]

Lucas's service as an agent for Graham led to the most important connection he would ever make. Graham was a neighbor of William Walters; both owned stately homes in the Mount Vernon neighborhood of Baltimore. On November 1, 1859, Lucas received from Graham a letter enclosing a separate letter from Walters. Lucas had never met Walters but certainly knew about his wealth and reputation as one of America's leading collectors of French art, and he was eager to please him. Unlike Graham, Walters knew exactly what he wanted. He requested Lucas to commission Hugues Merle, a well-established artist whose paintings had been regularly shown in the Salons since 1847, to paint an image of Hester Prynne, the heroine of Nathaniel Hawthorne's popular novel *The Scarlet Letter*. Published in 1850, *The Scarlet Letter* was a morality tale about how Hester, the mother of a child born out of wedlock, was forced by her community to display a scarlet letter "A," for "adulteress," stitched prominently to the bodice of her dress.[17]

Lucas lost no time in satisfying the request. Three days after receiving Walters's letter, Lucas met with Merle at his studio in Paris and obtained his agreement to paint this picture. He provided Merle with a copy of Hawthorne's novel, requested the artist to make two sketches of the image that he proposed to paint, and sent these sketches to Walters for his approval. Lucas selected and purchased a frame for the painting, and he withdrew from his own bank account 2,000 F, which he paid to Merle as a deposit. Later, he returned with an additional 1,500 F to make the final

payment. During the course of this project, Lucas visited Merle's studio frequently to oversee the work. Finally completed in April 1861, the painting would be the first in a long list of artworks that Lucas obtained for Walters and his son Henry.[18]

Merle portrayed Hester tenderly embracing her infant daughter during a critical episode in the story. She is forced to stand on a scaffold for hours on end and withstand the shouts of derision from the hostile crowd; meanwhile, her child innocently touches the letter "A," as if to show that she is instinctively tied to the mother's shame (plate 11). It is an image of grace under pressure, the mother protecting her child with the inner strength that only dignity and strength of character can provide. We can only speculate about what motivated Walters to commission Merle to paint this image, but it well might have been Hawthorne's reference in *The Scarlet Letter* to Hester Prynne and her baby daughter as "an image of Divine Maternity, which so many illustrious painters have vied with one another to represent."[19]

From a broader art-historical perspective, Merle's painting reflected the important midcentury evolution of French art. It was a change in direction that perceptibly shifted away from history paintings featuring muscular heroes of the past to more modern genre paintings that personified the often-harsh societal, economic, or political realities of the present. Unlike neoclassical paintings, in which women often were portrayed as pliable objects of sexual desire, Merle's painting imbued Hester with the moral courage traditionally reserved for males, as suggested by her dark, piercing glare, which heroically holds the mob at bay while she protects the child in her arms. While picturing Hester as the embodiment of moral strength, Merle portrayed the principal male characters in Hawthorne's story—the minister who impregnated Hester and her vengeful husband—as small cowardly figures, slinking away behind Hester's back into the margins of the painting.

Although Merle's painting faithfully conveys Hawthorne's description of Hester as "this beautiful woman . . . [with] deep black eyes," it was no accident that Merle also gave her the same handsome, chiseled Grecian features as an earlier French heroine—Delacroix's well-known personification of Liberty in his famous *Liberty Leading the People*. At a time when French women were yearning for a degree of freedom and independence, without sacrificing their reputation for virtue, and when the blend of realism and romanticism had become part of the fabric of French art, Merle's painting struck a positive chord with the judges of the 1861 Salon, who awarded Merle a second-class medal.[20]

◆ ◆ ◆

On April 4, 1861, just eight days before the bombardment of Fort Sumter and the beginning of the Civil War, Lucas received another letter from Walters. It was about his plan to leave the United States along with his family and visit Europe. It wasn't the art that beckoned him but the compelling need to find a safe haven from the threatened civil war. Walters, like many wealthy Baltimoreans, was a strong and vocal supporter of the South, and he was in danger of being arrested or worse by the Union

troops that were about to occupy the city. In this and subsequent letters, Walters conveyed his plan to settle in Paris, and he sought Lucas's help in facilitating this transition.[21]

Walters asked Lucas to render services well beyond any conceivable job description for a dealer, agent, or connoisseur of art. In addition to providing advice about art-related matters, Lucas was called upon to personally attend to practically all of the needs of Walters's entire family while they were in Paris. Upon Walters's arrival in Paris with his wife Ellen and two children in September 1861, Lucas became his constant companion and responded to every request, whether menial or grand. He found a comfortable apartment for the Walters family at 12 rue de l'Oratoire in the fashionable 1st arrondissement, not far from a row of art galleries that he and Walters would frequent. Lucas negotiated the terms of the lease with the owner. He accompanied the Walterses as they looked for furniture and china, and on their behalf he searched for carpets, linen, and kitchen utensils. Once the furniture, curtains, and other accessories had been found, he helped place them in Walters's apartment and made sure that the doors and household equipment were functioning properly.

Lucas remained by Walters's side practically every day during the months of September and October, whether to make arrangements for the new household or to lead Walters on tours of the paintings and sculpture at the Louvre and the Luxembourg and the art available at the Goupil Gallery. He introduced Walters to some of his favorite artists, including, most significantly, Barye, and he escorted Walters and his wife to the town of Ecouen to meet Frère and Duverger. Walters could not have found a better friend, and Lucas could not have found a better client.[22]

The outing to Ecouen was for both men a special occasion. They had become admirers of Frère and Duverger around the same time, albeit three thousand miles apart—Lucas in Ecouen in July 1859 (when he met the artists and purchased a Duverger painting) and Walters in New York in October 1859 (when he purchased paintings by both Frère and Duverger). One can imagine Walters and Lucas admiring each other's fine taste. To celebrate their mutual interest in these artists, on December 14, 1861, Lucas escorted Walters and his wife by train to Ecouen, where he had arranged for them to dine with the artists and their wives. They were joined at dinner by another Ecouen artist, August Schenck, whose work Lucas would later acquire for himself, Walters, Graham, and other clients.[23]

The dinner meeting served to bring Walters and especially Lucas closer to these artists. With Lucas's assistance, Walters would purchase seven additional paintings or drawings from Frère and an additional drawing from Duverger. Their robust interest was documented by Lucas in his diary on June 22, 1862: "To Ecouen, dined at Duvergers—Saw Frère, Dansaert, Signac, Schenck, & Soyer—Ordered drawings from *all* for Walters" (emphasis added).[24] Lucas became a devoted patron of the Ecouen artists, visiting the town more than seventy-five times over the course of the next twenty years and acquiring dozens of additional drawings and paintings from the artists for himself and his clients.

In October, William and Ellen Walters traveled from Paris to London for an extended vacation, leaving their thirteen-year-old son Henry and nine-year-old daughter Jennie behind—they were enrolled in private schools—for Lucas to look after. Tragically, in November, Ellen, at the age of forty, died of pneumonia. Grief stricken, Walters requested that Lucas escort young Henry to London, which he promptly did.

After Walters returned to Paris on November 21, Lucas sought to comfort him. For the following five weeks, he was with Walters almost every day, visiting him at home, joining him for breakfast, taking him to dinner, accompanying him on long walks through the city, and gradually rekindling his interest in art. The two became inseparable, like kindred spirits in an art-filled land, joined together by their passion for what they saw. The bonds of trust and affection that would link William Walters, his son Henry, and Lucas together over the course of their lifetimes were forged at that time.

In June 1863, Walters, with Lucas's advice, returned to the purchase of art. The immediate goal, however, was not to enlarge his own collection but to create an inventory of French and German works that Walters could resell to American buyers in the United States. In November, Lucas accompanied Walters to Düsseldorf, Germany, where they visited several salons and galleries and purchased an untold number of paintings. Walters's art was then shipped to New York, where in February 1864, it went on sale at the Düsseldorf Gallery. Many of the works that Walters had acquired through Lucas were sold, including drawings and watercolors by Ecouen school artists Chaplin, Duverger, Frère, and Soyer. From the sale, Walters grossed $36,099. Ten days later, he paid 500 F to Lucas for his services.[25] This success motivated Walters to mount a second sale of his art in New York in April; it was even more successful, netting $36,515.[26]

• • •

In 1863, Lucas's interest in art began to gravitate from the genre paintings of Ecouen to the landscape paintings of Barbizon. What propelled this shift was not a change in his taste but a compelling need to satisfy the changing and dominating interests of Walters. As a knowledgeable and sophisticated collector, Walters shaped Lucas's taste in French art as much as Lucas shaped his. Although Lucas was bred on the landscapes in his father's art books, he paid surprisingly little attention to the landscapes of Corot or Daubigny during his early years in Paris. Between 1857 and 1863, he did not mention Corot in his diary, and he mentioned Daubigny only once. Nor did he mention Rousseau or Millet, the undisputed leaders of the Barbizon school. Rousseau was not mentioned in Lucas's diary until July 1863, when Lucas saw an exhibition of his art, and Millet was not mentioned until October 1864. While Lucas visited Ecouen innumerable times during his first five year in France, during the same period, he neither visited the village of Barbizon nor mentioned it in his diary. Walters changed this.

In the fall of 1863, Walters directed Lucas to explore the availability and cost of

paintings by the three most celebrated landscapists of that time: Corot, Daubigny, and Rousseau. As reflected in the increased number of landscapes displayed in the Salons from the early 1850s to the early 1860s and exhibited at the premier galleries on the rue Laffite, it was evident that such paintings, especially those picturing the Fontainebleau forest, were commanding more and more attention and higher and higher prices. At the Universal Exposition of 1855, thirteen paintings by Rousseau, including seven depicting the Fontainebleau forest, were placed on display, and by the 1860s, landscape paintings represented around 30 percent of the art shown at the Salons.[27] The Georges Petit Gallery began to market landscapes by Daubigny, and the Durand-Ruel Gallery began to make heavy investments in the work of other Barbizon artists, especially Rousseau. This led to the decision by Durand-Ruel in 1866 to purchase from Rousseau practically every work in his studio, including unfinished paintings and preparatory sketches, for resale to collectors. Whether attracted by aesthetics or the prospect of owning increasingly valuable and popular works of art, Walters, with Lucas's assistance, decided to plunge into this market.

On November 27, 1863, Lucas purchased a "small Daubigny" for Walters that cost 600 F. A week later, he acquired a painting by Rousseau for Walters for 750 F, and on December 17, he ordered two more pictures from Daubigny's studio for 2,000 F. In mid-January, Lucas returned to Daubigny's studio to purchase more art, resulting in the acquisition of two small landscapes for 2,900 F. While busy buying Daubigny's and Rousseau's art, Walters began to focus on the dreamy, lyrical landscapes of Corot.[28]

On January 23, 1864, Lucas had dinner with Frère, Daubigny, and Corot (fig. 36 and fig. 37).[29] At that juncture, these artists were at the height of their fame. While Frère had the distinction of being John Ruskin's favorite French artist, Daubigny and Corot were recognized by practically everyone else as two of the greatest French landscape painters of that time. In an age when the annual Salons were a primary source of entertainment, attracting hundreds of thousands of Parisians each year, having a private dinner with three of the Salon's most famous medalists was tantamount to dining with the greatest rock or movie stars of today. It not only was a thrilling opportunity for Lucas but also a sign of the high standing that he had attained as America's premier agent for the acquisition of French art.

Lucas and Frère had become good friends. They had visited each other at their homes, dined together, and spent hours strolling together through the Ecouen countryside and along the Champs-Elysées. Frère introduced Lucas to other artists and to significant players in the trade, including his dealer Ernest Gambart.[30] Frère's willingness to assist Lucas in developing his network of key figures in the Parisian art market likely led to the dinner on January 23 and Lucas's personal introduction to Daubigny and Corot.

Frère and Daubigny had known each other since the 1830s, when both were students in the atelier of Paul Delaroche. By 1864, Daubigny's reputation among aficionados was even higher than Frère's. Among the growing number of landscape painters

FIGURE 36. Henri Lavaud and Lemercier et Cie, *Jean Baptiste Camille Corot*, c. 1865–1873. The George A. Lucas Collection, Baltimore Museum of Art, BMA 1996.48.626.

FIGURE 37. Etienne Carjat, *Charles François Daubigny*, c. 1865–1873. The George A. Lucas Collection, Baltimore Museum of Art, BMA 1996.48.4497.

in Paris during the Second Empire, Daubigny apparently was Napoleon III's favorite. He had won three first-class medals at the Salons, and his paintings had entered the Luxembourg Museum. In 1857, he purchased a small boat (his "Botin") and drifted along the banks of the Seine and its tributaries painting *en plein air* the many coastal landscapes that became a prominent part of his oeuvre. As reflected in the small delicate painting that Lucas would later acquire and place in his parlor beside his armchair (plate 6), the attractiveness of Daubigny's landscapes rested in their quiet unpretentiousness, their apparent open-air spontaneity, their fidelity to nature, their avoidance of any slick and pretentious finish, and their use of perspective in a manner that invited the viewer to enter the painting along a river or road and to become seemingly closer to nature.

Corot, who was born in 1796, was approximately twenty years older than Daubigny and Frère and was considered the patriarch of modern French landscape painting. His presence at the dinner with Lucas was probably due to his friendship with Daubigny. They met in 1852 and traveled through France and into Switzerland together. Although neither resided in Barbizon, they both lodged in the village's now

famous inn and artists' meeting place, the Auberge Père-Ganne, and became key members of the larger colony of Barbizon artists. When Daubigny purchased his Botin, he announced that Corot, as a symbol of their friendship, would be considered the "honorary admiral."

The turning point of Corot's long career occurred in 1854 when his poetic painting, *Une Matinée,* or *La Danse des Nymphes* (*The Dance of the Nymphs*), was admitted into the Luxembourg Museum, guaranteeing that his art and his own legacy would later be enshrined in the Louvre. The painting depicted a hazy, dreamlike scene of graceful nymphs dancing together in an ancient bacchanal among bending trees and along a serene body of water in an imaginary landscape. This and similar paintings by Corot bridged the gap between the seventeenth-century neoclassical landscapes of Claude Lorrain and the pure landscapes depicted in the modern Barbizon paintings of the mid-nineteenth century. The images were reproduced in engravings and became well known and sought after. When Napoleon III purchased one of these paintings in 1863, a parade of well-heeled collectors eagerly followed.

Walters's interest in Corot likely peaked in the spring and summer of 1863 when, accompanied by Lucas, he visited the Luxembourg Museum and saw *The Dance of the Nymphs.* He thereafter attended an exhibition of similar dreamlike paintings of female figures communing with nature. In early February 1864, Walters went to Corot's studio and saw a beautiful new work employing the same motifs, *The Evening Star* (plate 12). It depicts a graceful female figure reaching to the sky in the fading light of sunset as if to catch a star. She stands next to and almost touching a leafless tree, whose slender upper branch reaches skyward in the same direction. It is a beautifully composed elegy to the affinity of man and nature and the fragility of both. Walters informed Corot that he wanted the painting, but it was destined for Toulouse, where it would be exhibited and then acquired by the town's museum.[31]

Unable to acquire the original of *The Evening Star,* Walters directed Lucas to visit Corot and commission him to paint a replica of it. Having just met and dined with Corot the month before, Lucas must have looked forward to this assignment. Lucas became a devotee of Corot and would acquire many of his paintings for his clients and himself. On behalf of Walters, Lucas requested Corot to paint a "repetition" of *The Evening Star.* He also asked Corot to paint a "small landscape near Amiens" for himself. Corot replied that he would paint a smaller version of *The Evening Star* for 1,000 F and the small landscape for 300 F.[32]

When Lucas reported this to his client, Walters expressed an interest in purchasing two additional paintings by Corot (for a total of four) and trying to parlay the increased number of paintings into a reduction of the overall price. As both Lucas and Walters were well aware, the price of art was often negotiable, depending upon supply and demand, the relationship between the artist and the buyer, the number of works being acquired, the prospects for continued patronage, the amount of time it would take to complete the work, and a number of other objective factors, such as the type of materials used, the painting's scale, and the number of figures in the composi-

tion.[33] On February 9, 1864, Walters and Lucas returned to Corot's studio to nego-tiate. They were informed that the price of the two additional landscapes was 400 F each, and when added to the 1,000 F for the *Evening Star* and the 300 F for the landscape near Amiens, the total price was 2,100 F. When Lucas "asked if he could not put the whole at 2000 francs, [Corot] replied in an indefinite manner that it was too little." Lucas, however, recognized an air of indecisiveness in his reply and sagely noted that Corot "did not positively say he would not" reduce the price."[34] After de-liberating for about a week, Corot agreed to the reduction.

In April, Lucas returned to Corot's studio and purchased yet another painting, called *Landscape Road at Ville d'Avray, With Paris in the Distance,* for 400 F. It later was renamed *Sèvres-Brimborion, View Toward Paris* (plate 13). One of the jewels of the Lucas collection, this beautiful, atmospheric landscape depicted the ephemeral effects of light and shadow on the high road near the town where Corot's family lived.[35] Five days after acquiring it, Lucas returned to Daubigny's studio and purchased three more landscapes from him for 1,700 F. This series of transactions concluded on June 22, 1864, when Lucas paid Corot 1,000 F for *The Evening Star.* Within a period of eight months—from November 1863 to June 1864—Lucas had acquired for him-self and Walters thirteen landscapes by Daubigny and Corot.[36] These acquisitions became the bedrock of the ever-growing collections of paintings, drawings, and prints of French landscapes owned by Walters and Lucas.

Lucas benefited from these purchases in more ways than one. In December 1864, he took one of his newly acquired paintings by Corot and another by Daubigny to the Georges Petit Gallery and proposed that Petit sell them for him at a profit. A Corot that Lucas had acquired for 300 F was sold by Petit for 510 F, and a Daubigny that Lucas had likewise acquired for 300 F was sold for 600 F, resulting in a profit of approximately 510 F.[37] The sale or "flipping" of these two paintings by Lucas was not considered unethical or unusual. Although the lion's share of his time, knowledge, and effort was devoted to serving his wealthy American clients, Lucas throughout his career continued to supplement his income by buying and selling works of art and wheeling and dealing like other middlemen in the frenzied Parisian art market. While Lucas loved to buy art for himself and his clients, he also needed a steady flow of money to support this occupation. In any event, his decision to sell two works by Corot and Daubigny apparently had no adverse affect on his relationships with them. In apparent celebration of their dinner together one year earlier, on January 23, 1865, Lucas was again invited to share dinner with both of these masters.[38]

Around the same time, Walters requested Lucas to obtain a large, complex draw-ing called *The Ceremony of Dosseh* (fig. 38), by Alexandre Bida, widely considered one of the greatest French draftsmen of the nineteenth century. Bida's drawing depicts a Muslim sheik on horseback, riding over but leaving uninjured a group of believers who, while prostrated in positions of prayer, have carpeted the road with their bodies for the purpose of proving and celebrating the power of Mohammed. The assignment would test Lucas's skill and savoir faire as a go-between. The barriers to satisfying this

FIGURE 38. Alexandre Bida, *The Ceremony of Dosseh*, 1855. The Walters Art Museum, WAM 37.901.

requested were threefold. First, the Georges Petit Gallery had recently sold the drawing at the high price of 6,000 F to Ernest Gambart. Second, Gambart, a hard-driving and powerful dealer, was unwilling to relinquish the drawing for less than 7,000 F. And third, Walters was unwilling to pay Gambart more than 6,000 F to purchase it. Rather than battling mano a mano with Gambart, Lucas relied upon the rapport that he had established with Petit and offered to pay him a commission of 200 F to intervene in the dispute and convince Gambart to relinquish the drawing to Walters for the price he offered. The strategy somehow worked. Walters acquired the drawing for 6,000 F (plus 200 to Petit), and due in part to Lucas's skill, it found a prominent place in Walter's collection.[39]

As the American Civil War was coming to an end, Walters began to make plans to return to the United States. Lucas was charged with arranging for the sale of Walters's furniture and with packing and shipping back to Baltimore his art, carpets, and linens. As a farewell gesture, Lucas purchased a small gift for young Henry, and on the morning of March 7, 1865, he escorted the family to the port of Havre and watched them depart.[40]

◆ ◆ ◆

Aside from the commissions that Lucas earned and the knowledge and pleasure that he derived from his friendship with Walters, Lucas was indebted to him for another important reason. Walters had introduced Lucas to Samuel P. Avery. Among all of the American collectors whom Lucas served during his long career in Paris, Avery from a financial standpoint was by far the most important. Avery was a sophisticated New York art dealer who, beginning in 1867 and for twenty years thereafter, made annual trips to Paris to acquire work with Lucas's assistance for himself and for resale to his clients in the United States. The loads of French art that he channeled back to

FIGURE 39. Theodore Wust, *Samuel P. Avery Transporting His Treasures Across the Sea,* c. 1875–1880. Metropolitan Museum of Art 67.844.2.

America prompted one illustrator to picture Avery elegantly dressed and seated like a captain at the helm of a ship loaded with art, declaring that French art was on its way (fig. 39).

From Lucas's perspective, however, Avery was more than a meal ticket. The stream of French art that Avery purchased through Lucas enabled Lucas to become a wealthy man. According to one estimate, Avery, with Lucas's assistance, spent more than 2.5 million F to acquire over one thousand French works of art.[41] Based on Lucas's standard commission of 5 percent, these sales would have generated approximately 125,000 F for Lucas. In a letter written late in their lives, Avery looked back on their business relationship and the wealth it generated, and teasingly reminded Lucas, "How you did make money fly."[42]

Beginning in the early 1850s, Avery began to collect art, hosted "art gatherings" of artists and patrons in his Brooklyn home, and developed a reputation as a key figure in New York's budding art market. When William Walters began to acquire art in New York during that time, he looked to Avery for advice. Avery introduced Walters to local artists, and he arranged for the work that Walters acquired in New York to be shipped to Baltimore. Their mutual passion for art sealed their friendship. Following Walters's departure to France in 1861, he kept in touch with Avery, and in 1864, when Walters decided to auction most of the art that he had collected in France, he again turned to Avery to serve as his agent. The auction took place at New York's Düsseldorf Gallery on April 9, 1864. Walters consigned over one hundred

paintings to Avery, and under the terms of their agreement, he was entitled to one-half of the profits and Avery, one-third. Lucas was not named as a party in the agreement, but there is no doubt that he was, "the indispensable agent behind the scenes."[43] Although Lucas and Avery had never personally met, the auction brought them together as the bookends of this transatlantic sale, with Lucas helping Walters to find the art in Paris and Avery managing to sell it in New York.

In December 1864, Avery opened a handsome gallery at the corner of Broadway and Fourth Street, where he began to sell both American and European art. The gallery would later emerge as one of the most profitable centers in the country for the sale of French art. Hoping to capitalize on his acquaintance with Avery, Lucas on October 16, 1865, sent him a six-page letter expressing his interest in becoming his Parisian agent. The letter provides the best available evidence of Lucas's salesmanship, the services he offered, and the principles that he proposed to govern their relationship. At the outset, Lucas wisely expressed his admiration for Avery and his commitment to be guided by Avery's wishes, not his own. In this connection, he sought Avery's opinion about the French artists whom he liked and disliked in order to avoid making "serious mistakes." To illustrate his knowledge of the Parisian market, he touched upon the types of art that were readily available, where they could be purchased, and what they cost, referring specifically to the academic paintings of Bouguereau at the Durand-Ruel Gallery and to figurative paintings by August Sichel at Goupil. Finally, he provided an abbreviated list of approximately fifteen paintings that he had recently acquired, purportedly with Avery in mind. The list covered the gamut from academic paintings to landscape and genre paintings by well-known artists, as well as relatively obscure, up-and-coming ones whose work was considerably less expensive. The point that Lucas was attempting to make was that regardless of an artwork's style or price, Lucas had the means and the know-how to acquire it.

Among the artists whom he mentioned in his letter, Lucas highlighted Emile Plassan, who had become a close friend and had recently given Lucas one of his paintings. His paintings of domestic scenes had become very fashionable among American collectors. They had been shown successfully in New York, and William Walters had purchased one. Lucas suggested that Avery might be interested in a painting by Plassan that depicted a woman getting out of bed, which he hastily emphasized contained "*Nothing Shocking.*" In this manner, Lucas hammered home his own conservative aesthetic sensibilities and the important element of safety that would underlie the proposed relationship.[44]

The letter produced its desired effect. Avery agreed to purchase the art suggested by Lucas, and on November 23, 1865, Lucas packed and shipped fifteen paintings and one drawing to Avery. In the following year, Lucas continued from afar to cultivate Avery's business. Avery provided Lucas with a catalogue that showed the prices of the paintings he was selling at his gallery, authorized Lucas to open a bank account in his name for the purpose of acquiring art, and directed Lucas to explore the purchase of an expensive academic painting by Bouguereau for his wealthy Baltimore

client John Stricker Jenkins.[45] Lucas's endorsement of Plassan also paid off. Within the next two years, Avery purchased twelve works by Plassan that ranged in price from 75 to 6,000 F and totaled over 26,000.[46]

In February 1867, Avery announced that he would be coming to Paris and would likely remain there for several months. The primary reason for the visit was the International Exposition that was scheduled to open on April 1. Avery had been appointed as the American commissioner of fine arts to the Exposition, and with the assistance of an illustrious committee that included the dealer Michael Knoedler and the collector John Taylor Johnston (who would become the first chairman of the Metropolitan Museum of Art), he was responsible for selecting and exhibiting approximately 125 paintings, engravings, etchings, and sculptures by forty-five American artists.

On March 4, Lucas was at the Grand Hotel in Paris to greet Avery as he arrived. It was the first time they had met. During the next thirty days, Lucas served as Avery's concierge, guide, and art advisor. He found a comfortable apartment for Avery and his family in a fashionable section of Paris, led Avery on a personal tour of Paris, and guided him through the auctions at the Hôtel Drouot. On March 12, Lucas took Avery by train to Ecouen to meet some of the artists whose work he had shown in his New York gallery. They were received by almost the entire community of Ecouen artists (Dansaert, Dargelas, Duverger, Frère, Sauvage, Schenck, Signac, and Soyer), who undoubtedly were anxious to create a favorable impression on two Americans who held the key to the future sale of their work in the United States. Avery did not disappoint them, later buying works by all of them. Lucas also took Avery to the galleries of the International Exposition where the American art would be displayed, and he was by his side on April 1 when the Exposition opened.[47]

Lucas was cementing his valuable relationship with Avery when Jimmy Whistler got in the way. Avery had selected several etchings by Whistler for display in the galleries of the Exposition that featured American art. Whistler was also allowed to show four paintings in these galleries. Instead of expressing to Avery his appreciation, Whistler, like a spoiled and petulant child, erupted in a tirade of accusations against him. Dissatisfied with the relatively obscure placement of his work, Whistler sent a letter to Lucas in which he called Avery a "scoundrel" and a "d . . . d [damned] fool." He urged Lucas to "make a scene" at the Exposition if his pictures were not better displayed or, alternatively, "to have the pictures all taken away."[48] Although Lucas had satisfied almost all of Whistler's prior requests, he was not about to ruin his own relationship with Avery and damage his career by satisfying Whistler's belligerent demands. He promptly replied to Whistler's letter and met with him a few days later. It is not known what words he employed or balm he applied to pacify his combative friend, but Lucas likely reminded him about the old cardinal rule about not biting the hand that feeds you. It was likely the best advice Whistler ever received. He allowed his pictures to remain untouched in the exhibition. Avery began to express interest in his art and later became one of Whistler's greatest patrons, acquiring over 239 etchings, 25 lithographs, and 7 paintings. He organized one of the earliest exhi-

bitions in the United States of Whistler's art and was responsible for publishing one of the earliest American catalogues of his etchings.[49] Although Avery acquired most of the art directly from Whistler or dealers in London, he used Lucas as his agent when he wanted to purchase Whistler's work in Paris.[50]

By the early 1870s, Whistler no longer viewed Avery as a "scoundrel" or a "fool." Avery's patronage, like a tranquilizer, converted Whistler from a foul-mouthed cultural pugilist to a model of civility. "Do pray write me a line of news now and then—I am not much of a correspondent—but I shall be greatly pleased to read your letters," Whistler wrote to Avery, while inviting him in another letter to join him around five in his home in London "and have a cup of tea."[51]

◆ ◆ ◆

The American art displayed at the International Exposition of 1867 was not well received by critics from the United States and France, who concluded that it looked tired in contrast to the exuberant and award-winning canvases of Cabanel, Bouguereau, Gérôme, and Meissonier. Rather than trumpet the glories of American art, the display ironically served as a watershed moment in cultural history when the taste of American collectors decidedly shifted from American to French art.[52] In 1867, Avery placed himself at the vanguard of this movement.

During the ten months that he remained in Paris—from March 4 to November 26, 1867—Avery, with Lucas by his side, embarked on a shopping spree that would last for a generation. Avery had a strong sense of the types of art that his American customers wanted and a familiarity with the names and profiles of the artists, such as Cabanel and Meissonier, that would generate sales. Avery's stature in the art world had been established by his appointment as America's commissioner of art and the accolade of "connoisseur" bestowed upon him by the US secretary of state.[53] He did not need any elementary education from Lucas. As illustrated by his purchase of Whistler's work, Avery told Lucas what he wanted to buy, and Lucas took him to it or purchased it for him.

As Lucas soon discovered, Avery did not ruminate over each piece of art and treat it like a treasured jewel; instead, he decisively gathered up relatively inexpensive watercolors and prints, mindful that most would remain in his possession no longer than the amount of time it took for some customer to buy it. As a result, Lucas was unable to identify in his diary each work of art that Avery acquired during his initial ten months in Paris. In most cases, the best he could do was to identify the dealer and the quantity of pictures that Avery acquired. For example, on March 15, 1867, Lucas wrote, "To Thomas where he [Avery] bought a lot of aquarelles. To Baugniet where he bought second lot for 575 francs." On June 24, he recorded that he had gone "with Avery . . . at Lasalles paid him 350 f for picture, 160 for two pair, 50 fs for 1 aquarelle & 75 each for 3 aquarelles—ordered 2 more at 75 each."[54]

Several of Avery's early acquisitions stand out by reason of the fame of the artist and/or the significance of the price. He purchased a landscape and three drawings

from Gustave Doré for 3,500 F; a large landscape and another painting by Ziem for 5,800; a painting by Breton of a girl walking, knitting, and guarding sheep for 5,000; a painting entitled *Charity* by Bouguereau depicting a mother holding two infants in her arms for 12,000; and three genre paintings by Plassan for 6,600 F. The subject matter of these as well as the Ecouen school paintings reflected the three types of art that had become most popular in the United States and that Avery was seeking to buy: idealized or sentimental genre pictures of women and children, Barbizon landscapes, and images of rural life.[55]

In November 1867, as Avery's stay in Paris was coming to an end, Lucas was given the task of measuring, arranging, packing, and preparing for shipment all of the art that Avery had acquired. On the evening of November 24, just two days before Avery's departure, they met to settle up. Avery, it was determined, had spent 64,793 F on art during the previous ten months in Paris, which generated 3,200 F in commissions for Lucas.[56] Aside from commissions, Lucas had also been compensated with gifts of small paintings or sketches from artists or dealers whom he had introduced to Avery. Like watering a garden, giving works to dealers was a way for artists to cultivate patronage and make their sales grow. For example, in June, after Avery purchased two pictures from Jean Alexandre Couder for 400 F, Lucas received a watercolor as a "present" from Couder. On November 14, when Lucas, on behalf of Avery, paid Ziem 5,800 F for two paintings, Ziem promised in return to paint a picture for Lucas and to bring it to him. A few days later, when Lucas paid Breton for a picture sold to Avery, he asked the artist for a landscape "for me." He also received from Georges Petit "a small sketch of Troyon" as a gift for introducing him to Avery. And in December, when Lucas went to Bouguereau's studio to pay for *Charity,* he nonchalantly asked Bouguereau "to make me a sketch" of the same painting. The artist agreed and delivered the sketch to Lucas two weeks later (plate 14). All of these gifts, which entered Lucas's own collection, were tied to his work as an agent for Avery and were intended to encourage Lucas to purchase more art from these dealers and artists.[57]

On the day of Avery's departure with his family, Lucas gave his wife a Roman mosaic heart pin and his daughter a doll as a gesture of affection and farewell. It was also a way of expressing his hope that the business relationship that he and Avery had established would last for a lifetime.

From Ecouen to Barbizon

Prior to 1865, when Lucas left Paris in search of art, he ordinarily would travel by train approximately thirteen miles north to the town of Ecouen. With its colony of artists and the ready supply of "sympathetic" art that he and his clients adored, Ecouen had become his second home. In June 1865, however, Lucas began to venture south, much further afield, to the town of Melun and then to the village of Barbizon and the nearby Fontainebleau Forest (fig. 40). He was not alone.

During the reign of Napoleon III, the Fontainebleau Forest had become a magnetic retreat for middle-class Parisians seeking to escape the crowds and noise of the city in exchange for the tranquility of nature. Although the forest was thirty-five miles away from Paris, the construction of new railroad lines enabled tourists to make the trip in slightly more than an hour. Beginning in the mid-1860s, over one hundred thousand Parisians began to visit the forest each year. Trains left practically every hour. To encourage tourism, a network of newly designed promenades led visitors through forests of ancient oaks, birch, and Scots pine trees to gorges, grottoes, and astonishing formations of rock named after famous persons, including such artists as Nicolas Poussin, Claude Lorrain, and Eugène Delacroix, as if to suggest that the Fontainebleau Forest had itself become a work of art. Fortunately, much of the pristine quality of the forest was preserved, due in large measure to a group of artists led by Rousseau. They demanded that the area around the village of Barbizon where most of the artists lived and congregated be declared off-limits to any further retooling of nature. The appeal successfully

FIGURE 40. Rough map showing Ecouen in north, Paris and Barbizon in south. Drawn by author.

resulted in a decree by Napoleon III, which set aside thousands of acres as a natural preserve for artists, the first of its kind in modern history.[1]

Lucas went to the village of Barbizon and entered the Fontainebleau Forest for the first time on Friday, June 2, 1865. The experience had a magical effect, holding him there for three straight days, as if mesmerized by the sights and sounds of nature. At the end of the first day, Lucas wrote in his diary, "Promenades in the forest at Fontainebleau stopping at Barbizon." The next day, he was again "walking in the forest," this time with one of his closest friends, the artist Antoine Emile Plassan. The third day he spent "walking in forest all day."[2] His exploration of the Fontainebleau Forest was transformational. It caused the natural landscape and the painted landscape to merge in his consciousness as if they were one. The imagined spirit of the forest might have spoken to Lucas, as it did to Rousseau, who poetically reported, "I heard too the voice of the trees. . . . their unpredictable movements, the diverse forms they assumed, even their peculiarity of being attracted to the light, suddenly revealed to me the language of the forest. This whole world of flora lived like mutes whose signs I could understand, whose passions were becoming clear to me; I wanted to converse with them and affirm, in that other language, painting, that I had hit on the secret of their grandeur."[3]

The forest became Lucas's cathedral, his sanctuary away from the material world of buying and selling art. To remind him of the forest's beauty and solemnity, Lucas acquired several paintings by the artists who worked or lived there. He obtained one painting of the forest from Anastasi, two by Barye, two by Diaz, and two by Rous-

A Paris Life, A Baltimore Treasure

seau.[4] More significantly, the presence of the colony of Barbizon artists whom he admired, the accessibility of the forest by train from Paris, and his need for privacy convinced Lucas to search for a *maison de campagne* on the edge of the forest that he could call his own.

With the benefit of the commissions he had earned from Walters, Graham, and others, Lucas began his search. In October 1865, he found a temporary retreat in a country inn called La Maison Blanche that was close to the forest and along the Seine near Melun. It could be reached by steamboat from Paris in approximately three to four hours. He rented a room, and for days and sometimes weeks at a time, he relaxed there with friends, dined with artists, and explored the forest and nearby villages. He also searched for a home.

In 1868, in the small village of Boissise-la-Bertrand, Lucas found a house that had the character, privacy, and price he wanted. It was a modest, welcoming two-story home with a large front door, a red gabled roof, and dormers and windows that invited light in and offered views overlooking the river and countryside (plate 15). On a modest plot of land, it was surrounded by a variety of tall elegant trees and an ancient stone wall that provided the privacy that he sought. Most importantly, it was on the edge of the Seine and within a short distance from the Fontainebleau Forest. The home's setting along the river and nestled among trees made it appear as if it had emerged by magic from a canvas painted by Rousseau, Daubigny, or Corot.[5]

The asking price for the house was 6,000 F. Lucas countered with an offer of 5,000 F. On April 30, 1868, the parties agreed on a final price of 5,200 F, which included 500 to be paid by the owners for repairs. Lucas likely miscalculated the amount of money and time that it would take to put the house in prime condition. It needed a new roof, new rafters, three reconstructed fireplaces, new chimneys, new interior walls, and new windows, and the entire structure had to be repainted. Lucas, however, did not stop there. His goal was to own a larger, more comfortable home on a more extensive plot of land that he could share with his friends and new family.

With this goal in mind, Lucas hired an architect to redesign the house. Calling upon his earlier training in mechanical drawing, he also sketched some of the changes he wanted to make and roughly designed some of the furniture.[6] He retained a local builder to oversee the work and purchased an adjacent lot on which he planted new trees. He had a gardener plant a small vineyard and create what Lucas characterized as his private "plantation." Stonemasons rebuilt the walls around the enlarged property, and a carpenter was hired to fashionably remodel the inside of the house. Lucas purchased a small boat, fitted it with sails, and built a small boathouse to protect it. He also added a studio for the use of the artists among his many friends. For his own pleasure and as a means of expressing his hospitality, he constructed a large wine cellar that he would fill with barrels and bottles of vintage wine. Finally, Lucas hired a caretaker to look after his house when he was not there. The amount of money that he spent on enlarging and refurbishing his new home likely exceeded 10,000 F—more than twice his home's original cost.

On October 31, 1871, Lucas exclaimed in his diary, "New House!!—roof completely covered."[7] His joy was premature. All of the work would not be completed until the summer of 1875, when he at last brought a wagon full of furniture to his reconstructed home and filled his cellar with one hundred bottles of Champagne and cases of vintage wine from Bergerac, Medoc, St.-Émilion, and Graves.

The part of the house that drew the most attention from his friends was the newly constructed studio. When Whistler heard about it, he solicited an invitation: "I have heard of you from time to time through Avery and listened with great pleasure to his description of your new house you have lately built—The Studio in it naturally interested me immensely—He tells me that you invite me to come and paint in it! This princely offer I hope to remind you of and thank you for one of these days when I also intend to accept it."[8] It would take more than ten years for Lucas to accept Whistler's solicitation.

◆ ◆ ◆

On July 19, 1870, as Lucas was walking through the forest from his home in Boissise to the peaceful village of Barbizon, he could not have anticipated that the home that he had purchased and lovingly restoring would soon be in jeopardy and his world turned upside down. On that day, France declared war on Prussia, and eleven days later, Napoleon III, despite being old and lame, took command of the French army and led his country and the Second French Empire into defeat and disaster. For the next three weeks, Lucas seemed to be oblivious to the war raging between hundreds of thousands of troops in Alsace and Lorraine along the French and Prussian border. He acted as if he believed the idiotic assurances of the French government that the war would be easy to win. From his home in Boissise and his apartment in Paris, Lucas continued for the next six weeks to focus myopically on the acquisition and sale of art and the profits he had earned. He visited the deluxe galleries along rue Lafitte, looked at masterpieces at the Luxembourg Museum, acquired paintings by Gérôme and Couture, and kept close track of his bank accounts and financial condition.[9]

In August, the French army's stunning defeat at Wissembourg and in several other pivotal battles in Alsace dramatically changed the mood of the country. Short-sighted optimism turned into widespread pessimism, panic set in, and martial law was declared in Paris. Lucas was in Boissise on August 27 when the painful news arrived. He attempted to return to Paris to protect his art collection and business but found to his chagrin that no trains were available: "Crowds going to Paris fleeing the Prussians."[10] On September 1, the news got much worse. At the battle of Sedan, the French army was again defeated. Napoleon III, along with 83,000 troops surrendered, and the emperor became a prisoner of war. It was the end of the Second French Empire. Three days later, Lucas noted, "Republic proclaimed!!!"[11]

The war, however, was far from over. On September 6, the new provisional government posted warnings throughout the city that "the enemy is on the move toward Paris." It was followed by another notice, advising "all strangers who wish to leave

Paris to go at once."[12] The Prussian army was in the process of surrounding the city with 200,000 troops, and foreigners began to flee. While Lucas steadfastly remained, he helped some of his friends and clients to get out. On the eve of Napoleon's surrender, he helped Frank Newcomer, a client and railroad executive from Baltimore, to get to London despite the absence of trains, and a few days later, he shipped Newcomer's property to him. Likewise, toward the end of August, Frank Mayer, a friend and American artist, spent the night with Lucas before "passing the Prussian lines, en route for America."[13]

Concerned that his home in Boissise would be overrun or destroyed, Lucas on September 10 hired a guard to protect it. It was a wise decision. Many of the homes on the outskirts of Paris would be occupied and ransacked by the Prussian army. And six months would elapse before Lucas was able to return to Boissise and see his home again. On September 20, he recorded in his diary, "Siege of Paris commenced." The siege lasted for four months. Food was scarce and rationed; because coal was in short supply, many citizens froze. The city's sanitation systems failed to operate, hundreds died of smallpox, and to make matters worse, in early January, the Prussians began to rain artillery shells on the city, leaving hundreds dead or wounded. Many Parisian artists, including Meissonier and Manet, volunteered to serve in the National Guard while hiding their artwork in cellars. Others, like Daubigny, Monet, Cézanne, and Pissarro, fled the city and took refuge in London.[14]

Almost every day during the siege, Lucas would walk for hours along the grand boulevards like a flâneur absorbed not in painted pictures but in the sights of real-life historical events. To preserve his memory of these trying times, Lucas later acquired a set of etchings by Maxime Lalanne depicting scenes from the Franco-Prussian War. As noted in his personal "Catalogue—Eaux fortes," Lucas took special interest in an etching that showed the American consul to France, John Read, crossing the Seine in a small boat to escape the bombardment and siege.[15]

Sensitive to the suffering that he saw around him, Lucas gave money to the poor. Otherwise, he remained largely insulated from the desperate conditions, and there is no hint of fear in his diary. Having spent the last ten years catering to the expensive tastes of American visitors to Paris, he knew where to find and buy the delicacies that satisfied his own discriminating palate—the best sausages, beef, and cans of oysters, as well as the corks and bottles needed to preserve his wine. While his art business was significantly curtailed, he retained the contacts and financial resources needed to make, on behalf of Samuel Avery, a final payment of 4,000 F to Bouguereau for his horrifying painting *The Furies.* Based on Aeschylus's *Eumenides,* the painting depicted the Furies' relentless pursuit and torment of Orestes for murdering his mother Clytemnestra following the fall of Troy. The painting was a painful reminder of the horrible consequences of war.[16]

On January 28, 1871, Paris surrendered, and an armistice was signed. Lucas witnessed the Prussian army triumphantly entering the city and marching down the Champs-Elysées. The end of the Franco-Prussian war, however, did not end the tur-

FIGURE 41. Édouard Manet and Lemercier et Cie, *Civil War*, 1871–1873, published 1874. The George A. Lucas Collection, Baltimore Museum of Art, BMA 1996.48.13693.

moil, for the civil war was about to begin. Just as he had done in Boissise, Lucas retained the services of a guard to protect his Parisian apartment. And for the next two months, he chronicled in his diary the major events of that time: the construction of the batteries and ramparts by the "Red" communards, the toppling of the column at the Place Vendôme, and the deadly battles all around Paris between the volunteers of the Commune and the Army of Versailles. He later acquired a memorable lithograph by Manet, entitled *Civil War,* that depicted a dead French soldier lying on his back in front of a stone barricade (fig. 41).

By the beginning of April 1871, the troops of the Commune were near defeat, and Lucas returned to Boissise. What he found was not very comforting. The small town had been occupied by approximately twenty-four members of the Prussian army. Worse, a squad of four Prussian chasseurs had billeted in Lucas's house. It is not hard to imagine Lucas's chagrin upon discovering that the country house that he was rebuilding for his own pleasure and the comfort of his mistress and friends had become a refuge for the troops that had been strangling Paris. Lucas sensibly did not confront them. Instead, he convinced the troops to move to another nearby home, and he negotiated a deal with his neighbor to allow the troops to reside in his house in return for Lucas's payment to him of 60 F. By the end of May, the troops had left, and on June 4, Lucas contacted Avery to report that all was safe and that hopefully they could shortly resume their business.[17]

◆ ◆ ◆

On September 14, 1873, Lucas spent the morning with Avery in the Fontainebleau Forest, and later that day they walked through the forest to Barbizon to meet Millet.[18]

A Paris Life, A Baltimore Treasure

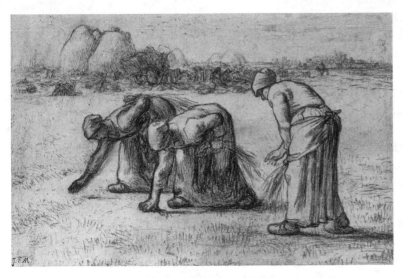

FIGURE 42. Jean-François Millet, drawing of *The Gleaners*, c. 1855. The George A. Lucas Collection, Baltimore Museum of Art, BMA 1996.48.18686.

It was the only time that Lucas and Millet ever met. Prior to this meeting, Lucas had demonstrated little interest in Millet's art. His only acquisition of a Millet had been nine years earlier when he purchased one of his etchings.[19] Although Lucas began to acquire landscapes by Corot, Daubigny, and Rousseau for himself and Walters, Millet's art apparently had remained largely out of bounds due to Lucas's belief that his politically oriented paintings of peasants were hostile to the economic and political interest of the aristocrats and wealthy bourgeois with whom Walters identified.[20]

Millet's death in January 1875 sparked a dramatic leap in the price and the perceived value of his art. Almost overnight, Lucas became absorbed not only in Millet's work but in preserving his place in art history. In the spring of 1875, he began looking closely at Millet's art displayed in private galleries, exhibitions, and auctions conducted at the Hôtel Drouot. On March 26, he purchased seven of Millet's engravings for the relatively modest price of 70 F. More importantly, on August 11, 1877, while accompanying Avery to the Georges Petit Gallery, Lucas purchased Millet's marvelous preparatory drawing of *The Gleaners* for 400 F (fig. 42).[21]

As Millet's fame posthumously grew, the price of his art dramatically climbed. In April 1879, Lucas acquired for Avery a painting by Millet that cost 5,000 F. By December 1880, the cost of a similarly sized painting had escalated to 10,000 F. In March 1881, Lucas acquired another Millet for Avery for 11,000 F, and in December, the Georges Petit Gallery was selling Millet's paintings for 15,000 F. In 1884, Walters, at Lucas's encouragement, finally entered the market for Millet's art, but because the price for his paintings had soared, Walters had to pay 12,500 F for a pastel replica of *The Sower,* one of Millet's most famous paintings.[22] Although expensive, it must have looked like a grand bargain when in 1890 *The Gleaners,* which had originally sold for 3,000 F, was back on the market for the astronomical price of 300,000 F.[23]

Following Millet's death, Lucas drew closer to members of the artist's family.

Whether as a friend, an opportunist, or both, he met with Millet's wife and children, served as their counselor, and conferred with them about the possible sale of their home, furniture, and art. He collected and preserved the catalogues, pamphlets, photographs, and other memorabilia that documented Millet's life, and he raised over 100,000 F to erect a life-size monument to Millet in his native town of Gréville. On August 23, 1884, after a bronze monument to Millet and Rousseau was installed on the face of a large boulder just outside of the village of Barbizon, Lucas walked for two hours through the forest from his country home in Boissise as if on a pilgrimage to see the monument (plate 16) He spent the day contemplating Millet's life, admiring his likeness, and paying the homage that was due.[24]

The care that he took to preserve Millet's memory and the support that he extended to his family were emblematic of the way Lucas treated most of the artists with whom he dealt. Lucas was not just a merchant and collector of their art but a keeper of their culture. His interest in the artists, their way of life, and their legacy was in large measure why they opened their doors to him so widely, why they gave him their palettes and showered him with tokens of appreciation. His intense interest was one of the underlying secrets of his success.

M, Eugène, and Maud

I t was not just the art that led Lucas to purchase a county home near Barbizon in the Fontainebleau countryside. Lucas had a more personal reason. It was a place where he could live privately and more comfortably with his mistress and her son.

Lucas met Octavie-Josephine Marchand (whom he referred to in his diary as M) in 1857 during his first year in Paris. She was twenty-four (nine years younger than Lucas) and separated from her husband, who apparently resided in London. Her son Eugène was only three. It was an especially awkward time to become entwined in a long-term sexual relationship with a married woman who had a young child. Parisian society at that time was obsessed with the moral issues raised by the publication of Gustave Flaubert's *Madame Bovary*. In January 1857, the novel had been condemned by the state, and Flaubert was prosecuted for offending "public and religious morality." Madame Bovary's great sin was not promiscuity but adultery, and Flaubert's alleged crime was his refusal as the creator of this character to sit in moral judgment and condemn her behavior.[1]

Sexual mores in Paris at that time were awash with double standards and bathed in hypocrisy. Women continued to be viewed stereotypically as either wives or prostitutes. While this Manichean view was honored in principle, in reality sexual relationships outside of marriage were widespread. It was not uncommon for an urban bourgeois businessman like Lucas to discreetly keep a mistress (*lorette*) hidden away in a private apartment. This type of relationship, as observed by the social historian Nicholas Green, walked the thin line between acceptability and disgrace.

While it was socially acceptable for a *lorette* to be introduced by her lover to his closest friends, no honorable man would introduce her to his family. In the case of Lucas and M, their affair was even more problematic due to the fact that she was married and had a young son. A sexual relationship between a single man and a married woman with a child was deemed by polite society to be immoral on the part of the man but criminal on the part of the woman.[2] Lucas was well aware that his adulterous relationship with M could tarnish the reputation he had cultivated as an honorable gentleman of flawless judgment and impeccable character. And he was rightfully concerned that this relationship, if known by his upper-crust American clients, could undermine the element of trust upon which his business was based. In an effort to avoid these consequences, Lucas hid his relationship with M under a veil of deception.

◆ ◆ ◆

Not long after Lucas arrived in Paris, he was introduced to Madame Marchand by a mutual friend, an English expatriate and artist by the name of Edward Harrison May. As suggested by Lucas's diary entry stating that "May and M breakfasted with me," Marchand and May were likely intimate friends. Soon thereafter, however, the entries in Lucas's diary indicate that Lucas captured M's attention. He wrote "M to dine with me" and, more suggestively, "M with me."[3] As a couple, Lucas and M began to share the pleasures of modern Paris—attending concerts, looking at the masterpieces on display at the Luxembourg Museum, strolling through the Bois de Boulogne, and dining alone together. By July 1858, hints began to appear in Lucas's diary that their friendship had evolved into a sexual relationship. On July 14 of that year, Lucas noted that "Mad [Madame] M" had joined him for dinner and that he had purchased for the occasion a fine bottle of wine—as well as a sponge and a toothbrush. Shortly thereafter, Lucas bought M a dress, and then a robe. And the occasional reference to an evening with M became "evenings."[4]

Lucas introduced M to his closest friends—Frank Frick, William Henry Huntington, Jimmy Whistler, and Antoine Emile Plassan, and they expressed their own affection for her. Frick referred to her as "Josephine." Whistler referred to her as "Madame." Noting the nine-year difference in their ages, Whistler's mistress Joanna Hiffernan referred to M as "your little girl." Whistler's subsequent mistress Maud Franklin ended her letters to M with words of endearment, "always your friend." Many years later when Lucas and M seemed permanently bound together, a few of his French friends and artists began to refer to M as "Mrs. Lucas," as if she were Lucas's wife. Lucas, on the other hand, continued to refer to her in his diary as simply "M," without any added words of affection or endearment.[5]

Little is known about M. Practically every sliver of information about her was excised from Lucas's personal records. She appears and then mysteriously disappears from his diary without any clues to the cause. Although they had frequently corre-

sponded when Lucas was traveling and away from Paris or Boissise, there are no extant letters between them. Nor are there any records or other memorabilia in which Lucas described M or provided any details about their relationship. Although he collected hundreds of photographs and other pictures of the artists he met in Paris, and although he repeatedly commissioned artists to paint, sculpt, or photograph images of himself, Lucas strangely did not keep a single picture of M. Whether Lucas or others intentionally destroyed such references to M is unknown. In the absence of such information, we do not know what she looked like, how she wore her hair, what color were her eyes, whether she was ever educated or employed, whether she read Balzac or Flaubert or listened to the music of Bizet, whether she could draw or paint, what languages she spoke, whether she had other lovers, where she resided when not with Lucas, what made her happy, or what made her sad. As a result, M remains a vitally important yet strangely enchanting dreamlike character in the story of Lucas's life.

Although Lucas introduced M to his close friends, he concealed his relationship with her from most of his wealthy American clients. Lucas had good reason to believe that William Walters, his most important client in the 1860s, would frown upon the affair. As reflected in the art he collected and as evidenced by his personal life, Walters was a strong believer in traditional family values. Fidelity to him was a cardinal virtue and adultery a damnable vice. The purpose of art, in Walters's view, was to educate yourself and your family with "illustrations of virtue and noble deeds—with admonitions of duty and affection."[6] Walters, like Lear, would later disown his own daughter for becoming engaged to be married without his express consent to a man whom he did not like. Aware of Walters's stiff social standards, Lucas never introduced him to M and apparently never even mentioned her name to him during the four years from 1861 to 1865 when Walters and his family resided in Paris. The same veil was cast over M when John Taylor Johnston, the first chairman of the Metropolitan Museum's board, and W. H. Vanderbilt later arrived in Paris and engaged Lucas to help them acquire art.[7]

The manner in which Lucas concealed his relationship with M from his wealthy American clients and the icy manner in which he referred to her in his diary might lead us to believe that Lucas treated her like an object that could be viewed, used, removed, and even hidden at his discretion. But an important event in their lives reveals that he was passionately in love with her. In August 1880, M informed Lucas that she and her son Eugène were leaving him to go to London to visit her ill husband. She provided Lucas with no assurance that they would return. On August 12, Lucas took M and Eugène to the train station and watched them leave; later that evening, he wrote in his diary, "my heart was broken." In the thousands of entries in his diary, these were the most passionate words that Lucas ever expressed. He immediately wrote to M urging her to return. He wrote to Eugène, as well, imploring him to bring his mother back to Paris. To his relief, M agreed to return, and on August 19, Lucas was at the Paris train station to welcome M and Eugène back home.[8]

◆ ◆ ◆

Lucas's desire to live privately as a family with M and Eugène in a manner that did not threaten his reputation and collide with his business in Paris motivated him to purchase his house in the small, out-of-the way town of Boissise. To provide M with a taste of the countryside and an appreciation of the beauty of the Fontainebleau Forest, in August 1866, he took her to his favorite haunt, La Maison Blanche, where they remained for close to a month. Two words, "Luncheon Fontainebleau," written in Lucas's diary on August 27, 1866, provide a hint of the happiness that Lucas and M likely shared at that time. Lucas also wanted to make sure that Eugène would like the new house and its natural environment. In April 1868, at a time when Lucas was in the final stage of negotiations for the purchase of the house, he took Eugène, who was then fourteen, to see it. They stayed together like father and son at La Maison Blanche, and accompanied by Plassan, they spent two days touring the area.[9]

Promptly after the purchase of the house and some furniture, M and Eugène were anxious to move in. On Saturday, August 1, 1868, Lucas wrote: "Left Paris on 9 a.m. train for Boissise . . . arrived at 11 1/2 . . . Furniture arrived at 3 p.m.—M and Eugène at 6 p.m."[10] However, they did not remain there long. The reconstruction of the house and the intervening Franco-Prussian War seemed to temporarily fracture Lucas's relationship with M. During the entire year of 1870, including the frightful four-month siege of Paris, Lucas did not mention her name in his diary, indicate where she was residing, or express any apprehension about her welfare.

After the Franco-Prussian War ended in 1871, Lucas and M reunited. They visited Boissise in April and returned periodically for short periods of time while the rebuilding of the house progressed. In the meanwhile, the bonds of affection between Lucas and Eugène tightened. Between 1871 and 1873, Lucas often took him to Boissise for a day or two to stay at the house and inspect the reconstruction.[11] During this formative period of his life, Eugène watched as the house in Boissise was literally being rebuilt around him, and he became attached to the house, treating it as if it were his own home and dreaming that one day that would come true.

In April 1875, after the final touches were completed and the final payments made, Lucas and M began to settle into the house. He filled the house with fine furniture and decorated it with dozens of pictures, including approximately ten similarly sized images of female figures painted on wooded panels that Lucas called his "months." These were commissioned by him and placed in the entry hall of his country home. Two of the paintings stand out from the others because they feature beautifully dressed, contemporary young women. The first, entitled *Skating,* portrays a woman adorned in a luxurious, long, fur-lined red coat and red fur hat, wearing ice skates while resting in front of a small boat along the banks of a river on a wintry day (plate 17). The other, entitled *Figure in Blue,* shows another or possibly the same young woman wearing a blue dress, blue shoes, and hat, while sitting comfortably on a gar-

den bench with a basket of fruit by her side on a bright summer day (plate 18). What united these paintings was not only the similarity of scale (each being approximately 12 1/2 × 24 inches in size) but also the similarity of the figures. The women appear to be the same age and height, they have the same brown hair, the same slender waist and attractive figure. Even the tilt and shape of their oval heads, the bend of their bodies and the way they wear their hats slightly off-center on the right side of their heads tie them together. We can only speculate about whether the paintings were intended to refer to M. Perhaps she was their inspiration or even the model. What seems more likely is that the settings relate to Lucas's own property in Boissise—his garden and the banks of the Seine. Although not by the same artist or painted at the same time, the paintings celebrated the pleasure of life in the countryside during the different seasons of the year and not incidentally, the pleasure of enjoying this life in the company of a lovely young woman.[12]

While residing in Boissise in 1875, Lucas and M, with the assistance of their servant Marie, entertained an endless parade of Lucas's friends. On July 22, the American journalist William Huntington arrived. Two days later, the American painter and expatriate William Babcock also arrived and along with Huntington remained in Lucas's home for five nights. On Sunday, August 8, the artist Charles Herbsthoffer arrived. An Austrian-born but naturalized French painter whose genre scenes were very popular at that time, Herbsthoffer had known Lucas for close to ten years. On August 12, Gustave Boulanger, well known for his academic, award-winning paintings of Oriental subjects (Lucas owned two of his works), brought his wife to Boissise and stayed for three nights. And on September 9, Plassan, Lucas's closest French friend, arrived. The two most welcome guests, however, were Samuel Avery and his fifteen-year-old son Harry. Their presence at Boissise and introduction to M indicate that Lucas's relationship with Avery had crossed the line from pure business to an enduring personal friendship. With a house full of guests coming and going, Lucas and M remained there until October 18, 1875, when they "left Boissise for winter quartier Paris."[13]

◆ ◆ ◆

Lucas's Paris residence, or *quartier,* as he called it, like his country home in Boissise, underwent some remarkable transformations. In May 1861, due to Haussmann's renovation of the area around the Rond-Point where Lucas had originally resided, Lucas moved to a newly constructed building located at the corner of rue de l'Arc-de-Triomphe and rue des Acacias. It was in a new and very fashionable part of town three blocks northwest of the Arc de Triomphe and within easy walking distance of the Champs-Elysées. Lucas initially occupied an apartment on the fifth floor, but in September 1872, he settled into a more spacious apartment on the fourth floor. Running the length of the building, his apartment had a small living room (his "Salon") with a fireplace, a dining room with a fireplace, an office, two bedrooms, and a

FIGURE 43. Photograph of adjacent front doors of Lucas's and M's apartments, 41 rue de l'Arc de Triomphe, Paris, where Lucas and his mistress M resided from 1876 to 1909. Photograph by author.

kitchen. There was at that time room to hang or store his burgeoning art collection and a place to keep track of the almost daily acquisition and shipment of the art he acquired for his clients.[14]

There was only one other apartment on the fourth floor, and in 1876, Lucas rented it for M.[15] To maintain the fiction that it was M's apartment, not his, Lucas leased it under her name. While his apartment overlooked the rue de l'Arc-de-Triomphe, hers overlooked the rue des Acacias, and they came together at the corner of the two streets. Most importantly, the front doors of the two apartments were only footsteps apart (fig. 43). This enabled Lucas to take one step out of his apartment and a second into M's. On the rare occasions when he needed to meet or entertain a client in his apartment who might not approve of his relationship, he easily was able to sequester M in her own apartment next door. This arrangement, which lasted until M's death in 1909, enabled Lucas and M to live together in Paris under the guise of living apart.

M's apartment served another important purpose. It was where Lucas stored a large part of his expanding and ultimately overflowing collection of art, especially his thousands of prints, watercolors, and drawings, together with photographs of the artists, letters from them, and other ephemera about their lives. Etchings and lithographs by Bonvin, Bracquemond, Daubigny, Daumier, Delacroix, Fantin, Frère, Géricault, Jacque, Manet, and Whistler, to name a few, found a home in M's apartment. The manner in which they were cared for and stored clearly shows that M played an active role in the handling and preservation of Lucas's art. Hundred of prints, including 113 lithographs attributed to Géricault, were placed on a shelf in her kitchen

(referred to as the "Cuisine Acacias"), where they were intended to be mounted on cardboard. Stored in a cabinet in her dining room ("Salle à Manger Acacias") were hundreds of other etchings. Hundreds of lithographs by sixty-seven different artists were kept in the armoire of her bedroom ("Grande chambre Acacias") and in another armoire in the "Salon Bleu Acacias." Throughout her apartment were dozens of cardboard cartons that held thousands more prints, including 475 etchings by Daubigny and 1,400 prints by Jacque.[16]

Lucas also kept dozens of watercolors, oil paintings, and drawings in M's apartment. Among these were a drawing by Millet (most likely his preparatory drawing for *The Gleaners*), a painting by Jacque, and a small oval painting by Couture that depicts the upper body of a woman at the moment of being undressed. Her long neck and voluptuous breasts are more visible than her face, as she turns away from the viewer in a gesture of shame. Lucas purchased this painting on May 12, 1883, at a cost of 1,200 F and referred to it as *Couture's Head* (plate 19).[17] The erotic nature of the profile suggests that it might have been painted by Couture as a preparatory sketch or a reference to his monumental painting, *Romans of the Decadence,* now in the Musée d'Orsay. In this famous painting, Couture depicted dozens of men and scantily clad women engaged in a chaotic scene of debauchery in ancient Rome. The painting offered a warning that the immorality that led to the fall of Rome might threaten France as well.

Like any knowledgeable art collector of French art at that time, Lucas probably associated his small erotic painting with Couture's masterful *Romans of the Decadence.* He was concerned, however, that his painting would offend the sensibilities of Walters and other conservative clients, who likely would consider it pornographic.[18] To avoid this possibility, Lucas elected to keep the painting in M's apartment, where few would ever see it. The presence of this and thousands of other works in M's apartment reveals that besides being Lucas's paramour, she also had become the keeper of his art.

◆ ◆ ◆

Lucas's lived two separate lives. In Paris, he was for all outward appearances a wealthy businessman who scrupulously complied with the mores of bourgeois society. In the Fontainebleau countryside, however, his life was more bohemian. Instead of courting wealthy American clients and attending to their every need, he surrounded himself with his friends and his adopted family, looking after them and taking pleasure in their pleasure. Long walks in the Fontainebleau Forest, shopping for food at the market, tending to his own vineyard, planning dinners for his guests, and buying fine wine and cognac became his occupations of choice. These were the ways in which he brought the comforts of the pastoral countryside into his own life.

The code of conduct among couples and the style of life in the Fontainebleau countryside was significantly different than in the upper-class Parisian neighborhood where Lucas resided. Open relationships between unmarried couples were neither

hidden nor forbidden. The well-known artists who resided in the nearby village of Barbizon, including Rousseau and Millet, had for years on end lived openly with their mistresses.[19] Lucas's personal friends also felt free to bring their mistresses to his home in Boissise. Whistler brought Maud Franklin, and Huntington often brought his mistress Angèle Allaine and sometimes stayed for weeks at a time.[20] As in the case of Maud, Angèle became a good friend of Lucas's. Following Huntington's death in October 1885, Lucas visited Angèle almost daily for two months, during which he paid her rent and otherwise supported her financially.[21]

◆ ◆ ◆

Over the years, the relationship between Lucas and M's son Eugène became as tight as that of a father and son, which is what Lucas wanted. In January 1874, at the direction of his father, Eugène was preparing to leave France to attend college in Rio de Janeiro. Lucas was concerned about whether he would ever return. To bridge the distance between them and make sure that he was not forgotten, Lucas gave Eugène an unusual present—one of the many portraits he commissioned of himself. Whether an exercise in narcissism or an expression of affection, Lucas had his portrait specially framed and gave it to Eugène as a parting gift.[22]

When Eugène completed college, he returned to Paris, where Lucas again took him under his wing. Lucas loaned him money, escorted him to his finest tailor, paid for his clothes, and, in an effort to cultivate his taste, purchased etchings for him. In August 1880, Eugène moved to London to pursue a career in civil engineering, but he struggled. Aware of Eugène's problems, Lucas on July 9, 1881, converted 1,000 F into pounds to send to him.[23] Two years later, at Lucas's request, Eugène returned to Paris. Lucas continued to support him, invited him to his home almost every night for dinner, and permitted him to come and go to his home in Boissise as if it were his own.

In 1886, Eugène, at the age of thirty-two, married Virginie Rapetout. They had five children, and as Eugène's family grew, they became ever more attached to Lucas and his home in Boissise. Eugène rented a nearby house, for which Lucas paid the rent, and he and his family began to regularly dine with Lucas.[24] Beginning in 1890, "Eugène and family to dinner," was the phrase most often recorded in Lucas's diary. To accommodate them, he added two beds, a bathtub, two chairs, and additional benches to his Boissise home. Because he was often feeding his extended family and friends at meals that numbered ten or more, his grocery bills climbed and, not including the wine, began to exceed 230 F each month.[25]

Lucas's family of M, Eugène, and Eugène's wife and children expanded further when Maud Franklin, Whistler's ex-mistress, became a regular guest. Her close friendship with Lucas evolved also into a close friendship with M and Eugène. Maud told M, "You have all of my heartfelt good wishes . . . accept on my part a big heart-felt kiss . . . I am always your friend."[26] Their relationship became even closer in November 1893, when Maud and Lucas became the godparents of Eugène's daughter Simone.[27]

To attend to his adopted family, Lucas employed a supporting cast. A caretaker,

Nicolas Chaveau, looked after the house when Lucas and M were not there. Marie, who resided in a small apartment on the top floor of Lucas's apartment building in Paris, worked full time for him and accompanied Lucas and M to Boissise. Lucas also employed a part-time servant named Louise and a carpenter named Alexandre Vallée who was called upon to repair anything that was broken. It was, of course, the wealth generated by Lucas's art-dealing business that enabled him to have two adjoining apartments in Paris, a large home in Boissise, paintings that covered his walls, prints that filled his and M's cabinets, vintage wine in his cellar, meals for his friends, cash to support his generosity, and servants and caretakers to attend to the needs of his large and unusual family.

◆ ◆ ◆

Lucas never returned to the United States. He twice was offered free transportation there but declined the invitations. In an effort to explain his decision and dispel any notion that he was estranged from his family, some of his relatives invented the story that Lucas had encountered a violent storm when traveling to France in 1857 and that he remained apprehensive about making the crossing again. The story was nonsense. Lucas did not return to the United States for the basic reason that he had a wonderful life in France that could not be replicated in Baltimore or anywhere else. It was his dream come true—a world surrounded by art and culture, a highly successful and profitable occupation in the field of art, a sterling reputation, a comfortable apartment in Paris, a lovely country home along the Seine, money to freely spend, good food and his own vineyard of wine to drink, great and interesting friends, a young "son" he adored, and a woman he loved.

When Money Is No Object

Beginning in the early 1870s, as America entered its Gilded Age and France a time of peace and prosperity known as the Belle Époque, the interest of American collectors in acquiring mid-century French academic, landscape, and genre paintings reached its peak. By the mid-1880s, French paintings began to outnumber and overshadow American ones in the private galleries of America's wealthiest collectors. The event that launched this preference was the colossal International Exposition of 1867. Led by Samuel Avery, a select group of important collectors, artists, and connoisseurs chose eighty-two oil paintings by forty-one contemporary American artists, including Bierstadt, Church, Durand, Homer, and Kensett, for display. The expectation was that the American art would hold its own against the 550 paintings submitted by other nations. To the chagrin of the artists and those who selected the paintings, the critics thought otherwise. The American art was viewed as dull, especially when compared to the French. At the Exposition were fourteen paintings by Meissonier; thirteen by Gérôme; ten by Bouguereau, Bonheur, and Breton; eight by Rousseau and Daubigny; and seven by Corot. The hope that the American artists would triumph was crushed by the judges, who awarded thirty-two medals to the French artists, including medals of honor to Cabanel, Gérôme, Meissonier, and Rousseau, in comparison to only one medal to an American—Frederic Church for his painting of *Niagara Falls*.[1]

If the lopsided score in medals was not sufficiently deflating, the criticism of James Jackson Jarves, an influential and cosmopolitan American collector and connoisseur, struck the finishing blow. He wrote that the

comparison between American and French artists at the Exposition only served to prove "our actual mediocrity."[2] Prompted by the art they saw at the Exposition, the medals that were awarded, and Jarves's biting opinion, wealthy American collectors turned their attention to the acquisition of more and more French art at higher and higher prices.

To collectors and dealers like William Walters, John Taylor Johnston, and Avery, attending the Exposition of 1867 was like shopping at a splendid world-class department store full of wonderful paintings, especially by the French artists whose work they wanted to buy. Lucas, of course, was there from day one, making his presence known and his services available. "At the opening of the Exposition (Champs-Élysées) all day," he recorded on April 15. He returned on five different days in April and May, spending "all day" with Walters, visiting with Frick, and going another time "To Exposition Champs Elysees with Avery until 3 1/2 p.m." On July 2, Lucas met his friend Jules Breton to look at the ten paintings he had on display and to commission him to paint for Avery one of his canonical images of a peasant girl guarding sheep in the countryside.[3] While guiding his new or potential clients through the Exposition, Lucas reached out to the scores of artists whom he most admired and became the conduit for bringing them and his wealthy clients together.

The effect of the Exposition on Avery, as recounted by his biographers, amounted to a "turning point" in his life and career as an art dealer. He sold his American paintings and attended the Exposition in Paris with the intent "to buy freely."[4] Although Avery would later observe that the sky-rocketing price of French paintings "was getting to be simply ridiculous," this did not deter him or others from diving in.[5] For the next twenty years, a succession of wealthy American collectors would follow Lucas to artists' studios to buy the most desirable works of mid-nineteenth-century French art at a time when money was no object.

◆ ◆ ◆

The Metropolitan Museum of Art was incorporated on April 13, 1870, but the doors to its permanent home at Fifth Avenue and 82nd Street were not opened to the public until March 30, 1880. French mid-nineteenth-century art played no role at the museum until 1887, when Catharine Lorillard Wolfe bequeathed to it her significant collection of French nineteenth-century paintings.[6] The Museum of Fine Arts in Boston opened in 1876, but it did not acquire its renowned collection of Millet paintings and other Barbizon landscapes until well after the turn of the twentieth century.[7] The Walters Art Gallery in Baltimore that housed another outstanding collection of French academic art did not open its newly constructed museum until 1909. Prior to the opening of these and other major American museums and their acquisition of French mid-nineteenth-century art, the primary repositories of French art in the United States were the lavish private galleries located in the homes of some of the richest men in America.[8]

Among the wealthy Americans who collected French art and permitted the pub-

lic to see it were three of Lucas's most important clients—Johnston, Walters, and William H. Vanderbilt. Born in New York in 1820, Johnston attended Yale Law School and was admitted to the New York bar in 1843. Following law school, he traveled abroad for two years, visiting the great art centers of Europe and acquiring an unquenchable taste for fine art. After returning to the United States, he changed careers, entered the railroad business, and at the age of twenty-eight became the president of a small company that grew into the large Central Railway of New Jersey. After the Civil War, Johnston began to amass a large collection of art, which he housed in a private gallery constructed on the grounds of his Fifth Avenue estate. He shared his collection with the public, opening his gallery each Thursday afternoon. At that time his collection was considered "second to none in New York."[9]

Avery invited Johnston to serve on the US Fine Arts Committee responsible for the display of American art at the Universal Exposition of 1867. While in Paris, Johnston, like Avery, became enamored with the French art on display. In 1868, he returned to Paris with his family to purchase as much French art as he could afford. Based on Avery's advice, he engaged Lucas to serve as his advisor, noting, "I intend to make considerable use of him [Lucas] in seeing pictures, making purchases, etc."[10] Neither Johnston nor Lucas would be disappointed with the results.

Lucas's success as an art agent rested not only on his connoisseurship and access to the finest available examples of contemporary French painting but also on the warmth and friendship that he extended to his clients. With the goal of making the acquisition of art into a highly pleasurable experience, Lucas provided Johnston with a personal tour of the masterpieces at the Louvre and the Luxembourg Museum. He strolled with Johnston and his wife Frances down the Champs-Elysées, casually rode by carriage with them through the lovely Bois de Boulogne, took Johnston to one of Paris's most expensive tailors to have his measurements taken for a velvet jacket, arranged for the Johnstons' photographs to be taken by Nadar, and satisfied their taste for luxury goods by escorting them to the finest Parisian jewelers, where Johnston spent over 70,000 F on diamonds for his wife. Most importantly, Lucas escorted Johnston to the Goupil and Petit galleries, introduced him to the owners, and examined the paintings that were for sale. Johnston was impressed and thought that Lucas was "remarkably well posted in reference to many interesting details and added very much to the pleasure of seeing the articles [of art]."[11]

On October 14, 1868, Johnston, with Lucas's guidance, embarked on an eighteen-month spending spree. By March 1870, Johnston had acquired dozens of paintings through Lucas, including major works by Bouguereau, Corot, Daubigny, Decamps, Diaz, Dupré, Gérôme, Charles Gleyre, Merle, Meissonier, Rousseau, Troyon, van Marcke, and Ziem. The high point was Johnston's acquisition of Decamps's *The Night Patrol at Smyrna,* which remains on view at the Metropolitan Museum of Art. Johnston paid 50,000 F for the picture—the most expensive painting he ever acquired.[12]

Among the many paintings that Johnston acquired in Paris, the most meaningful to him was a gorgeous portrait of his two young daughters, Eva and Frances, by Bou-

guereau (plate 20). Linked together by the touch of their hands on an open book edged in gilt, seated on a chair tufted in a luxurious golden fabric, and beautifully dressed in white with red and blue accents, Johnston's daughters, as portrayed by Bouguereau, embody a sense of refinement, high culture, and a love of learning that characterized the Johnston family as a whole. The wealth of the Johnston family and the wealth of America in general during its Gilded Age are also clearly conveyed by the painting's color scheme of red, white, blue, and gold.

Lucas played a significant role in arranging and overseeing the completion of this portrait. The first step was taken on October 28, 1868, when Lucas accompanied Johnston and his children to Bouguereau's studio to discuss the portrait. On December 8, Bouguereau gave Lucas a preparatory drawing and informed him that the painting would cost 12,000 F. After conveying this information to Johnston and obtaining his approval, Lucas delivered to Bouguereau photographs of the Johnston's daughters and the elegant dresses they would wear in their portrait. When the Johnston family returned to Paris in June 1869, Lucas took the children to Bouguereau's studio to pose, and when the painting was nearly completed, he selected its frame. Finally, on June 25, 1869, Lucas accompanied Johnston and his wife to Bouguereau's studio to see the finished product. The treasured painting would remain in the Johnston family for 144 years.[13]

As a result of the French paintings that Johnston acquired, his collection was characterized by the *New York Times* as "magnificent." On the evening of December 27, 1870, Johnston invited a large group of New York's wealthiest and most cultivated men to his gallery to examine his paintings and become sufficiently inspired to donate money to the establishment of the Metropolitan Museum of Art. Attending the event were Theodore Roosevelt, J. P. Morgan, William Cullen Bryant, R. J. Dillon, Henry Hilton, R. M. Hunt, Samuel Morse, James Renwick, Samuel Avery, and Rutherford Stuyvesant. As reported in the *Times,* they spent an hour examining the pictures in Johnston's collection and then speedily raised $45,000.[14]

Ten years later, Johnston returned to Paris to meet with Lucas under much different circumstances. In the intervening years, Johnston's business and his related wealth had collapsed. As a result of the financial panic of 1873, his railroad went into receivership, and he could not pay his debts, including payments that were overdue for some of the expensive paintings that he had acquired in Paris. As a result, in December 1876, he was forced to auction almost his entire collection of art. The only painting that was not for sale was the portrait of his children.

Notwithstanding Johnston's financial difficulties, he was revered by his fellow trustees of the Metropolitan Museum of Art. To honor his service as a founder and first president of the museum, the trustees in 1880 commissioned the renowned portraitist Léon Bonnat to paint a portrait of Johnston for display at the museum. While Avery was authorized to act for the trustees in connection with this commission, Lucas again was the obvious choice to effectuate the plan. He met with Bonnat and negotiated the price of 20,000 F.[15] With this understanding in place, the project

moved ahead. When Johnston arrived in Paris in June, Lucas was delighted to discover that he was accompanied by his wife and two daughters. Lucas again entertained the family, taking them to the Salon to look at the endless display of new paintings. On June 29, 1880, when the portrait was done, Lucas and Johnston went to Bonnat's studio to see it. In July, while the portrait remained in Paris, it was also seen by a *New York Times* reporter, who praised it as having "such an air of truthfulness about it that it must be a faithful likeness, as well as the portrait of a refined and cultivated gentleman."[16] Johnston and Lucas undoubtedly agreed. When Johnston left Paris, he left for Lucas a note of thanks, together with a parting gift of 1,000 F.[17]

◆ ◆ ◆

"The wealthiest man in America" is a sobriquet often used when referring to William Henry Vanderbilt. He also became in a short period of time the owner of one of the country's greatest private art collections. Unlike Avery, Johnston, and Walters, Vanderbilt's interest in collecting art arose late in his life. It was propelled by the death of his father, Commodore Vanderbilt, in 1877 and an inheritance of $90 million. At that time, William Vanderbilt's knowledge about art was debatable. One historian wrote that "he knew nothing about art," while another claimed that "he had a natural love of art."[18] Nevertheless, during a brief four-year period from 1878 to 1882, Vanderbilt amassed a remarkable collection of 184 paintings, mostly by renowned French academic artists. Displayed in a lavish gallery within Vanderbilt's sumptuous home, his collection was characterized as "certainly the best exemplification of the French school that has ever been massed outside of Paris."[19]

When Vanderbilt arrived in Paris in May 1878, he wanted to make sure that the Parisian art world understood that he was willing to spend whatever it took to acquire a great collection. Within one week after arriving, he made his splash by spending on a single day over 70,000 F. Four days later, on May 22, he commissioned a painting by Meissonier that cost 85,000 F.[20] Unlike most collectors, who sought to negotiate a reduction in cost, Vanderbilt took pride in the high prices that he paid. According to his biographer William Augustus Croffut, when Vanderbilt commissioned a painting, "it was not unusual for him to offer a higher price than was proposed."[21] This practice supposedly encouraged artists to produce their best works of art. It also enabled Vanderbilt to flaunt his wealth and claim that no other collector had better or higher-priced paintings. On other occasions, he did not bother to even ask about the price of a painting—his only condition was to extract from the artist a vow that it would be "the most important" painting he made.[22]

Vanderbilt claimed that he purchased most of his art on his own. While he apparently made the final decisions, there is no doubt that he relied heavily upon the advice of Avery and the services of Lucas. Vanderbilt had known Avery for many years, and in 1878 when he launched his plan to acquire an important collection of French art, he employed Avery to serve as his principal advisor.[23] Avery, in turn, enlisted Lucas to

help Vanderbilt acquire whatever he wanted. On May 13, 1878, three days after Vanderbilt's arrived in Paris, Lucas and Avery guided him to the studios of four of the artists he most admired—Meissonier, Cabanel, Alphonse De Neuville, and Édouard Detaille. Without hesitation, Vanderbilt began to acquire their art, which motivated Avery to happily note in his diary that it had been a "fine day."[24]

Unlike Lucas's close personal relationships with Johnston, Walters, Avery, and other clients, his relationship with Vanderbilt was more distant. Vanderbilt initially looked upon him as Avery's assistant, only a step above Vanderbilt's own team of four personal servants.[25] Lucas carried out routine assignments that included opening a bank account to pay for Vanderbilt's purchases, escorting him to the artists and dealers of Vanderbilt's choosing, and serving as his interpreter. (Vanderbilt did not speak French.) Lucas dealt with the artists to assure that Vanderbilt's commissions were completed in a timely manner, and he assured that the art was safely crated and shipped back to the United States. Playing the role of advance man, he would alert Parisian artists and dealers that "Vanderbilt was coming!"[26]

Although Vanderbilt might have looked down upon Lucas, he appreciated the quality of his services and gave Avery 1,000 F to "buy a present for Lucas."[27] When Vanderbilt returned to Paris in May of the following year, a closer relationship with Lucas began to develop. Vanderbilt began to trust Lucas's judgment in art, authorizing him to recommend works of art and upon Vanderbilt's approval to purchase the art in his absence. On June 1, 1879, as he was departing from Paris, Vanderbilt directed Lucas to purchase a painting by van Marcke. Lucas met with the artist and purchased the painting for 25,000 F. In October of that year, Lucas saw two paintings—one by Troyon and the other by Stevens—that he believed Vanderbilt should buy. He mailed photographs of these works to Vanderbilt, who authorized him to purchase both at the cost of 80,000 F. Around the same time, Lucas saw a "study of a white cow" by van Marcke that cost 10,000 F and sent Vanderbilt a letter "advising him to let me buy" it. Again Lucas's advice was accepted.[28]

When Vanderbilt returned to Paris in May 1880, his primary goal was to have his portrait painted by Meissonier. A few months earlier Meissonier had been described in the *Art Amateur,* a New York journal devoted to the arts, as the artist who "won more medals of honor in the great international expositions of Europe than any of his fellow artists ... [who] has been petted by kings and emperors and universally admired ... [and whose] works have commanded the highest prices ever paid for a modern painting."[29] In Vanderbilt's judgment, his own portrait by Meissonier would serve to crown his collection.[30]

Lucas, who had known Meissonier for many years, became responsible for making all of the arrangements, including accompanying Vanderbilt to Meissonier's studio and serving as interpreter during the many hours when Vanderbilt sat for his portrait.[31] Between May 24, the date of the first sitting, and June 25, when the portrait was completed, there were eleven sittings, each usually lasting around three hours.

FIGURE 44. Photograph of William Vanderbilt's House and Art Collection found in Edward Strahan's "Mr. Vanderbilt's House and Collection" (Boston, 1883–1884). Special Collections, The Sheridan Libraries, Johns Hopkins University.

Vanderbilt was delighted with the finished portrait. Although Meissonier had agreed to paint it for the modest amount of 20,000 F, Vanderbilt reportedly gave Meissonier an envelope in which there "was considerably more than the sum agreed upon."[32]

Continuing to rely upon Lucas, Vanderbilt asked him in August "to see about" the acquisition of a painting by Bonheur and another by Alberto Pasini. Lucas acquired both.[33] Two weeks later, Vanderbilt again asked him "to see about" the acquisition of a painting by Delacroix; Lucas promptly acquired the painting from the Petit Gallery for 55,000 F. He also helped acquire a painting by Lefebvre that was designed for the chamber of Vanderbilt's wife for 50,000 F; *La Mare* by Troyon, for 31,500 F; and a painting by Decamps, entitled *Intérieur de Cour en Italie,* for 36,800 F.[34] By the time Vanderbilt was finished, Lucas had been involved at one stage or another in the collector's purchase of paintings by twenty-one of the most important midcentury artists: Bonheur, Bonnat, Breton, Couture, Delacroix, Decamps, Detaille, Dupré, Gérôme, Jacquemart, Ludwig Knaus, Lefebvre, Leloir, Raimundo de Madrazo, Meissonier, Millet, Rousseau, Alfred Stevens, Troyon, van Marcke, and Jehan Georges Vibert.[35] As recorded in Lucas's diary, the amount of money that Vanderbilt spent to acquire these paintings exceeded 800,000 F.[36]

Following Vanderbilt's departure from Paris in the fall of 1881, Lucas did not see him again.[37] He likely read about the grand opening in March 1882 of Vanderbilt's gallery, which was attended by 2,500 guests, and about the praise showered upon the paintings that he had helped Vanderbilt acquire (fig. 44). But there is no indication that Vanderbilt ever mentioned his name or acknowledged the assistance that he had

provided. Vanderbilt's official biographer advanced the specious claim that Vanderbilt had no need to engage any person to advise him about art and that any advice that he received was offered "gratuitously."[38] But the diaries of Lucas and Avery told a much different story.

◆ ◆ ◆

The substantial wealth that William Walters obtained through his Atlantic Coast Line Railroad was not in any way comparable to the wealth that Vanderbilt obtained through his inheritance and his ownership of the New York Central. Nor could Walter's townhouse facing Mount Vernon Square in Baltimore compare in size or sumptuousness with Vanderbilt's New York mansion. But these factors did not diminish Walters's drive to compete with Vanderbilt for the laurel of owning the greatest art collection in America. In the late 1870s and early 1880s—following the sale of John Taylor Johnston's art collection and before Vanderbilt launched his acquisition of French art—Walters's collection was considered by many the finest in the United States. The art historian Earl Shinn (known by his pen name Edward Strahan), in his survey of the best art collections in America, devoted fourteen pages to Walters's collection and praised it as "magnificent."[39]

According to Strahan, the most valuable painting in Walters's collection at that time was a replica of Delaroche's famous panoramic mural, the *Hémicycle*. Referring to this painting, Shinn wrote, "I have seen nothing in America which seems so perfectly to bridge the civilization of the two continents and place the connoisseurship of the new world in connection with that of the old." Painted between 1836 and 1841, the *Hémicycle* covered a wall in the auditorium of the École des Beaux Arts in Paris. The importance of this monumental painting rested not only on the fame of Delaroche but on its scholarly depiction of seventy-five of the greatest painters, sculptors, and architects of all time—from the ancient Greek painter Apelles to the Dutch master Jan van Eyck and then on to Raphael, Leonardo, and Michelangelo—assembled on the steps of an ancient colonnade to pay homage to the oldest and greatest among them. Because the painting stood for the everlasting importance of art, it was beloved by art students, teachers, and collectors and characterized by one of the leading art journals of that time as "one of the most remarkable works that painting has ever produced."[40]

Delaroche and his assistant Charles Béranger completed a small *Replica* of the *Hémicycle* in 1853 (plate 21). The *Replica* was praised as an "exact copy" that was "executed with exceeding delicacy and beauty."[41] By 1855, it was owned by the Goupil & Cie and available for sale. Lucas's academic interest in the original mural and commercial interest in possibly acquiring the *Replica* for a client can be traced back to June 1861, when he initially went to the École des Beaux Arts to look at the painting and then returned time and again to study it. In October 1868, he took Johnston to the École to see the original mural, and five days later they went to Goupil to see the

Replica and to consider purchasing it. Johnston thought that it was "a beautiful picture," but upon learning that it cost between 100,000 to 120,000 F, he departed without making an offer.[42]

In March 1871, following the Franco-Prussian War, Lucas discovered that the *Replica* remained on the market and that its price had been substantially reduced to 75,000 to 80,000 F. Lucas informed Walters about the reduction in price and encouraged him to buy it. Walters did not leap at the opportunity. Three months later, Lucas learned from the dealer Georges Petit that the *Replica* remained available, but its price was rising. Petit offered to obtain it for Lucas for 90,000 F plus a commission for himself of 5 percent. Lucas again encouraged Walters to purchase the painting before its price escalated further. Although he rejected the amount sought by Petit, Walters authorized Lucas to buy the *Replica* for the bottom-line price of 80,000 F. On August 26, 1871, Lucas met with Petit, conveyed Walters's terms, and successfully negotiated the purchase.[43]

With the celebrated *Replica of The Hémicycle* in his collection, Walters reigned among American collectors of French art until 1882, when his collection was overshadowed by Vanderbilt's. With the goal of recapturing the attention of critics and connoisseurs and leaping ahead of Vanderbilt, Walters embarked on a two-year plan to increase the size and stature of his collection, to construct a beautiful new gallery adjacent to his house to display his art, and to orchestrate a grand opening of this gallery in February 1884 in order to influence members of the press and other movers and shakers in the art world to praise it.

The first step in this plan involved the acquisition of a monumental landscape, *Le Givre,* by Rousseau (plate 22). In April 1880, Lucas had recommended to Walters that he purchase it at auction, but Walters, to Lucas's chagrin, placed an unrealistic limit on the amount he would spend, and the painting was acquired by another bidder for 74,000 F. Lucas told Walters that he had lost the opportunity to buy "the biggest landscape by the biggest landscape painter." In December 1882, *Le Givre* was again on the market, at the much higher price of 150,000 F. This time, Walters was of a different frame of mind. To compete with Vanderbilt, he needed to dig much deeper into his pocketbook, and so he purchased the painting through Lucas for 112,000 F.[44]

One month later, Walters informed Lucas that he was returning to Paris to buy more art, and Lucas promptly responded with information about what was available. Likely inspired by Johnston's recent portrait, Walters requested Lucas to arrange for his own portrait to be painted by Bonnat. On March 30, 1883, they went to the studio for Walters's first sitting. In June 5, after a dozen more sittings, the portrait was completed (plate 23). Meanwhile, Walters, with Lucas's assistance, acquired eighteen additional paintings and drawings at a cost of 185,000 F by masters including Jacquemart, Gérôme, Delacroix, Millet, Hébert, Dupré, Rousseau, Isabey, Breton, Bouguereau, Corot, and Bonheur.[45] From the time of his acquisition of *Le Givre* at the end of 1882 until when he completed his buying spree at the end of the summer of 1883, Walters spent more than 300,000 F to enrich his collection.

Walters almost missed the pleasure of seeing these paintings in his new gallery and basking in the praise they would generate. On Saturday, July 28, 1883, Lucas learned that Walters was seriously ill. He was asked to come to London—where Walters was at that time—as soon as possible to care for him. By 6 a.m. on the following Monday, Lucas was by Walters's bed, seeking to comfort his friend. Later that day, he consulted with two doctors, who promised to see Walters right away; he obtained for Walters the medicine prescribed by these doctors, and he wrote a letter to Henry Walters, stating that he was in London, "here to stay with father." By August 7, Walters had regained enough strength to get out of bed and walk with the aid of crutches, but one week later, as Lucas reported to Henry, he had a "bad turn" and needed to remain bedridden for at least two more weeks. Stricken with gout and enfeebled by his advancing age, Walters was unable to return to the United States until mid-September.[46] The care provided by Lucas to Walters at this critical time demonstrated that theirs was a genuine and lasting friendship, not just a business relationship.

With Lucas's assistance, Walters returned to Baltimore in time to oversee the completion of his new art gallery. There were two rooms devoted to European art— a large rectangular room that could display in the style of a Parisian salon approximately two hundred oil paintings, and a smaller room devoted to watercolors and drawings.[47] The large room featured a skylight that helped to illuminate the paintings, walls covered in tapestries woven in France, soft crimson and blue carpets from the looms of one of England's best carpet makers, a large comfortable divan covered in dark-green velvet, and plate-glass display cases full of rare and exquisite objects, primarily from Walters's extensive collection of Asian art (fig. 45).[48]

To identify the art on his walls, Walters needed to quickly prepare a well-designed and informative catalogue. Rather than starting from scratch, he decided to use Vanderbilt's 1882 catalogue as his model. From a practical standpoint, that made sense.

Their collections contained works by the same French artists. Mindful of this similarity, Walters literally cut out large sections of Vanderbilt's catalogue and pasted them into his own, thereby creating a catalogue that appeared to be indistinguishable from Vanderbilt's in size, format, color, and biographical content.[49]

On the afternoon of February 26, 1884, Walters hosted a grand opening of his gallery. It was attended by two hundred guests, including a distinguished group of art patrons from New York, influential critics, members of the press, the mayor of Baltimore, and other public officials, as well as the foreign ambassadors of France, Great Britain, and Germany.[50] The superlative reviews in the New York and Baltimore newspapers immediately following the opening were evidence that Walters was as skilled in public relations as he was in collecting art. A long, hyperbolic article in the *Baltimore Sun* described Walters's paintings as "the best productions of great artists" and concluded, "A careful study of Mr. Walters's gallery reveals the works of the greatest artists that this age of modern art has ever produced."[51] A second article the following day crowned Walters's art "the finest collection of painting in oil and water color ever brought together under one roof in this country."[52]

As delighted as Walters must have been with the reviews in the *Baltimore Sun,* he must have been even more elated with an article appearing the same day in the *New York Sun.* It concluded that Walters's collection was far superior to Vanderbilt's. "There is no other collection of pictures in America," it opined, "that equals in importance and interest the Walters collection." Comparing the two collections, the article observed that Walters's collection intelligently displayed "priceless treasures," while Vanderbilt's was grounded on the principle that "nothing is for art and everything is for show." The *New York Sun* offered an apt analogy: "[Walters collection] is one of the few that has been made in the right way, and with a distinct purpose, as a library might be gathered together by a man learned in books, while another would build a room and order it to be filled with well-bound volumes."[53]

◆ ◆ ◆

Many of the French paintings that Lucas recommended and Walters acquired were intended to carry an underlying message, based on the theory that the purpose of great art, like great literature, was to educate the viewer. The theory that art existed for its own sake—an idea that was being advanced by Whistler and other members of the avant-garde, was in the judgment of Lucas and Walters an alien idea. In 1886, Walters wanted his collection to be recognized as not only aesthetically beautiful but intellectually linked to French history. To this end, he requested Lucas to acquire for him two paintings that would connect his collections to the Napoleonic emperors of France.

The first was a small preparatory sketch by Cabanel of his portrait of Napoleon III (plate 8). Napoleon III in 1863 had purchased Cabanel's masterpiece *The Birth of Venus*; in 1864 he had assured Cabanel's selection as an officer of the French Legion of Honor, and shortly thereafter he had commissioned a portrait for the apartment of

Empress Eugénie in the Tuileries Palace. Cabanel portrayed Napoleon wearing a dark frock coat and the red sash of France's Legion of Honor, as if to emphasize his position as president of the Third Republic; his ornamental crown and scepter rest on a royal red and gold cushion slightly behind him. When Napoleon was deposed in 1870, Eugénie fled to England, taking this portrait with her. The small preparatory sketch, however, remained behind. On February 3, 1886, Lucas apparently saw it in Paris and promptly wrote to Walters "about Cabanel's portrait of Nap. III."[54]

The second painting was by Meissonier. Entitled *1814,* it pictured Napoleon on horseback overlooking the battlefield following his victorious campaign against Austria (plate 24). It was originally painted for Prince Napoleon Bonaparte, the emperor's nephew. Purchased through Lucas on May 22, 1886, the painting cost 128,000 F, the most money that Walters would ever spend on a picture. Extremely proud of this image of Napoleon and wanting it to be noticed, Walters initially placed it on an easel and displayed it in the center of his gallery.[55]

By the end of the 1880s, Lucas had acquired over seventy-four oil paintings, watercolors, and drawings for Walters. (See appendix table 1.) They included the art in Walters's collection that was most highly praised by contemporary art critics— Delaroche's *Replica of the Hémicycle,* Rousseau's *Le Givre,* Gérôme's *Christian Martyrs,* Corot's *Evening Star,* Daumier's *First Class Carriage,* Meissonier's *1814,* Millet's *The Sower,* Breton's *The Close of the Day,* and Delacroix's *Christ on the Sea of Galilee.* Although the collection was owned by Walters, these great examples of mid-nineteenth-century French art became part of Lucas's legacy as well.[56]

◆ ◆ ◆

The crowd of aficionados who gathered in Walters's gallery in February 1884 to see his paintings and sing their praises were unaware that almost half of the French art on display had been acquired for Walters by Lucas. His name was not mentioned in the catalogue or in any of the laudatory reviews of the collection that appeared that year in the Baltimore and New York press. Wanting to remedy the oversight, Walters planned to express his gratitude to Lucas at a public event involving the art of Barye.

Lucas was a great admirer and connoisseur of Barye's work. From the day he first entered Barye's atelier on December 26, 1859, Lucas remained one of his most ardent supporters. Although relatively unknown in the United States, Barye had long been celebrated in France. He made his début at the Salon in 1827, succeeded in having one of his *animalier* sculptures prominently installed on the grounds of the Tuileries Palace, and was characterized by the poet, dramatist, and art critic Théophile Gautier as "the Michelangelo of the menagerie."

Shortly after Walters arrived in Paris in 1861, he also became enamored with Barye's art. He began to purchase some of Barye's masterpieces, including *The Tiger Hunt,* which Lucas acquired for him on February 20, 1872 (fig. 46).[57] By 1884, Walters had purchased approximately seventy Barye bronzes and paintings for his own collection and an additional 120 bronzes for the newly established Corcoran Art Gal-

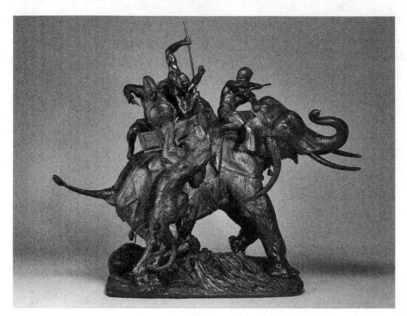

FIGURE 46. Antoine-Louis Barye, *Tiger Hunt*, 1834–1836. The Walters Art Museum, WAM 27.176.

lery, where he served as the chairman of the art committee.[58] Lucas, meanwhile, had accumulated well over one hundred of Barye's bronzes, watercolors, and drawings for himself.

In the spring of 1884, Walters decided to establish in his home a separate "Barye Room," dedicated to his large collection of the artist's bronzes. To enhance Barye's reputation, Walters decided to give to the city of Baltimore a gift of five bronzes that would be displayed in Mount Vernon Place, directly in front of his house. All five were modeled after well-known bronzes owned by the French government. Four of the original sculptures carrying the allegorical titles *War, Peace, Order,* and *Force* were displayed in the Louvre. The fifth was a life-size replica of Barye's *Seated Lion,* which was in the Tuileries Garden. To carry out his plan, Walters relied heavily upon Lucas's expertise and connections. Lucas conferred with French officials, commissioned the reproduction of the bronzes, carefully oversaw their casting and patination, designed the pedestals upon which they would sit, and arranged their shipment to Walters in time to be symmetrically placed in Mount Vernon Square (see fig. 9).[59]

On the afternoon of January 28, 1885, Walters opened his Barye collection and unveiled his gift of the outdoor sculpture at a social event that he called the "Barye Inauguration." Despite the cold weather, the guests, according to the *Baltimore Sun,* "paused in Mount Vernon Square to admire the splendid lion and other Barye bronzes there and the general verdict from the connoisseurs was that Baltimore may congratulate itself on possessing the finest single collection of out-door statuary in the country."[60] As part of the festivities, Walters distributed a leather-bound book that contained a series of laudatory descriptions of Barye's art written by leading French authorities. The book also contained a brief tribute to Lucas, written by Wal-

A Paris Life, A Baltimore Treasure

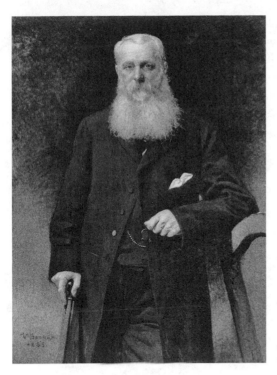

FIGURE 47. Léon Bonnat, *Portrait of George Aloysius Lucas*, 1885. The Walters Art Museum, WAM 37.759.

ters. It was, according to Walters, "a fitting place to set down in print" the following words of praise: "The debt I owe him for his good judgment, mature experience and cheerful cooperation in nearly all I have accomplished as amateur and collector, I find only less than the value I place upon his sterling truth, and upon his worth as a man and a friend."[61] The written tribute was accompanied by something even more important to Lucas: his portrait. In the spring of 1884, Walters commissioned Léon Bonnat to paint a life-sized, three-quarter-length portrait of Lucas (fig. 47). Along with a portrait of Barye, it was intended for display in the Barye Room of Walters's home. Although Lucas would never return to the United States, the idea of his portrait being shown in his native city for all to see and admire must have seemed to him like a very special kind of homecoming.

◆ ◆ ◆

As suggested by Bonnat's depiction of Lucas's full beard, the cane held firmly in his hand, and the lean of his elbow upon a supporting chair, Lucas had entered the senior years of his life. He also was approaching the finish line of the most productive period of his art-related career. By 1885, the robust business generated by his four best clients—Avery, Johnston, Vanderbilt, and Walters—was nearing its end. Lucas would never meet any of them again. After auctioning his collection in 1876, Johnston never rekindled his passion for collecting art. In 1882, Avery retired from his business as an art dealer and gallery owner, and his annual buying trips to Paris came to an end.

In 1885, three years after opening his heralded art collection, William Vanderbilt suddenly died at the age of sixty-four. William Walters's trip to Paris in 1883 was his last. By the end of the 1880s, his enthusiasm for collecting had wilted with age, and in 1894, he died.

Lucas continued to buy art, but at a much slower pace, for Avery's son Sam and Walters's son Henry. He escorted wealthy American patrons of the arts, such as Mary Frick Garrett (later Mary Frick Jacobs), to have their portraits painted by Bouguereau, Cabanel, or Bonnat.[62] But the period of his greatest productivity—during which he continuously served as the art agent for one of America's most influential dealers and four of the country's greatest collectors—had come to an end.

The Lucas Collection

When we look back at Lucas's collection through the haze of more than one hundred years of cultural history, it appears filled with long-forgotten names of artists who seem to us old-fashioned, and shaped by time-worn styles that have been laid to rest in the reliquaries of art history. But Lucas viewed his collection much differently. The art he collected was alive. It was vibrant. It had been made by scores of living artists who were his age, whose homes and studios he visited, whose palettes he owned, whose tastes for wine and women he knew, whose lives touched his, and whose aesthetics reflected part of the culture of that time. What Lucas collected was, by definition, contemporary art.

While helping his wealthy American clients acquire sterling pieces of French art, Lucas remained devoted to his own unique and ever-growing collection. From the time of his arrival in Paris at the age of thirty-three until he was old and lame and confined to his home at the age of eighty-three, Lucas never stopped searching for art. It was his passion. And by the end of his life, his collection of French mid-nineteenth-century art was the largest owned by any American collector.

It was not only the volume of art that made his collection unique. Its most distinguishing feature was the information he had acquired about the art and the artists. Lucas was a bibliophile who gathered from stores and stalls all over Paris more than fifteen hundred art books, gallery guides, art dictionaries, treatises on art history, biographies of artists, art journals, and art catalogues. His library attested to his encyclopedic interest in art across millennia of cultural history. He had a lengthy critical

study of the sculpture of ancient Greece, a 743-page history of medieval art, and the definitive guide to all of the paintings at the Louvre. Among his catalogues were photographic reproductions of the finest art in European museums, the catalogues of all of the official Parisian Salons, and the auction catalogues published by the Hôtel Drouot. He owned limited editions of books of drawings and prints, many of which were inscribed to Monsieur Lucas, and volumes of essays and published lectures by the foremost art critics, theoreticians, and art historians of that time. Lucas treasured the many books and journals that lined his shelves, and he treated them like relatives of the art that covered his walls.[1]

He supplemented his library of scholarly books with practically every shred of information, no matter how ephemeral, that he could find about the artists represented in his collection. He scoured newspapers and magazines for pictures of the artists, reproductions of their work, commentaries on their recent exhibitions, and other nuggets of information. He matted and framed their portraits and preserved them like family photos. He wrote brief biographical sketches of the artists that included such vital information as their dates of birth and death, where they lived, the awards they won, and the names of the teachers who inspired their work. As if presiding over a marriage between art and scholarship, he carefully separated the pages of several artists' catalogues raisonné, inserted pictures of the art, and bound the pages and the pictures neatly together, thus creating his own uniquely illustrated books of the artists' bodies of work. This bank of knowledge tied Lucas's sprawling art collection together and gave it meaning. And it signaled that the collection was designed for the mind as well as the eye. The result was not merely a large body of objects but a montage of the ideas and rhythms of culture of mid-nineteenth-century Paris that shaped Lucas's life.

• • •

In the marketplace for French art, Lucas became known as the "grand collectionneur américain."[2] Practically every midcentury French artist and his dealer knew Lucas's name and exactly where he lived. It was rare that a day went by without someone delivering to his door a work of art that he had purchased or bringing to his attention some new work that was for sale. Day by day, for years on end, Lucas methodically recorded in his dairy each of these visitors and the art that was added to his collection. On May 2, 1883, Lucas wrote, "Visit from Thiollet bringing picture 250fs & palette." On June 25, 1884: "Visit from Buhot to overlook his lot of eaux fortes." March 16, 1888: "Visit from Goeneutte from whom bought picture Pointe de l'Europe for 200fs." March 21, 1888: "Visit from Jacomin with photos of his large salon landscapes." May 8, 1888: "Visit from 2 of Barye's daughters bringing palette and plaster for which asked 300 francs." January 21, 1902: "Visit from Montaignac with present of palette of Corot." On some days artists and dealers visited one after the other, some delivering, some showing, and some seeking payment for the art that Lucas had acquired.[3]

It was also rare for Lucas to return home at night without a painting, group of etchings, or art book or journal under his arm. How he found the time and energy to organize, store, and keep track of his mounting collection is difficult to fathom. The only assistance that he could count upon came from his mistress M and Eugène. M's kitchen had been converted into a miniature production line where the preparation of food gave way to the seemingly endless preservation and storage of thousands of prints. In one note, apparently to M, Lucas wrote that the prints in the kitchen were "prepared for pasting," and in another he indicated that cartons of art that were on the kitchen shelf needed "to be overhauled." In accordance with these instructions, M glued and neatly mounted the prints onto cardboard, placed them in the artists' portfolios, and then stored the portfolios in cartons. In addition to performing these chores, M opened Lucas's mail, greeted visitors in Lucas's absence, assisted in the organization and documentation of the collection, and shouldered the broader responsibility of caring for the thousands of works of art stored in her apartment.[4] Eugène performed whatever tasks Lucas assigned to him, including hanging the paintings and binding the books and journals that lined the shelves of Lucas's apartment. Lucas, of course, made all of the decisions and performed the lion's share of the work himself. With a collection that was large enough to fill a museum and getting larger by the day, Lucas served as his own director, curator, registrar, librarian, archivist, conservator, art handler, accountant, and clerk. And while Lucas was not an artist, his massive collection as a whole became his private masterpiece.

The primary focus of Lucas's collection was the artists, not the art. Lucas provided each artist with his own portfolio, which was the place within Lucas's apartment—and mind—where the artist virtually dwelled. The portfolio was inscribed with the artist's name, it often contained a picture of what he looked like and a copy of his autograph, it included any writings by or about him, and it housed all of his prints, drawings, and other works on paper.

The artists' portfolios were kept in approximately 120 cardboard or metal boxes and placed in closets, cabinets, armoires, and almost every conceivable space in every room, including the bathrooms and kitchens, in Lucas's and M's adjacent apartments. Lucas gave a name to every room in both apartments and inscribed an identifying name or number on each box. In a seventy-two page notebook labeled "Catalogue—Eaux fortes," Lucas recorded the rooms in which each box and its contents were stored.[5] He also meticulously recorded the precise number of each artist's etchings, lithographs, drawings, letters, autographs, photographs, pamphlets, portraits, and other works on paper that were in the portfolio.

As documented in Lucas's *Catalogue,* he stored the portfolios of Manet, Daubigny, and Daumier in cartons that were located in the living room—named the Salon Acacias—of M's apartment. The page of the *Catalogue* devoted to the contents of Manet's portfolio (fig. 48) shows that it contained ten portraits of Manet, nine other "caricature portraits," an autographed letter, an article about Manet by the renowned journalist and art critic Théodore Duret, four lithographs, fifty-seven etchings, in-

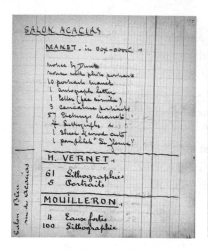

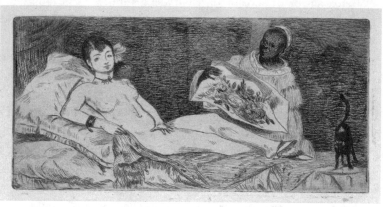

FIGURE 48. Page from Lucas's Catalogue—Eaux Fortes, documenting his prints by Manet. George A. Lucas Papers, Archives and Manuscripts Collections, The Baltimore Museum of Art.

FIGURE 49. Édouard Manet, *Olympia* (etching), 1867. The George A. Lucas Collection, Baltimore Museum of Art, BMA 1996.48.5153.

cluding Manet's etching of *Olympia* (fig. 49), and a copy of Baudelaire's sexually explicit and controversial book of poetry, *Les Fleurs du mal* (*Flowers of Evil*). The placement of *Les Fleurs du mal* alongside *Olympia* alluded to the close friendship between the artist and the writer and Baudelaire's claim that Manet was the greatest French painter of modern life.

The pages in Lucas's *Catalogue* devoted to Daubigny (fig. 50) indicate that his portfolio occupied nine cartons and included nine portraits of him; four copies of his autograph; several magazine and newspaper articles that pictured his house, his studio, and his boat; autographed copies of his exhibition catalogues; and 475 etchings, 74 engravings, 65 "*clichés glace*" (photographic prints), 36 lithographs, and many preparatory drawings, including Daubigny's etching of *The Studio Boat* (fig. 51). That etching depicts Daubigny seated before an easel in a small area of his boat, crowded with pots and paintings and evidently used as both kitchen and studio; he is shown painting a landscape visible through a wide opening in the back of the boat.[6]

The page of the *Catalogue* that refers to the contents of Daumier's portfolio indicates that it contained three portraits and seventy-six lithographs. It was in a carton that also held Paul Gavarni's portfolio (fig. 52). The side-by-side placement of Gavarni's and Daumier's portfolios was not accidental. Gavarni and Daumier were approximately the same age and had worked at one time together. By midcentury, they had become France's most popular caricaturists, whose astute prints and drawings offered biting commentaries on the family, social, and political life of their time. Lucas's decision to house these kindred spirits together reflected the scholarly man-

128 A Paris Life, A Baltimore Treasure

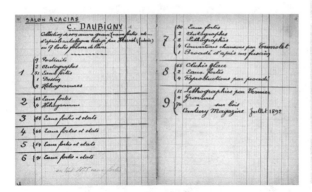

FIGURE 50. Page from Lucas's Catalogue—Eaux Fortes, documenting his prints by Daubigny. George A. Lucas Papers, Archives and Manuscripts Collections, The Baltimore Museum of Art.

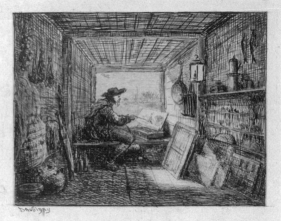

FIGURE 51. Charles François Daubigny, *The Studio Boat* (etching), 1861. Publisher A. Cadart. The George A. Lucas Collection, Baltimore Museum of Art, BMA 1996.48.4198.

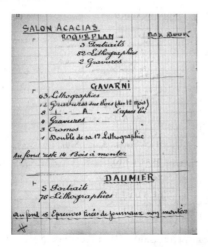

FIGURE 52. Page from Lucas's Catalogue—Eaux Fortes, documenting his prints by Daumier and Gavarni. George A. Lucas Papers, Archives and Manuscripts Collections, The Baltimore Museum of Art.

ner in which he organized and preserved their art and memorialized their place in art history.

Lucas also kept track of recently acquired prints that had not as yet found a permanent home in the artists' portfolios, recording the specific room and piece of furniture in which each new print was temporarily stored. For example, he wrote that some new prints were "in my chamber drawer," or "in drawer *demi-lune* furniture Salon Arc de Triomphe," or "in drawer piece of furniture dining room," or "in chamber commode—lower drawer and upper drawer."[7]

Although greatly outnumbered by the prints, Lucas's oil paintings seemed to be everywhere in the apartments. He spent an inordinate amount of time researching and

FIGURE 53. Lucas's notes and drawings documenting arrangement of pictures in M's room called Acacias Blue. George A. Lucas, Archives and Manuscripts Collections, The Baltimore Museum of Art.

FIGURE 54. Benjamin Constant, *Odalisque*, c. 1880. The George A. Lucas Collection, Baltimore Museum of Art, BMA 1996.45.63.

writing informative labels, deciding where the paintings would be hung, and keeping track of them all. He prepared a list of paintings for every room. For example, the list for Lucas's "Sleeping Room" identified forty-four paintings, while his "Salon" held thirty-two and M's "Salon Bleu Acacias" had twenty-seven.[8]

Toward the end of the nineteenth century, as Lucas's acquisition of paintings slowed to a snail's pace, he decided to take stock and rehang his paintings. By August 1899, with the assistance of the American painter William Baird, he had finished the task.[9] Thereafter, Lucas mapped room by room where the paintings were located, the manner in which they were arranged, their sizes in relationship to one another, and whether the paintings were prepared on canvas (*Toile*) or panel (*Panneau*). For example, on a page showing the paintings in the "Salon Bleu Acacias," Lucas sketched the relative sizes of five rectangular paintings (fig. 53). He identified their artists as Alfred Gues, August Schenck, Benjamin Constant, Camille Flers, and Alexandre Thiollet, and he provided tidbits of information about each of them. With regard to the painting by Constant, which Lucas named "*Femme morocain en harem*," he noted that Constant was a student of Cabanel, one of Lucas's favorite artists (fig. 54).[10] Based on these and other documents, it is evident that Lucas was absorbed not only in collecting French mid-nineteenth-century art but also in creating an archival record of how he cared for it.

◆ ◆ ◆

The most important room in Lucas's apartment was his small living room, his Salon. It became his showcase where he hung or otherwise displayed thirty-two paintings

A Paris Life, A Baltimore Treasure

that he considered to be among the finest in his collection. It was also where he greeted his occasional guests and where in 1904 he posed, surrounded by his art, for his final photographic portrait by Dornac (see fig. 1). The paintings in his Salon carried important names: Breton, Bouguereau, Cabanel, Corot, Courbet, Daubigny, Daumier, Decamps, Fantin-Latour, Gérôme, Jacque, Monticelli, and Ziem. There was also sculpture by Barye and boxes of prints marked Manet and Whistler.[11]

Among the paintings in the Salon were five exceptional landscapes. Two were by Corot, and the other three were by artists whose names have faded with time: Adolphe Hervier, Alexandre Thiollet, and Norbert Goeneutte. They reflected Lucas's taste and keen eye for Barbizon and other landscape paintings, as well as the relative affordability of this field of art and its emerging popularity among the French bourgeois and American collectors at that time.[12] The two paintings by Corot, *Thatched Village* (plate 25) and *Sevres-Brimborion View Toward Paris* (plate 13), reflected the artist's evolving practice of painting directly from nature as he became one of the forefathers of the plein air school. Unlike the classical or romantic landscapes of the past, these natural landscapes had a beauty that rested in their honest simplicity. Nothing in them was sharply defined or artificially finished; everything was filtered instead through the spontaneous effects of light and shadow and the natural haze created by distance.

In both paintings, the motif of an unpaved country road encourages the viewer to enter the picture and to observe small humble figures standing or walking along the same road as it passes through a rustic village to a church or the city of Paris in the far distance. The road, which begins in the immediate foreground and gradually narrows toward the vanishing point, might well have symbolized the transition from pure nature to man's engagement with nature to the uncertain consequences of future modernity. Corot painted these works in 1864, and Lucas purchased them directly from him that year, paying only 300 F for *Thatched Village* and 400 F for *View Toward Paris*.[13]

The painting by Hervier was one of Lucas's favorites (plate 26). Although admired by Corot, Hervier had little success during his lifetime and died penniless in 1879. Eight years later, in March 1887, Lucas attended a retrospective exhibition of Hervier's art and fell in love with it. He acquired a catalogue and certified copy of Hervier's signature, and he began to scour the market for his paintings, etchings, and lithographs, ultimately acquiring one of the largest and most representative collections of his art. In January 1889, Lucas was able to acquire for 450 F one of the gems of his collection, the beautiful *Village with Windmills*.[14]

Hervier's landscape created a seamless transition from pastoral to village life. The painting permits the viewer to visually climb a gentle hill, starting at a stream and cattle grazing in the foreground and ascending through a cluster of trees to a series of small white dwellings, which, like steps, carry the viewer to the top of the hill, where the arms of three windmills point to the sky. The entire scene was painted with a touch that seems as light as air and brushstrokes that cause the clouds to appear to move.

Thiollet was one of Lucas's favorite artists, and he purchased seven paintings

from him. Thiollet's *Fish Auction on the Beach at Villerville,* which Lucas purchased around 1873, was one of the loveliest in his collection (plate 27). It captures the harmonic relationship between the sea at low tide and the residents of a seaside village, whose women have gathered on the beach to purchase the day's bounty for their family dinners. With a fishing ship at anchor, the shadows of a cloud-filled sky gently blanketing the beach, and the group of women dressed in complementary shades of blue, purple, red, and brown, uniformly accented by sparkling white kerchiefs, the scene as a whole evokes a feeling of communal tranquility.[15]

In contrast to these quiet, natural landscapes, the painting by Goeneutte produced a striking impression of the heat, noise, and energy of urban life at the cusp of modernity (plate 28). Clearly influenced by Monet's painting of the same subject, Goeneutte's *View of St. Lazare Railway Station* pictured one of the largest steel bridges in Paris and the railway yards of Gare Saint-Lazare. Both were blackened by billows of smoke and steam arising from the engines of locomotives running under the bridge and to and from the yards as they enter and leave the city. But what gives the painting its special power is the manner in which the steel and smoke dominate the small specks of humanity who can barely be seen crossing the bridge on foot or by horse-drawn carriage. It raises the question of whether man is conquered by or in control over the forces of modernity. The scene was familiar to Lucas, who often walked across the bridge and entered or left the train station on his frequent trips between Paris and the countryside. Lucas bought it in 1888, the year after it was painted, for 200 F.[16]

◆ ◆ ◆

Given the time and loving care that Lucas devoted to his art, the most surprising thing about his collection was how little anyone else knew about it. The only contemporary eyewitness description was based on a visit to Lucas's apartment on February 11, 1904, by Théodore Duret and Elizabeth Pennell.[17] Duret was a friend of Lucas's and a revered art historian, collector, and champion of the art of Manet, Whistler, and the impressionists.[18] Pennell was a notable art historian from London. Both Duret and Pennell were planning to write separate books about Whistler, who had died the year before. They met in Lucas's Salon, which Pennell described as "a fairly small room, delightfully littered with his collections; the walls hung as close as possible with pictures—two Corots, a Daumier, a beautiful little Fantin like a Diaz, a Daubigny, a Hervier, and more than I had time to look at against the walls, two or three little cabinets covered with small bronzes by Barye, and a few low cases filled with portfolios labeled, Whistler, Manet, Jacque."[19] This brief description reveals not only what Elizabeth Pennell hastily saw but how little of Lucas's massive collection he actually showed.

Unlike his American clients, Lucas never opened his collection to the public or craved attention. He did not offer any tours to art lovers or students.[20] He rarely showed his art to his clients. He never published any catalogue, and no comprehensive essay or article about the collection ever appeared during his lifetime. Other than

M, Eugène, and a small circle of intimate friends, no one else ever saw or was given access to the entire collection.

Among Lucas's closest friends was the American journalist Theodore Child.[21] The Paris correspondent for *Harpers New Monthly Magazine,* Child wrote a series of articles for that magazine and for *Art Amateur* about the cultural life of Paris. He visited Lucas at his apartment in Paris over 110 times and went to his country house in Boissise an additional thirty times. He certainly was familiar with the paintings that Lucas displayed on the walls of his Salon, as well as with his burgeoning collection of prints. Yet Child never mentioned Lucas's art in his articles, other than a brief mention of his "important collection" of Barye sculpture.[22]

Although Lucas did not open his Parisian apartment or home in Boissise to the public, he allowed his Barye sculpture and drawings by Daumier to be displayed at temporary exhibitions held elsewhere. He also periodically allowed scholars, like Duret and Pennell, who expressed an interest in the work of a specific artist to come to his apartment to see it. These visits, however, were few and far between. Lucas's practice of recording in his diary the name of each visitor and the purpose of the visit enables us to measure the care he took in guarding the privacy of his collection. Over the course of dozens of years, for instance, he entertained only four visitors who wanted to see his landscapes by Corot, two to see his Whistlers, and one to see any of his art by Daubigny. Overall, there were only fourteen artists in his collection who attracted the attention of any visitors.[23] Most of the works by hundreds of artists remained stored in Lucas's and M's apartments and unseen by outsiders during his lifetime.

The only artist whose work attracted more than a handful of visitors was Barye. By the mid-1880s, Lucas was recognized as the consummate expert on Barye and his most enthusiastic patron. He possessed one of the largest private Barye collections in Paris—over 150 bronzes and dozens of oil paintings, watercolors, drawings, and prints. He played a leading role in the arrangement of a comprehensive exhibition of Barye's art at the École des Beaux-Arts in 1889 and lent a large number of his own works to this exhibition. He also took the lead in establishing five years later a large and impressive memorial to the artist.[24] To express its appreciation, the French government informed Lucas that it planned to place his name on the country's Légion d'Honneur, but for reasons that remain unclear, Lucas declined the honor.[25] For devotees of Barye's art, Lucas's apartment became a destination in the 1880s and 1890s.[26]

◆ ◆ ◆

Lucas had compelling reasons for keeping most of his art out of public sight. First, approximately half of his collection was in M's apartment. Lucas did not want his conservative American clients to know about his mistress. He had successfully cultivated an image of himself as a highly moral bourgeois gentleman who lived alone with his art. Indeed, upon his death, the *Baltimore Sun* obituary stated that Lucas "never married and lived quietly among his treasures."[27] To open the door of M's

apartment and allow the public to see all the art that he had stored there and that she had cared for would have been tantamount to opening his and M's private life to public scrutiny. It was a risk he was unwilling to take.

The second reason for his reticence in making his collection more available to the public had to do with the overall quality of Lucas's collection of oil paintings. It was uneven. The 300 paintings in Lucas's collection were done by 176 different artists, many of whom had medaled at the official Salons and otherwise enjoyed successful careers.[28] But with the exception of several landscapes, most of these paintings were not sterling examples of these artists' work. Very few had obtained the imprimatur of Salon judges and been accepted for public display at the Salons. Only one of the paintings had ever received an award. Hardly any would have been characterized as masterpieces or honored with a space on the wall of a French museum. The significance of many of Lucas's paintings rested more on the name of the artist than on the art itself. While he treasured his paintings, his collection as a whole was not by nineteenth-century standards a great body of art.

Anyone who stepped from Lucas's living room into his bedroom would have observed a steep decline in the work hung there. The walls were covered with forty-four paintings that had no common denominator other than their sentimental value and the comfort they presumably provided to Lucas. They were a hodgepodge of different styles, subjects, and quality by artists known and unknown. They included, for example, a poorly conceived 6×11-inch sketch by Gustave Boulanger of a mermaid that Lucas called his "nude" and had purchased for the paltry sum of 35 F (fig. 55) and a small study of a dog given to Lucas by Jean Goubie in gratitude for his purchasing Goubie's paintings for his clients (fig. 56).[29]

The most unusual painting that Lucas kept in his bedroom was a postcard-size landscape attributed to Meissonier, called *Port Marly, on the Banks of the Seine.* The Georges Petit Gallery gave it to Lucas in 1872 as a small gift to encourage him to bring his wealthy clients to the gallery.[30] The basic problem with the painting was not its miniscule size but the fact that it was totally uncharacteristic of Meissonier's well-known body of work. The artist's fame rested not on miniature landscapes but on his highly finished and sharply defined paintings of Napoleon and other historic figures, often on horseback. Lucas had idolized Meissonier from the day he arrived in France and was well aware that owning a painting by him was a symbol of refined taste and high status. If the painting had any value at all, Lucas would have found a prominent place of honor for it in the salon of his home. His decision to keep Meissonier's miniscule landscape in the privacy of his bedroom and in the company of an array of second-class paintings evidences his own assessment of its lack of merit.[31]

As suggested by this uneven array of art, Lucas's acquisition of paintings was more often the product of chance than the result of deliberate and discriminating choice. Lucas did not see many of his paintings before they came into his possession. Approximately one hundred—about one-third of his collection of oil paintings—were given to him by artists or dealers as tokens of appreciation for steering his wealthy American

FIGURE 55. Gustave Clarence Rodolphe Boulanger, *Mermaid*, n.d. The George A. Lucas Collection, Baltimore Museum of Art, BMA 1996.45.37.

FIGURE 56. Jean Richard Goubie, *Study of a Dog*, n.d. The George A. Lucas Collection, Baltimore Museum of Art, BMA 1996.45.119.

clients to them. (See appendix table 2.) Many were preparatory sketches for larger, more complex paintings. Many others were the result of commissions given by Lucas to artists to paint visually pleasing images that left the details to the artists' discretion. Practically all of these paintings had an underlying and personal meaning to Lucas, but viewed objectively most were not first-class works of art.

The breadth and quality of Lucas's collection of paintings also was hindered by the relatively small amount of money that he was able or willing to spend. The average amount that Lucas paid for an oil painting was 245 F. Fifty-seven of his paintings were purchased for 100 F or less. He purchased several for 15 F, another for 7.5 F, and one for 2 F, the equivalent of pocket change.[32] (See appendix table 2.) Mindful that the price often depended on the work's size and the number of figures (a painting with two figures ordinarily cost twice as much as a painting with only one), Lucas rarely purchased any paintings that had more than one figure. He limited his collection to easel-sized landscapes, small still lifes, and small portraits of unknown people—three categories of paintings that rarely won first-class medals and were denigrated by midcentury academicians as lower forms of art.[33]

The state-sponsored Salons served as the primary market place in Paris for purchasing what was presumed to be fine art.[34] Vetted by celebrated artist-judges, such as Cabanel, Gérôme, and Daubigny, three thousand or more paintings were displayed

there each year, carrying prices that usually began at 1,000 F. According to one study, the average price of a history painting—traditionally considered the highest form of French art—was 6,500 F and a genre painting, 2,800 F.[35] Between 1865 and 1890, Lucas acquired over 125 paintings for his clients at the Salons.[36] Their average price was around 5,000 F, more than twenty times the average amount (245 F) that he spent for his own paintings.[37]

During this same period, Lucas purchased only two Salon paintings for himself. They were by the same artist, the landscapist Marie-Ferdinand Jacomin. On March 6, 1884, Lucas purchased Jacomin's *Landscape in Cloud and Sunshine* for 2,500 F. It was the largest (32 1/2 × 46 inches) and most expensive painting he ever acquired (plate 29). It also was the only painting in Lucas's collection that obtained a medal at the annual Salon.[38] Lucas was drawn to this picture by its beautiful depiction of the forces of nature—the evanescent clouds, the spotlight created by the rays of the sun, and the line of grazing cattle receding and gradually disappearing into the forest.

Lucas likewise rarely purchased any paintings for himself at the luxurious galleries then considered the supreme arbiters of fine taste, most notably, Goupil, Durand-Ruel, and Georges Petit. Hardly a week would pass without Lucas visiting these galleries and shopping for his clients. But despite the temptation, he could not afford to buy many works for himself. He purchased only one modestly priced oil painting from Goupil and none from Georges Petit or Durand-Ruel.[39] As a result, the owners of these galleries looked upon Lucas as an important agent for other American collectors but not as an important collector himself.[40]

Unable to afford most of the paintings displayed at the Salons or sold by the fashionable galleries, Lucas went directly to the artists or their dealers and acquired humbler works at a fraction of the cost. A comparison of the amounts of money that Lucas and William Walters spent for works of art by the same artists (table 1) illustrates the disparity of the cost and, inferentially, the quality of the art in their collections.

The cost of paintings by Emile Plassan that Lucas obtained for William Walters and the cost for those he bought for himself illustrates the point. Plassan was a highly regarded painter who had medaled at the Salons in 1857 and 1859. Having acquired

TABLE 1. Price Comparison: Lucas vs. Walters Paintings

Artist	William T. Walters's Paintings		George Lucas's Paintings	
	Painting	Price (francs)	Painting	Price (francs)
Breton	*The Close of Day*	2,000	*Study for the Communicants*	0 (gift)
Cabanel	*Pandora*	10,000	*Portrait of Lucas*	0 (gift)
Corot	*Evening Star*	1,000	*Near Amiens*	300
Daubigny	*Sunset on the Coast of France*	20,000	*Through the Field*	300
Delacroix	*Collision of Moorish Horsemen*	40,000	*Lamentation over Christ*	0 (gift)
Meissonier	*1814*	128,000	*Oil Study: Landscape*	0 (gift)
Plassan	*Prayer* and *Devotion* (2 paintings)	3,500	*Village* and *Landscape* (2 paintings)	0 (gift)
Rousseau	*Le Givre*	112,000	*Oil Study: Landscape*	200

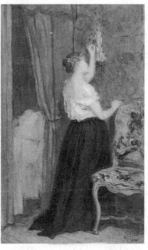

FIGURE 57. Antoine Emile Plassan, *Devotion*, 1863–1864. The Walters Art Museum, WAM 37.45.

FIGURE 58. Antoine Emile Plassan, *At the Shrine*, n.d. The George A. Lucas Collection, Baltimore Museum of Art, BMA 1996.45.221.

a taste for his art, Lucas in 1862 met with him to determine his prices for relatively simple figurative paintings. He learned that a painting with one figure cost 1,200 F and a painting with two figures, 2,000 F. These prices were out of Lucas's range but easily affordable by Walters, his primary client at that time. In December 1863, he purchased for Walters two paintings by Plassan for 3,500 F. One, entitled *Devotion* (fig. 57), depicted a woman in a white nightgown looking reverentially upward and placing a strand of rosary beads on a devotional object affixed to the wall alongside her bed. On June 30, 1864, the day that Lucas delivered a check for the paintings, he asked Plassan "to make me a sketch." The small sketch that was given to Lucas was around half the size of the painting (fig. 58), but it was free of charge. Between 1863 and 1870, Lucas purchased four Plassan paintings for Walters that in total cost 15,000 F. During the same period, he obtained eight paintings from Plassan for himself that together cost 1,200 F. Two were 600 F each, and the other six were free.[41]

Lucas's collection of oil paintings was in large measure the byproduct of his work as an agent for wealthy American collectors. During the periods when he heavily was engaged in acquiring paintings for his clients, he was also busily engaged in obtaining paintings for himself. Lucas acquired most of his oil paintings during three brief periods. The first was from 1861 to 1865, when Walters was residing in Paris and Lucas was engaged practically full time in helping him buy art. The second was from 1866

FIGURE 59. Lucas's acquisitions of oil paintings, by date.

to 1870, when he was the principal agent in Paris for Samuel Avery and John Taylor Johnston. And the third was from 1881 to 1885, when Lucas was engaged by Walters and William Vanderbilt to purchase paintings for both as they competed for the crown of owning the finest collection of French art in America. Thereafter, as the business generated by these clients declined (leading to Lucas's retirement in 1897), Lucas's acquisition of paintings for himself sharply declined as well (fig. 59).[42] In contrast to the more than one hundred paintings that he acquired between 1861 and 1870, he obtained only eighteen between 1896 and 1907.[43]

The ten-year period from 1861 to 1870 yielded not only the highest number of paintings but also some of Lucas's best bargains, including paintings by Camille Pissarro, Eugène Boudin, and Johan Barthold Jongkind. On January 7, 1870, while at a small gallery owned by Pierre-Fromin Martin, Lucas noticed a winter landscape (he called it "snow") painted in the style of the Barbizon school. Lucas did not know Pissarro, but upon noticing that the painting employed the motif of an open road passing through a village—a hallmark of Corot and other Barbizon artists—and learning that Pissarro had been a student of Corot, Lucas became interested in acquiring it. However, he was not so taken with the picture that he was willing to pay its asking price. Instead, he offered to trade a still-life painting of an apple by Auguste Boulard that he had acquired from the same gallery for 100 F the previous year for Pissarro's "snow" (plate 30). Martin agreed, but to consummate the deal, Lucas had to pay Martin an additional 20 F (about $4).[44] In hindsight, it was the best bargain Lucas ever made.

A century later, the painting was renamed *Route to Versailles, Louveciennes,* and celebrated as "Pissarro's first foray into the style that eventually became known as Impressionism."[45] Lucas could not have foreseen this development. When he purchased the painting, the term or concept of impressionism had not entered the vocabulary of art.[46] Moreover, there is no reason to believe that Lucas prized this painting. He did not keep it in his apartment but stored it in M's apartment, where it remained hidden from public view. He also misspelled Pissarro' s name in his records—calling him

A Paris Life, A Baltimore Treasure

"Pizzaroo—and the only complimentary words recorded on the back of the painting were that the artist was a "Pupil . . . of Corot."[47]

The two other paintings that turned out to be excellent bargains were Boudin's lovely white and blue seascape, *Outside the Bar,* and Jongkind's beautiful scene of Dutch windmills, *Moonlight on the Canal* (plates 31 and 32). Lucas purchased Jongkind's painting in 1866 for 130 F and Boudin's the next year for even less—only 75 F.[48] Although these artists later became associated with impressionism, Lucas viewed their paintings as traditional landscapes aligned indirectly with the "School of 1830," a name given to the early nineteenth-century giants of realistic landscape painting, such as Corot, Rousseau, Millet, Daubigny, Troyon, Diaz, and Jacque, who around 1830 had gathered to work in the village of Barbizon and the nearby Fontainebleau Forest.[49] Jongkind and Boudin at that time were in the early stages of their careers and struggling to sell their art. Jongkind's paintings sold for as little as 40 F, and he was having trouble making a living.[50] Boudin likewise was at a crossroads in his career. He had ceased making pictures of sailing ships, such as the one Lucas acquired, in favor of much more delightful and far more marketable scenes of fashionable crowds gathered on the beaches of Normandy.[51] It was a period of transition for both artists and, fortunately for Lucas, a period when their art was very affordable.

Like the Pissarro that he acquired, the paintings by Jongkind and Boudin did not seem special to Lucas. They were in his judgment at a level below his landscapes by Corot and Daubigny. As a result they were not shown in his Salon but relegated to his sleeping room, where they remained out of view. Years later, after Durand-Ruel began to actively market Boudin's art and the artist's reputation as well as his prices soared, Lucas reconsidered the significance of his Boudin painting. He attached to the back of it a label that referred to Boudin as "Last of the Great Masters of the School of 1830, but first to adopt Impressionist Methods, though in a rational fashion."[52]

Lucas's assertion that Boudin adopted impressionist methods "though in a *rational* fashion" (emphasis added) carried a punch. It was Lucas's shorthand way of distinguishing the realistic landscape paintings of the School of 1830, which he admired, from the irrational flatness, subjectivity, and crudely unfinished nature of the impressionist art that he disdained.

◆　◆　◆

Lucas's collection was for the most part the product of his own generation. Over 90 percent of his paintings were by artists who, like him, were born prior to 1850. Indeed, twenty-seven of his oil paintings were done by artists—Aubert, Boudin, Boulanger, Cabanel, Gérôme, Lhuillier, Mery, Monticelli, Muraton, and Thiollet—who were born in 1824, the same year as Lucas. The problem was that Lucas's attachment to the School of 1830 and his own generation of artists operated like an anchor that halted his appreciation of new art, most notably impressionism.

More than any other American collector of his time, Lucas by reason of his unique position as an art agent in Paris had the connections and the means to acquire the

most iconic impressionist and modern works of nineteenth-century art. Offered at remarkably low prices, many of these paintings were virtually his for the taking.[53] Lucas attended almost all of the historic exhibitions of this art, beginning on May 15, 1863, when he went to the opening of the Salon des Refusés, where Manet's *Le Dé-jeuner sur l'herbe* and Whistler's *The White Girl: Symphony in White No. 1* were available for purchase. He attended five of the eight exhibitions of impressionist art held between 1876 and 1882. At the 1876 exhibition—Lucas called it "the exhibition Monet and others"—he would have seen 252 paintings, including 20 by Degas, 17 by Renoir (including his now famous *Dance at Le Moulin de la Galette*), and work by Caillebotte, Monet, Morisot, Pissarro, and Sisley. At the subsequent impressionist exhibitions he also would have seen canvases by Cézanne, Cassatt, Gauguin, and Seurat.[54] When Durand-Ruel held his one-man exhibitions of the impressionists—Renoir in May 1892, Degas in November 1892, and Manet in April 1894—Lucas was again on hand. Although he would have seen hundreds of impressionist paintings that were for sale and within his budget, he never purchased for himself a single painting that he considered to be impressionist.[55]

Aside from the short cryptic note on the back of his Boudin, Lucas left behind no written explanation for dismissing the numerous opportunities to acquire work by the greatest impressionists of that period. Yet the visible patterns of the art he collected for his clients and himself provide the explanation. Lucas was not a trailblazer. His tastes were conventional. He likely construed Émile Zola's *L'Oeuvre,* the popular novel about an impressionist artist who suffers from the inability to complete a painting, as a condemnation of impressionism.[56] Moreover, he was guided by the academic midcentury voices of the judges of the Salons and the conservative voices of his own staid American clients. Prior to 1885, there was little interest in impressionist art among American collectors, and his key clients, including Walters, Johnston, and Vanderbilt, frowned upon it. Prior to 1885, Avery likewise eschewed impressionist and modern art. His diaries for the twelve-year period from 1871 to 1882 made no reference to Manet, Monet, Degas, Renoir, or the word "impressionism."[57] For Lucas, his clients' lack of interest in impressionism must have subdued any inclination he might have had toward acquiring it.

The only recognizably impressionist painting that entered Lucas's collection did so by happenstance. In December 1885, sparked by the new interest in the United States in impressionist art, Avery requested Lucas to purchase two impressionist paintings for him. On December 10, 1885, Lucas wrote in his diary, "At Durand-Ruel & bought Pissarro & Sisley @ 300 fs each for SPA, to be returned if not sold on the footing of 1000 fs in Paris." A week later, after sending Avery an invoice for the "Impressionists," Lucas had the paintings crated and shipped to him.[58] What happened to them thereafter is not clear. The only thing that is certain is that the Pissarro was returned to Lucas and in this odd way entered his collection (plate 33).

On May 12, 1890, Lucas attended the International Exposition in Paris. Paintings by Manet, Monet, Degas, and Cézanne overwhelmed those by the mid-nineteenth-

century academic artists Lucas favored. Monet had fourteen paintings on display; Meissonier, only four. In contrast to thirteen paintings by Manet, there was only one painting by Cabanel. There were eleven by Renoir but only one by Bouguereau. And while there were seven paintings by Pissarro, there was not a single one by Plassan.[59] By the turn of the century, the Luxembourg Museum—the official gateway to the Louvre—provided ample proof of the triumph of impressionism. Its walls were covered with forty paintings by Degas, Monet, Pissarro, Renoir, and Sisley, and it provided a place of honor for Manet's *Olympia*.[60]

The key role Lucas had played for many years in acquiring academic midcentury art for his American clients was superseded by the taste of a younger generation of American collectors for modern and impressionist art. In 1903, Henry Walters, the fifty-five-year-old son of William Walters, requested Lucas to assist him in obtaining paintings by Degas and Monet. Whereas Lucas had cultivated personal relationships with the artists whose work he had promoted and passionately collected, he hardly knew Degas or Monet. For the first time in a long while, Lucas felt like an outsider looking in on the world of art. Instead of being the go-between, Lucas needed a go-between of his own. To acquire these paintings for Walters, Lucas turned to Mary Cassatt.

Lucas had met Cassatt in November 1884, when, at the behest of Avery, he purchased several of her prints from the printer and publisher Auguste Delâtre and took them to Cassatt for her signature. Thereafter, he began to acquire her prints directly from her, and their business relationship blossomed into friendship. In March 1890, Cassatt invited Lucas to her home to examine a new and now famous series of ten color prints that pictured the intimate relationship between mothers and their children. Lucas soon decided to acquire several of these prints for himself. The one he undoubtedly prized the most was entitled *The Maternal Caress* and inscribed, "To Mr. Lucas with my best compliments" (plate 34).

While Cassatt's fame rested primarily on her prints and paintings, she also began to serve as an advisor to American collectors, most notably, Louisine and Henry Havemeyer. Preaching that every great collection needed to be measured by its modern art, Cassatt urged her clients to acquire the paintings of impressionists.[61] Aware that Cassatt had been actively helping the Havemeyers to acquire art by Degas and Monet, Lucas contacted her in 1903 on behalf of Walters to purchase paintings by these artists.

On the evening of April 19, 1903, Henry Walters arrived in Paris, and early the following morning Lucas escorted him to Cassatt's home. There they saw a quintessential Monet, called *Springtime*, which portrays the artist's wife, seated on the lawn in the family garden, where light filters through the leaves of a nearby tree and speckles her dress (plate 35). The other painting they viewed, *Portrait of a Woman*, by Degas, was completely different in mood and style. It portrayed the ruddy face of a woman dressed in black.[62] Although the two paintings were expensive, costing $25,000, or 125,000 F, Walters did not hesitate in buying them. By 6 p.m. that evening, he had

left Paris and was sailing for Nice.[63] The speed with which Walters gobbled up the two paintings conveyed to Lucas that the younger generation of American collectors had turned to impressionism and that his love of traditional mid-nineteenth-century paintings was out of date.

In December 1906, toward the end of Lucas's life when, as a result of age and illness he was confined to his home and no longer actively collecting, the fledgling dealer Henry Bodmer brought to his apartment a "small oil Manet" and offered to sell it to Lucas for the astonishingly low price of 300 F. *Portrait of the Marine Painter, Michael de L'Hay* depicts L'Hay reading to a young female artist before an open window with the skyline of Paris in the background (fig. 60). Lucas had reason to suspect that the painting was not what it pretended to be. By 1906, Manet had been lionized as one of the greatest masters of French modern art, and Lucas was well aware that paintings by him were not available for 300 F or any amount close to this.[64] Lucas also knew that Bodmer was struggling financially—Bodmer had borrowed 20 F from Lucas earlier that year. Motivated by a spirit of generosity, Lucas agreed to purchase the painting, while telling Bodmer that he could "reclaim it if he wishe[d]." It was the last painting that he would acquire.[65]

◆ ◆ ◆

Lucas had the good fortune of being very knowledgeable about the art of etching at a pivotal time when it emerged from fifty years of slumber. In 1862, the Parisian art dealer and publisher Alfred Cadart embarked on an ambitious and well-organized campaign to promote etching as a highly creative, individualistic form of original art

FIGURE 61. Adolphe Théodore Jules Martial Potémont, *Siege of the Société des Aqua fortistes, 79, rue de Richelieu*, 1864. The George A. Lucas Collection, Baltimore Museum of Art, BMA 1996.48.2436.

and to distinguish it from engraving, photography, and other forms of photomechanical reproduction used for copying. Cadart founded an organization of etchers called the Société des Aqua-Fortistes, using his fashionable gallery located at 79 rue de Richelieu as its headquarters (fig. 61). He anointed Rembrandt, then considered the founding father of etching, as the organization's patron saint, and he recruited dozens of eminent artists who had become devoted to etching—including Bracquemond, Corot, Daubigny, Flameng, Jacque, Jacquemart, Lalanne, Manet, Charles Méryon, and Ribot—to join his cause. Under Cadart's direction, a monthly publication called *Eaux-Fortes Modernes* provided subscribers with five new etchings each month. In September 1863, the first issue containing etchings by Bracquemond, Daubigny, Alphonse Legros, Manet, and Ribot was launched. Baudelaire and Théophile Gautier were among the venture's earliest literary supporters, with Baudelaire writing that etching served "to glorify the individuality of the artist" and Gautier declaring in the preface of the first issue that "each etching is an original."[66]

To attract a wide market for his publication of etchings, Cadart made the price affordable. He offered a yearly subscription that included sixty etchings for only 50 F and sold the etchings individually for only 1.5 F. To the expanding Parisian middle class, the idea of owning an original work of art at such an affordable price was irresistible. As the market expanded, etchings began to regularly appear in the *Gazette des Beaux-Arts,* Paris's leading art journal, and they were sold by practically all of the leading dealers, printers, and galleries, as well by the string of small shops along the quay of the Seine. Etchings seemed to be available everywhere as Paris entered into a short but vibrant period of cultural history that became known as "the etching revival."[67]

On December 18, 1863, Lucas visited the Cadart Gallery and at the same time stepped into the vanguard of this artistic movement. He purchased a lot of etchings,

and four days later he subscribed to *Eaux-Fortes Modernes,* becoming the first American collector to do so.[68] Lucas acquired etchings by most of the artists whose work appeared in Cadart's publications, but those acquisitions constituted only a small sample of what he would eventually accumulate. He would buy etchings, lithographs, and other types of prints from over five hundred different artists, including practically all of the midcentury masters working in Paris. Ultimately, Lucas built a collection of over fifteen thousand prints, one of the finest and largest of its kind belonging to an American collector.[69]

Lucas entered the vibrant new market for French etchings with a head start gained from a lifetime of knowledge and experience. During his childhood, he had been introduced to the art of etching by way of the books published by his father.[70] While residing in New York in the 1850s, he began to purchase etchings from the local branch of Goupil and from other galleries. On July 11, 1854, alone, Lucas "bought 5 etchings."[71] After arriving in Paris, he studied the historic collections of prints by the French masters, as well as those by Rembrandt and Dürer, housed in the Bibliothèque Nationale, the world's greatest repository of this art form.[72] And in November 1858, he began to bid on and acquire prints auctioned at the Hôtel Drouot.[73] His appreciation of prints, especially etchings, was undoubtedly aided by his personal relationship with Jimmy Whistler—the most prodigious young etcher of that time—who on June 24, 1862, wrote to Lucas requesting him to oversee his now famous *Thames Set,* on display at the Martinet gallery. Confident that Lucas understood and would appreciate his etchings, Whistler encouraged him to return to the gallery in December to see one of his new etchings: "You will like it I am sure." [74]

Lucas acquired prints with both the passion of a collector and the intellectual incisiveness of a connoisseur. He filled his shelves with books about prints and the artists who made them. Among these was an indispensible treatise on etching written by Maxime Lalanne, an astute and scholarly leader of the etching revival. Lucas acquired 374 of Lalanne's etchings, including a masterful cityscape that documented the demolition of Boulevard St. Germain during the reconstruction of Paris in the early 1860s under Haussmann (fig. 62).[75] Lucas made lists of the painter-etchers whose work he wanted to acquire, as well as separate lists of their most precious prints, which took extra knowledge and connections to obtain.[76] He sought to acquire complete sets of the best prints and the various states of an etching in order to study and understand the creative ways in which an image evolved. He appreciated the different weights, qualities, and colors of the paper on which the images were printed. And most importantly, he treated his etchings like pages of poetry that were to be held in one's hands or placed carefully on a desk and read and studied.[77] In contrast to his oil paintings, he never intended his prints to adorn the walls of his home or to be subjected to the light of day. Sensitive to their fragility, Lucas carefully studied his prints one by one and returned them to the safety of their portfolios. Because of their didactic quality, Lucas's prints became a principal source of his intellectual pleasure. They became known, appropriately, as "a study collection."[78]

A Paris Life, A Baltimore Treasure

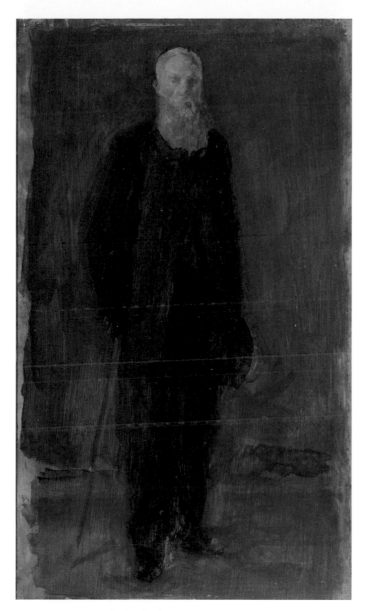

PLATE 1. James McNeill Whistler (American, 1834–1903), *Portrait of George A. Lucas*, 1886. The Walters Art Museum, WAM 37.319.

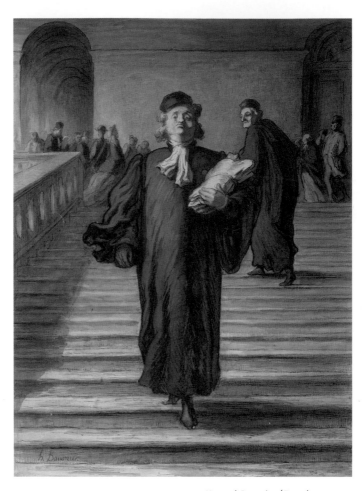

PLATE 2. Honoré Daumier (French, 1808–1879), *The Grand Staircase of the Palace of Justice*, c. 1864. The George A. Lucas Collection, Baltimore Museum of Art, BMA 1996.48.18685.

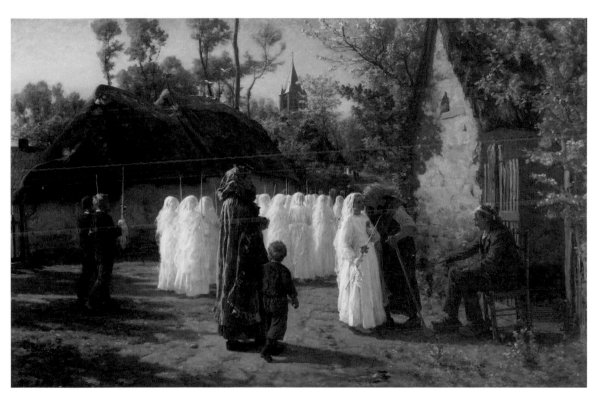

PLATE 3. Jules Breton (French, 1827–1906), *The Communicants*, 1884. Private collection.

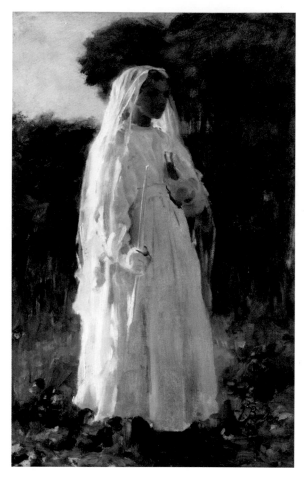

PLATE 4. Jules Breton (French, 1827–1906), *Study for "The Communicants,"* 1883. The George A. Lucas Collection, Baltimore Museum of Art, BMA 1996.45.46.

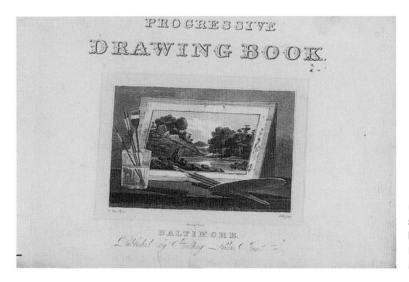

PLATE 5. Fielding Lucas Jr., *Lucas' Progressive Drawing Book*, title page, 1827. Published by Fielding Lucas, Jr., John D. Toy, Printer, Baltimore. Rare Books Collection, Maryland Historical Society.

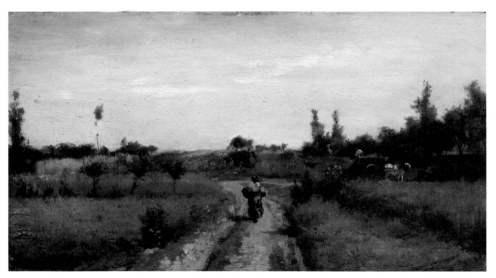

PLATE 6. Charles François Daubigny (French, 1817–1878), *Through the Fields*, 1851. The George A. Lucas Collection, Baltimore Museum of Art, BMA 1996.45.75.

PLATE 7. Alexandre Cabanel (French, 1823–1889), *George A. Lucas*, 1873. The George A. Lucas Collection, Baltimore Museum of Art, BMA 1996.45.50.

PLATE 8. Alexandre Cabanel (French, 1823–1889), *Portrait of Napoleon III*, c. 1865. The Walters Art Museum, WAM 37.146.

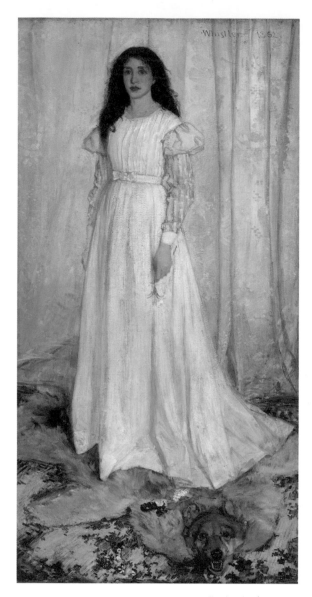

PLATE 9. James McNeill Whistler (American, 1834–1903), *Symphony in White, No. 1: The White Girl*, 1862. Courtesy National Gallery of Art, Washington.

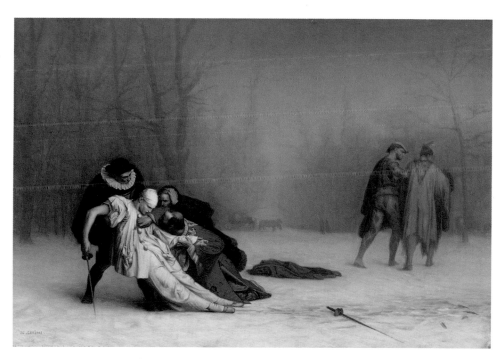

PLATE 10. Jean-Léon Gérôme (French, 1824–1904), *The Duel After the Masquerade*, 1857–1859. The Walters Art Museum, WAM 37.51.

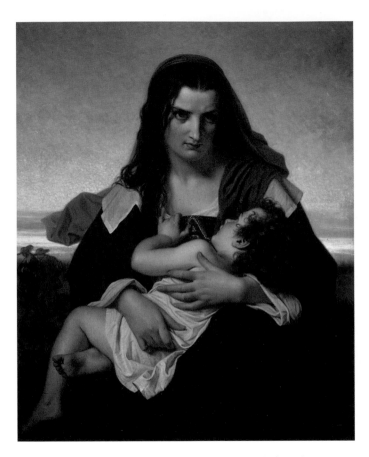

PLATE 11. Hugues Merle (French, 1823–1881), *The Scarlet Letter*, 1861. The Walters Art Museum, WAM 37.172.

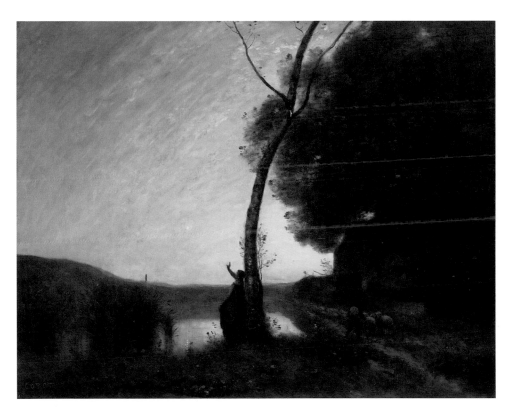

PLATE 12. Jean-Baptiste-Camille Corot
(French, 1796–1875), *The Evening Star*,
1864. The Walters Art Museum, WAM
37.154.

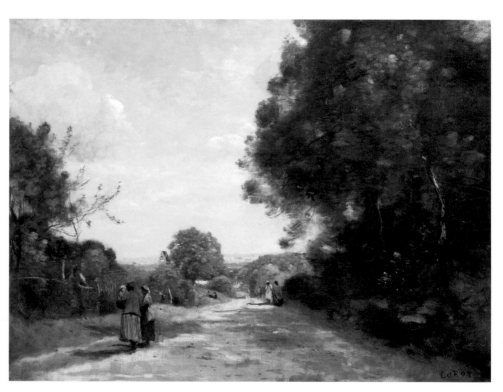

PLATE 13. Jean-Baptiste-Camille Corot (French, 1796–1875), *Sèvres-Brimborion, View towards Paris*, 1864, The George A. Lucas Collection, Baltimore Museum of Art, BMA 1996.45.66.

PLATE 14. William Adolphe Bouguereau
(French, 1825–1903), *Sketch for "Charity,"*
c. 1872. The George A. Lucas Collection, Balti-
more Museum of Art, BMA 1996.45.35.

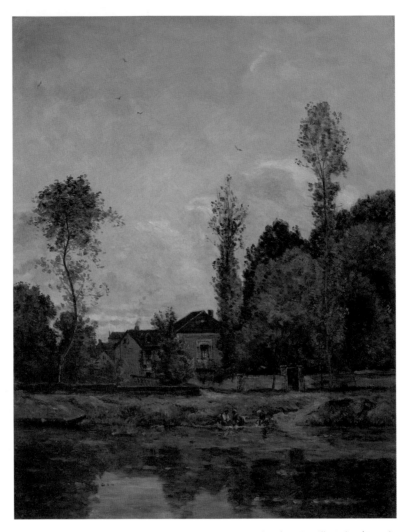

PLATE 15. Hippolyte Camille Delpy (French, 1842–1910), *On the Seine at Boissise Le Bertrand*, c. 1885–1890. The George A. Lucas Collection, Baltimore Museum of Art, BMA 1996.45.84.

PLATE 16. Henri Chapu (French, 1833–
1891), *Bronze Medallion of J. F. Millet and
Théodore Rousseau*. Fontainebleau Forest,
Barbizon, France, c. 1884. Photograph by
author.

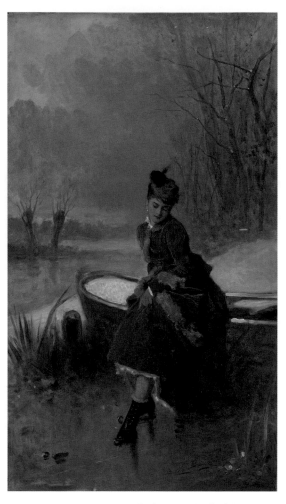

PLATE 17. Charles Baugniet (Belgian,
1841–1886), *Skating*, c. 1883. The George A.
Lucas Collection, Baltimore Museum of
Art, BMA 1996.45.21.

PLATE 18. Alfred Alboy-Rebouet (French,
1841–1875), *Figure in Blue*, 1874. The
George A. Lucas Collection, Baltimore
Museum of Art, BMA 1996.45.1.

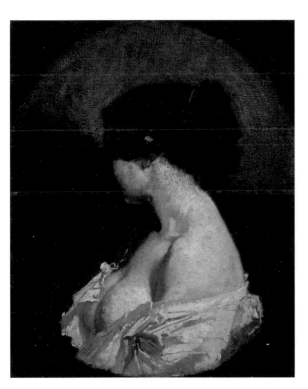

PLATE 19. Thomas Couture (French,
1815–1879), *Woman in Profile*, c. 1860s.
The George A. Lucas Collection, Baltimore
Museum of Art, BMA 1996.45.72.

PLATE 20. William Adolphe Bouguereau
(French, 1825–1903), *A Portrait of Eva and
Frances Johnston*, 1869. Private collection.
Courtesy of Bonhams.

PLATE 21. Paul Delaroche (French, 1797–1856) and Charles Béranger (French, 1816–1853), *Replica of The Hémicycle*, 1853. The Walters Art Museum, WAM 37.38.

PLATE 22. Théodore Rousseau (French, 1812–1867), *Effet de Givre*, 1845. The Walters Art Museum, WAM 37.25.

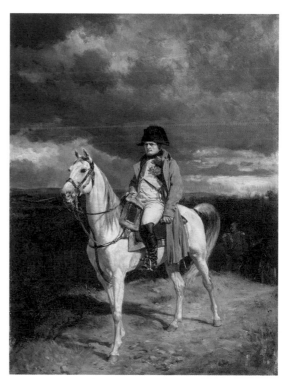

PLATE 23. Léon Bonnat (French, 1833–1922), *Portrait of William T. Walters*, 1883. The Walters Art Museum, WAM 37.758.

PLATE 24. Jean Louis Ernest Meissonier (French, 1815–1891), *1814 (Napoleon on Horseback)*, 1862. The Walters Art Museum, WAM 37.52.

PLATE 25. Jean-Baptiste-Camille Corot (French, 1796–1875), *Thatched Village*, 1864. The George A. Lucas Collection, Baltimore Museum of Art, BMA 1996.45.69.

PLATE 26. Adolphe Hervier (French, 1817–1879), *Village with Windmills*, 1851. The George A. Lucas Collection, Baltimore Museum of Art, BMA 1996.45.135.

PLATE 27. Alexandre Thiollet (French, 1824–1895), *Fish Auction at the Beach of Villerville*, c. 1873. The George A. Lucas Collection, Baltimore Museum of Art, BMA 1996.45.257.

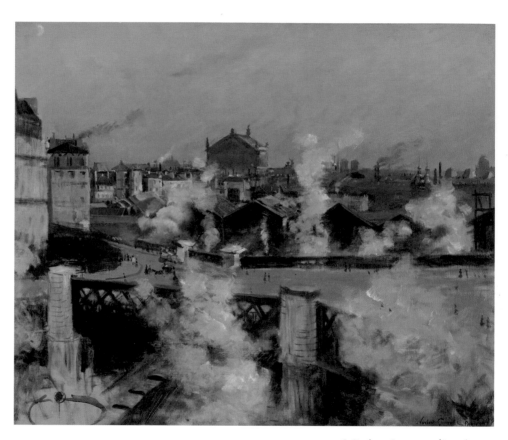

PLATE 28. Norbert Goeneutte (French, 1854–1894), *View of St. Lazare Railway Station, Paris*, 1887. The George A. Lucas Collection, Baltimore Museum of Art, BMA 1996.45.118.

PLATE 29. Marie Ferdinand Jacomin
(French, c. 1843–1902), *Landscape: Clouds
and Sunshine*, 1870s. The George A. Lucas
Collection, Baltimore Museum of Art, BMA
1996.45.142.

PLATE 30. Camille Pissarro (French, 1830–1903), *Route to Versailles, Louveciennes*, 1869. The Walters Art Museum, WAM 37.1989.

PLATE 31. Eugène Boudin (French,
1824–1898), *Outside the Bar*, c. 1860s. The
George A. Lucas Collection, Baltimore
Museum of Art, BMA 1996.45.32.

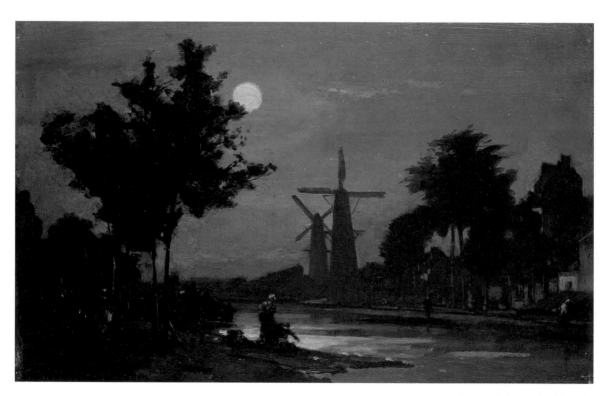

PLATE 32. Johan Barthold Jongkind (Dutch, 1819–1891), *Moonlight on the Canal*, 1856. The George A. Lucas Collection, Baltimore Museum of Art, BMA 1996.45.152.

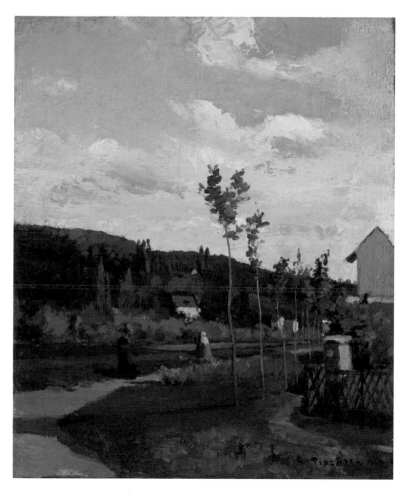

PLATE 33. Camille Pissarro (French, 1830–1903), *Strollers on a Country Road, La Varenne Saint Hilaire*, 1864. The George A. Lucas Collection, Baltimore Museum of Art, BMA 1996.45.221.

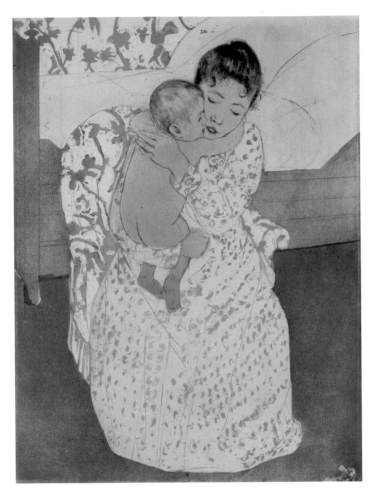

PLATE 34. Mary Cassatt (American, 1844–1926), *Maternal Caress*, 1890–1891. The George A. Lucas Collection, Baltimore Museum of Art, BMA 1996.48.14788.

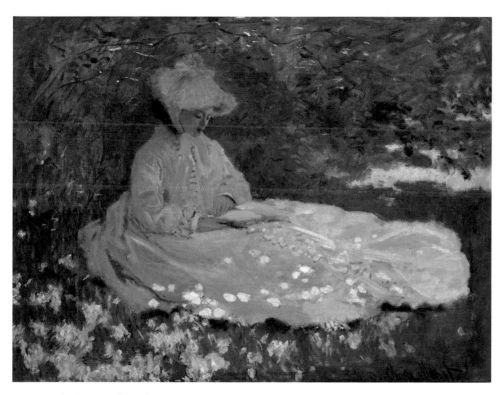

PLATE 35. Claude Monet (French, 1840–
1926), *Springtime*, 1872. The Walters Art
Museum, WAM 37.11.

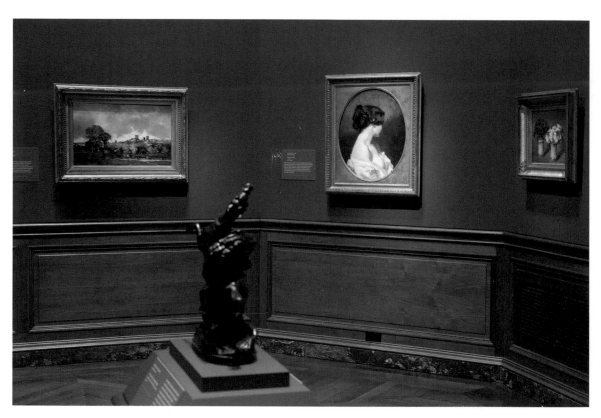

PLATE 36. Baltimore Museum of Art, Room with Lucas's Paintings and Sculpture. Photograph by author.

FIGURE 62. Maxime Lalanne, *Demolitions for the Drilling of Boulevard St. Germain*, 1862. The George A. Lucas Collection, Baltimore Museum of Art, BMA 1996.48.8447.

Unlike his collection of paintings, Lucas's collection of prints was not constrained by cost or governed by any need to satisfy the conservative tastes of his clients. In acquiring prints, he was a free agent, guided by his astute knowledge about the art in this field and his passion to acquire it. As evidenced by his purchase on November 29, 1867, of thirty-six etchings by Daubigny for 72 F, he could purchase prints by the dozen by the finest painter-etchers in France and pay what amounted to forty cents or less for each picture.[79]

Lucas's collection of prints continued to focus primarily on midcentury painter-etchers, but it also included Manet, Whistler, Degas, and Cassatt. He acquired 137 etchings by Whistler, including *The French Set* (12 etchings), *The Thames Set* (16), and *The Second Venice Set* (26). He acquired fifty-seven etchings and four lithographs by Manet, including two rough sketches of his iconic *Olympia*.[80] He also acquired twenty-six etchings from Cassatt, among them her memorable *The Maternal Caress*. As a result, Lucas's collection of prints became more representative of nineteenth-century art than his more conservative collection of paintings.

Although Lucas began acquiring prints in the early 1860s, for ten years his focus remained on paintings. In the mid-1870s, however, his interest in acquiring prints began to accelerate exponentially. By the mid-1880s, it had become the focus of his collection, and by the 1890s, he was acquiring prints with abandon. As suggested by the entries in his diary, the three words "buy lot of" became his mantra. Lucas often ended his day by walking along the quay and browsing for prints at the stalls and small stores that lined the way. As if intoxicated, he began to buy bundles at a time without any certainty of who made them. As a result, his collection began to bulge

TABLE 2. Artists with Most Etchings in Lucas Collection

Artist	Etchings	Lithographs	Price Range (F)	Years Collected
Charles Émile Jacque	1,407	168	.75 to 10	1863–1903
Charles François Daubigny	475	36	2 to 5	1867–1896
Maxime Lalanne	374	12	2 to 20	1882–1902
Félix Bracquemond	320	20	10 to 50	1876–1897
Félix-Hilaire Buhot	259	6	20	1881–1901
Leopold Flameng	251		18	1874–1908
Henri-Charles Guérard	246		1 to 15	1883–1903
Norbert Goeneutte	219	1	10	1887–1898
Charles Chaplin	209	41	10	1876–1902
Louis-Adolphe Hervier	148		10	1887–1898
Jules-Ferdinand Jacquemart	146	89	6	1886–1896
James McNeill Whistler	139	13	12 to 162	1884–1896
Jules Michelin	137	18	5	1887–1898
Théophile Chauvel	118		10	1882–1902
Auguste Delâtre	116		1.75 to 6	1871–1898

not only with prints by celebrated artists but also with hundreds of prints by unknown artists, as well as with mere reproductions of art cut out of newspapers and journals and sold as prints.[81] Toward the end of his life, when his days of collecting were over, Lucas began to count the number of etchings and lithographs made by each artist in his collection. Fifteen of the artists produced one hundred or more of his prints, led by Charles Émile Jacque, who made over one thousand of them (table 2).

The price of the prints differed based on a number of variables, including when the prints were acquired, the fame of the artist at that time, the number of images printed, whether the print was signed, the quality of the paper, and the rarity of the print. The most expensive were the etchings by Whistler, but, like the prints of others, they varied in price. In October 1895, for instance, Lucas purchased seven rare etchings by Whistler that ranged in price from 20 to 120 F and six lithographs that ranged in price between 15 and 40 F. The next year, he bought seven more etchings by Whistler that were even more expensive, ranging from 50 to 162 F apiece.[82]

In collections as sizable as Lucas's, there often comes a point in time when the driving force ceases to be the quality of the art but rather the collector's almost blind obsession to acquire it. A case in point is Lucas's acquisition of the etchings by Jacque. Lucas had good reason to become enamored with his art. Although relatively unknown today, Jacque was recognized in the nineteenth century as "one of the earliest pioneers" of the etching revival and better yet as one of the five "greatest" French etchers of his time.[83] In 1849, Jacque at the age of thirty-six moved to the village of Barbizon, where he became closely associated with Millet, Rousseau, and Daubigny, and his career as an artist took off. His art—both paintings and etchings—focused on rustic scenes of village life featuring peasants and their farm animals, especially pigs and sheep, as illustrated by *Peasants' Thatched Cottage* (fig. 63). Jacque became one of the most prolific artists of his time, producing nearly five hundred etchings.

FIGURE 63. Charles Émile Jacque, *Landscapes: Peasants' Thatched Cottage*, 1845. The George A. Lucas Collection, Baltimore Museum of Art, BMA 1996.48.5627.

Because a large number of them portrayed the same two animals in different phases of their lives, he was often sarcastically referred to as "the Raphael of sheep" and "Le maître au cochon."[84]

By the mid-1870s, Jacque's popularity spread to the United States. Avery and other American collectors began to acquire his work, and reviews appearing in American art journals referred to him as the "best" etcher in France.[85] The elevation of Jacque to stardom on both sides of the Atlantic sparked Lucas's interest; he bought his first etching by Jacque on November 6, 1863. But it was not until March 1875 that he apparently fell in love with Jacque's etchings and began to acquire practically every one that he could find. On eighteen days of that month, Lucas searched for Jacque's etchings at the stalls along the quay and in the dealers' showrooms. By the end of the month, he had acquired "lots," including two full sets made in 1864 and 1865.[86] He continued to buy Jacque's etchings—sometimes a few at a time but more often in albums and in large quantities—for years on end. The price of Jacque's etchings was a large part of the appeal. They cost only 1 to 2 F and sometimes less, and in exchange for purchasing multiple etchings at one time, Jacque agreed to reduce the price for Lucas by 25 percent.[87] Over time, Lucas acquired 1,407 of Jacque's etchings for an amount that approximated the cost of a single painting by Meissonier, Cabanel, or Bouguereau.

Lucas became recognized as Jacque's most knowledgeable and devoted patron. In September 1901, the Bibliothèque Nationale asked him to assist the library in arranging its large and permanent collection of Jacque prints.[88] Two years later, Lucas made his sixtieth and final purchase of Jacque etchings. By then he had become the owner of the largest private collection of them in the world.[89] What Lucas ignored to his peril, however, was the repetitive nature of a large portion of Jacque's work. As some critics observed, the artist had sacrificed originality for profitability by producing a stream of etchings that looked essentially the same but were sought nevertheless

by his adoring public.[90] Over one hundred of his prints were no larger than a postage stamp on which a tiny image of a sheep or pig was sketched. If there were any differences between these small pictures, the differences were either microscopic or measured only by the type of paper used. Inevitably, Jacque's stardom began to fade, and by the early twentieth century, his name was all but forgotten.[91]

Why did Lucas buy 1,407 etchings and an additional 168 lithographs by the same artist, knowing that it was highly unlikely that anyone other than himself would ever see or care to see them? The answer is that he did not view his vast collection of Jacque's etchings as separate small works of art. Instead, he treated these prints as a single unified body of art. It was a tribute to the artist, an archive for future scholars, and emblematic of Lucas's collection as a whole whose ultimate value rested not on the quality of the individual pieces but on the sweeping picture of mid-nineteenth-century French culture and the small but memorable role he had played in it. As he turned eighty, what began to haunt Lucas was the question of what would become of it all.

The Final Years

The robe and slippers worn by Lucas on February 24, 1904, when Dornac photographed him, supplied ample evidence of his condition. Suffering from rheumatism that affected his back, shoulders, and arms, Lucas rarely left his apartment. His worries were compounded by M's failing health. She became seriously ill in November 1903 and was placed under a doctor's care. As a result, neither she nor Lucas could adequately care for one another. They had long ceased going to Boissise and enjoying arm-in-arm the pleasures of the Fontainebleau countryside. Their last trip there had been in 1897. While they continued to reside in Paris next door to each other, their long relationship had been drained by age and infirmity. After 1903, M's name was only mentioned in Lucas's diary to document her need for medical care.[1]

Lucas's relationship with Eugène remained as solid as the fifty years of affection on which it was built. Between 1902 and 1904, Lucas and Eugène—often joined by Eugène's wife and children—frequently dined together as a family. In 1904, as Lucas's heath and condition deteriorated, he became more dependent on Eugène. On May 7, he gave Eugène a check in the amount of 3,000 F that was "to be used for me [Lucas] according to circumstances & to my verbal and written instructions."[2] Lucas also began to pay Eugène 200 F each month for his assistance.[3] He would scribble reminders or what he called "Davios" (fig. 64) to Eugène on loose sheets of paper, listing the chores he wanted him to accomplish—repairs that needed to be made to Lucas and M's adjoining apartments, wine that needed to be stored in the cellar, books that

FIGURE 64. Lucas's to-do list (Davios) for Eugène J. de Macedo-Carvalho, c. 1908. George A. Lucas Papers, Archives and Manuscripts Collections, The Baltimore Museum of Art.

needed to be shelved, and art that needed to be framed, catalogued, and otherwise cared for.[4]

To express his affection for Eugène and his interest in the needs of his family, Lucas had given Eugène the keys to his house in Boissise and permission to use it as if it were his own. On July 10, 1904, after it became clear that Lucas would never return to Boissise, he formalized his gift by presenting to Eugène what Eugène always wanted: title to the house and most of its furnishings.[5] Eugène's ownership of the country home, however, did not distract him from continuing to visit Lucas day to day at his apartment in Paris. In 1906 and 1907, Eugène, often accompanied by his teenage sons Manuel Gaston and Henri Roger, visited Lucas two to three times each week, sharing dinner with him, caring for him, and undoubtedly caring for Eugène's mother as well.

By the summer of 1904, most of Lucas's oldest friends and immediate family had died, including William Huntington, Theodore Child, William Walters, his brother William Lucas, and his closest French friend, Antoine Emile Plassan. On August 14, Lucas received the depressing news that Samuel Avery had also died. To fill the void created by these losses and to oversee Lucas's needs and interests, Frank Frick, Henry Walters, and Lucas's niece Bertha began to travel back and forth to Paris. While caring for Lucas, they became engaged in a mission that had more lasting consequences. In concert, they sought to reduce his reliance on M and Eugène in order to gain control over his art collection and convince him to give it to the Maryland Institute in Baltimore.

The interest in obtaining the collection for the Maryland Institute arose, para-doxically, from the school's destruction in February 1904 during the great fire that swept through the center of Baltimore. There was an immediate outpouring of sup-port by public-minded citizens like Frick and Walters to quickly rebuild it. Within the year, close to $500,000 was raised; a valuable parcel of land in the prosperous neighborhood of Bolton Hill was donated by Michael Jenkins, a cousin of Lucas; and a magnificent neoclassical building was designed to house the Maryland Institute. Walters kept Lucas informed about these developments, and sometime before the end of that year, he suggested to Lucas that he donate his entire art collection to the school.[6]

There was a tall tale written in 1911 that Lucas harbored a life-long dream of giving his art collection to the Maryland Institute. It was written by a nephew whom Lucas had never met and published in a catalogue that accompanied the initial exhi-bition of Lucas's art held that year at the Maryland Institute. According to the story, it was Lucas's "great desire through life to place his collection in the care of a worthy and useful institution in his native city, to be dedicated to sincere art education."[7] Over the years this tale turned into conventional wisdom. But there has never been a shred of evidence to support it.

Lucas did not mention the Maryland Institute in his diary nor any other docu-ment until August 23, 1904, when he was over eighty years old and entering the last phase of his life.[8] As Lucas remembered it, the Institute had never served as a reposi-tory of fine art but was a school primarily devoted to the teaching of mechanical arts. It was not in his judgment an appropriate place for the care and display of paintings by such masters as Corot, Daubigny, Cabanel, and Bouguereau or prints by Whistler and Manet. When Walters initially suggested that Lucas leave his collection to the Maryland Institute, Lucas balked at the idea. He proffered a variety of reasons for opposing it, including his concern that the Institute was without the resources neces-sary to properly care for his collection, that its value would decline, or, worse yet, that it would be imperiled if not destroyed in the event of another fire.

In a series of letters to Lucas, Walters sought to alleviate these concerns. On March 19, 1905, he wrote, "I do not think you need feel disturbed about the value of your things in connection with that Institute. They will be practically the only things that they will have of any value and real merit." The next year, he wrote again: "There is a great deal of interest being taken in the Maryland Institute, and I am satisfied that it will congeal into something practical in the art line, which will make your project much more valuable than under the old conditions." And on October 8, 1907, he remarked that "the building of the Maryland Institute is fireproof and is surrounded by an open lot, so there is no danger of anything falling upon it."[9] Aside from address-ing Lucas's specific concerns, these letters conveyed Walters's assessment of the value of the collection. It was not very high. Using the word "project" to describe Lucas's collection and the word "things" to describe his art, Walters conveyed to Lucas that the value of his collection rested not on its aesthetic quality but on its capacity to

serve as a tool for the teaching of art. What Walters sought to convey was that the best way for Lucas to enhance the value of his collection was to give it to the Maryland Institute.

Walters's opinion about the quality of Lucas's collection was also conveyed in a more powerful and painful way. It was to ignore Lucas's willingness to donate his art to Walters's magnificent museum, scheduled to open in Baltimore in 1909. As an overture to this proposition, in 1908, Lucas gave Walters twelve bronzes by Barye, followed a few months later by two paintings by Whistler—the small portrait of Lucas and a watercolor of Maud Franklin. But these gestures failed to ignite in Walters the slightest interest in possessing more of Lucas's art. He thought that the two small paintings by Whistler were better suited for use by art students at the Institute than for display in his museum. Although he kept the two paintings, Walters did not show them. Neither was included among the 990 paintings listed in the museum's catalogues, published by Walters in 1909, 1915, and 1922.[10] From Walters's perspective, Lucas's massive collection of prints, sketches, and small paintings was in a different league than the collection of expensive and celebrated French masterpieces that Walters and his father had acquired.

◆ ◆ ◆

The interest of Frank Frick and Henry Walters (figs. 65 and 66) in comforting and providing guidance to their friend about the disposition of his art coincided with their own fervent interest in promoting the arts in Baltimore. Both had significant stakes in this matter. Frick was Lucas's closest life-long friend. They had known each other since childhood and attended St. Mary's College together, After Lucas moved to Paris, Frick traveled to Paris more than a dozen times to visit him.[11] But Frick's effort to persuade Lucas to leave his collection to the Maryland Institute was guided as much by his devotion to Baltimore as by his lifelong friendship with Lucas. A member of one of the city's oldest and most established families, Frick was considered "one of Baltimore's best citizens." He resided in a large and fashionable home in Bolton Hill that was full of fine art. He served as chairman of the city's Municipal Art Society and president of the Baltimore Board of Trade. He became known as the "apostle" of a project, referred to as "city beautiful," that sought to establish new venues for the arts in Baltimore. One of his most significant projects involved the extension and beautification of Mount Royal Avenue, the street on which the new Maryland Institute would be constructed.[12] The idea of housing the Lucas collection in the Maryland Institute on Mount Royal Avenue thus fit perfectly with the cultural projects that he had been championing. In 1905, Frick began to inform other Baltimore leaders about the Lucas collection and the possibility of obtaining it for the city.[13]

Henry Walters, like Frick, had known Lucas for many years. While serving as William Walters's art agent, Lucas had also nurtured and looked after Henry. As he matured, he returned to Paris on numerous occasions to meet with Lucas and acquire art for his father and later for himself. Although they were twenty-four years apart

FIGURE 65. Frank Frick. Photograph from
Baltimore: Its History and Its People, Biogra
phies (Lewis Historical, 1912).

FIGURE 66. Henry Walters, c. 1908. The
Walters Art Museum Archives.

(Lucas was born in 1824 and Henry Walters in 1848), their relationship gradually evolved into a friendship.

In 1884, Henry Walters left Baltimore and never resided in the city again. He moved to Wilmington, North Carolina, and then to New York City. As a result of the death of his father in 1894, Henry Walters inherited over $4 million, became president and the principal owner of the Atlantic Coast Line Railroad, and was known in New York society as the "richest man from the south." Walters also became an influential trustee and vice president of the Metropolitan Museum of Art. However, unlike his father, Henry Walters did not focus his aesthetic interests on French art. He sailed around the world on his 224-foot-long private yacht visiting historic centers of culture including London, Venice, Rome, Athens, Istanbul, and Saint Petersburg, and returned with shiploads of ancient art that when displayed under the same roof constituted one of the country's greatest encyclopedic collections. His ambitious goal, as he described it, was to obtain "a thoroughly rounded collection which would give to the observer an understanding of the whole history of the world's artistic development."[14]

Although Henry Walters lived in New York and served in a position of leadership at the Metropolitan, his philanthropic interests remained rooted in Baltimore. Following a precedent established by his father, Walters opened his father's art collection

to the public each spring for the purpose of raising money for the Poor Association of Baltimore. He donated $100,000 to the endowment of Johns Hopkins University, gave several works of art to the Women's College (later known as Goucher), and served on the board of the Peabody Institute and chaired the committee that oversaw the Peabody's gallery of art. Most importantly, around the turn of the century, he decided to build a magnificent Italianate museum in Baltimore as a memorial to his father.[15] In these and other ways, Walters became in absentia the cultural prince of his home city. In 1902, following the announcement of his plan to build his museum in Baltimore, Walters acquired a large collection of Italian Renaissance art that purportedly included self-portraits by Raphael and Michelangelo. The *New York Times* later opined that "New York has lost the chance of a generation and at one blow Baltimore has raised herself far above all other American cities by the purchase of the collection of Don Marcello Massarenti of Rome."[16]

Having decided to invest millions of dollars in constructing his museum in Baltimore and filling it with magnificent art, Walters wanted his museum to be nourished by an urban environment rich in culture. From Walters's perspective, if the Lucas collection were housed in the Maryland Institute, it would be beneficial not only to the students at the school and to the residents of Baltimore but also to the health and sustainability of his own museum. With this idea in mind, Walters decided to financially support the rebuilding of the Maryland Institute and to persuade Lucas to leave his collection to it. Between 1904 and 1908, as Lucas's heath declined, Walters repeatedly visited Lucas at his apartment in Paris to look after him and at the same time to try to influence him to change his will and bequeath his collection to the Institute.[17]

While Walters and Frick shared a deep-seated interest in bringing Lucas's collection to Baltimore for the good of the city, Lucas's niece Bertha Lucas had narrower and more self-centered interests in mind. Specifically, she was attracted by the prospect of obtaining some of Lucas's art for herself and becoming the principal beneficiary of his bountiful estate. The youngest child of George Lucas's brother William and an heir to the family fortune, Bertha was a prominent member of Baltimore high society, a world traveler, and an appreciator of fine art. The grand parties that she threw in Baltimore and her travels throughout Europe and the Near East were covered in the society columns of the *Baltimore Sun*. Her carefree life was reflected in the description she provided to the newspaper in May 1907 of her travels to the Levant and Europe. "I am going to remain here (in Istanbul) until the end of the week," she wrote, "and then go to Smyrna for several days and visit Ephesus then on to lovely Greece and remain in Athens for a week and then on to sunny Italy staying at Naples for a week, then Florence and Rome and slowly back to Paris by Switzerland."[18]

Bertha's first visited Lucas in May 1896. Thereafter, she returned to Paris and briefly visited him again in September 1901, June 1903, and October 1904.[19] Upon discovering Bertha's interest in art, Lucas looked upon her not simply as his niece but as a kindred spirit. Together, they visited the Louvre and the Luxembourg, strolled through the Tuileries Garden, purchased numerous etchings, and dined at some of

FIGURE 67. Norbert Goeneutte, *Girl in a Rocking Chair* (Bertha Lucas), c. 1901. The George A. Lucas Collection, Baltimore Museum of Art, BMA 1996.45.117.

Paris's best restaurants. Lucas also arranged for the French artist Norbert Goeneutte—whose work he had begun to collect—to paint Bertha's portrait (fig. 67). By depicting her lounging in a rocking chair with a silver tea service by her side, silver bracelets on her wrists, and Asian art hanging on her walls, the painting captured the cosmopolitan, comfortable, and privileged circumstances of Bertha's life.[20] Around this time, however, Bertha's actions began to reveal something else about her. She coveted Lucas's art. On at least one occasion, Lucas noted that she had "carried off" a lot of his bronzes, china, and watercolors.[21]

◆ ◆ ◆

When Frick visited Lucas in September 1904, he became alarmed by the noticeable decline in his friend's health and physical condition. "Rheumatism is depriving him of his alacrity," he wrote, "and benumbing his activity." When Frick returned in 1906, he found Lucas in even worse shape: "Has very much gone to pieces." The next year, Frick again found Lucas "in bad condition." Lucas by this time had become bedridden and his world confined to his sleeping room. To keep his diary within arm's reach, Lucas tied it to the post of his bed; to sustain his passion for the art of Barye, he directed Eugène to place plaques referring to the artist on his bedroom wall; and to be reminded of his magical strolls through the Fontainebleau Forest, he propped on the seat of a nearby chair a cherished landscape by Corot. These surrounding objects, like old friends, remained by Lucas's bedside during his waning days and reminded him of better times.[22]

In September 1907, Lucas's niece Bertha, who had been vacationing in Lucerne, Switzerland, returned to Paris to help care for her uncle. Shortly thereafter, she and Frick met to discuss what they should do to comfort him and how to persuade him to leave his collection to the Maryland Institute. They shared the view that Lucas had been "neglected" and that M and her son Eugène were at fault. In their opinion, M was a "hopelessly helpless woman incapable of rendering him [Lucas] any services." They also believed that Eugène was undeserving of the money that Lucas had given

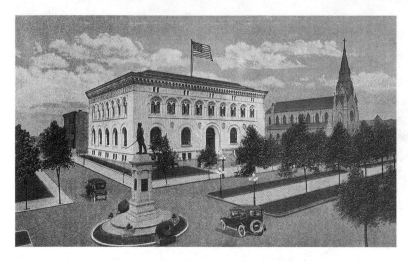

to him and had "no possible claim" to his art.[23] Aside from Lucas's health, their primary worry, however, was the possibility that he might leave his art collection and his substantial estate—Lucas had over 130,000 F in a bank account in Paris and over $50,000 in railroad bonds in the United States—to M and Eugène.[24] Bertha and Frick concluded that "something must be done." Their plan, as Frick put it, was to place Lucas in the "affectionate care" of Bertha and to push M and Eugène out of Lucas's life.[25]

Walters had a hand in engineering this arrangement and in obtaining Lucas's acceptance of it. On January 31, 1908, he wrote to Lucas that, "I was very much delighted to know that your niece stayed in Paris. At first I was a little afraid it would worry you, but afterwards I made up my mind that it would be the best thing for you, and was certainly a most creditable thing for her to want to do."[26] The plan appears to have worked. Bertha took command over Lucas's life, and in October 1908, Eugène's name disappeared from Lucas's diary. There is no record that Lucas ever spoke to Eugène again.

◆ ◆ ◆

The construction of the Maryland Institute's new home was completed in October 1907. It was greeted with praise. The American Association of Architects called it one of the most notable works of the year, and it won a prize for its Renaissance Revival design (fig. 68). As reported in the *Baltimore Sun,* the director of the Institute asserted, "It is an ideal building, the finest ... in the country.... [W]ith its sister building, the Walters Art Gallery, soon to be thrown open to the public, it will mark an epoch in the era of Baltimore's love of the beautiful."[27] Within the building was a large, well-illuminated picture gallery, in which Lucas's entire collection of oil paintings could be displayed. Hoping to capitalize on this favorable publicity, Walters sent an engraving of the school to Lucas and renewed his effort to persuade him to leave his art collection there.[28]

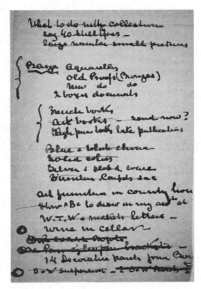

FIGURE 69. Lucas's notes about "what can be done" with the collection, c. 1908. George A. Lucas Papers, Archives and Manuscripts Collections, The Baltimore Museum of Art.

FIGURE 70. Lucas's notes about "what to do" with the collection, c. 1908. George A. Lucas Papers, Archives and Manuscripts Collections, The Baltimore Museum of Art.

By 1908, there were compelling reasons for Lucas to leave his collection to the Maryland Institute. His father was an original founder of the Institute, and the land on which it was located had been donated by his cousin Michael Jenkins. Lucas's closest and most trusted friends—Walters and Frick—both urged him to do this. The Institute wanted his collection, and it had a large picture gallery in which his paintings could be displayed. Baltimore, whose population at that time was close to 1 million, had emerged as one of the most vital centers of culture in the United States. And, most significantly, neither Walters nor the owner of any other museum or institution expressed any interest in acquiring his collection. Nevertheless, Lucas remained undecided about what to do with it.

In the fall of 1908, Lucas began writing notes to himself on scraps of paper about what to do. One note was expressly headed, "What to do with collection," and another, "What can be done with collection" (figs. 69 and 70). Both notes reveal the painful choices he was trying to make about whether to divide his collection, giving his paintings to the Maryland Institute but leaving his prints, small paintings, watercolors, and art books to M. With regard to his many fragile prints, he wondered whether they would be appreciated and used by the students: "Will etchings be desirable?" He also expressed concern about his "large number of still life paintings and small pictures," as well as the "decorative panels" in his country home, his watercolors ("aquarelles") by Barye, and his catalogues and art books, many of which were in French.[29]

The question of whether he should leave all or parts of his collection to M and Eugène weighed heavily on his mind. Although he never married M, Lucas had treated her and Eugène as his real and only family. In 1866, around the time when Lucas and M began living together, he took her on a month-long vacation, which was tantamount to their honeymoon. That same year, he revised his will and most likely made M the beneficiary.[30] He made other enduring commitments as well. Lucas not only provided M with an adjacent apartment but registered it in her name. He stored a large share of his art in her apartment and asked her to care for it. When M left Lucas to return to her husband, Lucas begged her to return to him. He supported her financially and emotionally and lived with her as man and wife for over forty years. He became for all intents and purposes the stepfather of her son Eugène and the actual godfather of one of her granddaughters. And, by the 1880s, as he was aware, some of his French friends began to refer to M as "Mrs. Lucas."[31] For good reason, Lucas was very reluctant to remove all of the art from M's apartment and leave her in her old age with nothing but a broken heart. Torn between his devotion to M and Eugène and the opportunity to preserve his art collection at the Maryland Institute, Lucas agonized over what to do. As long as M was alive, he struggled to find the answer.

◆ ◆ ◆

The tragic events of 1909 are shrouded in darkness. Lucas's diary for that year mysteriously disappeared. Likewise, not a single document describing the events was left behind. No eyewitness accounts, no fire or police reports, and not a word written by Lucas about M's death was preserved. The only thing that is known about the tragedy is based on the abbreviated notes that Frick wrote in his diary a month later. According to Frick, on July 30, 1909, M burned to death in a conflagration in Lucas's apartment. Lucas miraculously escaped. And the thousands of prints, paintings, and other objects of art that filled the apartment miraculously escaped as well. M died, but somehow all the art was saved.[32]

When Frick visited Lucas in August, one month after the tragedy, he found Lucas "completely broken up and totally shattered." Trying to place the tragedy in a favorable light, Frick wrote, "It was a shocking affair, but in the main a blessing. She had outlived her day and suffered very little in her sudden death. Her association had become intolerable to him and an almost invincible problem."[33] There is no evidence that Lucas shared this callous assessment.

The death of M seemingly established a pathway for the transfer of Lucas's entire collection to the Maryland Institute. But it was blocked temporarily by Eugène, who claimed that his mother had owned the art that had been stored in her apartment and that, therefore, it now belonged to him, her descendant. Walters urged Lucas to retain counsel and fight against this claim. To boost Lucas's resolve, he not only denounced but attempted to vilify Eugène. Claiming that Eugène was filled with the sin of "ingratitude," he proffered that Eugène, "knowing you to be almost helpless, took advantage of the occasion in a most wretched manner." And he told Lucas that Eu-

gène "was without the slightest claim of any kind upon you."[34] Like salt on an open wound, Walters's harsh and insensitive words must have been as painful to Lucas as they were injurious to Eugène. But they had their desired effect. On October 22, 1909, Lucas scribbled a note to Walters stating that "in consequences of the sad events.... I feel it necessary to make a new will."[35] It deleted any reference to M and left nothing to Eugène.

On the following day, October 23, 1909, Lucas executed his last will and testament. He promptly sent it, along with his earlier will, to Walters. Expressing his approval, Walters replied, "Your last will is now right and makes everything clear." He treated these documents as if they were the spoils of a war. Walters hid Lucas's old will in his safe deposit box, from which it never resurfaced. He wrote to Lucas, "I sincerely hope that it will never be necessary to have the others seen by anyone."[36] Lucas, in turn, informed Walters that he would promptly arrange for his art to be packed and made ready for shipment.[37]

◆ ◆ ◆

Lucas at the end of his life was the pitiful victim of his own generosity. He had lost or given away everything dear to him. In his mind, he had nothing left. The tragic death of M, the estrangement of Eugène, and the departure of all of his art had robbed him of what he had cherished most. In his last letter to Walters, Lucas referred to a poem called "The Beggars Petition" and compared himself to the fictive old beggar who is left with nothing except for the dreadful certainty of his approaching death.

Pity the sorrows of a poor old man!
Whose trembling limbs have borne him to your door
Whose days are dwindled to the shortest span
O give relief, and Heaven will bless your store

These tattered clothes my poverty bespeak
These hoary locks proclaim my lengthened years
And many a furrow in my grief worn cheek
Has been the channel to a stream of tears

... My tender wife—sweet soother of my care!—
Stuck with sad anguish at the stern decree,
Fell—lingering fell, a victim to despair,
and left the world to wretchedness and me.

Pity the sorrows of a poor old man.[38]

Unable to hide his grief, Lucas concluded his final letter to Walters with these words: "Pity the sorrows of a poor old man."[39] On December 16, 1909, six weeks after revising and signing his will, Lucas died. M, Eugène, and his art collection were gone, and only a nurse was by his side.

The Terms of Lucas's Will

Lucas did not bequeath his art collection directly to the Maryland Institute. Instead, he left it to Henry Walters with the understanding that Walters would promptly give it to the Institute. As odd and awkward as this plan might seem, under the circumstances, it made perfect sense. Although Walters never saw Lucas's entire collection (it would have taken months to do that), he was one of the few who knew in general what type of art it contained. He orchestrated Lucas's gift of the collection from beginning to end. He had the wealth, power, and influence to make sure that the Maryland Institute and the leaders of Baltimore would graciously accept it. And as one of the country's most revered collectors, the owner of his own great museum, and the vice president of the Metropolitan Museum of Art, his words of praise about the Lucas collection would cause critics and the public at large to collectively nod in agreement.

As reviewed and approved by Walters, Lucas's will in pertinent part stated, "All my Baryes, Bronzes, oils and other paintings, etchings and all of my other collection of pictures, works of art, and all articles of like kind, I give unto my friend Mr. Henry Walters, of New York City, State of New York, if he survives me; but, if he should predecease me, then I give the same to the Maryland Institute for the promotion of the mechanical arts, located on Mount Royal Avenue, in Baltimore City, Maryland, and I direct that the expenses of shipping the same to Baltimore shall be paid out of my estate." While leaving his art collection to Walters and indirectly to the Maryland Institute, Lucas left the remainder of his sizable estate, including all of his money, stocks, and bonds to his niece

Bertha Lucas and to two nephews whom he had never met, William F. Lucas and John Carroll Lucas.[1] Not fully satisfied with what she acquired under the terms of the will, Bertha later claimed to be the owner of dozens of pieces of his art.

◆ ◆ ◆

Named by Lucas as the executors of his will, Henry Walters and Bertha Lucas moved quickly ahead to effectuate it. On December 16, 1909, immediately upon receiving notice of Lucas's death, they filed through their attorney a petition for probate with the Orphans Court for Baltimore City. Six days later, a hearing was held, attended by Walters, Michael Jenkins, and Frank Frick. According to the court's records, Walters testified that he had received Lucas's will by mail and did not know of any other will, a representation belied by the fact that Walters had secreted Lucas's earlier will in his safe-deposit box. Jenkins and Frick both testified that they were personally acquainted with Lucas and that the signature on the will was his. The hearing was short and successful. The Orphans Court concluded that the will was valid and could take effect.[2]

When Walters and Bertha Lucas tried to arrange for the shipment of Lucas's collection from France to the United States, however, they ran into a new obstacle—the French authorities did not recognize the validity of the action taken by the Baltimore court. Lucas had prepared a duplicate copy of his will, which, upon his death, was submitted to a court in Paris known as the Civil Tribunal of the Seine. That tribunal ruled that, because Lucas resided and died in Paris, it had primary jurisdiction over Lucas's will and that the will had to be probated under French law. The ruling effectively nullified the action of the Baltimore Orphan's Court and placed Lucas's will in limbo. Walters and Bertha Lucas, through their attorney, requested the tribunal to probate the will, which it did on January 28, 1910. They then returned to the court in Baltimore and requested it to accept the French tribunal's probate of the will as a substitute for the action it had previously taken. The *Baltimore Sun* reported these entangled proceedings under an equally twisted headline: "France Will to Stand— Court Revokes Document of Late G.A. Lucas Probated Here."[3] While complicated, the effort to probate Lucas's will succeeded.

The confusion over probate was compounded by confusion over the collection's final destination. Because the collection was expressly bequeathed to Henry Walters, it was generally assumed that the art was destined for Walters's new museum. On December 23, 1909, the *Sun* reported that Lucas's art collection "may be added" to the Walters Art Gallery. And on March 9, 1910, *the newspaper* asserted that "the Walters Art Gallery in this city would probably be enriched by the magnificent collection of bronzes and paintings that Mr. Lucas bequeathed Mr. Walters."[4]

At a public ceremony on May 10, 1910, the collection was officially given to the Institute, but Walters was not there. He was on his way to Florence, Italy, to meet and be wined and dined by Bernard Berenson, the great connoisseur of Italian Renaissance art, at his beautiful villa known as I Tatti.[5] With his attention focused on

his relationship with Berenson and on expanding his own collection of Italian art, Walters requested his friend and business associate Michael Jenkins to act on his behalf and give the Lucas collection to the Maryland Institute. Jenkins, however, had never previously seen the collection and had met Lucas only once, when visiting Paris sixteen years earlier.[6]

On May 9, 1910, Jenkins met with the board of managers of the Maryland Institute and publicly presented a letter declaring the gift to the school. It stated:

> Mr. Henry Walters has the pleasure to present to the Institute the collection of Art Works of the late George A. Lucas, a citizen of the United States, who died in Paris, on the 16th day of December 1909.
>
> By will of Mr. Lucas the collection was bequeathed to Mr. Walters, who, in accordance with the Testator's desire, delivers it to your Institution, in order that it may serve as a continuing example and incentive to earnest ambitious efforts of Art Students in your care.
>
> The collection includes a large number of pictures, sketches, engravings, etchings, bronzes and porcelains, acquired by Mr. Lucas during a sojourn of many years in Europe, all of rare excellence and first artistic merit, which he desired to have placed in your charge to be dedicated to sincere art education in his native city.[7]

Jenkins signed the letter, styling himself the "Atty. for Henry Walters." Jenkins, however, was not an attorney, and the fabrication apparently was based on the belief that an attorney was needed to legally effectuate the gift.

Upon receiving the gift, the Institute's president John M. Carter issued a "Letter of Acceptance" that in pertinent part stated, "On behalf of the Institute, the board of managers gratefully acknowledges this magnificent gift and the debt of obligation it owes to the memory of the generous donor, as also to Mr. Walters for his co-operation in its bestowal. The committee on museum will be charged with the duty of the proper installation in the gallery of the Institution and cataloguing this splendid collection of art works which shall be known as the George A. Lucas gift."[8] Both Walters's gift and the Institute's acceptance were well publicized. On May 10, 1910, both letters were published in the *Baltimore American,* accompanied by an article observing that it was Lucas's "unmistakable intention" to cause his "entire splendid collection of art treasures . . . to become the property of the Institute."[9]

◆ ◆ ◆

It is safe to say that no collection of art has ever received more praise by so many who have never seen it. At the time of his death, very little was known in Baltimore about George Lucas or his collection. The *Baltimore Sun,* on March 9, 1910, admitted, "There has been much speculation among the art-lovers of this and other cities as to the extent and exact nature of the collection. *No one in the city seems to know much about it* although it is certain that in the collection there are many rare bronzes, paintings, curios and the like" (emphasis added).[10]

The absence of firsthand knowledge, however, did not deter the press and art critics from praising the Lucas collection. Even before it arrived in Baltimore in July 1910, the city's newspapers were heralding it as "magnificent," "splendid," "unique," "invaluable," "great," and "unmatched."[11] These accolades were in tune with Jenkins's description of the collection as being "of rare excellence." Eighty years later, in an attempt to glorify and preserve the Lucas collection, these exaggerations would be adopted and then surpassed.

Besides offering hyperbolic descriptions of his art, the press exaggerated Lucas's knowledge, accomplishments, and qualities. According to the obituary in the *Baltimore Sun,* Lucas had "graduated" from West Point, he was "one of the leading art connoisseurs of Europe," he "would not accept remuneration" for his services, he had a "retiring disposition," and he had a "distaste for public notice."[12] None of this was true. Lucas did not graduate from West Point, he regularly charged a healthy commission for his services (and grew wealthy as a result), he tirelessly promoted himself and marketed his services, and although very knowledgeable about mid-nineteenth-century French art, he was not well known in artistic circles outside of Paris and did not rank among Europe's great connoisseurs. While correctly noting that Lucas "never married," the writer of his obituary apparently guessed that "he lived quietly among his treasures," unaware that half of the collection was stored in his mistress's apartment and that he frequently entertained a procession of his friends and their wives or mistresses at his country home in Boissise.

♦ ♦ ♦

Lucas's body was returned to the United States and laid to rest on February 26, 1910, in Baltimore's Greenmount Cemetery. Walters and Frick served as the honorary pallbearers. As reflected by the description of him on his death certificate, Lucas remained an enigma. "Sans profession"—without a profession—is what it said.[13] It would take more than fifty years before a reasonably accurate assessment of Lucas's entire collection would be made, more than sixty before a reasonably accurate portrayal of Lucas's life in Paris and Boissise would be written, and more than eighty-five years before a judge would decide the meaning and consequences of the words set forth in Lucas's will and Walters's gift to the Maryland Institute.

A Collection
in Search of a Home

It took two steamships to carry the Lucas collection from the port of Le Havre to the port of Baltimore. In July 1910, when the hundreds of crates containing the thousands of works of art were unpacked, John M. Carter, the president of the Maryland Institute, began searching in vain for a comprehensive catalogue that described what had been delivered. The problem, as he soon realized, was that it did not exist. He tried to figure out the raw number of prints, but his estimate of fourteen thousand was at least one thousand shy of the mark. He appointed a committee to engage in the laborious task of cataloguing the collection, to arrange for its storage, and to embark on an ambitious plan to mount as soon as possible an exhibition of the paintings, bronzes, ceramics, and palettes.

Within days of the collection's arrival, however, Carter's plan was interrupted by an odd request from Bertha Lucas. Although George Lucas's will expressly provided that "all" of his art was given to Henry Walters and then to the Maryland Institute, and although Bertha was charged with the duty of faithfully executing these terms, she claimed that nine paintings and more than sixty other art-related objects in her uncle's collection had been given to her. Bertha asserted to Carter that, "In sending my uncles' gift to the Institute, some of my personal things were put in by mistake." According to Bertha, her uncle had given them to her as Christmas gifts. A major problem with this claim was that Bertha had little evidence to support it. Only one of the works of art— a painting by Plassan—was inscribed by Lucas with the words, "To be given to my niece." In a self-serving effort to circumvent this problem,

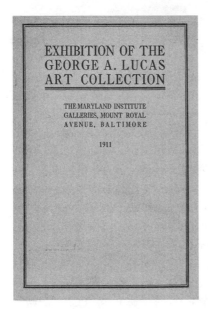

FIGURE 71. Cover page of catalogue of exhibition at Maryland Institute in 1911. MICA Archives, Decker Library, Maryland Institute College of Art.

Bertha contended, "I know exactly what my uncle wished." Tacitly recognizing her conflict of interest, she added that she was "truly embarrassed to make this claim." Notwithstanding her alleged embarrassment, Bertha provided the Institute with a long list of so-called "personal things" that included nine paintings (including one by Cabanel), twenty-three painted medallions, four painted panels taken from bookcase doors, thirty-three carved wooden stands, and a pair of blue vases. Carter graciously replied that he would honor her request.[1]

Faced with the need for additional resources to properly display the collection, Carter called upon Walters for assistance. Walters agreed to pay for the cabinets needed to protect and display the Barye bronzes and ceramics, the bookcases to hold and safeguard Lucas's collection of fifteen hundred volumes, and the picture frames for all of the paintings that the Institute wanted to exhibit. "I hope you will give me the pleasure of contributing this much to the proper display and care of the objects," Walters asserted.[2] Walters also requested Faris C. Pitt, whom he had retained as the director and chief curator of his museum, to provide advice and direction to the Institute.[3] Acknowledging Walters's invaluable assistance, Carter invited him in 1911 to inspect the upcoming exhibition of the Lucas collection at a private viewing to be held at any time, day or evening, at his convenience.[4]

On February 18, 1911, the exhibition opened (fig. 71). Two hundred and seventy-three paintings filled the large picture gallery on the Institute's second floor. Next to each was a short statement about the painting and its artist, drawn from notes Lucas had placed on the back of each painting. At the entrance of a smaller gallery, labeled "The Barye Room," a bronze bust of Lucas greeted the visitors. In the room were 140 Barye bronzes, reliefs, and small objects once owned by Lucas. In yet another room were seventy-one palettes on whose backs Lucas had pasted newspaper and magazine

clippings about the artists' honors and accomplishments. It was as if the spirit of Lucas had accompanied his collection across the ocean and had emerged to curate his collection's first exhibition.

Lucas's nephew, William Fielding Lucas Jr., wrote a brief essay about his uncle that appeared on the opening pages of the exhibition catalogue. His words, like the letter written by Michael Jenkins, emphasized Lucas's intention to have his collection used for the education of the Institute's students: "It was his great desire to place his collection in the care of a worthy and useful institution in his native city, to be dedicated to sincere art education, and, having selected the Maryland Institute as his beneficiary, he bequeathed the entire collection by his will to Mr. Henry Walters for that purpose."[5] The catalogue also contained a promise from the Institute's managers to retain the collection in "trusteeship of the people of our city and State." More specifically, "The Maryland Institute Through its Board of Managers accepts with gratitude the trusteeship of the people of our city and State and for lovers and students of art the magnificent Collection generously bequeathed to it by . . . George A. Lucas."[6]

The crowds at the exhibition were large and the reviews splendid. The *Baltimore Sun* boldly characterized the large body of art as a "Collection of Masterpieces" and ranked it with the "great ones across the water." The paintings, although small, were "veritable gems of color and design." The bronzes were "magnificent." The collection of palettes, "exceedingly interesting and unique."[7] In light of this praise, one might have expected the Lucas collection to remain at the Institute indefinitely, but this large and celebrated exhibition was the only one of its kind to be held there.

The comparison of the Lucas collection with the great collections of Europe and the description of its paintings as "masterpieces" were symptomatic of a tendency to plaster the collection with hyperbole—to characterize it as a "treasure" and to repeatedly define it as "great" without carefully exploring or understanding what was in it. It caused the Lucas collection to acquire a mythical stature that existed much more in the mind than in the field of vision. When the exhibition was taken down in 1912, and the initial fanfare subsided, reality began to sink in. Basic questions about the enormous collection—such as where to store it, what to do with it, how to conserve it, how to protect it, how to evaluate it, and even, more basically, what was in it—became intractable problems. The Institute made a dent in solving these problems but not much more. It prepared inventories of the three hundred paintings and seventy-five palettes and stored this art under lock and key in a special room called the "Lucas Case."[8] As tools for teaching art, the Barye bronzes were used as models for drawing and the many small sketches in oil as valuable illustrations of artistic spontaneity.[9] The Institute distilled from its massive collection of prints an important selection of Whistler etchings, which it exhibited in April 1927 and again in February 1933, along with a group of small paintings by Corot, Breton, and Jacque.[10] But after twenty years, the Lucas collection was used for little else, and the pride of ownership was greatly outweighed by the heavy costs of simply trying to maintain it.

As the Institute reluctantly realized, it did not have the resources or facilities to

adequately study, conserve, protect, house, and display the entire collection. No one at the Institute had the time or expertise to study and catalogue the thousands of prints. With the exception of the Whistlers, the others were largely neglected. Many were torn, soiled, and scattered throughout the Institute, some purportedly used like rags to stuff cracks in broken windows. Close to a thousand prints were misplaced and their identity as part of the Lucas collection obscured. Other pieces were treated like disposable objects and warehoused in the same room with piles of old newspapers, lumber, shipping crates, abandoned student art, a lawnmower, an ice cooler, and broken furniture. Without any security to guard the work, some of the objects were lost or stolen. Seven of the Barye bronzes mysteriously disappeared. A unique collection of 187 letters from French artists to Lucas was placed in a safe and literally forgotten for over twenty years. At the core of these problems was the misguided notion that a fledgling art school with a small staff could effectively serve as a museum for one of the largest collections of art and related objects to ever come to this country.[11]

The Institute's ability to care for the Lucas collection was further crippled by the Great Depression. Enrollment at the Institute sharply declined. Faculty had to be cut. Struggling to stay afloat, the Institute had to seek funds from the relief administrations of the state and federal governments.[12] Walters no longer was available to come to the rescue. He rarely came to Baltimore, and on the few occasions when he did, he never spent the night. Although Walters influenced Lucas to give his collection to the Institute and assigned his curator Faris Pitt to assist in its display, there is no evidence that Walters ever went to the Institute to see Lucas's art. In 1922, following Pitt's death, Walters closed his Baltimore museum to the public, using it primarily as a warehouse and leaving it a dark and lonely place. In 1931, Walters died.[13] By 1933, it had become painfully obvious that the Maryland Institute did not have the financial support or resources needed to care for the Lucas collection. It was too big to handle, and the Institute desperately needed a partner to shoulder the load.

◆ ◆ ◆

The Baltimore Museum of Art (BMA) was founded in 1914. Along with the Walters Art Gallery, it became a cornerstone of the early twentieth-century cultural renaissance of Baltimore. Temporarily housed in the Mount Vernon section of the city, in 1929 the BMA moved into its permanent home, an impressive neoclassical building designed by the renowned architect John Russell Pope. Visitors entered the museum, as if it were a sacred place, by ascending a dramatic flight of twenty-four stairs that led to a portico of six monumental Ionic columns and then into a large colonnaded central court covered by an elegant coffered ceiling. Although its building was solemn and grand, the BMA's permanent art collection at this early stage was thin. Most of the art initially shown at the museum, such as Jacob Epstein's great collection of Italian Renaissance and seventeenth-century Dutch art, was on loan or the product of temporary exhibitions.

The most important part of the BMA's collection in the early 1930s was its many prints. In August 1930, the BMA received an indefinite loan of approximately twenty thousand prints owned by John W. Garrett, the US ambassador to Italy, and his brother Robert Garrett, a wealthy banker, member of the board of the B&O Railroad, former Olympic athlete, and one of the museum's most generous benefactors.[14] Anticipating the acquisition of this collection, the BMA hired Adelyn Dohme Breeskin as its first curator of prints. Breeskin was brilliant, well educated, and well trained. She had spent the previous six years as an assistant curator in the print department of the Metropolitan Museum of Art. Her interest in leaving the Metropolitan in favor of the BMA was influenced by her father, who was one of the founders of the BMA and a member of its first board of trustees.[15] She arrived at the BMA with the ambitious agenda to make its print collection into the largest and finest in the country. Aware of the Maryland Institute's problems in caring for the Lucas collection, she diplomatically conveyed her willingness to study and catalogue this collection if it were placed in her care.[16] Breeskin's interest in acquiring the Lucas collection of prints and the Maryland Institute's corresponding interest in being relieved of the burden of caring for it fit perfectly together.[17]

On June 19, 1933, the Maryland Institute's board of managers adopted a resolution that transferred custody of the Lucas prints to the BMA. The resolution, however, expressly stated that the Institute retained ownership. It provided that "the ownership of the prints remain with the Maryland Institute and such prints are subject to the order of the Board of Managers." Furthermore, it called for the BMA to perform certain tasks and satisfy certain obligations with regard to the collection. The BMA was required to identify all of the prints using a method acceptable to the Maryland Institute. It was required to prepare a catalogue of the prints. And at the request of the Institute, it was required to arrange for the prints to be exhibited at the Institute. The BMA accepted these terms, and on July 13, 1933, most of the collection of prints, along with Lucas's books, reference materials, and a large group of letters were transferred to the BMA.

"New Glory in the Museum of Art," was the way Mark Watson, art critic for the *Baltimore Sun,* announced the transfer. He admitted that "there is no precise knowledge of what the collection holds." Nevertheless, he crowned it "the great Lucas collection" and opined that the BMA had become the country's most "outstanding print center" as a result of its acquisition. Finally, Watson reported, the museum "cheerfully accepts the responsibility for completing a much-needed catalogue," and he forecast that the Lucas prints would be "more accessible" than ever before.[18] Watson could not have imagined that it would take eighty more years before all of the prints were identified, provided with accession numbers, and fully catalogued.[19]

The transfer provided the BMA with the distinction of possessing close to forty thousand prints—the largest collection of its kind in the country.[20] Breeskin had become not only one of the highest regarded experts in her field but also a tireless promoter. She established a print club at the BMA, initiated a lecture series on

Wednesday afternoons, wrote articles about prints for the *Baltimore Sun,* and organized a series of well-publicized and well-attended exhibitions. In January 1934, her exhibition of Whistler's famous painting of his mother, augmented by more than one hundred prints and related objects from the Lucas collection, attracted thirty-six thousand visitors within its first ten days.[21] "Baltimore can well be proud of the fact that nowhere in the world is there a finer group of Whistler etchings and lithographs," the *Baltimore Sun* proclaimed. The popularity of the show caused the museum to extend its hours.[22]

The successful transfer of the prints was quickly followed by a second agreement on December 11, 1933, giving the BMA custody over the Lucas collection's paintings, watercolors, and drawings. Again, the BMA was obligated to "put the paintings in proper condition" and at the Institute's request to arrange for exhibitions of the paintings at the Institute. The resolution contained one significant difference. It legally obligated the BMA "to pay" for the costs of repairing and keeping the paintings in proper condition. Like the fine print that bedevils many contracts today, these two words would play a decisive role in the contentious litigation that erupted sixty years later.

◆ ◆ ◆

"Lucas Paintings on View for the First Time" is the way the *Baltimore Sun* on October 14, 1934, announced the BMA's first exhibition of Lucas's art. It contained, according to the newspaper, some of the finest examples of the paintings in the Lucas collection, as illustrated by Pissarro's *Village Street in Winter.*[23] Hastily put together to provide an early glimpse of Lucas's art, the exhibition did not last long and closed four days later on October 18, 1934. At the time, there was hardly anything written about the quality of the art. To remedy this problem and provide the public with a broader view of Lucas's paintings, the exhibition was reinstalled in June 1935 and expanded to include an array of Lucas's smaller paintings by relatively unknown artists.

The writer A. D. Emmart had a long and distinguished career as a maker and shaper of tastes and opinions in Baltimore. At one time or another over the course of forty-seven years, he served as editor-in-chief of the *Baltimore Sun* and the art critic and book review editor of the Sunday *Sun.* He delivered scholarly lectures on the humanities at Johns Hopkins University, wrote well-received books, and set a high standard in his opinions about art. What he wrote mattered.[24] When Emmart entered the BMA in June 1935 to see that summer's exhibition of paintings from the Lucas collection, the staff of the museum stood by anxiously awaiting his verdict. The paintings were displayed in two rooms. The larger room had paintings by the best-known artists, such as Cabanel, Corot, Courbet, Daumier, and Delacroix. The smaller room had an array of small paintings by lesser-known artists. Although relatively limited in number, the paintings exemplified the quality of the entire collection and provided Emmart with a sufficient basis to hammer it with condemnation.

At the beginning of his review, Emmart delivered a backhanded complement that

was as sharp as it was scathing. He wrote that the paintings were "not bad or dull," and some, he conceded, were "pleasant." But they were "not very important or very exciting either." What he reported, as Lucas himself had recognized, was that, "the names are rather more important than the pictures." He called Lucas's small painting by Delacroix "trivial" and opined that the Barbizon paintings "do not amount to very much." Using his pen as his scalpel, Emmart cut the entire collection of paintings down to size. He opined that they represented the culture of an earlier time that had little current interest, and concluded, "The truth is that they are all small, slight works."[25]

Emmart's review quickly deflated the belief that the Lucas collection of paintings was full of masterpieces. Soon after the review was published on June 16, 1935, the painting collection lost its glow and faded from sight. No room at the museum or space on the walls was reserved for Lucas's art. Almost all of the paintings were placed in storage along with the prints, and there they remained in the shadows of the museum for years on end. A small selection from the Lucas collection resurfaced temporarily in June 1941 as part of an exhibition called *A Century of Baltimore Collecting, 1840–1940*. It was curated by Adelyn Breeskin. In the catalogue, Breeskin praised Lucas's prints but, like Emmart, acknowledged that Lucas's paintings were not nearly as important.[26] Ten years later, she chose thirty-one works from the Lucas collection to appear in another exhibition, *From Ingres to Gauguin, French Nineteenth Century Paintings Owned in Maryland.* It was the first time that Lucas's paintings and other works of art were displayed side by side and compared to the art that William Walters had acquired during the same period. Although Breeskin selected for this comparison several of Lucas's finest paintings, in general his art did not fare well.[27] In an essay that accompanied the show, Breeskin euphemistically described Lucas's paintings as "most interesting." The word "great" or any similar superlative was not part of the description. She observed that many of Lucas's paintings were by "names now almost forgotten yet of historical value because of their association with major artists at the time." And she concluded that when compared to Walters's paintings, they were "very much more modest."[28]

In the early 1960s, as the BMA approached its fiftieth anniversary, two well-publicized articles about the museum's history marginalized the importance of the Lucas collection. In 1961, a lengthy article entitled "The Growth of The Museum" appeared in the *Baltimore Sun*. It focused on the BMA's seven most important donors—the donors who, according to the author, "were responsible for putting the Baltimore Museum of Art on America's artistic map." It referred to the collections of art given by Jacob Epstein, Mary Frick Jacobs, sisters Etta and Claribel Cone, and Saidie May. George Lucas was not mentioned.[29]

Three years later, the BMA commissioned Kent Roberts Greenfield, an eminent scholar and the chairman of the History Department of the Johns Hopkins University, to research and write an official history of the museum. The BMA provided

Greenfield with all of its records—the minutes of its board meetings, the catalogues of its exhibits, the reports about its art, and all of the newspaper articles and other publicity about the museum. The BMA's director, curators, and staff consulted with Greenfield and were, in his words, "helpful in every way." Greenfield's essay, "The Museum: Its First Half Century," was ninety-eight pages long and contained 114 illustrations, including pictures of the museum's most celebrated paintings, prints, and sculpture. The Lucas collection was referred to only once, on page 18, when it was briefly mentioned as containing twenty thousand prints, including excellent work by Daumier, Whistler, and Manet. But no reference was made to any of the paintings, sculpture, or other objects in the collection. And among the dozens of illustrations of fine art that appeared in the article, there was not a single picture of any oil painting, watercolor, drawing, or print that belonged to the Lucas collection.[30]

◆ ◆ ◆

Almost from the time that it arrived at the BMA, the Lucas collection was overshadowed by the museum's mounting interest in and collection of modern and contemporary art. In 1935, Roland J. McKinney, the director of the BMA, charted a new course for the museum's acquisitions. He stated that "from now on we should concentrate on accessions in the field of contemporary painting and sculpture, ancient and modern drawings and prints and Americana."[31] No reference was made to mid-nineteenth-century French art—the field that defined the Lucas collection. What followed was a series of exhibits in the 1930s featuring Claude Monet, Edgar Degas, Auguste Renoir, and other great impressionists; early twentieth-century surrealists, such as Paul Klee, Salvador Dali, Max Ernst, and Giorgio de Chirico; and the two great giants of modern art, Pablo Picasso and Henri Matisse. In 1941, Saidie A. May, one of the country's most astute collectors of modern art, offered to loan many of her best modern paintings and sculptures to the BMA if the museum would set aside a comfortably furnished room for their display. The result was the creation of the "Members Room for Modern Art," which at its opening in November that year presented art by Joan Miró, André Masson, and Alberto Giacometti (fig. 72). It later would be the temporary home of Jackson Pollock's famous *Blue Poles,* which was on display in the room for two months.[32]

In the 1940s and 1950s, the BMA was enriched by the bequests of several great collections. Although they could not compete in size with the Lucas collection, they dwarfed it in quality and financial support. New wings of the museum were constructed to house the Saidie A. May collection of four hundred works of modern art and the Cone Collection, a treasure trove of masterpieces by Cézanne, Gauguin, Matisse, Picasso, and Van Gogh, which to this day is considered one of the world's greatest collections of early modern art. During the same span of time, a string of innovative exhibitions, such as the BMA's show of abstract expressionism, kept pace with the march of modern art. The BMA's focus on modernism resulted in one critic

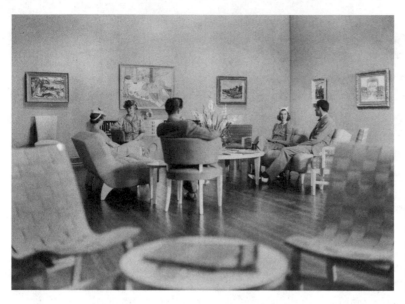

FIGURE 72. Members' Room for Modern Art, the Baltimore Museum of Art, c. 1950s. Building and Grounds Photograph Collection, Archives and Manuscripts Collections, The Baltimore Museum of Art, PCBG4.06.001.

crowning it "the champion of the art of this century."[33] Although initially wary, the public soon flocked to see the new art, and the Lucas collection was quietly pushed deeper into obscurity.

From 1951 to 1965, the Lucas collection was, as one critic put it, "the recipient of only desultory attention."[34] Occasionally prints or paintings by some of the well-known artists in the collection, such as Daumier or Corot, were displayed.[35] However, no major exhibitions under the banner of Lucas's name were mounted.[36] For example, on August 31, 1952, the *Baltimore Sun* briefly reported that the two paintings by Corot were on display at the BMA but cautioned that "the artist did not consider these sketches from nature worthy of display in the salon."[37] Any claim that the BMA was building its collections around the Lucas collection or that the Lucas collection was full of masterpieces that were vitally important to the culture of Baltimore—as was endlessly repeated many years later when the collection was threatened to be sold—would have seemed absurd.

◆ ◆ ◆

By the early 1960s, few people other than the BMA's curators and a few of the Maryland Institute's teachers had ever seen or heard of the Lucas collection. Like most of the public, the trustees of the Maryland Institute had little idea of what the collection looked like or what was in it. They began to view it less as a body of art and more as some foreign, unseen asset that they owned but did not use. In 1962, the Institute's trustees were informed that hundreds of prints in the Lucas collection appeared to be "duplicates." As a result, they began to evaluate whether to sell the duplicates and place the proceeds in the Institute's endowment to support some educational goal.

Before taking this step, the Institute sought the advice of William Marbury. A

A Paris Life, A Baltimore Treasure

graduate of Harvard Law School, the founder and senior partner of prestigious Baltimore law firm Piper and Marbury, and a lawyer dedicated to public service, Marbury had been awarded the Presidential Medal for Merit, one of the highest national awards given to a civilian. Due to his experience and stature, Marbury's legal opinions were considered irrefutable. On May 17, 1963, Marbury delivered his advice to the Institute. He wrote that the right of the trustees to dispose of any part of the Lucas collection was governed by the terms of Lucas's will and Henry Walters's gift. These terms, Marbury found, established that Lucas and Walters's overarching intent was to use Lucas's art collection to educate art students. However, the question of how the collection should be used for this purpose was left to the good judgment of the trustees. On this basis, Marbury concluded that there could be "no legal objection" to selling the collection so long as the proceeds from any sale of the prints were used to educate the Institute's students.[38]

Armed with this opinion, Eugene "Bud" Leake, the director of the Institute, informed the BMA of his plan to sell not only duplicates of the prints but also paintings that were "not worth keeping." Sensitive to the BMA's interests, he also conveyed that he did not want to dispose of anything that was of value, and he suggested that the Institute and the BMA jointly retain an outside curator "to cull the collection."[39] There was at that time no barrage of opposition. To the contrary, it was generally believed that the Lucas collection was not sacrosanct and that parts could be sold for good reason. Selling art was not prohibited, and indeed the BMA's former director Adelyn Breeskin quietly had sold several fine etchings by Whistler that she believed to be duplicates. After evaluating the collection of prints and determining which were most disposable, in 1965 approximately three hundred "duplicate" prints that carried such illustrious names as Daubigny, Jacque, and Rousseau were sold by the Maryland Institute to an art dealer for $1,500. Later that year a portfolio of four Manet lithographs was also sold to a print dealer for $7,000. The Institute leaped to the conclusion that Marbury's letter gave it license to dispose of other art as well, and in the following year, ten Barye bronzes described as "duplicates or near-duplicates" were sold for $3,600.[40] The Lucas collection was for sale, there was no public outcry of opposition, and no one could predict what would happen next.

◆ ◆ ◆

In the mid-1960s, two German-born art historians, one employed by the BMA and the other by the Walters Art Gallery, changed the fortune of the Lucas collection. Lilian Randall and Gertrude Rosenthal examined the collection as a whole instead of focusing myopically on its individual works. What they both realized and then conveyed through their writings and curatorial skills was that the Lucas collection, like none other in the United States, was a unique reflection of mid-nineteenth-century French art made at the time when American collectors initially developed a passion for collecting it.

Randall had a mind open to discovery, a patience unique even among art histo-

rians, and a willingness to devote twelve years of her life to a single scholarly project. In the world of manuscript scholarship, where perseverance was the norm, she was renowned for her "persistence of almost superhuman intensity."[41] Randall was born into a German family of scholars. Her father, Henry Frederick Cramer, was a professor of history and an avid race-car driver. In 1938, the family left Nazi Germany and immigrated to the United States, where Cramer was employed as a visiting lecturer at Harvard before accepting a full-time professorship at Mount Holyoke College. Lilian completed high school at the age of fourteen, studied French history and culture, graduated cum laude from Mount Holyoke College, and obtained her doctorate in art history at Radcliffe. In 1964, her husband Richard Randall became the director of the Walters Art Gallery, and she accompanied him to Baltimore, later becoming employed as the museum's curator of medieval manuscripts and rare books. Although her specialty was in medieval art, Randall retained a deep-seated interest in mid-nineteenth-century French art, stemming from a thesis she had written on Napoleon III.

In February 1965, not long after her arrival at the Walters Art Gallery, Randall found two musty shoe-box-sized cartons sitting unattended on a table in the rare book room. Inside were fifty-one old, beaten-up, pocket-sized, leather-bound diaries. They had belonged to someone named George Lucas. Her only knowledge of the Lucas name was the Lucas Stationery Store, where she was a customer. The connection was enough to pique her interest, and she soon discovered that George Lucas had been the most famous member of that family. His niece Bertha had given the diaries to the Peabody Institute, where they had lain for many years in the library.[42] Rather than disposing of them, the Peabody fortunately had given them to the Walters Art Gallery.

Randall had a passion for preserving old books and documents and bringing to life the information hidden within them. As soon as she recognized who Lucas was and what the diaries represented, she embarked on a personal odyssey to reconstruct his life and to discover the culture and history of his time. It was a formidable task. The thousands of entries were in small handwriting with words spelled phonetically and sentences unfinished; some were almost indecipherable. Even more challenging was the difficulty of understanding the meaning and significance of Lucas's terse words, abbreviations, and phrases. To give the diaries meaning, their entries had to be placed in historical context. Randall studied the art and ephemera that Lucas collected, perused his financial and business records, and pored over his letters. Like a detective she traveled to Paris to track down the places where he once resided, the galleries of art and other places that he frequented, and the graveyards where his friends and adopted family were buried. Her goal was to unearth everything she could about him. After many years, she had become so intimately involved in the project that she began to imagine that Lucas was by her side and residing in her household.[43]

One of Randall's earliest sources of information about Lucas was Gertrude Rosenthal, the chief curator of the BMA. Like no one else before her, Rosenthal objectively examined and evaluated the artistic and historical nature of the Lucas collec-

tion. In 1963, in response to Bud Leake's proposal to cull the collection of insignificant art, Rosenthal cautioned against the plan. She recognized that it contained, in her words, "only a few great paintings," but she believed that the paintings, regardless of their quality, should not be sold because as an "entity" they represented "a very personal collection made during the second part of the 19th century by an educated Baltimorean who was the link between some of the great artists of the period and American collectors." On this basis, she used the word "document" to characterize the collection. It was, in her view, a "historical aesthetic document" that was "important and also unique."[44] Recognizing the need to share the collection with the public, Rosenthal began to organize an exhibition. By 1965, the same year Randall discovered Lucas's diaries, Rosenthal was placing the final touches on the show. Randall and Rosenthal shared their discoveries about Lucas and together became the guardian angels of his legacy.

Rosenthal, like Randall, was born in Germany. She obtained her PhD in art history at the University of Cologne shortly before Hitler came into power. In 1938, she fled Germany with 10 marks—the equivalent of $3—in her pocket and a permit to work as a domestic servant in London. It was just before the Nazis slammed the door on Jewish emigration. She was able to convince the chief librarian at London's Courtauld Institute of Art to provide her with a position that matched her intellect and knowledge about art. After two years at the Courtauld, she immigrated to the United States and by chance found a job as a fine arts librarian at Baltimore's Goucher College. In 1945, she applied and was hired by the BMA as its director of research. In 1947, she became a curator, and in 1961, she was elevated to the position of chief curator.[45]

Rosenthal's exhibition, fittingly entitled *The George A. Lucas Collection,* opened at the BMA in October 1965. It presented 296 paintings, 45 watercolors and drawings, 78 bronzes, several unlisted prints, and a group of painted palettes. It was the first comprehensive exhibition of Lucas's art in fifty-four years. In her catalogue essay, Rosenthal's assessment was remarkably restrained and balanced. It contained none of the hoopla that would be manufactured years later to save the collection from sale. Although she was the chief curator, she did not oversell the quality of the art. Like Adelyn Breeskin before her, Rosenthal offered an assessment of the Lucas collection that was carefully measured and intellectually honest. She noted that many of the paintings were small sketches by unknown artists, that others were by giants of mid-nineteenth-century art who by the twentieth century had fallen out of favor, and that works by the French avant-garde were noticeably absent. She conceded that many of the paintings had not "preserved their aesthetic appeal" and some "have little meaning today." She modestly concluded that the collection was "informative—and often entertaining." But what was most important was her recognition that Lucas's collection needed to be considered "in its entirety." It was a "unique phenomenon in American collecting . . . [that] reveals the artistic background against which the inaugurators of modern art rebelled but from which they had learned."[46]

The exhibition was greeted with lukewarm praise. It had taken courage to mount the exhibit, wrote Cherrill Anson of the *Baltimore Sun,* because "only a few years ago, the idea of resurrecting the *non-avant-garde* nineteenth century would have been laughed at in most museum circles." Anson characterized the show as a "period piece" or "window on the nineteenth-century Parisian art world" that offered "modest visual pleasure." She also noted derisively that "it has taken 54 years" for visitors to have a chance to see the collection. But in the 1960s, when museumgoers in Baltimore hungered for modernism, there were few who had any interest in looking at art long past its time. With little to see that was purportedly great, beautiful, imaginative, or modern, the crowds were small, and the praise faint.[47]

◆ ◆ ◆

A French-made gilded clock that had been in Lucas's apartment was one of the many pieces of memorabilia displayed in "A Baltimorean in Paris," Randall's brilliant effort to bring Lucas and mid-nineteenth-century Paris back to life. In conjunction with the upcoming publication of Randall's transcription of Lucas's diaries,[48] the exhibition opened at the Walters Art Gallery on January 28, 1979, and provided a virtual tour of Lucas's life, loves, and tastes through a juxtaposition of over two hundred paintings, prints, and art-related objects displayed in eight rooms on the first floor of the gallery. Randall wisely enlisted William Johnston, chief curator of eighteenth- and nineteenth-century art, to assist her. Johnston was in the process of writing the definitive book on the museum's nineteenth-century paintings, many of which had been acquired through Lucas.[49] As a result, the curatorial team of Randall and Johnston was unsurpassable in its ability to design an exhibition that married knowledge about Lucas's life with knowledge about the art he had collected for himself and others.

The exhibition was an homage to Lucas. Beginning with Sully's portraits of Lucas's parents, it showed the objects that influenced his early life, such as the illustrated guide to Baltimore published by his father in 1834 and an engraving of St. Mary's College, where Lucas in his teenage years learned French and obtained a classical education. The exhibition then moved to Paris, filling teak and gilded display cases with pages from his diaries, letters from Whistler and other artists, a picture of Samuel Avery, and shorthand glimpses of Lucas's life as recorded in Frank Frick's diary. Viewers could also see artists' palettes endorsed to Lucas, books by his favorite writers, pictures of his friend Maud Franklin and his niece Bertha, and other ephemera. On the walls hung paintings that enabled viewers to visualize the world in which Lucas lived—a painting of the Paris station where he boarded the train to his country home in Boissise, a picture of the house with its footpath down to the Seine, and landscapes of the Fontainebleau Forest where he loved to stroll. In one room hung the art that he displayed with pride in the salon of his Parisian apartment—his oil paintings by Breton, Daubigny, Fantin-Latour—and in another the art that he had in his home in Boissise. Also lining the walls were the magnificent paintings that he

acquired for William Walters, including Corot's *The Evening Star*, Delaroche's *The Hémicycle*, and Rousseau's *Le Givre*. The exhibition, of course, displayed the portraits of Lucas by Bonnat and Cabanel and the photograph by Dornac. It concluded with a photograph of Lucas's grave in Baltimore's Green Mount Cemetery. The exhibition showed that Lucas's life, his work, and his art were inextricably tied together.[50]

Elizabeth Stevens at the time was Baltimore's most influential art critic. She would serve for approximately ten years in that capacity for the *Baltimore Sun* and continue her illustrious career as an art critic for the *Washington Post* and *Wall Street Journal*. In February 1979, she visited the exhibition and wrote a critical review of it. Some of her remarks were jarring. Stevens, like several critics before her, had serious misgivings about the quality of the paintings. She characterized some as "Masterpieces of Kitsch"—a dramatic fall from the *Baltimore Sun*'s first review of the Lucas collection in 1911, when it had blindly labeled Lucas's art as a "Collection of Masterpieces." Her opinion of the exhibition was summarized in a bold headline: "Lucas show valuable as history, not as art."[51]

Stevens's review was axiomatic of the steep decline in public opinion about the artistic merit of the Lucas collection. While scholars like Rosenthal, Randall, and Johnston sought to defend it, serious questions began to surface about whether the collection as a whole was worth saving.

The Shot across the Bow

In July 1974, the Maryland Institute selected William J. Finn to succeed Eugene (Bud) Leake as the school's president. Trained as a sculptor and photographer, Finn had been the director of the Swain School of Design in New Bedford, Massachusetts, where he expanded the fine arts department and gained prominence by doubling the school's enrollment. Selected from a field of eighty applicants, Finn's age (he had just turned forty-four), his artistic background, and his successful leadership of another school all combined to suggest that he would be a perfect leader for the Institute for many years to come.[1]

The most pressing issue that Finn initially faced was raising money to pay for facilities needed to house the Institute's growing number of students. Between 1960 and 1970, the size of its enrollment had doubled to over one thousand students, and there was not adequate space to house them. A possible solution arose in early 1975 with the announcement that the large, four-story Cannon Shoe factory directly across the street from the Institute's main building would be sold at auction. In a bold but financially risky gamble, the Institute seized the opportunity, entered the bidding, and successfully acquired the factory for $226,000. However, it did so without carefully determining how to pay for it or, more importantly, how to raise the estimated $900,000 needed to convert the factory into studios and other facilities.[2]

The Institute at that time had no cushion to finance any major capital expenditures. Its small endowment of barely $1 million was needed for operating expenses, and a capital campaign had just gotten off the ground. It was clear that additional sources of revenue were desperately

needed. One idea that was studied and then hastily pursued by Finn was to sell part of the Lucas collection. From his perspective, the plan made sense. The Lucas collection, he determined, had an appraised value of approximately $2.3 million.[3] The Institute's students were no longer actively using it. The critics had dismissed parts of the multifaceted collection, such as the small sketchy paintings, as second rank, and their loss, Finn believed, would not detract from the collection's overall quality. Finally, there was strong precedent for selling parts of the collection. Finn was mindful of the fact that in 1963 the Maryland Institute had obtained a legal opinion from William Marbury that authorized its trustees to sell any prints that were duplicates, and pursuant to this opinion, it sold three hundred from the Lucas collection.

Finn was not alone at that time in viewing art as a financial resource. The leaders of other institutions in the city likewise had decided to sell art in order to stay afloat. In January 1976, the struggling Peabody Institute of Baltimore announced its intention to sell its art collection, valued at close to $1 million, to solve its financial problems. And two months later, in March 1976, the Evergreen House of Johns Hopkins University sold its important rare-coin collection for $2.3 million to support its operating and maintenance expenses. As reported by John Dorsey, the widely read art critic and columnist for the *Baltimore Sun*, the city was in the midst of an era when "Art for the Sake of Money" was driving the financial decisions of many community leaders.[4]

The part of the Lucas collection that Finn wanted to sell was the Barye bronzes. In 1966, when Bud Leake had needed additional money for the Institute, he had sold several Baryes without any objection from the BMA. Indeed, Gertrude Rosenthal, the BMA's chief curator, helped Leake find a buyer.[5] Unlike the paintings and prints that had been transferred to the BMA in the early 1930s, the Barye bronzes had remained at the Institute, where the students used them as models. When the bronzes were transferred to the BMA in 1965, half of them were splattered with paint, some had been broken, and they were covered with dust. It would take many years before they regained their luster.

By the 1970s, Barye's small bronze sculptures of wild animals were considered by many to be merely decorative coffee-table pieces, antiques rather than art.[6] Those interested in sculpture tended to look to the modern, intellectually challenging work of such artists as David Smith, Anthony Caro, Robert Morris, and John Chamberlain. Figurative pieces of *animalier* sculpture depicting lions, tigers, bears, and other animals devouring their prey no longer excited the contemporary imagination. In August 1975, a small exhibition of thirty Barye sculptures was held at the BMA. The organization of the show had been delegated to four student interns, a reflection of Barye's low status at that time. Hardly anyone paid attention to it. The review in the *Baltimore Sun* was entitled, "Sculptor Who Never Found a Public." With regard to the sculpture itself, the newspaper's brief assessment captured the ho-hum feeling about Barye at that time. "Pleasant" is the word the reviewer used to describe them.[7]

Finn astutely recognized that although Barye's sculpture was not attracting many

visitors in Baltimore, it was marketable elsewhere. In October 1975, a collection of 150 Barye bronzes that had been owned by the wealthy socialite Geraldine Rockefeller Dodge was auctioned at Sotheby's for over $200,000.[8] Believing that the Institute's collection—most of which had been obtained by Lucas directly from the artist—had a better provenance than Dodge's, Finn estimated that the sale of 122 bronzes by Barye could generate around $250,000 to $300,000.

The rationale that Finn developed for disposing of the Institute's entire collection of Barye bronzes was that similar, if not better, examples were abundantly available in Baltimore at the Walters Art Museum and in nearby Washington, DC, at the Corcoran Gallery. There was an element of truth in this argument. In 1873, William Walters had commissioned Barye to make a cast of every available subject for the Corcoran, resulting in that museum's acquisition of 107 bronzes, the most that could be found at that time in any museum outside of Europe. In response to the commission, Barye was reported to have said, "Ah, Monsieur Walters! My own country has never done anything like that for me."[9] Thus, the Baltimore-Washington area became the world center for Barye's art. Because many of the Institute's bronzes were not dated and had been cast by different foundries and finished by the hands of different artisans and *patineurs* following Barye's death in 1875, it was often difficult to determine with any certainty which could be considered pristine and which were inferior casts made outside of the purview of Barye's supervision. Finn circumvented this delicate task of determining authorship by assuming that equal if not better duplicates existed at the Walters or the Corcoran. The bottom line, according to Finn, was that the people of Baltimore would not be deprived of any cultural treasure because the same objects could easily be seen in or around the city.

The primary market for these bronzes, Finn believed, was other museums across the United States. He drafted a letter to twenty-six of them, announcing that "our entire Barye collection is available for purchase by museums in the United States." Before mailing this letter, Finn decided to bring it to the attention of the directors of the Walters Art Museum and the BMA for their approval. In June 1976, he submitted a copy of his letter to Richard Randall, the director of the Walters, for his comments. Randall responded, "Your letter is excellent." Randall also suggested that Finn explore whether the Louvre wanted to buy the sculpture, and he generously offered to help in this inquiry.[10] Randall's reaction was in keeping with the spirit of collegiality that united the leaders of the Walters, the BMA, and the Institute at that time. Moreover, from his perspective, the disposition of the Institute's Baryes would not harm the Walters collection of Baryes and might possibly add to their value.

Tom Freudenheim, who had served as the director of the BMA since 1971, had an excellent relationship with Finn. They were working collaboratively on an exhibition at the BMA of Lucas's prints. In the foreword to the exhibition catalogue, Freudenheim thanked Finn for his help and acknowledged that the "project represents the fruits of collaboration between two Baltimore institutions (the BMA and the Maryland Institute) and their staffs."[11] Freudenheim took pride in the spirit of

cooperation that he encouraged between the museum directors, and in an interview, he opined that in no other city did the directors meet and assist one another as often.[12]

On July 8, Finn met with Freudenheim and presented his plan to sell the entire collection of Barye bronzes. Notwithstanding Freudenheim's genial and cooperative disposition, he was taken aback by the idea and hesitated to endorse it. He informed Finn that he would discuss the matter with the BMA's trustees, while expressing his personal opinion that such a sale was "extremely unwise." Nevertheless, Freudenheim agreed to give the idea additional consideration and to meet again the next month to discuss it further.[13]

The next day, Finn met with the Institute's board of trustees and proposed that "in order to clear away our old debts and in order to proceed with short-term financing of the [Cannon Shoe] Factory," the Institute should "sell the entire Barye collection."[14] The board agreed, and without hesitation, Finn mailed the letters to the twenty-six museums, offering to sell the bronzes.[15]

What Finn had failed to appreciate was the special role that Barye's art played in Baltimore's cultural history. As symbolized by his massive bronze *Seated Lion* that was permanently installed in Baltimore's Mount Vernon Square, Barye more than any other French artist was historically tied to the city. As Finn soon realized, his plan to sell the bronzes became engulfed in a firestorm of opposition that not only would scuttle the plan but also would cost him his job.

◆ ◆ ◆

Francis Murnaghan, the chairman of the board of the Walters Art Museum, was one of the most brilliant, erudite, and tenacious lawyers that anyone would ever have the misfortune of fighting. As an attackman on the championship Johns Hopkins University lacrosse team and throughout his career as a litigator, Murgnaghan was fiercely competitive. He invariably seized the high ground, speaking as if from a pulpit, fervently believing in the moral and legal superiority of his views and presenting himself as a champion of virtue. As Judge Harvie Wilkinson of the US Fourth Circuit Court of Appeals once observed, any effort to debate with Murnaghan was "one of life's more invigorating challenges."[16]

In addition to being admired for his prodigious skills as an advocate and lawyer, Murnaghan was revered for his devotion to public service. He served as president of the Baltimore City School Board, a trustee of the Johns Hopkins University, and a director of the Peabody Conservatory of Music. His large collection of Irish and other European art likely led him to the Walters Art Gallery, where in 1963 he began serving as the president of the board of trustees. No mere figurehead, Murnaghan was passionately devoted to the encyclopedic art owned by the Walters and governed the museum with an iron hand.

When Murnaghan learned of Finn's plan to sell part of the Lucas collection, he immediately wrote a strong letter to Edwin (Ned) Daniels, the chairman of the Maryland Institute's board, expressing his opposition in no uncertain terms. Daniels

was a highly respected philanthropist and patron of the arts, and he had no interest in picking a fight with Murnaghan. The feeling, however, was not mutual. Murnaghan initially made it clear to Daniels that he, not Randall, spoke for the Walters, and he asserted that if Randall had conveyed approval of Finn's plan to sell the Baryes, "it was inaccurate."[17]

Murnaghan accused Daniels of a "breach of trust" and reminded him that the art given to the Maryland Institute by Lucas was not intended to be "the equivalent of cash or marketable securities from which to meet maintenance, operational or capital expenditures." The objects in the Lucas Collection," Murnaghan reiterated, "are not mere chattels with which the Maryland Institute may do as it pleases. They belong to the community as a whole and enhance its cultural resources." Murnaghan demanded that the Institute not only cease any efforts to sell the Lucas collection but also pledge to never sell any object in the Lucas collection that could be preserved or displayed at the BMA or the Walters Art Gallery.[18]

The leaders of the BMA quickly joined forces with Murnaghan. On July 26, Rosenthal wrote a passionate letter to Freudenheim urging him to take action to stop the sale. She was "appalled by the news that the Maryland Institute intends to sell its impressive group of Barye works," which she characterized as "a very nearsighted and even destructive action undertaken by people devoid of a sense of art and history."[19] The rest of the BMA's curatorial staff jumped in, and on August 4, they collectively sent a "Memorandum of Record" to Finn asking him to set aside his plan.[20]

Mindful of the opposition that was being mounted by the BMA curators, Finn hoped that the private meeting he had scheduled with Freudenheim for August 9 would quell the uproar. Instead, the meeting turned into an ambush. Rather than arriving alone, Freudenheim brought Frank Murnaghan and a team of eight other people with him. Outnumbered and outmaneuvered, Finn protested but to no avail. Murnaghan seized the floor, raised his voice, and delivered a stinging lecture on the immorality and unlawfulness of Finn's action. During his diatribe, he repeatedly threatened Finn with legal action. Although Finn had called the meeting, Murnaghan completely controlled it. After he finished his lecture, he adjourned the meeting. Finn was left speechless.[21]

The support that Finn tried to cultivate from his own trustees also began to crumble. Eleanor Hutzler, an important donor and the future chair of the Institute's board, wrote to Finn that she felt that "there are still many questions to be asked and answered about the proposed sale." She also raised the fundamental ethical question: "Aren't we under some moral, if not legal obligation to keep the art here?" Lincoln Johnson, another trustee, denounced any plan to sell the Lucas collection. Johnson was an art historian, faculty member at Goucher College, and art critic for the *Baltimore Sun*. In 1972, he had written an article praising the Lucas collection and describing it as "exceedingly comprehensive. . . . [I]t illustrates the life, manners and many of the events of historical significance in the period." On August 26, 1976, Johnson wrote to Daniels, "I should like to add my name to the growing list of those who are

distressed at the proposed sale of certain items from the Lucas collection." Johnson claimed that the sale "would constitute an act of cannibalism that would bring only discredit to the Maryland Institute of Art, its administration and its Board." Other scholars joined in. Gabriel Weisberg, a highly regarded curator at the Cleveland Museum of Art, recalled his use of the Lucas collection during his doctoral work at Johns Hopkins University and stated that "it would be a terrible tragedy to find this paramount collection of 19th-century taste severed or liquidated."[22]

By the end of August, it was clear that Finn had lost the war. Accused of being an outsider who had entered the city to destroy its culture and confronted by all-powerful Baltimore-based intellectual and legal giant Francis Murnaghan, Finn did not stand a chance. The Institute's board decided to table the sale and to make peace with the two museums. In September, Finn and Daniels scheduled a meeting with Freudenheim, Murnaghan, and other museum leaders to inform them about the Institute's change of heart and its future plans. At the meeting Finn expressed regret for what had occurred. "We obviously stubbed our toe on the proposed sale with a number of people and institutions," he conceded.[23] Then, in a broad gesture of conciliation, Finn offered the following three-point proposal.

1. That The Maryland Institute, working through The Walters Art Gallery and The Baltimore Museum of Art where a major portion of the Collection is on loan, will undertake a complete evaluation of the Lucas Collection including a study on the condition of the Collection with detailed information on the needed repairs, restoration, protection and future use;

2. That we mutually explore any circumstances under which the transfer and/or sale of items from the Lucas Collection could take place without undue cultural loss to the community and which would be acceptable to all three institutions; and

3. That the proceeds of any sale be used to establish a fund for the purpose of protecting, exhibiting, preserving and otherwise enhancing the Collection. In addition, consideration would be given to circumstances whereby other uses of the proceeds would be acceptable.[24]

To the extent that the proposal was designed to heal the rift between the Maryland Institute, the BMA, and the Walters, it seemed to work. Murnaghan and Freudenheim left the meeting content that they had prevailed. Following the meeting, Daniels sent letters to the Institute's important donors, explaining that the conflict had ended and that no items would be sold until "we . . . hopefully work out a plan for the future protection, repairs, restoration and use that is mutually agreeable to the Baltimore Museum and the Walters." On the next day, Douglas Frost, the Institute's vice president for development, wrote to Freudenheim, "Everyone was overjoyed by the success of yesterday's meeting regarding the Lucas collection." Freudenheim replied, "Yes, I do think a new friendship will grow." Murnaghan informed the Walters board about the resolution of the dispute, and on October 6, 1976, he wrote to Daniels in-

forming him that "the Walters Trustees authorize me to state their general satisfaction with the approach outlined in your September 21, 1976 statement."[25]

<center>• • •</center>

Everything appeared to be settled. But there was one big hole in the apparent agreement. Prior to submitting the three-point plan to Freudenheim and Murnaghan, Daniels and Finn had failed to submit it to the Maryland Institute's board for formal approval. To remedy this problem, one of the lawyers on the Institute's board prepared a resolution that adopted the plan, and on October 28, 1976, the board gathered to discuss and act upon it. Surprisingly, the board revolted and unanimously decided to table the resolution.[26] At the meeting, the trustees made it clear to Daniels and Finn that in seeking to resolve the problem, they had gone too far in giving away the board's control and authority to sell the Lucas collection. In explaining the board's defection, Daniels would write that having "rushed into the proposed sale [of the Lucas collection]," the board did not want to repeat this mistake by "rushing into giving away the right to sell."[27]

Daniels informed Murnaghan that the board had tabled the resolution "for intensive further discussion." He added, "The reaction of our governing board does not necessarily question the reasonableness of my proposal, but the board truly wanted to give the entire matter further consideration before making such a commitment. . . . Until then, there will be no sales without consultation with your museum."[28]

That is how the matter was left. Although no formal written agreement was ever signed, the leaders of the Walters and the BMA believed that they had a deal or at least a gentleman's agreement that safeguarded the Lucas collection.[29] The leaders of the Maryland Institute, on the other hand, believed that the board had preserved its discretion to sell the Lucas collection if and when the need arose. Both sides lowered their voices and went their own way, placing the issue aside, at least temporarily, and silently hoping to avoid another fight.

In 1977, Daniels stepped down as chairman of the Maryland Institute. In March of that same year, Finn resigned in lieu of being fired. Freudenheim left his position of director of the BMA in 1978. Murnaghan resigned from his leadership at the Walters upon being selected by President Jimmy Carter in 1979 to become a judge on the Fourth Circuit Court of Appeals, where he remained and was revered for the next twenty-one years. The Maryland Institute, through the generosity of its trustees and the support of the state, raised the funds needed to pay for and renovate the Cannon Shoe building. And the Lucas collection remained in its resting place in the storage vaults of the BMA, rarely to be seen or cared about for the next twelve years.

The Glorification of Lucas

On April 7, 1984, a long article entitled "Museum Has Art for Everyone" appeared in the *Baltimore Sun*. Using the BMA's "Guide to the Galleries," the article's author provided readers with a virtual tour that began with paintings by Rembrandt, van Dyck, and other old masters. It moved to the magnificent Cone collection of impressionist and postimpressionist paintings by Cézanne, Matisse, and Picasso. Then it looked at the Wurtzburger collection of African art, the galleries of ancient and oriental art, Maryland nineteenth-century furniture and silver, and finally to the new and extensive array of contemporary art, including paintings by Helen Frankenthaler, Jasper Johns, and Robert Rauschenberg. The tour covered, according to the writer, all of the "treasures" in the museum. There was, however, not a word in this article about the Lucas collection or any of the eighteen thousand works of art in it.[1]

The director of the BMA at that time was Arnold Lehman and the deputy director, Brenda Richardson. Both focused on the acquisition and exhibition of modern and contemporary art, and neither had much interest in the type of mid-nineteenth-century French art that was in the Lucas collection. As they acquired and exhibited more contemporary art and raised money to build a new wing to house it, the Lucas collection fell further out of sight and out of the public consciousness. If the Lucas collection were sold, in Lehman's judgment, there would be no reduction in the number of people visiting the BMA.[2]

Richardson was recruited and hired by the BMA in 1975 for the specific purpose of introducing contemporary art to Baltimore and con-

verting the museum into a major venue in the country for showing it. When she arrived and looked at the BMA's art, she was "horrified" by what she saw. In her view, the paintings by Matisse in the Cone collection represented the museum's "only redeeming feature."[3] Brilliant and tough, Richardson quickly became the aesthetic leader and driving force at the BMA. She decided what would be exhibited and what would not. Her decided preference for abstract and what she called "cerebral art" led her to orchestrate a series of intellectually stimulating exhibitions by some of the most illustrious contemporary artists, including Andy Warhol, Barnett Newman, Bruce Nauman, and Frank Stella. Enamored with Warhol, she acquired over eighteen of his major works, including his twenty-five-foot version of *The Last Supper*. In a cultural environment abuzz with Warhol and contemporary art, little attention was paid to Lucas.[4]

Four years after Richardson's arrival, Lehman was selected as the director of the BMA. Describing himself as an "activist," Lehman pushed the museum in the same artistic direction as Richardson but much closer to the edge. "I feel very strongly [that] we have a major commitment to contemporary art in this city," Lehman announced. But his unorthodox methods for enticing new and younger audiences into the museum was what gathered attention. At a BMA show called "Saturday Night Art Fever," conducted in December 1985, Lehman took the gallery floor and jitterbugged while calling for the crowd to join in the fun. As Lehman demonstrated, he was both a cerebral art director and an energetic showman, looking forward not backward, reaching out to new audiences, and trying to remake his museum into an exciting place to go.[5] There was no place on Lehman's stage for Lucas's old art.

For the next fifteen years, under the leadership of Lehman and Richardson, the primary focus of the BMA remained on post–World War II modern and contemporary art. The construction of a large new wing to house the BMA's burgeoning collection of this art was undertaken, and upon its completion in October 1994, it was universally praised. One museum director opined that the BMA had created "one of the country's most important centers for twentieth-century art," while the director of the Museum of Modern Art in New York exclaimed that he was envious of the BMA's expansion. At the opening of the new wing, Lehman and Richardson were described as the "proud parents of the bride," and Lehman announced that the event marked "a new beginning for the museum."[6]

In the meanwhile, in March 1987, a group of oil paintings and sculpture from the Lucas collection had emerged like ghosts from the storage rooms of the museum. It was the first time that a group of Lucas's oil paintings had been shown together to the public in over twenty years.[7] However, instead of stimulating the public's taste for Lucas's art, the exhibition merely served as a reminder of how old-fashioned it seemed to be. Critic John Dorsey reminded his *Baltimore Sun* readers that this art had long been out of fashion: "Of all the periods of art history, probably none have suffered a worse reputation in recent generations than the more traditional French 'realist' art of the 19th century." Dorsey placed Lucas's collection at the center of this uncreative

period of art. He characterized Lucas as "a very conservative collector" and reported that the work on display "doesn't break any ground." As if to kill the exhibition with kindness, Dorsey concluded that the only reason to see it was to be reminded that "there was a place in the world for pretty pictures."[8] In a subsequent notice, he described the paintings as "small-scale."[9] The word "small" could have been used as well to describe the attention paid to Lucas's collection at that time. Hardly anyone went to the BMA to see it. And no visitor or patron of the arts in the 1980s would have suggested that it was great or an irreplaceable treasure.

◆ ◆ ◆

On January 30, 1988, a strong-willed group of new trustees of the Maryland Institute met at a board retreat to discuss the Lucas collection. It was the first time that the Institute's trustees had met to address the issue since 1976, when the Institute's previous director, William Finn, had been battered into submission after proposing to sell part of the collection. No longer willing to shy away from the problem, most of the trustees were bracing for a fight. They were united in the conviction that the Lucas collection belonged solely to the Institute, that it was an economically valuable asset, and that as trustees they and no one else had the authority and fiduciary responsibility to decide what to do with it.

Although the Institute had owned the collection for seventy-eight years, the trustees, like most everyone else, remained uncertain what was in it. None of the trustees professed to have seen or studied it. The vast majority of the art had been out of sight for over a generation. The trustees also were uncertain about the number of objects and their quality. They estimated that the collection might be worth between $5 and 10 million but were without any hard data or current appraisal of its actual monetary value. They were aware that the BMA and the Walters Art Gallery considered the Lucas collection to be a part of the culture of Baltimore, but they were uncertain as to why. Was the collection's alleged importance based on myth or reality? Most importantly, they did not know whether or the extent to which the collection was being utilized to meet the original goal of educating the Institute's students. All of the trustees who attended that meeting were anxious to obtain concrete answers to these important questions before making any decision about what to do with it.

The president of the Institute was Fred Lazarus. He had been selected as president ten years earlier in July 1978, following the short and chaotic presidency of William Finn, and when, as one trustee observed, "the fate of the institution [was] on the line."[10] When Lazarus arrived, the school was struggling financially, its facilities cramped and dilapidated, its academic standards low, its faculty small and demoralized. The school was essentially rudderless. Lazarus was young—only thirty-six—but he had big ideas and the quiet confidence to achieve them. He was born and raised in Cincinnati in a family that felt passionately about art and had the wealth to support it. As suggested by his MBA from Harvard Business School and his service as a Peace Corps volunteer, Lazarus was guided by an inner compass that valued both the real and the

ideal. He was colorblind and not an artist; he never had attended, worked at, or managed any art school; and he knew virtually nothing about the Institute at the time of his interview. Still, Lazarus was, to the amazement of many, selected to be the school's new president. As the Institute's newsletter put it, he was "the right man, at the right place, at the right time."[11]

By the time of the board's meeting in January 1988, Lazarus had revitalized the Institute. Its endowment had been increased, its academic standards raised, and its reputation elevated. It not only recruited inspirational and talented teachers but also attracted students from thirty-five states and thirty foreign countries. Lazarus, however, was not satisfied with how far he had carried the school. His vision was to transform it into the finest art college in the country.

To reach this objective, Lazarus needed to substantially increase the Institute's endowment. In 1988, the endowment, although higher than before, amounted to only $5 million. It covered less than 3 percent of the Institute's operating expenses. In contrast, other leading art schools had endowments more than ten times that size. The limited revenue derived from the endowment, Lazarus believed, hampered the Institute's financial ability to provide adequate housing for the increasing tide of out-of-town students, to increase the availability of student aid, to enhance the liberal arts curriculum, to elevate the school's academic standards, and in general to successfully compete against the elite group of wealthier, better-funded, and better-known art schools.[12]

Selling all or part of the Lucas collection, Lazarus believed, was one way of quickly increasing and even more than doubling the size of the endowment. The matter had weighed on Lazarus's mind for some time. As early as December 1981, he suggested to Alan Hoblitzell, the chairman of the Institute's board of trustees, that parts of the Lucas collection "could and should be sold."[13] However, because of the controversial nature of this issue and Lazarus's interest in establishing rapport and good relations with the leaders of the BMA and the Walters, he tabled the idea for several years. But in 1988, at the urging of several new trustees, he placed it at the top of the Institute's agenda.[14]

In the intervening years, Lazarus, with the assistance of Alonzo Decker (the chairman and principal owner of Black and Decker Corporation) and George L. Bunting Jr. (the chairman and CEO of Noxell Corporation), strengthened the board. Lazarus added or placed in positions of authority leaders in business, law, and philanthropy who were wealthy and wise, had clout, shared Lazarus's vision and ambitious agenda, and were not afraid of a fight. Among them were three leaders who would serve in succession as chair and direct the course of the battle over the Lucas collection. Sheila Riggs had honed her knowledge and passion for art, especially mid-nineteenth-century French art, while studying in Paris and taking classes in the Louvre, and her leadership qualities were repeatedly demonstrated while chairing the boards of the Greater Baltimore Medical Center and the Baltimore Council on Foreign Affairs. LeRoy Hoffberger, a wealthy and sophisticated entrepreneur and philanthropist, was

president of his family's extensive business holdings and large charitable foundation, and also served as the president of the Associated Jewish Charities. And Robert Shelton, a Harvard Law School graduate, successful corporate lawyer, and partner in the firm of Venable, Baetjer, and Howard, had earned his stripes by serving as deputy counsel on the US House of Representatives Impeachment Committee of President Nixon. Lazarus convinced these three not only to join the Institute's board but also to assume positions of responsibility and leadership.[15]

Riggs chaired the meeting on January 30, 1988, but Hoffberger was the trustee most insistent on coming to grips with the status and future of the Lucas collection. Based on his extensive business experience, he firmly believed that it was irresponsible for any organization to own a potentially valuable asset like the Lucas collection and not obtain its maximum benefit. As treasurer of the board, he issued a report recommending that the Lucas collection be reviewed and analyzed to determine its worth and what should be done with it. Agreeing with Hoffberger, Riggs reminded the other trustees that they—not the BMA or the Walters—were ultimately responsible for deciding what to do with the collection and that this was not "a shared decision-making process." Shelton, on the other hand, urged the trustees to use caution, especially in light of the belief held by some that the Lucas collection was part of the city's cultural heritage. His dissent drew a long pregnant silence. Lazarus responded that the need to study the collection and determine its value did not necessarily mean it would be sold or lost to the city, especially if the BMA acquired it. With this clarification, Shelton withdrew his objection, and the trustees voted unanimously to review, evaluate, and decide what to do with the collection and to hire a knowledgeable consultant to advise them.[16]

◆ ◆ ◆

Had Ted Klitzke lived in earlier times, he would have been known as a man for all seasons. He was an intellectual, a passionate devotee and collector of the arts, a strong advocate of social justice and civil rights, a teacher, and a highly respected man of good conscience. Highly educated, he received his bachelor's degree and doctorate from the University of Chicago, studied at the Sorbonne and the École du Louvre in Paris, and was fluent in German and French. While employed as an assistant curator of prints at the Art Institute of Chicago, he also was teaching art history at the University of Chicago. He became dean of the art history department at the University of Alabama and marched in 1965 from Selma to Montgomery with Martin Luther King Jr. In 1968, he was hired by the Maryland Institute as its vice president of academic affairs and subsequently became the dean of its faculty. During the turbulent 1970s, Klitzke was credited with holding the Institute together, serving in 1977 and 1978 as the acting president prior to Lazarus's appointment. In addition to his administrative responsibilities, Klitzke taught a popular course on the history of prints while gradually acquiring his own impressive collection.[17]

As a result of his knowledge of art history and experience as dean and acting pres-

ident of the Maryland Institute, Klitzke knew far more about the history and use of the Lucas collection than anyone else at the school. His knowledge about its prints was augmented by a study undertaken by his daughter Margaret. In 1975 and 1976, at the behest of the Institute and the BMA, she undertook the laborious task of preparing a handwritten card catalogue of the thousands of prints in the collection and wrote an essay in which she praised its "remarkable homogeneity," noting that it was "primarily a study collection, meant to be looked at in portfolios rather than exhibited on a wall."[18] Her father agreed.

Following the board meeting in January 1988, Lazarus retained Klitzke (who had retired) to study the Lucas collection and to prepare an objective report of his findings and recommendations. Klitzke worked on the project for over two years, conferring with Lilian Randall about Lucas's life in Paris and reading parts of his diaries. He analyzed the collection's importance to the community and interviewed art historians, museum curators, and artists about its quality and value. He discussed the collection with the BMA's director and key members of the BMA's and the Walters' curatorial staffs. And he analyzed the degree to which students used the collection. In February 1990, he submitted a forty-two page report and a separate summary of his conclusions.[19]

"It is in 19th century prints that the Lucas collection excels," he wrote, noting that most of them were from the second and third quarters of the century and included multiple impressions or states, which revealed subtle changes in how a print evolved. Klitzke also was impressed with the voluminous information that Lucas had gathered about the artists, which provided a historical context for evaluating their work. While acknowledging the importance of the collection to scholars, Klitzke questioned what benefit the hundreds of similar images had for the museum-going public who would rarely if ever see them. He noted that no one could see the prints, including himself, without scheduling an appointment with a member of the museum's staff. As a result, he opined that the collection of prints, while known to scholars, added little to the visible culture in the city and the population's enjoyment of art.[20]

His criticism of the paintings echoed the earlier comments of Adelyn Breeskin, Gertrude Rosenthal, and various *Baltimore Sun* art critics. Among the three hundred oil paintings, he opined that only fifteen "could be considered of exceptional quality." While many were "pleasant" to look at, he concluded that "there are few masterpieces." He also noted that the authenticity of paintings by Courbet and Manet had been discredited, that questions had been raised about the authenticity of several other paintings given to Lucas as gifts, that many of the paintings were by unknown artists, and that the manner in which the paintings had been acquired by Lucas was "haphazard." Klitzke qualified his praise of the 122 Barye bronzes, noting that many appeared to be duplicates of works in the Walters Art Gallery. And while he recognized that the seventy-one palettes reflected Lucas's interest in art and to a degree documented the manner in which painters worked, he concluded that they currently were "of little interest."[21]

Following his assessment of the quality and significance of the collection, Klitzke turned to the central question of whether it was serving its intended goal: "The Lucas collection does not serve the students of the Maryland Institute well, except for the print collection . . . [and] only a minority of Institute students ever see the prints. . . . The great majority of the Institute students also have little contact with the paintings, bronzes, porcelains and palettes." As far as the faculty went, "Not many know what it contains."[22]

◆ ◆ ◆

In 1989, Lazarus established an "Art Assets Committee," whose actual purpose was to guide the Institute through a thicket of anticipated opposition to the Lucas collection's possible sale. Recognizing the likelihood of litigation and the need for legal direction, Lazarus appointed Shelton to chair the new committee.[23] Strong willed, independent, and unafraid of tackling the establishment, Shelton proved to be the perfect choice for this assignment. His first step was to obtain solid confirmation of the Institute's legal right to sell the collection. With this goal in mind, he asked Richard Emory, a senior partner in the law firm of Venable, Baetjer, and Howard, to research and write an opinion that addressed this pivotal question.

Emory was highly revered in Baltimore. A graduate cum laude of Harvard Law School and editor of its law review, Emory had turned down repeated opportunities to become a federal judge in favor of remaining at his law firm and engaging in other forms of public service. An early and strong advocate of civil rights, Emory had served as chairman of the Baltimore Equal Employment Opportunity Commission, general counsel to the city's housing authority, and chairman of the board of Morgan State University. When he became chairman of the elite Gilman School, his first goal was to racially integrate it. The *Baltimore Sun* applauded his actions, writing that "Mr. Emory's legal talents and level-headedness frequently have been called into public service."[24]

In response to the Institute's request, on October 8, 1990, Emory presented the Maryland Institute with a ten-page opinion letter. He charged no fee for his work. The letter was prepared in a highly professional and apparently objective and independent manner. Emory characterized his response as a "studied opinion" and set forth the salient facts (mostly drawn from the Klitzke report) upon which his opinion was based. Having applied what he considered to be the governing case law, he offered the following conclusion: "The Maryland Institute has the legal right to dispose of the Lucas Collection, in whole or in part, in return for money or other assets which can or will be devoted to the art education of its students, which art education was the donative intent and purpose for the collection having been given to the MI." He advised that the Institute not only had the right to sell the Lucas collection but that the facts and circumstances "may even require" it to do so.[25] According to Anne Scarlett Perkins—an Institute trustee who also served the public as a lawyer, teacher, elected member of the Maryland House of Delegates, and chair of its Constitutional

and Administrative Law Committee—Emory's opinion was the "turning point." It galvanized Institute leaders to proceed with their plans to sell the collection.[26]

Emory wrote a second letter, dated the same day, that abandoned any pretense of objectivity. The second letter assumed that the Institute planned to sell the collection and recommended an aggressive game plan for successfully doing so. Emory recommended that the Institute hire a good trial lawyer to defend its decision, expert witnesses to justify it, and an experienced and well-qualified public relations firm to help the Institute present its case to the public. Finally, he recommended that the Institute not wait to be sued but "initiate the litigation by asking a court to approve of its plan to dispose of the Lucas Collection."[27]

◆ ◆ ◆

In June 1989, when Klitzke was still working on his report and Emory had not yet offered his legal opinion, *Warfield's Magazine* published an article about Fred Lazarus's ambitious plans for the Institute. With regard to the Lucas collection, Lazarus was quoted as saying, "I don't think it is appropriate for the Institute to sit on a $15 to $20 million asset without looking good and hard at how the asset is being used for the good of the community." He revealed that he was "considering selling the Lucas collection," and if the Institute's board agreed, he was "willing to do it."[28]

The article alarmed the staffs of the museums responsible for preserving the Lucas collection. Jay McKean Fisher, the BMA's curator of prints, reported that he was "shocked," and Sona Johnston, the BMA's curator of pre-nineteenth-century paintings, reported that she was "extremely distressed."[29] Although the Institute's trustees had never relinquished their right to sell the Lucas collection, they had agreed in 1976 that if they ever wanted to do so, "the Baltimore Museum of Art and the Walters Art Gallery would be contacted for further consultation and advice."[30] Lazarus's published remarks about the probable sale suggested to the BMA and the Walters that the Institute had reneged on its promise and was presenting the museums with a fait accompli.[31]

The threat to sell the Lucas collection had the most immediate effect on Fisher. In 1975, after obtaining his MA at Williams College and developing an expertise in nineteenth-century French graphics, Fisher was recruited by BMA director Tom Freudenheim to join the curatorial staff and focus on the museum's many prints, with special emphasis on those in the Lucas collection. They quickly became the focus of his academic and curatorial career. Without much fanfare, Fisher quietly studied, cared for, and gradually brought the prints to the attention of the public. He curated scholarly exhibitions and authored important catalogues involving three of the stars of the French etching revival: Théodore Chassériau, Félix Buhot, and Edouard Manet.[32] His Manet exhibition was the first major retrospective of the artist's prints to be held in the United States. Fisher shared his intimate knowledge and passion for the prints in the Lucas collection with other scholars and aficionados, taught a course

at the Maryland Institute each semester on the history of prints, and became so absorbed in Lucas's unique place in mid-nineteenth-century French culture that he organized a full-year museum-studies course on the subject.[33] Mesmerized by the quality of some of the prints, Fisher imagined that they came alive when held in his hands. To celebrate Lucas's life, he would invite his staff to join him for lunch and "a good glass of French wine, slightly chilled" by Lucas's graveside. Fisher became devoted to the preservation of the collection, and like an evangelist he sought to convert the leaders of the Maryland Institute and a doubtful public into believing in its greatness.[34]

While Fisher was directly responsible for the prints, Sona Johnston was the curator in charge of Lucas's paintings and sculpture. Her responsibilities, however, extended to the vast field of American and European art prior to 1900. Hired as a curator in 1971, Johnston delved into late nineteenth-century American art, especially the paintings of Winslow Homer, Thomas Eakins, and Theodore Robinson. In 1983, she published a book, *American Paintings, 1750 to 1900,* and subsequently authored critically acclaimed books on impressionism and the paintings of Robinson, earning recognition as the "world's leading expert" on his work. Among the BMA's curatorial staff, she was admired for her meticulous research and impassioned scholarship.[35]

Consistent with the goals of the BMA at that time, Johnston's focus on late nineteenth- and early twentieth-century American artists took priority over the older, lesser-known French painters in the Lucas collection. She had a full plate and was given no mandate to push any of her scholarly projects aside in favor of Lucas.[36] However, when she learned in 1989 that there was a plan afoot to sell his collection, Johnston angrily began to use her pen to ward off the attack. Her creative descriptions and zealous praise of the Lucas collection became her way of saving it.

Fisher and Johnston promptly brought the *Warfield*'s article to the attention of Lehman and Richardson and urged them to take action "to head this off at the pass."[37] Although Lehman and Richardson previously had paid little attention to the Lucas collection, the threat by the Maryland Institute to sell it became their call to arms. Lehman realized that in order to save the Lucas collection, it no longer could be described as an old-fashioned, traditional collection of French art that contained, as Rosenthal once said, "only a few really great paintings."[38] The collection had to be reshaped, repackaged, and persuasively sold to the press and the public as a sparkling new version of its former self.

After conferring with the leaders of the BMA's board, Lehman issued a memorandum that set the tone and parameters of the BMA's response to the threat. He instructed Richardson and Fisher to prepare a concise, one-page statement that would describe the importance of the Lucas collection, that would be understandable to a lay audience, and that could be used like a script by BMA leaders to vehemently oppose the sale. Lehman wrote that the BMA's response "needs to be 'fierce.'" He also directed that the Lucas collection's history should be referred to "only" if it under-

scored the unique quality of the collection. As conveyed by these instructions, what Lehman called for was a form of acrimonious advocacy that bordered on belligerency, not objectivity.[39]

Fisher suggested a more civil, historically accurate, and idealistic approach to solving the problem. He proposed to Klitzke "a full and open discussion" about the future of the Lucas collection.[40] Aware that most Institute trustees had never seen it, Fisher also proposed that he and Johnston provide them with a personal tour that hopefully would arouse their interest, increase their appreciation, and dissuade them from selling it. To Fisher's delight, the trustees accepted his invitation.[41]

The tour was scheduled for August 27, 1990, a date that seemed perfect to Fisher and Johnston because it coincided with their exhibition of Lucas watercolors and drawings. There was, however, a risk in showcasing this part of the collection. Dorsey in the *Baltimore Sun* had described the watercolors and drawings as appearing "unfinished" and had cautioned that they were "not for those who want to see great statements by great masters."[42] Not surprisingly, the Institute's trustees, upon seeing the small, apparently unfinished drawings and watercolors, were unimpressed. They were then led to the museum's basement vault, where most of the oil paintings, Barye bronzes, and the prints were stored. Again they found nothing that excited them. Unlike the BMA's Cone collection, there was not, from their perspective, a masterpiece in sight. Moreover, the realization that most of Lucas's art was stored out of sight in the bowels of the museum reinforced their belief that the art was not worth keeping. Following the tour, the members of the Art Asset Committee huddled together and exchanged their impressions. As Shelton remembers, they were "collectively underwhelmed" and—most importantly—undeterred from possibly selling some or all of the collection.[43]

• • •

In January 1991, the Maryland Institute provided copies of the Klitzke report to the BMA, the Walters, and the press. The *Baltimore Sun* immediately sounded a warning. It construed the report as a sign that "some—or all—of it [the Lucas collection]—will leave the city."[44] The incoming chair of the BMA's board of trustees, Constance Caplan, interpreted the Klitzke report in the same threatening way. She proposed that the BMA and the Walters join forces and aggressively respond to the report, pointing out its flaws and challenging the notion that the Institute had the right to sell it. The Lucas collection, in her judgment, was a gift to the city and an invaluable part of its heritage.[45]

Caplan was an ideal leader for the BMA. A strong-willed, highly intelligent, and politically well-connected philanthropist and community leader, she was passionately connected to the art of the present yet devoted to preserving the culture of the past. She was owner of one of the greatest collections of contemporary art in the country and a major contributor to the BMA's new contemporary wing. She was also devoted to the welfare of the city, serving as the founder and chair of an organization

designed to preserve Baltimore's beautiful and historic Mount Vernon Cultural District. But among her virtues, the most important was her capacity to see the big picture and to envision not only a way to effectively fight the looming battle with the Maryland Institute but also a way to peaceably resolve it.

The BMA sought and was granted nine months or until January 1, 1992, to respond to the Klitzke report. The museum judged that it needed this amount of time to prepare a response and to launch a major public-relations campaign that would glorify the Lucas collection and bury the Institute's plan to sell it in an avalanche of adverse publicity. Lehman appointed Richardson to lead the campaign.[46] Given her devotion to contemporary art, her selection might have seemed odd. But by 1991, she viewed Lucas as a kindred spirit who, at an earlier period of cultural history, had been just as passionate about contemporary art as she. For this reason, Richardson began to describe Lucas to other contemporary art lovers as "one of us."[47]

The campaign led by Richardson had two components. The first was the preparation of a script that glorified the Lucas collection. In order to overcome the problems arising out of the collection's uneven quality, old-fashioned style, and relative anonymity, Lehman and Richardson thought that the collection had to be described in a manner that appealed more to the mind than to the eye, more to broad concepts of history and culture than to the quality of the individual objects, and more to the civic pride associated with the ownership of an alleged treasure than to the money that could be exchanged for it. The plan was to downplay the collection's weaknesses and accentuate its strengths. Richardson assigned the task of writing this creative script to Johnston, sarcastically commenting, "I do think we have a bit of work ahead of us."[48]

The second component involved the dissemination of such information to the Baltimore public through a variety of means, including exhibitions, lectures, articles in the *Baltimore Sun* and elsewhere, and letters to the public, ghostwritten by the staff of the BMA for prominent figures in the art world to sign. In March 1991, Richardson and Johnston began to compile a list of such persons.[49] The most famous candidate was J. Carter Brown, director of the National Gallery in Washington. On March 17, a long article about his life and accomplishments appeared in the *Baltimore Sun*.[50] It quoted Arnold Lehman, who was convinced that Brown was one of the few figures in the art world whose name was recognizable and who had "the necessary clout" to persuade the leaders of Baltimore to save the Lucas collection for the city. Shortly after the article was published, Lehman contacted Brown and scheduled a meeting to talk about Lucas.[51]

J. Carter Brown was known as America's "unofficial minister of culture." Handsome, tall, and debonair, Brown was raised in a wealthy, aristocratic family in Rhode Island (his grandfather founded Brown University) and educated at Groton and Harvard. He was often pictured in newspapers and magazines standing alongside American presidents, as well as such idols as Jackie Kennedy and Princess Diana. In the 1970s and 1980s, he orchestrated exhibitions of so-called "treasures" — *The Treasure*

Houses of Britain and the *Treasures of Tutankhamun*—that attracted more than a million visitors. Whether shopping for masterpieces, greeting dignitaries from around the world, giving commencement addresses, or organizing blockbuster exhibitions, Brown was the personification of great art and high culture in America.[52]

Lehman wanted Brown to lend his name to the BMA's effort to save the collection not only because he was a national celebrity but also because he had a connection, albeit tenuous, to Baltimore. His mother Anne Kinsolving was the daughter of the rector of Old St. Paul's Episcopal Church there. She was raised in the city, graduated in 1924 from Bryn Mawr School, became a violinist with the Baltimore Symphony Orchestra, and was a music critic for the *Baltimore News* before getting married and moving away. Unlike his mother, however, J. Carter Brown never lived in Baltimore and rarely came to the city. While there was no basis to believe that he had ever seen or heard of the Lucas collection, Lehman nevertheless thought that Brown's family connection to Baltimore would lend an element of personal interest and sincerity to any comment he made about it.

In early April 1991, Lehman and Robert Bergman, the director of the Walters Art Gallery, met with Brown in his grand office in the East Wing of the National Gallery overlooking the Capitol. Following a presentation about the Lucas collection and the looming battle in Baltimore over its possible sale, Lehman and Bergman enlisted Brown to lend his name to their cause. On April 12, 1991, after apparently obtaining permission from the board of the National Gallery, Brown informed Lehman that he was willing to help but needed "a draft of what you would like me to write or say." Lehman replied that the BMA staff would write Brown's statement "in its entirety" and submit it to him for approval. He also predicted that Brown's statement "would carry substantial weight with the decision-makers in Baltimore," exclaiming, "How could they dispute one of Baltimore's own!"[53]

In May 1991, Johnston informed Richardson and Lehman that she would "take on" the responsibility of writing a report for Brown's signature. However, she needed some clarification as to whether it should be in the form of a memo or position paper and what should be in it. Lehman responded, "We basically need a well written cover letter for Carter touching on all the critical points as to the importance and significance of Lucas as a collection . . . for Baltimore."[54]

◆ ◆ ◆

Throughout art history, the line between scholarship and salesmanship has never been clear. The obligation of directors and curators of art museums is not only to identify, preserve, and display the art and objects under their control but also to interpret the meaning, assess the quality, explain the place and context of the art in cultural history, and enable the public to appreciate it. All of this calls for the exercise of judgment in a complex field where the quality and importance of art is not an exact science. There is, of course, a presumption that a museum's staff will act with integrity and stand behind the interpretations and opinions it presents to the pub-

lic.[55] But there is also an understanding that the opinions to some degree are shaded by the director and curator's correlative responsibility to serve as advocates—to promote the museum and especially the art under their care. Marketing the museum and making the art interesting to the viewers is an implicit part of the process. Displays and interpretations that make art seem a little grander, more exciting to look at and more stimulating to think about, are what attract the public and brings people through the door. The age-old license to exaggerate is what permitted the great connoisseur Bernard Berenson to label some of his paintings by relatively minor artists as "Raphaelesque" or "Leonardesque." It was what Thomas Hoving, the director of the Metropolitan Museum of Art, once referred to as "making the mummies dance."[56]

The challenge facing Lehman, Richardson, and the BMA's curators in the 1990s was without precedent. It was not a question of simply shining up an object that was being placed on exhibition, inflating the importance of objects that the museum was seeking to sell, or convincing an accessions committee of trustees to purchase a new work of art. What was at stake was the preservation of a gigantic and arguably treasured collection of eighteen thousand works of art. The only way to save it was to shout about it, to glorify it, and to make art lovers, community leaders, and the Baltimore public believe that the collection was a vital part of the city's cultural heritage—that it belonged to them. There were no rules or strict ethical standards about what could be said or done to express these ideas. The stakes were high, and the public-relations campaign, in Lehman and Richardson's judgment, needed to be equal to the task. The dilemma they faced was how close to the line between scholarship and salesmanship—or how far beyond it—they were willing to go in redefining the Lucas collection in the hope of saving it.

◆ ◆ ◆

On February 7, 1990, Sona Johnston wrote a brief description of the Lucas collection that served as the template for its glorification. She wrote that it was "one of Baltimore's great assets from both an artistic and historical point of view ... [and] recognized internationally as presenting a comprehensive overview of 19th century French academic art."[57] Johnston's description caught on and was repeated over and over again during the BMA's public relations campaign. "Great," "artistic," "historical," and "comprehensive" became the catchwords for describing the Lucas collection and for covering up any need to actually see it.

Johnston's statement also spawned the use of another word to describe the collection: "treasure." As in the title of Carter Brown's exhibition *Treasures of Tutankhamun,* the word "treasure" produced in many people's minds a picture of great wealth that had been hidden for a long time. To accentuate the significance of Lucas's alleged treasure, the adjective "irreplaceable" was used. In the 1990s, the leaders of the BMA began describing the collection as an "irreplaceable treasure," and the Walters followed suit, calling it an "irreplaceable art treasure."[58]

In June 1991, Johnston retained Faith Holland to research and draft a flattering

description of the history and importance of the Lucas collection that could serve as the BMA's response to the Klitzke report. A graduate of Radcliffe and highly respected for her intellect and knowledge about art, Holland had been employed for many years as a spokesperson and director of public relations for the museum.[59] Holland worked on the project throughout the summer and early fall. In October, she submitted a thirty-page draft of her report to Johnston. As Johnston and Richardson pored over the draft, they recognized that it contained many uncomfortable facts that were not on message and needed to be erased.

According to Holland's report, "There is no evidence that George Lucas had any particular interest in the training or education of young artists." She further found that as late as 1908, he "continued to fret about the final destination of his art." Based on her research, Holland wrote that Lucas had wanted Henry Walters to acquire his art collection and place it in his new gallery but that Walters did not accept because its "contents did not particularly interest him." Turning to more recent times, Holland found that the Maryland Institute had ceased using the Lucas collection for educational purposes. "Some MICA catalogue/announcements of recent years have not even mentioned the Collection, its present location, or its accessibility to students," she wrote.[60]

Because these and other findings in Holland's draft were out of sync with the kind of laudatory description the BMA planned to use to rebut the Klitzke report, Richardson and Johnston decided to abandon most of what Holland had written and to rewrite the report. They reduced it from thirty to ten pages and separated it into two parts. The first and most important part was a three-page letter to the public that glorified the Lucas collection and was to be signed by J. Carter Brown. The second part was an abbreviated seven-page summary of supplemental information about the use of the collection. Both parts were reviewed by Richardson, who also, in her words, "keyboarded the final report."[61]

The letter supposedly authored by Brown was finalized on December 6, 1991, and promptly submitted to him for his signature. Designated "An Open Letter to The Citizens of Maryland," it opened, "I am writing today about a matter of some urgency, involving a threat to the cultural and artistic heritage of Baltimore and Maryland: the potential dispersal of all or part of the George A. Lucas Collection of the Maryland Institute, College of Art." Thereafter, the letter was artfully stitched together with exaggerations that bore little resemblance to the truth. They included the following three claims: (1) "the BMA from the earliest stages of its own development built its permanent collections around the strengths of the Lucas holdings"; (2) the Lucas collection "is today recognized both nationally and internationally as a remarkably inclusive resource recording the progress of art in 19th-century France"; and (3) "through exhibitions, publications, education programs and loans, these [the Lucas collection's] riches have been made accessible locally, nationally and internationally." Brown's letter closed with these words of caution: "Dispersal of any part of this unique assemblage which comprises an acclaimed artistic and scholarly resource

would be a loss to art lovers everywhere." Without changing a word and apparently without ever seeing the Lucas collection, Brown signed the letter.[62]

It is hard to find much support for the farfetched claim made in Brown's letter that the BMA "built its permanent collections around the strengths of the Lucas collection." No such claim had ever been made in any book or article about the history of the BMA.[63] The museum's oil paintings by such European masters as Botticelli, Raphael, Titian, Hals, van Dyck, and Rembrandt that were given to the BMA by Jacob Epstein and Mary Frick Jacobs comprised a collection that was certainly not inspired or in any way "built" upon the Lucas collection of small French paintings and prints. Nor did the museum' s permanent holdings of Roman mosaics from the ancient Syrian city of Antioch have anything to do with Lucas. Nor had its accumulation of African, Asian, Native American, and American decorative art been "built" on the Lucas collection. There also is no evidence that the great gift of Claribel and Etta Cone of their magnificent collection of impressionist and modern art by Gauguin, Matisse, Picasso, and others was in any way inspired or in any way "built around the strengths" of the Lucas collection. The Cone sisters did not know Lucas and probably would have frowned upon his conservative taste.[64] The Lucas collection did not play any decisive role in the creation of the beautifully landscaped sculpture garden in which the masterworks of twentieth-century sculpture are on display. And, perhaps most importantly, it played no role in attracting Brenda Richardson to the BMA in 1975 to acquire and curate the permanent collections of abstract, minimalist, conceptual, and other forms of contemporary art. Richardson had little interest in or knowledge about the Lucas collection at that time.[65]

The claim in Brown's letter that the Lucas collection was "recognized . . . internationally" was also fictitious. Relatively few of its thousands of works of art had ever been exhibited abroad. Moreover, no books or articles about the Lucas collection had ever been written outside of the United States. And the notion advanced in Brown's letter that it was a "remarkably inclusive resource recording the progress of art in 19th-century France" was also a distortion. The Lucas collection concentrated on conservative mid-nineteenth-century art and intentionally did not include impressionist paintings. While there were ample reasons to praise the Lucas collection, the suggestion that it recorded the progress of art during the entire century was off track.

On December 10, 1991, the BMA submitted Brown's letter to the Maryland Institute, claiming that this letter, like the testimony of a great expert witness, proved "the singular historical and aesthetic importance of the collection."[66] A copy was sent to the *Baltimore Sun,* and as anticipated, three days later the newspaper quoted Brown's letter and asserted that it represented the best evidence as to why the collection should not be sold.[67]

Brown's letter became the BMA's and the Walters' banner for glorifying the Lucas collection and opposing its sale. It also opened the door to even greater embellishments. Arnold Lehman told the *New York Times* that the Lucas collection was "among the greatest single holdings of French art in the country."[68] He also inflated its impor-

tance in a memorandum sent to the members of the American Association of Museum Directors in which he claimed, "The Lucas Collection is not only a collection of art; it is a reflection of the history of 19th century France."[69] While this collection, together with his books, ephemera, and diary provide a unique view of art in France during the middle of the nineteenth century, to suggest that it also reflects the complex political, military, economic, and cultural history of France during the entire century evidences a willingness to exaggerate the collection's importance in order to keep it afloat.

Perhaps the most amazing thing about all of these dubious claims about the aesthetic and historical greatness of the Lucas collection was that no one challenged them. Because the praise came from revered curators and directors of major museums, it was treated as gospel and repeated by others. Thus it became an article of faith in Baltimore and beyond that the Lucas Collection not only was unique but also was one of the greatest cultural treasures that ever belonged to Baltimore or any other city.

◆ ◆ ◆

The public relations campaign was remarkably successful. The glorification of the Lucas collection was widely accepted. The campaign against its sale garnered the support of the press, obtained the allegiance of museum directors and scholars across the country, influenced the teachers and students at the Institute to stand with the BMA, convinced local artists and art lovers to write letters in protest, and received the endorsement of an active and influential organization called the Art Seminar Group, whose large membership was devoted to the study and support of the arts in Baltimore. Most importantly, it captured the attention of city and state political leaders and a judge who had the power and authority to prevent the collection from leaving. The public relations campaign orchestrated by Lehman, Richardson, and Johnston tied the collection to Baltimore and saved it for the city.

The *Baltimore Sun* became the BMA's principal ally. It published a series of articles and editorials that parroted the claims invented by the BMA and openly expressed its belligerence toward the Institute's plan to sell the collection. On October 14, 1990, John Dorsey indicated in the *Sun* that he had undergone a remarkable conversion. Three years earlier he had dismissed the collection as merely traditional "pretty pictures" that broke no new ground; now, in an about-face, he wrote that the sale of the Lucas collection "would constitute the greatest loss in the history of the fine arts in Baltimore." He concluded that to sell it would be an act that "Baltimore could neither forget or forgive."[70]

The most powerful statement against the sale printed in the *Baltimore Sun,* however, was not written by a reporter or editor but by a beloved and important member of the Institute's own family. Eugene "Bud" Leake had been the president of the Maryland Institute from 1961 to 1974. A graduate of Yale and a celebrated landscape painter, Leake was an inspiration to students and faculty. Because his own style of painting was influenced by landscapists such as Rousseau and Corot, Leake felt as if

he had a personal connection to Lucas's collection. Never afraid of speaking his mind, he wrote a passionate letter to the editor, letting everyone know where he stood.

> If the Maryland Institute College of Art decides to sell the Lucas Collection . . . the art resources of Baltimore will be sadly diminished. We will all be losers—the museums, the Institute and the public. . . . As a former president of the Institute, I do not want to interfere with decisions made by the current very successful administration, but as an artist I must shout from the roof tops: don't do it! . . . If the collection is sold, this community will be poorer in spirit, poorer in fact, and George Lucas will be poorest of all with his unique gift to the Institute scattered to the winds.[71]

Other letters opposing the sale began to pour in to the *Sun.* Several were from faculty who, to the Institute's dismay, had joined together in revolt against the plan to sell the collection. Calling themselves "The Ad Hoc Faculty Lucas Committee," the group included Norman Carlberg, an internationally acclaimed sculptor whose work was in the collections of the Whitney, the Guggenheim, the Hirshhorn, and the BMA. A graduate of the Yale School of Art, Carlberg in 1961 became the chair of the Institute's Rinehart School of Sculpture and remained in this position for thirty-five years. In a letter that likely knocked the breath out of the leaders of the Maryland Institute, Carlberg argued that because the Institute had failed to care for the Lucas collection and had placed it in the care and custody of the BMA, the BMA "may have a greater moral right to the collection than does the Maryland Institute." He asserted that "honesty and justice" precluded the Institute from selling it. On May 1, 1992, Carlberg's letter was submitted to Fred Lazarus, the Institute's president, together with a memorandum from the Ad Hoc Faculty Committee announcing that it had "voted unanimously against selling the Lucas collection."[72]

◆ ◆ ◆

In the midst of the campaign, Sona Johnston conceived of an exhibition that sought to visually demonstrate the collection's importance. Entitled *Parallels and Precedents: Baltimore's George A. Lucas Collection in Context,* its purpose was to promote the idea that the Barbizon landscapes and other works in the collection were the progenitors of the more famous impressionist and modern art in the Cone collection and that therefore they were tied inseparably together. To this end, Johnston juxtaposed landscapes by Corot, Jongkind, and Boudin with impressionist paintings by Pissarro and Monet. This idea was premised on the widely held belief among art historians that Barbizon school landscapes paved the way for the development of the plein-air paintings of the impressionists. Johnston subsequently sought to stretch this claim even further, asserting that the Lucas collection led not only to impressionism but also to contemporary art. "There is a flow," she claimed, "from the Lucas collection into the Cone collection into the Saidie May collection and into contemporary and modern art."[73]

Although it sounded good, her theory collided with the writings and analyses of

earlier curators, especially the BMA's former chief curator Gertrude Rosenthal, who had observed that the Lucas collection contained the kind of art "against which the inaugurators of modern art *rebelled*" (emphasis added).[74] Nevertheless, the press and the public enthusiastically embraced Johnston's idea. The grand opening of *Parallels and Precedents* was packed with art lovers, art patrons, public figures, and the movers and shakers of Baltimore and the state of Maryland, who joined the chorus and collectively demanded that the Lucas collection be saved for Baltimore.

Dorsey, in a glowing article, characterized the show as "Exhibit A" in the battle to save the Lucas collection. And echoing the theme of the exhibition, he argued that the Lucas, Cone, and Walters collections of French art were tied inextricably together and that the loss of one would damage the others. He concluded with this dramatic warning: "If the [Lucas] collection leaves our community . . . we will have lost part of our civilization that we can never regain."[75]

◆ ◆ ◆

It was increasingly clear that the BMA's campaign had succeeded in capturing the support of the public. The Maryland Institute had taken a hit, and its leaders knew it. It did not, however, cause them to retreat. Sheila Riggs found additional grounds for resisting the onslaught. She discovered that the BMA and the Walters, while vigorously opposing the Maryland Institute's sale of the Lucas collection, had sold many important works of art from their own collections. In the early 1990s, the BMA sold over one hundred paintings that had belonged to its Saidie A. May collection, including works by Delacroix, Dufy, Gris, Renoir, and Rouault. This sale, according to the press, generated approximately $5 million. The Walters around the same time decided to auction through Sotheby's thirteen large pieces of ancient Roman sculpture, most of which had been acquired by Henry Walters in 1902 as part of the Massarenti collection.[76] Riggs considered the museums' decisions to auction their art while opposing the Maryland's Institute's proposed sale to be highly hypocritical, and she brought this matter to the attention of Lazarus and the other trustees. They seized upon these auctions as precedent for their own contemplated sale of the Lucas collection, and it strengthened their resolve to proceed.[77]

Shelton, who in 1992 was elevated to board chairman of the Institute, viewed the success of the BMA's public relations campaign from a different perspective. Shelton believed that the BMA's glorification of the Lucas collection would ultimately be more beneficial to the Maryland Institute than to the BMA. His theory was that the more the Lucas collection was hyped, the more its value would grow and the more the BMA would ultimately have to pay the Institute to acquire it. Shelton's theory gradually turned into the Institute's strategy. Instead of minimizing the importance and value of the Lucas collection, the leaders of the Maryland Institute began to express their wholehearted agreement with the BMA about it. The strategy was framed by the Institute's consultants as follows: "It is our belief that MICA should encourage every possible positive statement about the value of the Lucas collection. . . . and un-

derscore our belief that it is up to the BMA and the Walters to provide leadership and resources to keep the collection in Baltimore."[78] As a result, both sides of the dispute over the Lucas collection joined together in singing its praises. There was not a word of doubt from any quarter about its alleged greatness, and its glorification was secure.

◆ ◆ ◆

In 1992, Neal Friedlander, a Harvard-trained lawyer, doctor, and community leader, joined the board. At his initial board meeting in January 1992, Friedlander had the confidence to take the floor and challenge the other trustees to take action. "I think that it is a breach of our fiduciary obligation," he asserted, "that we have not sold it." While the boldness of his statement surprised some trustees, Lazarus admired his candor, agreed with his stance, and promptly named him the new chair of the Art Asset Committee. In this capacity, Friedlander became the Institute's spokesperson. He was guided by his strong belief that the Maryland Institute over the course of generations had been and would continue to be a "good citizen" and one of the city's bright shining lights. Its primary obligation, as he told the public, was not to own art but to use its resources to enhance the school's curriculum, provide excellent facilities, expand scholarship opportunities, develop an outstanding faculty, and in general provide the best possible education for its students. Friedlander made it clear that the Institute's decision to sell the Lucas collection was grounded on these principled goals and would not be reversed.[79]

By the end of 1992, the battle lines were drawn. No compromise was in sight. The leaders of the Maryland Institute firmly believed that the Lucas collection was theirs, that they had the fiduciary obligation to sell it, and that they had the legal right to so. The BMA and the Walters, on the other hand, believed that the collection belonged to the community, that they as custodians had been entrusted with its care, and that it would be morally if not legally wrong to dispose of any painting, print, or other part of it. Each side believed that its position rested on holier ground than the other's. They were at an impasse, and there was little doubt that the controversy was heading toward litigation. The only question was which side would strike the first blow.

In Judge Kaplan's Court

On January 30, 1995, the trustees of the Maryland Institute gathered to vote on whether to pursue a lawsuit against the BMA and the Walters Art Gallery that would resolve any question about its right to sell all or part of the Lucas collection and dedicate the proceeds to the Institute's endowment. The meeting was only a formality, for the trustees had carefully explored their options and made the decision to proceed with the lawsuit a year earlier. During the interim, they had been getting ready for the battle. They had retained a top-notch litigator. A complaint seeking a declaratory judgment that the Maryland Institute owned the collection and had the right to sell it had been drafted and was ready to be filed. Board chair Robert Shelton had written a formal statement explaining the reasons for the lawsuit. Press releases were ready for distribution. Fred Lazarus had prepared a notice to the Institute's students, faculty, and staff. Individual trustees had written personal letters to VIPs whom they knew, and these were ready for delivery. Everything was in order. Only the formal vote of the trustees was needed to file the lawsuit and go to war. They all believed that they were doing the right, albeit difficult, thing, and when the unanimous vote was taken, they spontaneously stood and applauded together.[1]

The lawyer hired to represent the Maryland Institute, Benjamin Rosenberg, was listed in *Best Lawyers in America* and rated by *Baltimore Magazine* as one of the city's ten best attorneys. Rosenberg teamed up with two outstanding lawyers from the law firm of Covington & Burling: Harris Weinstein and Eugene Gulland. Weinstein had graduated from

Columbia Law School, where he was editor in chief of the law review; he had served as an assistant to the US solicitor general and specialized in complex civil litigation. Gulland was a graduate of Princeton and Yale Law School, was also recognized in *Best Lawyers in America,* and represented clients before the Supreme Court, as well as in trials across the country and around the world.

The BMA and the Walters would not be outgunned. The BMA retained Andy Graham, a Yale graduate with an LLB from NYU, who was widely considered Baltimore's finest litigator and the lawyer of choice in high-profile cases. Graham's partner and right-hand man in the lawsuit was Max Lauten, who had previously worked at the Department of Justice, where he had received its Outstanding Attorney Award. The Walters selected George Beall and Melvin Sykes. Beall was the former US attorney for Maryland and the senior partner in the Baltimore office of Hogan & Hartson. Sykes was a living legend who would be honored with a "Lifetime Achievement Award" from the American Association of Trial Lawyers. Based on the lineups on both sides, a lawyers' version of an all-star game was about to be played.

◆ ◆ ◆

The lawsuit that the Maryland Institute filed against the BMA and the Walters Art Museum was captioned, "Complaint for Declaratory Judgment." It requested the court to declare that the Maryland Institute had the legal right to sell the Lucas collection. In support of this request, the complaint alleged that (1) in 1909, George Lucas bequeathed his art collection to Henry Walters; (2) in 1910, Michael Jenkins, acting on behalf of Henry Walters, gave the collection as a gift to the Maryland Institute; (3) the words used in conveying the gift did not expressly prohibit the Maryland Institute from selling all or part of the collection; (4) in 1933, the Maryland Institute transferred the collection to the BMA with the express understanding that the Institute retained ownership and control of the collection; (5) the Institute's trustees decided that the collection no longer provided any significant educational benefit to the Institute's students and that greater educational benefits could be obtained by selling the collection; and (6) a dispute had arisen between the Maryland Institute and the BMA and the Walters over whether the Institute could sell the collection and that the court should resolve the dispute by declaring that it had the legal right to do so.

The Maryland Institute attached to its complaint the 1910 letter from Michael Jenkins conveying Henry Walters's gift of the Lucas collection to the Maryland Institute and the legal opinions of William Marbury and Richard Emory, both of whom concluded that the Maryland Institute had the legal right to sell the collection.[2] As reflected by the allegations and attachments, the Institute claimed that it was entitled to a judgment declaring that it had the right to sell the collection as a matter of law.

On April 3, 1995, the BMA and the Walters filed a joint response to the Maryland Institute's complaint. While the complaint relied primarily on the cold letter of the law, the response relied primarily on a commonsense notion of what was fair and equitable under the circumstances. The BMA and the Walters challenged the Mary-

land Institute's claim that Jenkins's letter gave the Institute the absolute right to sell the collection, arguing that the language in that letter and the words used by the Institute's president in accepting the gift implied that the Lucas collection would forever be held in trust for the students and people in Baltimore and the state of Maryland. More specifically, they pointed to the language in Jenkins's letter that stated the collection was intended to "serve as a *continuing* example and incentive to earnest ambitious effort of Art Students in your care" and that the collection was "placed in your charge to be dedicated to sincere art education in his [George Lucas's] native city" (emphasis added). And most importantly, they noted that the president had announced that the Institute was accepting it as a "*trusteeship* for the people of our city and State and for lovers and students of art" (emphasis added).

These expressions of intent, the museums contended, meant that the Lucas collection was given to the Maryland Institute not as an absolute gift that could be disposed of at the Institute's pleasure but as a charitable trust that was to be held by the Institute for the benefit of its students and more broadly for the people of Baltimore. The BMA and the Walters further contended that when, as in the present case, a trustee claims that it cannot carry out the original intent of the donor, a court, under a legal doctrine called cy pres (as near as possible), can devise and direct the trustee to do something similar. The bottom line of the cy pres argument was that in order to satisfy Lucas's and Walters's intent that the collection be used to benefit the people of Baltimore, the Maryland Institute should be prohibited from selling it and the collection should remain in the custody of the BMA and the Walters.[3]

The BMA coupled its answer with an unusual and creative counterclaim based on the doctrine of "unjust enrichment." Under this doctrine, a court could award monetary damages to a person or corporation if (1) it provided something of value to another person or corporation; (2) the recipient understood that it would benefit from what it received; and (3) it would be unjust under the circumstances for the recipient to retain the benefit without compensating the person or corporation that provided the benefit. Applying these conditions to the circumstances of the Lucas case, the BMA argued that over the course of sixty years, it had spent an inordinate amount of money storing, conserving, promoting, exhibiting, and otherwise caring for the Lucas collection in ways that substantially increased its value; that it had provided such care based on the reasonable belief that the Maryland Institute intended to permanently keep the collection intact at the BMA and preserve it for the citizens of Baltimore; that it would be extremely inequitable for the Maryland Institute to sell the collection and pocket all of the proceeds leaving the BMA with nothing in return; and that therefore, if the Maryland Institute were permitted to sell the collection, all of the proceeds from that sale should go to the BMA as a form of compensation for all the work that it had performed.

Both the strength and the weakness of the claim for unjust enrichment rested in its ingenuity. In the world of museums, there was no precedent for it. It was well es-

tablished that the terms that governed loans of art to museums were ordinarily discussed and determined in advance of the loan, not afterward. Yet the BMA had never requested the Maryland Institute to compensate it for caring for the Lucas collection. As one highly experienced expert in the field of museum policies, standards, and practices opined, a belated demand by a museum for compensation for caring for a collection of art that it did not own was "contrary to museum, policy practice and standards."[4]

Notwithstanding the unusual nature of its claim, the BMA's answer and its counterclaim for unjust enrichment were appealing. They provided alternative theories based on law and equity for keeping the Lucas collection in Baltimore. They requested the court either to reject the Maryland Institute's claim that it owned and could sell the Lucas collection or to require the Institute to compensate the BMA, in which event the museum would use these funds to purchase and house the Lucas collection. In either case, the collection would remain an instrumental part of the city's culture.

◆ ◆ ◆

Joseph H. H. Kaplan was a judge who many believed possessed the wisdom of Solomon. Both a scholar and a pragmatist, Kaplan carefully applied the law in the cases before him with a significant measure of common sense. After graduating from the University of Chicago Law School (where he was editor of the law review) and working as an assistant US attorney, Kaplan became a partner in the Baltimore law firm of Venable, Baetjer, and Howard. In 1977, at the age of forty, he was appointed to a judgeship on the circuit court for Baltimore City and thereafter elevated to administrative judge and then chief judge. Outside of his legal and judicial responsibilities, Kaplan became known for his devotion to the best interests of the city. On the basis of his service as president of the Baltimore Civil Service Commission and president of the Library Committee of the Bar Association, Kaplan was given a Distinguished Citizenship Award.[5]

Kaplan was also known for his fine taste and interest in art and culture. He was raised in a family of art and antique collectors, who passed down beautiful Oriental rugs from one generation to the next. He was a long-time member of both the BMA and the Walters Art Museum, and he became familiar with their collections. He closely followed the controversy that had erupted over the Lucas collection and was troubled by the apparently inability of the BMA, the Walters, and the Maryland Institute to resolve their differences and preserve the collection for Baltimore. Influenced by the reams of laudatory information about the Lucas collection disseminated by the BMA and printed in the *Baltimore Sun,* Kaplan subscribed to the view that the Lucas collection was one of the country's greatest collections of French art and one of Baltimore's greatest cultural assets.[6]

As a result of his position as the court's administrative judge, Kaplan had the authority to assign special cases to any of the twenty judges who served with him on the bench. In 1995, promptly after the Maryland Institute filed its complaint and the

BMA and the Walters answered it, Judge Kaplan reviewed the pleadings, recognized that the fate of the Lucas collection was at stake, and decided to appoint himself as the judge. Without hearing anything further from the parties, he made up his mind to do whatever he could to convince the parties to settle the case and retain the Lucas collection in Baltimore.

On May 9, 1995, Judge Kaplan conducted a preliminary conference with all of the parties. At the outset, he wanted to know whether anyone objected to him serving as the judge. As both sides recognized, Kaplan knew most of the players involved in the litigation and had previous professional ties with several of them. Three of the key figures on the Maryland Institute's side of the case had been Kaplan's partners at Venable. Kaplan had been a partner of Robert Shelton, the chairman of the board of the Maryland Institute; Ben Rosenberg, the Maryland Institute's primary lawyer; and Richard Emory, whose opinion letter was used by the Institute to support its case. Kaplan, however, also had been a partner of two key figures allied with the BMA and the Walters—Frank Murnaghan, who had served for many years as chairman of the board of the Walters, and Harry Shapiro, who was on the BMA board of trustees and served as its in-house counsel. Moreover, as he advised the parties, Kaplan for many years had been and remained a member of the BMA and the Walters. None of these associations appeared to upset the parties. Whatever conflicts existed, they seem to have been ironed out by Kaplan's connections to all sides of the controversy and his sterling reputation for resolving cases in a fair and even-handed manner. As a result, in response to Kaplan's inquiry about whether there were any objections to his presiding over the case, there was not a word of opposition.

◆ ◆ ◆

At the preliminary conference, Judge Kaplan urged the parties and their lawyers to promptly get together and try to settle the dispute. From that day forward he wore two interchangeable hats, one as the trial judge responsible for applying the law to the facts and ruling on the merits of the case, and the other as a mediator who used his judicial power to bring the parties together and convince them to settle. With the goal of obtaining a quick settlement, Judge Kaplan informed the lawyers at the conference that they could not engage in discovery until he had ruled on a motion by the Maryland Institute based solely on the pleadings that sought a judgment from the court that it owned and could sell the collection. He hoped that the threat of quickly losing the case would prompt the BMA and the Walters to settle.

The strategy proved futile. The museums refused to budge. After the initial court conference, the president of the Maryland Institute conveyed to the BMA and the Walters the Institute's willingness to sell the collection to them and thereby preserve it for Baltimore. The idea, however, was flatly rejected. Several key members of the BMA's board, including its in-house counsel, viewed the proposal as blackmail. Arnold Lehman, the BMA's director, responded that the Institute's proposal that the museum buy the Lucas collection was analogous to a demand by an uncaring biolog-

ical parent to a loving adoptive parent, who had protected and nurtured a child into adulthood for sixty-two years, to buy the healthy person whom it had raised.[7] Lehman made it clear that the BMA would not pay a cent to the Maryland Institute. After waiting hopefully for a more positive response, Fred Lazarus, the Institute's president, issued the following statement to the press: "If the museums believe that the Lucas collection is so important and that it should remain in Baltimore, then they should do as they have done in the past when they have wished to acquire works of art—raise the necessary funds and purchase it."[8]

With the parties at a stalemate, the court on September 27, 1995, conducted a hearing on the Maryland Institute's motion for a judgment in its favor based on the undisputed allegations in the pleadings. After listening to the arguments on the merits of this motion, Judge Kaplan turned to the issue that was primarily on his mind— how to convince the parties to settle the matter. As he undoubtedly was aware, Baltimore mayor Kurt Schmoke had recently written a letter stating that "it was in the best interest of the city and the arts community for the George A. Lucas Collection to stay in Baltimore [and that] I am sure that reasonable people, working together, can devise a plan to achieve the dual goals of strengthening the financial condition of the Maryland Institute and preserving a significant asset in Baltimore's cultural heritage."[9]

Judge Kaplan suggested to the lawyers that he was amenable to postponing any decision on the Institute's motion if the parties wanted time to explore whether the mayor would become involved in the case and contribute city funds to purchase and thereby save the Lucas collection. In response, the Maryland Institute's attorney observed that the city was strapped for money and unless the court indicated that the Institute had the right to sell the Lucas collection, the mayor would have no incentive to use the city's sparse resources to buy it. With neither side expressing any interest in actively pursuing this avenue for settlement, Judge Kaplan replied that he would be handing down his decision shortly.[10]

• • •

Counsel for the BMA and the Walters were confident that they had defeated the Maryland Institute's motion. But much to their surprise, Judge Kaplan declared that the Institute owned and had the right to sell the collection. In his opinion and order, Judge Kaplan focused on Michael Jenkins's short three-paragraph letter that purportedly was written on behalf of Henry Walters and that gave the Lucas collection to the Institute. The basic question before the court was whether this letter provided the Institute with a gift that it could use or sell at its discretion or whether the letter presented the Institute with a gift whose use was expressly limited. As Judge Kaplan observed, under a well-established principle of Maryland property law, a gift that was in writing could not be rescinded unless it contained a clause (referred to as a "reversionary" or "gift over" clause) that expressly limited the use of the gift and provided that it would be rescinded or returned to the giver if the receiver used it for a prohibited purpose. Applying this principle, Judge Kaplan found that there was no provision

in Jenkins's letter that expressly prohibited the Maryland Institute from selling the Lucas collection and using its proceeds for the education of its students. As a result, the court declared that the Institute owned the Lucas collection and had the right to sell it.

This ruling, however, did not end the matter. The court also held that the Maryland Institute could not sell the collection until the court decided the BMA's counterclaim for unjust enrichment and whether the BMA was entitled to all or any of the proceeds from such a sale. Judge Kaplan's decision effectively placed the collection in limbo and kept pressure on both sides to get together and sensibly resolve their dispute. But again his approach did not immediately achieve its desired result. The BMA and the Walters were up in arms over his decision that the Institute owned the collection and could sell it. From his office in the Fourth Circuit Court of Appeals, Judge Murnaghan wrote a letter to Mel Sykes in which he strongly criticized Kaplan's decision and fed the belief that it could be overturned on appeal.[11] In an interview with the *Baltimore Sun,* Lehman compared Kaplan's ruling to the infamous decision and action by Robert Irsay, the despised one-time owner of the Baltimore Colts, who took the city's beloved football team away from Baltimore and gave it to another city in the middle of the night.[12] Thus the BMA expressed its intent to pursue its claim for unjust enrichment without wasting a moment on settlement.

◆ ◆ ◆

Following the court's ruling, both sides proceeded to gauge how much money was at stake in their quarrel. The Maryland Institute contracted with Christie's and Sotheby's to obtain evaluations of the collection, and the BMA began to collect data from which it could calculate how much money it had spent over the years in caring for the Lucas collection and how much it could receive if it prevailed in its counterclaim of unjust enrichment.[13] Sotheby's evaluation, dated December 21, 1995, included some advice about the large collection of prints. It characterized the prints as the most "unique" aspect of the collection, "a collection unto itself" whose value if kept intact was greater than the sum of its thousands of individual prints. Sotheby's estimated that if sold together, the prints could bring $5 million at auction. The estimated auction price for the oil paintings was between $3,749,200 and $5,216,000. The total auction price for the entire collection (including the drawings, watercolors, sculpture, palettes, books, photographs, letters, and Asian art) was estimated at a low of $9,864,010 and a high of $13,587,547.[14]

Christie's evaluation of the entire collection was approximately $1 million less than Sotheby's. The major difference involved the prints, which Christie's candidly stated were difficult to evaluate because many of the artists were relatively unknown and their prints had no market value. Like Sotheby's, it suggested that the auction price of the prints would be higher if the collection of prints were sold as a whole. Christie's estimated that the entire collection would bring at auction a low of $8,912,040 and

a high of $12,663,920.[15] The Maryland Institute compared the estimates and found that the average low was $9,388,025 and the average high was $13,125,730. On this basis, the Institute concluded that the collection would likely generate at auction approximately $11,250,000, and it decided to offer the collection to the BMA and the Walters for this amount.[16]

The BMA faced a more challenging burden. In order to prevail on its unjust enrichment claim, it had to actually prove with concrete evidence that it had spent a considerable amount of money in caring for the Lucas collection, that it was not obligated to do this, and that, as a result of its expenditures, the Lucas collection had significantly increased in value. Brenda Richardson, who shouldered the burden of gathering the hard evidence, approached this task in three creative ways.[17] First, she estimated that the BMA had spent more than $40 million in caring for and promoting the Lucas collection over the course of sixty-two years. Based on a rough estimate that the number of works of art in the Lucas collection represented 20 percent of all of the works of art in the entire museum, Richardson claimed that 20 percent of all of the operating expenses of the museum over this extended period of time had been devoted to the Lucas collection. The obvious problem with this estimate was that it was skewed by the tremendous number of prints. Under this methodology, a practically worthless print by an unknown artist in the Lucas collection was counted the same and assumed to have received the same care and attention as the BMA's prized painting by Rembrandt.

Richardson's second approach rested on what was characterized as "direct expenses" that the BMA allegedly incurred in conserving, exhibiting, storing, publishing, and teaching courses about the Lucas collection.[18] These expenses purportedly amounted to over $3.2 million and were divided into five main categories: (1) the wages and benefits paid to the museum's employees ($876,000); (2) the cost of exhibitions ($880,000); (3) the cost of conservation, including the purchase and maintenance of the museum's climate-controlled environment ($300,000); (4) the costs entailed in loaning the art back to the Maryland Institute or to other museums ($644,000); and (5) the cost of publications that mentioned the art in the Lucas collection ($244,508).

The basic problem with this claim was that there was little hard evidence to support it. The BMA had no line items in any budget for expenses that specifically referred to the Lucas collection. Nor had any employee kept any records of the time spent caring for the Lucas collection. Consequently, the BMA again had to determine the amount of money that it had spent overall for everything in the museum in each of these five categories and then estimate how much of that amount was applicable to its care of the Lucas collection. Aside from the guesswork involved, the biggest flaw in this approach was that a giant share of these expenses, such as the salaries of its curators and conservators, would have been incurred by the BMA even had the Lucas collection not been there.

The BMA's third approach to estimating its expenditures was based on a comparison of the estimated value of the Lucas collection in 1996—around $11.25 million, using the estimates from Sotheby's and Christie's—with the much lower estimate of around $2.2 million that had been made nineteen years earlier. The dramatic increase in value since 1977, Richardson argued, was due entirely to the BMA's care of the Lucas collection.[19] The problem with this opinion was that it was unsupported by any hard evidence and was undermined by the testimony of the BMA's own expert witnesses.

During the process of discovery, it became painfully evident that the BMA did not have sufficient facts to support its claim of unjust enrichment. The BMA's own director and curators admitted that the museum had a basic obligation to provide the same level of care for art on loan to it as it did for the art that it owned. In conformity with this standard, the BMA's loan agreements specifically provided that it "will exercise the same care with respect to loans as it does in the safekeeping of its own property." The BMA's primary expert witness, a former president of the American Association of Museum Directors, likewise testified that in accordance with professional standards, museums were expected to treat and care for objects that they had borrowed in the same basic way that they treated objects that they owned.[20] As a result of its professional responsibilities, the BMA had no basis for claiming that the Maryland Institute was unjustly enriched by all of the care the museum had given to the Lucas collection. Instead, it had to limit its claim to any care and attention given to the Lucas collection that exceeded basic expectations under well-established museum standards.

It became increasingly clear that the BMA would have a very difficult time meeting this test. One of its primary expert witnesses conceded that he had made no analysis and could not state what percentage of the BMA's care of the Lucas collection exceeded the customary care and attention expected of a museum.[21] Furthermore, the BMA's records indicated that the museum had provided significantly *less* care to the Lucas collection, including its prints, than it provided to other collections of the same kind of art.[22] As a result, the BMA could prove that it had spent money in caring for the Lucas collection, but it was without any concrete proof that such expenditures went beyond what was ordinarily expected under professional standards.

The BMA's claim that the work of its staff had substantially increased the value of the Lucas collection was also undermined by the common understanding that the value of art was determined in large measure by the gyrations of the art market. Tom Freudenheim, who had served as the BMA's director from 1971 to 1978, opined that the value of the Lucas collection had increased but "not necessarily because of what the BMA has done."[23] Another witness that the BMA identified as an "expert" testified that the value of French mid-nineteenth-century art was influenced by the market. More specifically, he testified that in the last twenty years, similar French art had dramatically increased in value. By way of example, he testified that a work of French art that was worth $1,000 in 1975 could be worth $20,000 by 1995.[24] In light of this

expert's testimony, the BMA's factually unsupported argument that the increase in the value of the Lucas collection was due solely to the museum's care carried no weight.

◆ ◆ ◆

Recognizing the vulnerabilities in the BMA's counterclaim for unjust enrichment, on March 8, 1996, the Maryland Institute filed a motion for summary judgment, claiming that there was no dispute about the material facts and that it was entitled to judgment in its favor as a matter of law against the BMA's claim of unjust enrichment. On April 22, 1996, a hearing on the motion was held before Judge Kaplan. Two days later, on April 24, Judge Kaplan issued his ruling.

The court's decision turned on whether the BMA was contractually required to provide the care that it claimed unjustly enriched the Institute. In deciding this matter, Judge Kaplan carefully examined the language in the two separate agreements that had resulted in the loan of the prints and then the loan of the paintings, watercolors, and drawings to the BMA in 1933. He found that the agreement that covered the loan of the paintings specifically required the BMA "to put the paintings in proper condition, and agree to pay the cost of necessary repairs, and to keep the collection in proper condition." The court found that in light of its express agreement to pay for the care of the paintings, the BMA could not escape its obligation to bear these costs. Accordingly, it dismissed the BMA's claim for unjust enrichment with regard to its care of the paintings.

On the other hand, because the same provision was not found in the loan agreement involving the prints, the sculpture, and the palettes, the court allowed these components of the BMA's counterclaim to proceed to trial. Both sides declared that the ruling was a victory and vowed not to give up the fight.[25] But in reality, the BMA's remaining claim for unjust enrichment was slipping away. The court noted in its opinion that three of the BMA's witnesses admitted that in accordance with museum standards, the BMA was required to provide the same degree of care for objects that were on loan as for objects that it owned. In this light, the court cautioned the BMA that it would have to prove at trial that its care of the prints, sculpture, and palettes in the Lucas collection went "beyond" or, in other words, was much better than the care that it provided to the rest of its art.[26] Given that the BMA had kept practically all of the Lucas collection in storage and had paid little attention to it for years on end, this was a burden of proof that the BMA was highly unlikely able to carry.

Judge Kaplan's decision to dismiss the BMA's claim for unjust enrichment pertaining to the paintings but to allow the remaining claim pertaining to the prints to proceed to trial had the purpose of persuading the parties to make a last-ditch effort to settle. Both sides remained at risk. The Maryland Institute still had to cross a final hurdle at trial in order to sell the Lucas collection. It also faced the possibility of an appeal that might overturn the decisions that had been rendered in its favor.

The BMA was in a much more precarious position. It had lost the battle over whether the Institute could sell the collection, had lost the battle over whether it was

entitled under the doctrine of unjust enrichment to the proceeds from the Institute's sale of its paintings, and was facing a steep uphill battle to prove that it had provided special care for the Lucas collection of prints, sculpture, and palettes that had resulted in a quantifiable increase in their value. As its leaders and lawyers reluctantly realized, the BMA had a far better chance of saving all or part of the Lucas collection by settling the case instead of proceeding to trial.

Lucas Saved

At the height of the battle over the Lucas collection, the city of Baltimore was struggling with important, much tougher issues. These included the adverse impact of a recession and declining economy, the loss of jobs, the departure of major businesses, the fall in family income, the chronic unsolved problem of de facto segregation in the city's schools and neighborhoods, an increase in crime, and the need for more social services at a time of dwindling governmental resources. Between 1970 and 1990, the city's population had dropped from about 900,000 to 700,000. The number of manufacturing jobs had been sliced in half. By 1992, the unemployment rate had swelled to 9.4 percent. Federal aid to Baltimore, which in 1980 supported 39 percent of the city's budget, had precipitously dropped to 12.5 percent. Baltimore, as described in one report, was "in serious decline."[1] And on September 22, 1992, the *Sun* offered this depressing headline: "City Pinched as Its Citizens' Income Drops—Recession Blamed but So Is Continued Flight to the Suburbs."[2] In the context of these serious problems, concern about the fate of the Lucas collection might have seemed frivolous. And the leaders of Baltimore had reason to question whether anyone in the city should spend a dime or give a hoot about it.

The question was answered that same year by a short incisive report, *Building Community: The Arts and Baltimore Together,* by Ernest L. Boyer, the former US commissioner of education and president of the Carnegie Foundation. Boyer interviewed over fifty of the city's political, business, religious, charitable, educational, judicial, and cultural leaders. Although these leaders approached the subject of art from various per-

spectives, they were united in the view that Baltimore's deeply rooted cultural heritage remained vital to the health and spirit of the city. According to the report, the arts in Baltimore—including painting, sculpture, dance, and music—were what "cut across the separations" and held the city together.[3] Although the looming battle over the Lucas collection was not mentioned, the widespread interest among city and state leaders in preserving Baltimore's cultural heritage as documented in the report was what kept the Lucas collection afloat and ultimately saved it.

The report was commissioned and published by the Baltimore Community Foundation (BCF), an organization composed of business leaders and philanthropists dedicated to improving the quality of life in the city. Founded in 1972, BCF's support for the arts steadily increased in line with its growing assets. By 1992, when its assets reached $30 million, BCF announced that it would invest $1 million in a program that would improve art-related programs in the public schools. But among all of its activities that benefited the city, the one that earned BCF the most attention and the highest accolades was the action it took to settle the Lucas litigation.

◆ ◆ ◆

During the 1990s, Janet and Edward (Eddie) Dunn were among the city's most active and philanthropic citizens and supporters of the arts. For over thirty years, Janet had been actively involved with the BMA. She served as a docent from 1960 to 1973, became a trustee in 1989, and served as president of the museum's Print and Drawing Society from 1992 to 1994. Under the tutelage of Jay Fisher, whom she idolized, Dunn became very familiar with the Lucas collection of prints and quietly became its guardian. In September 1995, when Judge Kaplan ruled that the Maryland Institute had the right to sell the Lucas collection, she apprehended that the prints were on the verge of being lost, and she was equally fearful that their loss would result in the departure of Fisher. Compelled to take some action to stop this from happening, Dunn turned to her husband Eddie for help.

Eddie Dunn was president of the Mercantile Bank and Trust Company, the oldest bank in the city, and chairman of the Baltimore Community Foundation. Mindful of the BCF's active role in supporting the arts, Janet urged Eddie to get the foundation involved in the dispute and to help save the Lucas collection for Baltimore.[4] Around the same time, Eddie Dunn also was contacted by Fred Lazarus, the president of the Maryland Institute. Although the Institute had obtained from Judge Kaplan the authorization to auction or otherwise sell the collection, Lazarus's goal was to sell it to the BMA and keep the collection in Baltimore. The problem was that the BMA would not offer any money to buy it. Lazarus wanted Dunn and the BCF to broker a deal that would satisfy both the Institute's right and need to sell the collection in order to enhance its endowment and the BMA's correlative interest in owning the collection and preserving it as part of the city's cultural heritage.[5]

Dunn promptly scheduled a meeting with the two other leaders of BCF, Vice Chairman Calman "Buddy" Zamoiski and President and Chief Operating Officer

Tim Armbruster. With a doctorate in political science and public management, Armbruster arrived in Baltimore in 1979 to serve as the director of the Goldseker Foundation, and ten years later he assumed the presidency of BCF. Over the years, Armbruster quietly played a key role in shaping Baltimore's urban policies and channeled millions of dollars to nonprofits devoted to improving the city's health, education, and welfare. Among his peers, Armbruster became known as an "unsung hero" and one of the city's "grand visionaries."[6]

Although Armbruster was the most cerebral of the BCF leaders, Zamoiski was the most influential. He knew practically every political leader in the city and the state and was instrumental in helping the highest ranking among them, including Maryland governor Parris Glendening, gain office. Every door in Annapolis (Maryland's capital), it was believed, was open to him, and once inside, his persuasiveness dissolved any opposition to what he was after.[7] As a philanthropist and civic leader, Zamoiski's primary interest was in the field of culture. From 1978 to 1983, he served as chairman of the board of the BMA, which in recognition of his leadership and generosity named the entrance to the museum after him. Despite his close connection to the BMA, both sides in the dispute over the Lucas collection sought his advice and active involvement. He considered himself to be a "free agent."[8]

In the fall of 1995, when Zamoiski initially became involved in the dispute, he knew nothing about the art in the Lucas collection. During the late 1970s and early 1980s, when he was chairman of the BMA's board, hardly anyone paid any attention to it. Needing to learn something about it, Zamoiski was briefed by the BMA's chief curator Brenda Richardson. She described its importance to Baltimore and, as Zamoiski recalled, "made everyone think it was the greatest collection in the world." Zamoiski adopted her script and likewise began to sing the collection's praises in his effort to entice political and community leaders to help save the collection.[9]

BCF's overarching goal was to broker a deal that would keep the Lucas collection in Baltimore. As Zamoiski and the other BCF leaders quickly learned, this was much easier said than done. On December 22, 1995, Robert Shelton, the chairman of the Maryland Institute, sent a letter to Dunn in which he thanked the BCF for trying to find a way to keep the Lucas collection in Baltimore and offered to sell it to the BMA and the Walters for $11.25 million, an amount based on the appraisals that the Institute had received from Sotheby's and Christie's. The proposal, however, generated no counter offer or expressions of interest from the museums. Dunn, Armbruster, and Zamoiski reached the conclusion that the only way to fill the $11.25 million gap and save the collection was for the state of Maryland and the BCF to step in.

The BCF devised a plan under which the state of Maryland would purchase the Lucas collection and become its owner, BCF would contribute $100,000 toward its purchase and become its sole trustee, and the BMA and the Walters would be allowed to retain and display the collection for the benefit of the public.[10] The plan obviously depended on the willingness of Governor Glendening to commit state funds for this purpose, and it depended as well on Zamoiski's ability to convince him to do so.

In December 1995, Zamoiski, along with Dunn and Armbruster, met with Glendening in the governor's mansion in Annapolis. They briefed him on the importance of the Lucas collection, Judge Kaplan's decision that the Maryland Institute could sell it, and the likelihood that it would be lost as a result of the litigation. Afterward, Zamoiski and Glendening continued the conversation over lunch at the governor's favorite Italian restaurant. Zamoiski told the governor that "we can't afford to lose this collection and you need to rescue it." Glendening, however, was distracted by more pressing economic issues and declined to commit any state funds for this purpose. Although disappointed, Zamoiski was unwilling to give up. He turned to another friend in Annapolis: Frances Glendening, the governor's wife.[11]

Zamoiski was well aware of Frances Glendening's knowledge of and passion for the arts. In college, she had been a serious student of art history, and after her husband became governor, she initiated a statewide program of art exhibitions for adults and children called "Celebrating Art in Maryland." When visiting the BMA and the Walters Art Museum, she was courted by Sona and William Johnston, who introduced her to the Lucas collection and converted her to being one of its champions. She was especially attracted to Breton's *Study for The Communicants,* one of the most interesting small sketches in the collection (plate 4). As a result, even before Frances met with Zamoiski, she was inclined to offer whatever assistance she could to save the collection. When Zamoiski informed Frances about his inability to obtain the governor's support and his need for her help, she quickly agreed.[12]

Frances Glendening doggedly began to pursue the issue with her husband. She told him that it would be a "travesty" if the Lucas collection were sold and the state of Maryland lost it. And in what was later characterized as "pillow talk," she convinced him to provide state money to rescue it. She became, as Armbruster and Zamoiski recognized, one of Lucas's most terrific allies.[13]

◆ ◆ ◆

Due in large measure to the influence of Zamoiski and Frances Glendening, in February 1996, Governor Glendening agreed to provide approximately $2.8 million in state funds to save the Lucas collection, with the understanding that the state and/or the BCF would own it and that the amount would be matched by funds raised by the BMA and the Walters. When Zamoiski conveyed this idea to the BMA and the Maryland Institute, it received a chilly reception. Continuing to insist that the Institute receive $11.25 million for the collection and nothing less, Shelton called the proposal a nonstarter. The BMA's response was even tougher. It not only remained unwilling to pay anything for the collection but was adamantly opposed to the idea of state and/or BCF ownership. Brenda Richardson, with the legal advice of the BMA's astute in-house counsel Harry Shapiro, prepared a persuasive six-page memorandum entitled "BMA/WAG Concerns to Potential Ownership," which asserted that the Lucas collection would be imperiled if it were subject to the political whims of state ownership or the inevitable changes in the BCF's leadership and goals. The BMA and

the Walters submitted the memorandum to Zamoiski and insisted on owning the collection as a part of any settlement.[14]

In late April 1996, the Maryland Institute offered a compromise. It informed the BCF and Judge Kaplan that it was willing to sell the entire collection of prints or other components that approximated one half of the Lucas collection for $5 million. Shelton wrote to Dunn that this compromise "would permit the museums to acquire those parts of the Lucas Collection that are most significant to them."[15] With the trial of the case scheduled to begin on May 13, 1996, and time for any settlement running out, Judge Kaplan decided to use this proposal as the springboard for restarting negotiations.

On May 6, the attorneys for both sides attended a pretrial conference in Judge Kaplan's court. Although such conferences ordinarily are used to discuss the schedule and procedures that will be followed at trial, Judge Kaplan used the conference instead to place pressure on the lawyers, especially the BMA's lawyers, to settle the case. The time had come, as Kaplan observed, to finally "take the bull by the horns."[16] Using the tactics of King Solomon, Kaplan told the BMA's attorneys that the collection had to be split. The BMA could retain the large collection of prints and the Barye bronzes, but the BMA had to relinquish its claim to the three hundred paintings. He instructed the BMA's lawyers to return in two days with their client for a settlement conference, at which time the BMA would have "to be prepared to say what portions of the collection should be saved."[17]

Before concluding the pretrial conference, Judge Kaplan issued a warning to the BMA's lawyers. He told them that they were on the verge of losing the case. He reminded them that any claim for unjust enrichment involving the paintings, watercolors, and drawings had been dismissed. And to increase their anxiety, he cautioned them that the evidence that they submitted at trial pertaining to the prints and sculpture could not be based on speculation. As reflected in the notes of the BMA's attorneys, Judge Kaplan's remarks left them with the impression that he was placing "gun to head" and that things did "not bode well for recovery."[18]

On May 8, the lawyers and representatives of the Maryland Institute, the BMA, and the Walters assembled in Judge Kaplan's courtroom for the settlement conference. The BMA was represented by Connie Caplan, Dennis Shaughnessy, Frank Burch, and Harry Shapiro; the Walters by Gary Vikan; and the Maryland Institute by Robert Shelton, Neal Friedlander, and LeRoy Hoffberger. Individually, they were highly distinguished doctors, lawyers, business leaders, venture capitalists, philanthropists, art collectors, and museum officials. But collectively, the most significant characteristic of this gathering of adversaries was their practicality. They were not zealots but problem solvers who realistically had sized up the situation, understood the risks of litigation, and were anxious to make a deal.

Caplan had taken charge of the BMA contingent. She felt that the time for arguing was over. From her perspective, the dispute over the Lucas collection no longer was a battle to be won or lost but a problem that needed to be solved without either

side claiming victory or defeat. The offer on the table was enticing. It enabled the BMA to retain the collection of prints and the Barye bronzes without paying the $5 million that the Maryland Institute wanted for this art. As explained by Judge Kaplan, the state of Maryland would pay half of the $5 million, and the other half would be raised by the BFC. The BMA's lawyers and representatives huddled to consider the offer. According to one account, most were "ecstatic" about the prospects for settlement. A consensus among the BMA representatives was forming to take the deal, even though it would leave all of the oil paintings, watercolors, and drawings behind. In the interests of settling the litigation, the Lucas collection at that moment came within a breath of being split apart and as a unified collection forever destroyed.[19]

A few words of caution prevented this from happening. Caplan suggested that the proposal be tabled until the BMA's curators, in particular Jay Fisher and Sona Johnston, were consulted to "determine what we really want." It was a decision that called for the application of their expertise and not the unilateral judgment of the members of the museum's board. At Caplan's request, the BMA's attorneys obtained from the court a two-day postponement of the trial to provide the parties with more time to further consider the issues and try to settle the case.[20]

The idea of somehow splitting the collection between the prints, sculpture, drawings, and paintings, as Caplan quickly realized, would have had devastating consequences to the panoramic picture of mid-nineteenth-century French art provided by the collection as a whole. As luck would have it, forty-eight hours later, on the evening of May 10, Caplan ran into Lazarus at a cocktail party. Although they were in leadership positions on opposite sides of the controversy, they remained friends and retained great respect and admiration for one another. They decided to take a break from the party, place their differences aside, and figure out how to promptly and sensibly settle the case. Caplan had reevaluated whether the Lucas collection should be split and concluded that the entire collection needed to stay in the city. Moreover, she was willing to shoulder a large part of the effort to make this happen. During her conversation with Lazarus, Caplan indicated that the BMA might be willing to pay the Maryland Institute a reasonable amount of money to acquire it. Despite the informality of the setting and her offer, it amounted to a break-through moment. It was the first time in the long and contentious battle over the collection that the BMA had offered to pay some amount of money for the collection. It took only five more days before the case was settled.[21]

Caplan's step toward settlement motivated Lazarus to compromise as well. Although the Maryland Institute was winning the case, Lazarus sensibly was concerned that the Institute's reputation in the community would be tarnished if the matter were not settled in a way that preserved the collection for Baltimore. He understood that the BMA could not raise $11.25 million to pay for the entire collection, that the Institute had to reduce its demand, and that more matching funds from the state would be needed to effectuate a deal. That evening he contacted Shelton to inform him about his discussion with Caplan and the improved prospects for settlement. He

also asked Shelton to contact Howard "Pete" Rawlings and solicit his assistance in obtaining more money from the state.

Rawlings represented Baltimore in the Maryland House of Delegates and occupied the powerful position of chairman of the State Appropriations Committee. As a former trustee of the Maryland Institute, he kept an eye out for its interests. Shelton met with Rawlings over dinner and briefed him on the status of the negotiations. Most importantly, he obtained Rawlings's commitment to sponsor a state bond in the amount of $4 million to help pay for the collection.[22]

While Shelton was meeting with Rawlings, Zamoiski was meeting with Governor Glendening and Frederick Puddester, the governor's secretary of the budget and his key financial advisor, in a continuing effort to obtain a larger commitment of state funds. It is not known exactly what Zamoiski said, but it produced the desired results. On May 14, he called Caplan and provided her with the good news that he had obtained from Glendening "a new plan to save entire collection." The plan called for the state to contribute 50 percent of the total price of the Lucas collection on the condition that the BMA and the Walters would together pay an equal amount.[23]

On May 15, 1996, the day that the trial was supposed to begin, the parties met again in Judge Kaplan's courtroom for the purpose of making one last attempt to settle the case. It was understood that the parties were no longer interested in splitting the collection and needed to reach an agreement regarding the price for the collection as a whole. Urging both sides to compromise, Judge Kaplan told them that they both had a "moral obligation to the community" to preserve the collection.[24] The BMA initially proposed that the total price should be $7 million; the Maryland Institute countered with a demand for $10 million. However, what ultimately drove the final amount was not the visceral back and forth of bargaining but something far more practical. From Caplan's perspective, the amount had to be "doable." As chair of the BMA's board, Caplan would take charge of raising the money. After conferring with other board members and making some critically important telephone calls to potential contributors, she concluded that under her leadership the BMA could raise $4 million. And based on the understanding that the state would match this amount, the BMA and the Walters offered to pay the Maryland Institute $8 million for its collection.

The leaders of the Maryland Institute carefully weighed this offer and decided to accept it. Lazarus, Shelton, and Friedlander balanced the interest in increasing the Institute's endowment against the interest in protecting the Institute's reputation as a great citizen and community resource and sharing the credit for keeping the collection in Baltimore. The rationale for reducing its demand from $11.25 million to $8 million was based on the theory that all three of the primary players—the BMA, the state of Maryland, and the Maryland Institute—would contribute a relatively equal amount to save the collection. The state and the BMA would each pay around $4 million, and the Institute would reduce what it arguably could obtain at auction by $3.2 million in order to enable the BMA and the state to acquire it.[25] The final

price was adjusted to $8.5 million based on the Walters's willingness to join in the settlement and pay approximately $425,000 in order to retain one piece of sculpture and four paintings, including the valuable painting *Winter,* by Pissarro, that had been loaned to it by the Institute.[26]

Judge Kaplan then contacted Governor Glendening and asked him to confirm that the state would pay one-half of the $8.5 million purchase price to save the collection. When word came back of the governor's agreement, the settlement for all practical purposes was done. Word quickly spread that the parties had reached a tentative agreement to settle the lawsuit and save the entire collection. The parties were jubilant. Everyone won. The long and often contentious battle over saving the Lucas collection and preserving the city's cultural heritage was over.

◆ ◆ ◆

On June 5, 1996, all three parties signed a settlement agreement, and the lawsuit officially came to an end. The Lucas collection for the first time in its long and often troubled history was safe. The final agreement expressly provided that the collection would be "kept in Baltimore forever." And the museums promised to treat the entire collection as "restricted material" that was precluded from sale, trade, or disposition by any means.[27]

The settlement was officially announced that day by Governor Glendening. He praised Judge Kaplan and BCF for the key roles they played. A press release was jointly issued by the BMA, the Maryland Institute, and the Walters that expressed their "pride and enthusiasm" about the outcome and their satisfaction that it met all of their primary objectives. Brenda Richardson issued a letter to the entire staff of the BMA in which she expressed her gratitude to them as well as to the trustees for their stalwart support.[28]

The press joined the celebration. The editors of *Warfield's* wrote that Baltimore was "preserving a priceless piece of its soul" and thanked those who were involved "for allowing wisdom to prevail."[29] The editors of the *Baltimore Sun* ran a big, bold headline on its editorial page: "It's Baltimore's Art Forever." John Dorsey wrote, "Picture-perfect decision: Everybody gives something, everybody gets something and everyone should agree: Lucas is where it belongs." And in another article, entitled "Faces Behind the Deal that Saved the Lucas Collection," the paper presented photographs of seven key players—Kaplan, Zamoiski, Caplan, Shelton, Eddie Dunn, Dena Testa, and Arnold Lehman. The list, however, could have occupied dozens of pages, for in reality the Lucas collection was saved not just by these seven but by the combined voices of an entire community. What had brought them all together was not the mountain of art in the Lucas collection but the more important, commonly held belief that in the life of their city, culture mattered.[30]

The celebration continued in the Government House in Annapolis, where the Glendenings in conjunction with the BMA sponsored an exhibition of Lucas's art. Many of the best works from the collection were on display—paintings by Breton,

Corot, and Gérôme, sculpture by Barye, and prints by Daumier, Delacroix, and Manet. At the opening, Frances Glendening expressed her appreciation of the efforts by all sides to save Lucas's art and her conviction that "the cultural fabric of our state is so much richer because of him."[31]

Almost everyone who had a hand in saving the collection was there, toasting each other and paying homage to Lucas and his art. Lucas was there as well. Handsomely attired in his finest dark suit as if dressed for the great occasion, he was the center of attention (plate 7). His portrait by Cabanel that announced his place as one of the greatest American agents and collectors of French mid-nineteenth-century art was on display for all to see.

Postscript

There is nothing as fickle as the taste for art. And no better illustration of this phenomenon than the Lucas collection. The cyclical rise and fall of the Lucas collection, the praise and criticism it has received, and its mercurial ups and downs in popularity are indelible parts of its history. In 1911, shortly after arriving in the United States and being exhibited at the Maryland Institute, the collection was described as a "collection of masterpieces" and praised as "magnificent." However, it was neglected by the Institute in the 1920s, transferred to the Baltimore Museum of Art in the 1930s, ridiculed as "small, slight works," and all but buried during the 1940s and 1950s. In the 1960s, it was resurrected, exhibited at the BMA, and lauded "as a unique phenomenon in American collecting." But ten years later, its reputation again descended when its paintings were characterized in the *Baltimore Sun* as "masterpieces of kitsch." In the 1980s, there was little interest in the collection; according to one report, the Institute's art teachers and students were not even aware of it. But this situation changed dramatically in the 1990s when, in response to the Institute's threat to sell the collection, the BMA glorified it as one of the country's finest collections of French art and one of Baltimore's greatest cultural treasures. Although acquired by the BMA twenty years ago in 1996, the Lucas collection's place in Baltimore's culture and standing in art history remain as insecure and unpredictable today as it has been in the past.

Art celebrated by one generation has often been dismissed by the next. Beautiful objects of religious devotion created by artists in the fif-

teenth century were considered idolatrous and destroyed by iconoclasts during the Reformation of the sixteenth.[1] The tremendous popularity of French academic art in the mid-nineteenth century dramatically collapsed when challenged by the ascendency of impressionist and modern art.[2] The shifting tastes in art continued throughout the twentieth and into the twenty-first-centuries, as one style or "ism" (cubism, fauvism, surrealism, abstract expressionism, Pop, minimalism, postminimalism, conceptualism, etc.) captured the public's attention, redefined the language of art, and in the process virtually pushed the earlier "isms" aside.[3] As recently observed in the *New York Times,* crowds entering the Metropolitan Museum of Art flock to see the new, most edgy acquisitions of contemporary art, causing the museum's great collections of historic art to be labeled a "hard sell."[4] Due to the ever-changing taste in art, more and more paintings once considered precious have been stripped from museum walls and relegated to dark and crowded areas of storage, described by one prominent curator as "cemeteries nobody visits."[5]

Museum officials have had to grapple with the sensitive subject of what to do with art that has fallen out of favor and that is rarely seen or appreciated by the public.[6] To minimize the risk of being permanently tied to such art, the Association of Art Museum Directors (AAMD) has discouraged museums from accepting donations tied to restrictions that prevent the art from being sold, exchanged, or disposed of in other ways. More specifically, the AAMD's "Statement of Mission" provides that "gifts and bequests of art should be unrestricted whenever possible."[7] In accordance with these standards, the Metropolitan Museum of Art and the Museum of Modern Art have adopted rules that in general call for the rejection of gifts that contain any restrictions on the authority of the museum to dispose of the art.[8]

In acquiring the Lucas collection, the BMA did not follow the AAMD's advice. To the contrary, it expressly agreed to keep every work of art in the Lucas collection forever. More specifically, under the terms of the BMA's agreement with the Maryland Institute, the BMA promised to "accession the collection in its entirety (each and every work of art and archival document) as restrictive material, precluded from sale, trade, or disposition by any other means, [and] maintained by the BMA . . . in trust and in perpetuity on behalf of the citizens of Baltimore City and the State of Maryland." To underscore the legal significance of this obligation, the agreement authorized the attorney general of Maryland to sue the BMA if it violated any of the terms. Furthermore, the agreement was incorporated into the Maryland statute that authorized the state to pay for the collection.[9]

Although the wisdom of the BMA's decision to keep the entire Lucas collection forever might be debatable, the decision was compelled by the force of the museum's own representations. Through a farrago of fact and fiction, the BMA embellished and glorified the collection, convinced practically everyone that it was an inseparable part of Baltimore's culture, and persuaded the governor of the state of Maryland to pay for half of it. As a result, the BMA could not back away from the promise to

preserve the entire collection "in perpetuity" without destroying its own credibility. Thus, the Lucas collection acquired the dubious distinction of being one of the nation's largest art collections that has rarely been seen but can never be sold.

<center>◆ ◆ ◆</center>

After the glasses were raised, the toasts to Lucas made, and the party ended at the governor's mansion some twenty years ago, the BMA was faced with the sobering question of what to do with the massive collection. The basic problem remained that it was much too large, too full of unfamiliar objects by unknown artists, and too fragile to be lifted from storage for the general public to see. The solution was to mine the collection, reexamine what was in it, and selectively bring its finest pieces to light.

For several years, the BMA did everything possible to make the Lucas collection shine. It dedicated as its new home two adjoining rooms in the wing of the museum reserved for European old masters. Octagonal in shape, with high ceilings, dark oak parquet floors, wainscoted panels, and walls in a rich, soft shade of red, the rooms together created an elegant space fit for the display of fine art (plate 36).[10] Along with Cabanel's handsome portrait of Lucas, approximately thirty landscapes, still-life images of flowers and tableware, and pictures of individuals from different walks of life encircled the walls. (See plates 4, 5, 6, 15, 19, 25, 26, and 28.) Modest in scale, nice to look at, and easy to understand, the paintings exemplified the art that Lucas could afford and that once had filled his home. Along with the paintings, five bronzes by Barye were stationed on pedestals, and a large plaque honoring Lucas and praising his art was prominently positioned for all to see.[11]

Between 1996 and 2006, Lucas's art was also featured in significant exhibitions curated by William Johnston, Sona Johnston, and Jay Fisher. Lucas's paintings by Corot, Goeneutte, and Pissarro were included in *The Triumph of French Painting,* which opened at the BMA in March 2000 and was described by the *Baltimore Sun* as an "exquisite French feast."[12] Traveling across the Atlantic to the Royal Academy of Art in London, the exhibition was again praised, this time as an illustration of "a cultured city, two top museums, and the legacies left by some of Baltimore's prominent collectors." It was "fantastic," a London critic observed, "to have a little corner of Baltimore in London."[13]

In November 2000, a small but lovely exhibition, *Nature Revealed,* featured landscapes and still-life paintings by Corot, Hervier, Jongkind, and Bonvin. It opened in Maryland's Government House in Annapolis and was accompanied by a brochure that reminded viewers that the Lucas collection was held in trust "for the cultural enrichment and educational benefits of generations of Marylanders yet to come."[14] In June 2005, the BMA mounted a marvelous exhibition entitled *The Essence of Line,* of many of its best French watercolors, drawings, and other works on paper, which included Daumier's masterful *The Grand Staircase of the Palace of Justice,* Millet's preparatory sketch of *The Gleaners* (plate 2 and fig. 43), and twenty-five other pieces from the Lucas collection. The *Baltimore Sun* wrote, "Every once in a while, an exhibition

comes along that reminds one of the truly operatic passions that motivated the men and women who assembled Baltimore's great art collections. The stunning collaborative exhibition of French works of art . . . is just such an event."[15]

One year later, the BMA commemorated the tenth anniversary of its acquisition of the Lucas collection by mounting an ambitious show of approximately two hundred works of art. Entitled *A View Toward Paris,* it was the first exhibition in over twenty-five years that focused solely on Lucas. It presented the large portrait of Lucas by Léon Bonnat (see fig. 47), information about Lucas's life, and paintings, prints, and sculpture that exemplified the rich diversity of his collection.

In the interest of providing a balanced account of the types of paintings Lucas collected, *A View Toward Paris* included many by artists whose names and work were not well known. Their inclusion carried a risk. Based on an earlier string of criticism about Lucas's seemingly old-fashioned paintings by relatively unknown artists, an unwritten rule had emerged. It was, simply stated, that showing too much of the Lucas collection was not a good thing. The failure to abide by this rule produced depressing consequences. The critics offered the same biting words that had tarnished Lucas's art in the past. One critic characterized the art as "idiosyncratic."[16] Another wrote that it was "not the stuff" of an awe-inspiring exhibition.[17] But these comments were mild compared to the review by Blake Gopnik, the chief art critic of the *Washington Post,* who wrote that the exhibition, in a perverse way, was engaging not because of the quality of the art but because it showed Lucas's "unerring knack" for missing the paintings of the "right" artists and instead buying the "wrong" ones.[18] The criticism marked the latest and sharpest turn in the mercurial history of the collection's reputation.

◆ ◆ ◆

From 2007 through 2016, the two adjacent galleries devoted to Lucas changed in a subtle but significant way. The small paintings and Barye sculpture are still there but the visitors are missing. They sometimes walk quickly through the space, as though it were a passageway, or else pause for a moment to glance at some of the art. But most of the time, the space is so empty and quiet that the pictures seem to be the only things that stir.

A collection that not long ago was ballyhooed as one of the country's best collections of French art and one of Baltimore's greatest cultural treasures has become, once again, largely forgotten. The honorary plaque that identified Lucas and glorified his art has been taken down. Among the maps, guides, and other handouts that visitors can obtain upon entering the museum, there is not a single reference to the Lucas collection of art. The *Baltimore Sun* has also stopped writing about it. During the last ten years, not a single positive word about the collection's paintings or prints was published in the newspaper.[19] In a gesture that confirmed the lack of interest in visiting the two rooms devoted to Lucas, the BMA transferred three of his most celebrated paintings—Goeneutte's *View of St. Lazare Railway Station,* Jongkind's *Moonlight on the Canal,* and Pissarro's *Strollers on a Country Road* (plates 28, 32, 33)—to

the galleries dedicated to impressionism, reasoning that the paintings more likely would be seen there.

In 2011, a survey sought to identify what was considered "must-see" art in Baltimore. Thirty-seven art aficionados in the city, including the leaders of the major museums, were asked to respond. As expected, the BMA's Cone Collection of Matisse, Gauguin, Van Gogh, and Cézanne was at the top of the list, followed by Asian and Dutch art at the Walters Art Museum and African American art at the Reginald Lewis Museum. Work by dozens of other individual artists were also referred to as "must see." Significantly, neither the Lucas collection nor a single one of its eighteen thousand works of art was mentioned.[20] More recently, when I asked two BMA attendants, who were stationed in the vicinity of the rooms dedicated to Lucas's art, what they knew about Lucas, they replied that they had never heard of him. When I asked two young art students—one a recent graduate of the Maryland Institute who majored in painting and the other a current student of the college—whether they were familiar with the French paintings in the Lucas collection, they quizzically shrugged their shoulders and said that Lucas's name and his art had never been mentioned to them at school or anywhere else. Likewise, when I recently asked the same question to a full-time member of the Institute's faculty, she responded that she had never seen or heard of the Lucas collection of French art.[21]

♦ ♦ ♦

While French mid-nineteenth-century art might now seem stale and out of date, the passion that a great collector feels for his art is timeless. Lucas did not merely collect art—he embraced it. He held it in his hands, studied it day and night, thought about it, wrote about it, cared for it, and loved it. He acted almost as if he were married to it. What stood at the center of Lucas's collection was not a painting, print, or other inanimate work of art but Lucas himself.[22]

In order for the Lucas collection to attract and be meaningful to viewers of today and tomorrow, it must offer more than a string of thirty mid-nineteenth-century paintings hanging quietly on the walls of two usually empty rooms and a very small selection of prints infrequently brought to public view. The collection needs to be rekindled, displayed in the rich context in which it was formed, and offer not just a sampling of objects to look at but big ideas and questions to think about.

A dynamic way for the BMA to achieve this goal would be through the construction of a large installation that replicates Lucas's salon and invites visitors to enter and become absorbed in a space where clusters of art and related information seem to be everywhere. Upon entering, visitors would be greeted by a life-sized picture of Lucas—based on Dornac's photograph (see fig. 1)—seated comfortably in his salon and surrounded by a constellation of paintings by many of the stars of mid-nineteenth-century French art, including Bouguereau, Breton, Cabanel, Corot, Couture, Daubigny, Fantin-Latour, Gérôme, Goeneutte, Hervier, Jacomin, Pissarro, and Thiollet. Digitized copies of Lucas's finest etchings, drawings, and watercolors by Whistler,

Manet, Cassatt, Jacque, Jacquemart, Buhot, Daumier, and Ribot and sculpture by Barye would be stationed on nearby cabinets or cases bearing their names. The installation would visualize the words of Elizabeth Pennell, who after visiting Lucas in 1904, wrote that his salon was "delightfully littered with his collection."[23]

Visitors to the installation would need only to turn around in order to see another side of Lucas's art-filled world—his beautiful country home on the banks of the Seine. An enlarged picture of the house, based on the painting by Delpy (plate 15), would cover a large portion of this wall. In recognition of Lucas's taste for Barbizon art, the picture of his home would be accompanied by landscapes of the Fontainebleau Forest by Rousseau, Millet's famous drawing of *The Gleaners,* and Whistler's portrait of Lucas, informally dressed and holding a walking stick as if ready to embark on a stroll through the forest on the way to Millet's home in the rustic village of Barbizon (plate 1).

Constructed on the wall between these fields of art would be a replica of Lucas's extensive library of fifteen hundred journals, treatises, and books about art. Biographies of Whistler, Rousseau, and other famous French artists would fill one shelf. Books about the French etching revival would fill another. Auction and exhibition catalogues published by the Hôtel Drouot would fill a third, followed by another shelf of art criticism authored by such aestheticians as John Ruskin and Théophile Gautier. And on the last but most important shelf would be volumes of art history that extend like a bridge from classical Greek and Roman art through the Italian Renaissance to the mid-nineteenth-century French art of Lucas's own time.

The wall next to the bookshelves would be transformed into a pictorial history lesson about the dynamic culture and history of Paris during the years that Lucas lived there. Borrowed from Lucas's prints, newspaper clippings, and other ephemera, the pictures would include a small portrait of Napoleon III, a print by Maxime Lalanne illustrating Baron von Haussmann's reconstruction of Paris, another print picturing the bloody consequences of the Franco-Prussian War, an etching by Manet of the great French writer Charles Baudelaire, a picture of the Cadart Gallery crowded with customers at the time of the etching revival, and clippings from Parisian newspapers and journals about the art on display at the annual Salons and the paintings that were lionized by their admission into the Luxembourg Museum and ultimately into the Louvre.[24]

The final wall would be covered by a tableau of portraits of artists, dealers, clients, friends, and other major figures in the Parisian art world who had a significant role in shaping and ultimately directing the fate of Lucas's collection. Among those pictured would be his clients William Walters, Samuel Avery, John Taylor Johnston, and William Vanderbilt; his dealers Goupil, Petit, and Cadart; and his friends Frank Frick, Maud Franklin, Henry Walters, and Bertha Lucas. The portraits of such artists as Corot, Frère, and Cabanel would be accompanied by their colorful palettes dedicated to Lucas and their letters to him. The final space in the installation would be reserved for the most important but overlooked person in Lucas's life—his mistress

M. Although there are no verifiable portraits of M, her presence in Lucas's life and her care for Lucas's collection would be documented by the entries in Lucas's diary that revealed his love for her and the drawings and notes that he made about the art that was stored in her apartment.

◆ ◆ ◆

What was it like to enter the Parisian home of America's most cerebral collector and agent of French art and find yourself immersed in thousands of works of art, books, and journals during one of the most vibrant periods of cultural history? If Lucas's art, books, and ephemera were selectively joined together and viewed through the prism of his remarkable life, the exhibition could answer this fascinating question. It would reveal that the Lucas collection was brought together not simply by the nature of its art but by the intellect and passion of its collector, and it would provide visitors with a communion with art that is timeless.

TABLE A1. Art Acquired by George A. Lucas for William T. Walters

Date Acquired	Artist	Title	Medium
1859, Nov. 4	Hugues Merle	*The Scarlet Letter*	Oil
1862, June 24	Pierre-Édouard Frère	*Interior Scene with Woman Praying*	Drawing
1862, July 17	Hugues Merle	*The Good Sister*	Watercolor
1862, Nov. 23	Théophile-Victor Lemmens	*Chickens, Ducks and Farm Buildings*	Drawing
1862, Dec. 17	Léon Bonvin	*Cook with Red Apron*	Watercolor/gouache
1862, Dec. 27	Charles Chaplin	*Girl with Birds Nest*	Watercolor
1862, Dec. 30	Paul Gavarni	*Actors*	Watercolor
1863, Feb. 28	Léon Bonvin	*Flowering Chrysanthemum*	Watercolor
1863, Mar. 14	Charles Émile Jacque	*Chickens*	Oil
1863, Mar. 29	Charles Chaplin	*Le Premier Baser*	Gouache
1863, June 1	Alexandre Bida	*Moses*	Drawing
1863, Sept. 21	Félix Ziem	*Constantinople*	Watercolor
1863, Sept. 21	Félix Ziem	*Tuna "Thins" Fishing*	Watercolor
1863, Sept. 21	Félix Ziem	*Venice*	Oil
1863, Dec. 5	Antoine Emile Plassan	*Evening Prayer*	Oil
1863, Dec. 5	Antoine Emile Plassan	*Devotion*	Oil
1863, Dec. 23	Antoine-Louis Barye	*Lion and Serpent*	Watercolor
1864, Feb. 4	Charles-François Daubigny	*Sunset on the Coast of Villerville*	Oil
1864, Feb. 8	Jean-Baptiste-Camille Corot	*Evening Star*	Oil
1864, Feb. 17	Charles Émile Jacque	*Ewe and Lamb*	Drawing
1864, Mar. 18	Honoré Daumier	*The Omnibus*	Drawing/Watercolor
1864, Apr. 2	Félix Ziem	*Ancient Venice*	Watercolor
1864, June 6	Honoré Daumier	*First Class Carriage*	Drawing/Watercolor
1864, June 6	Honoré Daumier	*Second Class Carriage*	Drawing/Watercolor
1864, Oct. 5	Gustave Brion	*Peasants Decorating Wayside Shrine*	Watercolor
1864, Nov. 14	Antoine Emile Plassan	*Disappointment*	Oil
1865, Jan. 19	Alexandre Bida	*The Ceremony of Dosseh*	Drawing
1865, Jan. 28	Alexandre Bida	*Interior: Woman Kneeling*	Drawing
1865, Feb. 14	Jules Breton	*The Close of the Day*	Oil
1865, Oct. 9	Charles Gleyre	*Lost Illusions*	Oil
1865, Dec. 16	Charles Müller	*A Portrait*	Oil
1867, Apr. 9	Alexandre Calame	*The Jungfrau, Switzerland*	Oil
1871, Aug. 17	Paul Delaroche	*Replica of The Hemicycle*	Oil
1872, June 8	Emile van Marcke de Lummen	*The Approach of a Storm*	Oil
1873, Sept. 30	Charles-François Daubigny	*Coming Storm; Early Spring*	Oil
1873, Oct. 26	Alexandre Cabanel	*Pandora*	Oil
1875, Jan. 16	Edouard Detaille	*Sentinel*	Watercolor
1875, Dec. 11	Benjamin Vautier	*Consulting His Lawyer*	Oil
1878, Sept. 26	Alphonse de Neuville	*Information*	Oil
1878, Sept. 30	Alphonse de Neuville	*In the Trenches*	Oil
1878, Nov. 18	Ludwig Knaus	*Mud Pies*	Oil
1881, Feb. 23	Alberto Pasini	*Damascus (La Rue)*	Oil

Date Acquired	Artist	Title	Medium
1881, Apr. 4	Jules Jacquemart	*Interior de Cour a Rouen*	Drawing
1881, Apr. 4	Jules Jacquemart	*Les Platanes en Hiver, Route de Nice*	Drawing
1882, Dec. 26	Théodore Rousseau	*Hoarfrost (Le Givre)*	Oil
1883, Jan. 19	Théodore Rousseau	*Landscape with Cottage*	Drawing
1883, March 30	Léon Bonnat	*Portrait of William T. Walters*	Oil
1883, Apr. 7	Jules Jacquemart	*Landscape*	Watercolor
1883, Apr. 11	Alexandre Bida	*And Jesus Said*	Drawing
1883, May 7	Antoine-Louis Barye	*Python Swallowing a Roe-Deer*	Watercolor
1883, May 9	Eugène Delacroix	*Collision of the Moorish Horsemen*	Oil
1883, May 11	Jean-François Millet	*The Angelus*	Drawing
1883, May 11	Ernest Hébert	*Going to the Well*	Oil
1883, May 11	Jules Dupré	*A Bright Day*	Oil
1883, May 17	Eugène Isabey	*Fishing Boats*	Watercolor
1883, May 30	Charles Camino	*Nun in Prayer*	Watercolor
1883, June 9	Jules Breton	*Repose*	Drawing
1883, June 11	William Adolphe Bouguereau	*The Flagellation of Christ*	Drawing
1883, Aug. 11	Jean-Baptiste-Camille Corot	*St. Sebastian Succoured by Holy Women*	Oil
1883, Sept. 10	Rosa Bonheur	*Andalusian Bulls*	Drawing
1884, Mar. 2	Jean-Baptiste-Camille Corot	*Study for St. Sebastian*	Watercolor
1884, Mar. 21	Hector Giacomelli	*A Perch of Birds*	Watercolor
1884, June 9	Jean-François Millet	*The Sower*	Pastel
1885, Jan. 10	Léon Bonnat	*Portrait of Barye*	Oil
1885, Jan. 10	Léon Bonnat	*Portrait of George Aloysius Lucas*	Oil
1886, Feb. 3	Alexandre Cabanel	*Napoleon III*	Oil
1886, May 22	Ernest Meissonier	*1814*	Oil
1886, Nov. 25	Eugène Delacroix	*Christ on the Sea of Galilee*	Oil
1886, Nov. 25	Constant Troyon	*Cattle Drinking*	Oil
1887, May 14	Jean-François Millet	*The Shepherdess and Flock*	Pastel
1888, Mar. 22	Eugène Delacroix	*Lion and Snake*	Watercolor
1888, May 18	Félix Ziem	*Venice Sunset*	Oil
1889, Dec. 20	Gustave Courbet misattribution / unknown artist	*Hind Forced Down*	Oil
1890, Jan. 29	Joseph Mallord William Turner misattribution / unknown artist	*Grand Canal Venice*	Oil

TABLE A2. Lucas's Collection of Paintings[†]

Date Acquired	Artist	Title	Size (in inches)	Price (in francs)	Gift
1858, Dec. 22	Narcisse-Virgile Diaz de la Peña	*Landscape*	2⅝ × 3¾	25.20	
1859, Feb. 12	Auguste Xavier Leprince	*Parisian Milk Seller*	4⅞ × 5¾	14.70	
1859, Mar. 5	Abraham Teniers	*After the Meal*	6⅞ × 9⅛	11.65	
1859, May 26	Jules Dupré	*Windmill*	10 × 17	2.1	
1859, May 27	Amédée Baudit	*Landscape with Peasant Woman*	9 × 13⅛	21	
1859, Aug. 9	Antoine Pascal	*Flowers*	10¼ × 8¼	15	
1861, Feb. 4	Louis Eugene Lambert	*Cat and Rabbits*	5½ × 9	61	
1861, Feb. 11	Jean Baptiste Simeon Chardin	*Peaches and Grapes*	14¾ × 18	315	

[†]Lucas had approximately 300 paintings in his collection. The information in this table is for 260 of these, for which information about date of acquisition, price, and mode of obtaining (purchase vs. gift) could be found.

Date Acquired	Artist	Title	Size (in inches)	Price (in francs)	Gift
1861, Feb. 23	Théophile-Victor Lemmens	*In the Barnyard*	4½ × 5¾		*
1861, Mar. 2	Théophile Duverger	*Morning after the Storm*	9⅜ × 12¾		*
1861, June 29	Théophile-Victor Lemmens	*Roosting Time*	6¼ × 9⅜		*
1861, June 29	Théophile-Victor Lemmens	*His Majesty*	6¼ × 9⅜		*
1861, Aug. 3	Jean Berré	*Cattle in the Landscape*	9½ × 12⅛	unknown	
1861, Nov. 4	August Schenck	*The Cry for Help*	12¾ × 13⅞		*
1862, Mar. 10	Henri Fantin-Latour	*Nature Morte Fruit*	6¾ × 12¼		*
1862, Mar. 22	August Schenck	*Sea*	12¾ × 31⅞	100	
1862, Mar. 24	August Schenck	*Women in Field*	6⅛ × 12⅞		*
1862, Apr. 5	François Bonvin	*Woman Reading*	11⅝ × 8¾	26.25	
1862, Apr. 5	Eugene Villain	*Dish with Fruit*	7½ × 12¼	36.75	
1862, May 12	Paul Soyer	*Grandmother''s support / Baton*	18¼ × 14½	200	
1862, Feb. 22	François Bonvin	*Still Life with Asparagus*	15¾ × 12½	50	
1862, Feb. 22	François Bonvin	*Still Life with Vegetables*	15⅞ × 12⅜	50	
1862, Dec. 13	Émile Lambinet	On the Seine	4¾ × 10¼	50	
1862, Dec. 13	Émile Lambinet	The Fisherman's Hut	4⅝ × 9⅞	50	
1862, Dec. 24	Jules Veyrassat	*Ferry on the Marne*	6¼ × 12¼	80	
1863, Jan. 23	Théophile-Victor Lemmens	*Duck Pond*	3⅛ × 6⅗		*
1863, Feb. 23	Jean Fauvelet	*Smoker*	6⅝ × 4⅝	100	
1863, Mar. 16	Alexandre Guillemin	*By the Fireside*	4½ × 4½		*
1863, Mar. 16	Alexandre Guillemin	*Hauling Fish*	6½ × 8½		*
1863, Apr. 21	Eugene Villain	*Still Life with Fowl*	9½ × 12⅜	20	
1863, May 16	Benjamin Eugène Fichel	*In the Library*	6⅝ × 3¾	100	
1863, Sept. 21	Félix Ziem	*Sketch of Grand Canal, Venice*	6¾ × 9⅝		*
1863, Oct. 8	Edouard Armand-Dumaresq	*Head of Joseph*	7⅜ × 5½		*
1863, Nov. 17	Philippe Rousseau	*Cock and Pearl*	7⅟₆ × 5	50	
1863, Dec. 3	Pierre-Édouard Frère	*Little Girl Eating Porridge*	5⅞ × 4⅞		*
1864, Feb. 8	Jean-Baptiste-Camille Corot	*Near Amiens*	14⅝ × 18⅛	300	
1864, Feb. 17	Jean-Baptiste-Camille Corot	*Sèvres-Brimborion View towards Paris*	18¼ × 24¼	650	
1864, Feb. 17	Jules Veyrassat	*Ferry*	4½ × 8⅞	300	
1864, Mar. 1	Charles Émile Jacque	*In the Barnyard*	5 × 6⅞	150	
1864, Mar. 1	Philippe Rousseau	*Rustic Still Life*	5⅝ × 9½	20	
1864, Apr. 10	Jean-Baptiste-Camille Corot	*Road at Ville d'Avray*	12¾ × 16	400	
1864, Apr. 23	Auguste Anastasi	*Moonlight*	8⅝ × 13⅝	100	
1864, June 16	Isidore Patrois	*Russina Singing and playing*	9⅞ × 7⅜	50	
1864, June 23	Antoine Vollon	*Vase with Flowers*	18⅛ × 15⅛	62.50	
1864, June 23	Antoine Vollon	*Still Life with Flowers*	18⅛ × 15⅛	62.50	
1864, June 29	Auguste Anastasi	*View in Forest of Fontainebleau*	5⅜ × 8⅝		*
1864, June 30	Antoine Emile Plassan	*At the Shrine*	6 × 3¾		*
1864, Oct. 10	Antoine Emile Plassan	*Promenade*	5½ × 3½	100	
1864, Oct. 14	Philibert Leon Couturier	*Feeding the Cock*	8¾ × 5½		*
1864, Oct. 25	Leon Loire	*The Picket at Angelus Time*	9 × 6¼	40	
1864, Nov. 6	Théophile-Victor Lemmens	*Barnyard*	3⅜ × 5¼		*
1864, Nov. 6	Théophile-Victor Lemmens	*Study of Fowls*	4 × 5½		*
1864, Dec. 21	William P. Babcock	*The Quartet*	8⅜ × 10⅜		*
1864, Dec. 29	Eugene Villain	*Still Life with Fowl*	9½ × 12 3.4		*
1865, Feb. 14	Jean Alexandre Couder	*Still Life*	7⅜ × 5½		*
1865, Mar. 25	Félix Ziem	*Nature Morte Fish*	10⅞ × 15⅜	250	
1865, Sept. 16	Félix Ziem	*Venice*	9¾ × 15		*
1865, Sept. 16	Félix Ziem	*Venice*	6¾ × 9⅝		*

Date Acquired	Artist	Title	Size (in inches)	Price (in francs)	Gift
1865, Oct. 5	Antoine Emile Plassan	*Landscape*	5⅛ × 9¾		*
1865, Oct. 15	Antoine Emile Plassan	*Village of Courrances*	4½ × 7		*
1865, Nov. 15	Armand Leleux	*Woman Peeling Vegetables*	18⅛ × 14½	200	
1865, Dec. 2	Alexandre Veron	*Wooded Landscape*	7¾ × 14	125	
1866, Feb. 24	Johan Barthold Jongkind	*Moonlight*	8⅝ × 13⅝	130	
1866, Mar. 2	William P. Babcock	*Flowers in Pitcher*	10⅝ × 8⅝		*
1866, May 16	Jules Héreau	*Opening the Sheepfold*	14⅞ × 23⅛	500	
1866, July 7	Théophile-Victor Lemmens	*A Lessen for Wrongdoers*	6¾ × 9¾		*
1866, Nov. 27	Alexandre Thiollet	*Fish Auction at Villerville*	9¾ × 14	150	
1866, Dec. 31	Frank Howland	*Studying the Album*	10 × 8⅕	unknown	
1867, Mar. 22	Eugène Boudin	*Marine*	12¾ × 18⅜	75	
1867, Apr. 25	Alexandre Thiollet	*Fishing Boats (Marine)*	4¾ × 8	100	
1867, May 4	Francois Théophile Gide	*The Monastery Laboratory*	8½ × 6½	500	
1867, June 20	Alexandre Thiollet	*Beach at Villerville at Low Tide*	10½ × 16	unknown	
1867, Aug. 20	Armand Gautier	*Still Life Flowers*	15⅞ × 12⅜	100	
1867, Oct. 15	Alfred Gues	*The Source*	23¾ × 29⅛	125	
1867, Nov. 20	Constant Troyon	*Across the Meadow*	10¼ × 8¼		*
1867, Dec. 29	Félix Ziem	*Study of Vegetables*	11 × 15¼		*
1868, Jan. 2	George Henry Boughton	*Head of Olivia*	9 × 9		*
1868, Jan. 9	William Adolphe Bouguereau	*Sketch for Charity*	11¾ × 8⅛		*
1868, Feb. 3	Auguste Boulard	*Flowers in Vase*	20 × 17½	200	
1868, Mar. 20	Charles François Daubigny	*Through the Field*	7⅛ × 13⅛	300	
1868, Mar. 20	Jean Louis Hamon	*The Fugitive*	8½ × 11	200	
1868, Apr. 22	Euphemie Muraton	*Still Life with Cake*	12¾ × 16		*
1868, Apr. 24	Alphonse Muraton	*Sketch Praying Monk*	14⅛ × 9		*
1868, Nov. 2	Timoleon Lobrichon	*Portrait of Young Man*	7 × 7		*
1868, Nov. 6	Alfred Mery	*Apple Boughs*	19⅝ × 39½	60	
1868, Nov. 6	Alfred Mery	*Nestlings amid the Blossoms*	19½ × 39½	60	
1868, Nov. 17	Jacob Maris	*Breeze from the Sea*	14⅝ × 24		*
1868, Nov. 19	Antoine Emile Plassan	*Sill Life*	14 × 10½	300	
1868, Nov. 19	Antoine Emile Plassan	*Breakfast Table*	14 × 10½	300	
1869, Jan. 19	Attributed to Jean Baptiste-Camille Corot	*Study: The Bridge*	7¾ × 10 × 10⅜	unknown	
1869, Mar. 4	Charles Lhuillier	*Sketch of Horses*	24½ × 19	55	
1869, Mar. 13	Leon Rousseau	*Study of Flowers*	6⅝ × 5	80	
1869, Mar. 18	Florent Willems	*Forest of Fontainebleau*	19 × 13¼		*
1869, May 14	Auguste Boulard	*Nature Morte*	18½ × 15	100	
1869, May 29	Georges Michel	*In the Forest*	16⅝ × 28⅝	50	
1869, June 2	Alexandre Thiollet	*Woman with Fish Basket*	9½ × 6⅞	50	
1869, Oct. 31	Francois Rivoire	*Cherries*	10⅝ × 8¼	70	
1869, Nov. 17	Armand Gautier	*Nature Morte*	11¼ × 18¾	80	
1869, Dec. 2	William Adolphe Bouguereau	*Study for Oranges*	15¾ × 12⅓		*
1870	Joseph Coomans	*Girl in Classic Drapery*	8 × 6		*
1870, Jan. 7	Camille Pissarro	*Village Street in Winter*	15⅛ × 18¼	20	
1870, Feb. 1	Jules Alex Patrouillard Degrave	*Studying the Vase*	13¾ × 10¾	200	
1870, Mar. 18	Adolphe Lesrel	*Study in Poppies*	10½ × 14¾	360	
1870, Apr. 23	Camille Flers	*Landscape*	10½ × 16¼	50	
1870, May 23	Jules Breton	*Head*	11¼ × 7¼	200	
1870, June 5	Albert Brendel	*In the Stable*	10¾ × 13¾	100	
1870, Aug. 19	Thomas Couture	*Portrait of a Child*	24 × 19½	50	
1870, Aug. 26	Alberto Pasini	*In the Market Place*	9⅜ × 15⅛		*

Date Acquired	Artist	Title	Size (in inches)	Price (in francs)	Gift
1871, June 25	Adolphe Lesrel	*Study of Poppies*	11 × 5⅛	300	
1871, June 29	Paul Leyendecker	*Study of Fontainebleau Forest*	10½ × 14¾	150	
1871, July 5	Gustave Boulanger	*Sketch: Two Moors*	8⅞ × 5		*
1872, Feb. 29	Adolphe Monticelli	*Sketch: Women in Landscape*	9⅝ × 7⅜	35	
1872, Apr. 8	Jean Louis Ernest Meissonier	*Landscape*	3 × 4⅛		*
1872, May 11	Edmond Rudaux	*Under the Orchard Tree*	8 × 5¼		*
1872, Dec. 23	Alfred Alboy-Rebouet	*Figure in Blue*	23¾ × 11⅝	150	
1873, Feb. 17	Édouard Castres	*On the Seine*	10⅝ × 8⅝		*
1873, Mar. 14	Henri Fantin-Latour	*Study: Three Figures in a Park*	8⅞ × 12¼		*
1873, June 8	Alexandre Cabanel	*Portrait of Lucas*	21¾ × 18		*
1873, Mar. 27	Blaise Desgoffe	*Still Life with Pomegranates*	9¼ × 7¼		*
1873, Mar. 27	Blaise Desgoffe	*Small Vase in Louvre*	4¾ × 6¾		*
1873, Dec. 26	Adolphe Jourdan	*Sketch of Peasant Child*	10⅝ × 7		*
1874, Apr. 20	Emile Munier	*Under the Lilacs*	23¾ × 12	450	
1874, May 2	Jean Aubert	*Sketch of Greek Fisher Girl*	10½ × 7⅛		*
1874, June 9	Louis Joseph Raphael Collin	*Flowers in a Vase*	34¼ × 13¼	150	
1874, June 9	Louis Joseph Raphael Collin	*Flowers in a Vase*	34¼ × 13¼	150	
1874, June 1	Louis Priou	*Sketch of Family of Satyrs*	20½ × 24½		*
1874, Oct. 27	Marc Gabriel Charles Gleyre	*Return of Prodigal Son*	14¾ × 11		*
1874, Dec. 5	Alexandre Thiollet	*Sea and Sky at Villerville*	17 × 11	unknown	
1874, Dec. 14	Richard Bonington (attributed)	*Landscape*	11⅜ × 14¼	unknown	
1875, Feb. 1	George Henry Boughton	*Portrait of Young Girl*	8½ × 7⅝		*
1875, Mar. 25	Louis Hector Leroux	*The Vestal Tuccia*	10⅝ × 8⅛		*
1875, Apr. 3	Adolphe Monticelli	*Study of Sunset*	8 × 11½	75	
1875, Apr. 9	Adolphe Steinheil	*Poppies*	15⅞ × 18	800	
1875, Apr. 13	Louis Hector Leroux	*Sleeping Vestal*	12⅞ × 6¾		
1875, July 14	Ulysse Butin	*Month of February*	24⅛ × 13⅛	150	
1875, Dec. 8	Pierre Paul Léon Glaize	*Panel of Month: Fishing*	24¾ × 13⅛	unknown	
1876, Jan. 19	Antonio Pascutti	*Costume Study*	6½ × 3¼		*
1876, Mar. 30	Adolphe Weisz	*Sketch for Waiting Room*	6⅞ × 12		*
1876, Oct. 4	Armand Charnay	*April Showers*	9¾ × 13⅛		*
1877, Feb. 14	Emile van Marcke de Lummen	*Cattle*	9⅞ × 14⅝		*
1877, Mar. 18	Pierre Charles Comte	*Study*	15⅝ × 11⅛		*
1877, Oct. 19	Jean Aubert	*Panel of Month: Spring Maiden*	24⅛ × 13⅛		*
1877, Oct. 28	Paul Signac	*Autumn*	24⅛ × 13⅛	300	
1878, Aug. 7	Jules Lefebvre	*Mignon*	19¾ × 11⅞		*
1878, Sept. 27	Louis Emile Villa	*Entrapped*	3¾ × 7⅛		*
1878, Nov. 9	Adolphe Steinheil	*Still Life with Skillet and Jar*	6½ × 5		*
1879, May 29	Antoine Emile Plassan	*Month: Lady with Dog*	24 × 13½		*
1879, July 23	Alexis Kreyder	*Flowers*	14½ × 20		
1880, Jan. 27	Jules Lefebvre	*Sketch: Vanderbilt Ceiling*	17⅞ × 24¾		
1880, Jan. 27	Jules Lefebvre	*Spirit of the Morning Mist*	10⅝ × 12⅜		
1880, Feb. 20	W. Baptiste Baird	*Village Church*	12⅞ × 9⅝	100	
1880, Mar. 18	Jean-Leon Gérôme	*The Dandy*	12¾ × 9¾		*
1880, Apr. 12	Léon Bonnat	*Landscape*	7 × 12½		*
1880, Aug. 26	Martin Rico Y Ortega	*Grand Canal*	6 × 4¾		*
1880, Dec. 28	Georges Jeannin	*Flowers*	10¾ × 13⅝	100	
1881, Feb. 19	Jean Jacques Henner	*Sketch of Nymph*	8⅝ × 12⅛	100	
1881, Mar. 19	Camille Flers	*Landscape Orchard*	20 × 24	500	
1881, Apr. 12	Jules Héreau	*At the Horseshoer's*	9 × 18¾	350	

Date Acquired	Artist	Title	Size (in inches)	Price (in francs)	Gift
1881, May 15	Martin Rico y Ortega	Sketch: Grand Canal	6 × 4¾		*
1881, June 13	Honoré Daumier	The Lodge	9½ × 12⅛	1000	
1881, June 16	Emilio Sanchez-Perrier	Sketch: Vigo Galicia	6½ × 5½		*
1881, Aug. 25	Prosper Marilhat	Beneath the Archway	12 × 8¼	300	
1881, Nov. 28	Emile van Marcke de Lummen	Cattle Drinking	10¼ × 13¾		*
1881, Nov. 15	Alexandre Louis Leloir	The Angel of Dawn	12¾ × 9¼		*
1881, Dec. 15	Alexis Kreyder	Hollyhocks and Currants	42 × 31½	700	
1882, Jan. 13	Anatole Vely	The Well	10½ × 6		*
1882, Feb. 3	Camille Flers	Landscape: The Footbridge	15 × 22¼	360	
1882, Mar. 1	Victor Vignon	Nature Morte	12¾ × 16	100	
1882, Mar. 6	Francisco Domingo y Marques	Study of Old Man	7¾ × 5¼		*
1882, Apr. 15	Charles Baugniet	Panel of Month: Skating	24 × 13⅝		*
1882, Dec. 1	Adolf Schreyer	Arab Horseman	12⅜ × 9¼		*
1882, Dec. 1	Adolf Schreyer	Tending the Horses	5⅝ × 8¾		*
1883, Feb. 1	Jean Richard Goubie	Study of Dog	6⅝ × 3¾		*
1883, Feb. 21	Maxime Lalanne	Sketch Trouville	8¼ × 14½		*
1883, Mar. 5	Victor Vignon	Nature Morte	12¾ × 16	100	
1883, May 2	Alexandre Thiollet	Port of Villerville	14⅝ × 23⅜	250	
1883, May 12	Thomas Couture	Oval Woman in Profile	25 × 20	1,200	
1883, June 5	Alexandre Thiollet	Fisherwoman of Villerville	24 × 13½	110	
1883, June 7	Louis Auguste Loustaunau	Study of the Chateau at Fontainebleau	25⅝ × 19⅝	250	
1884, Feb. 13	François Bonvin	Shoes	12¾ × 16		*
1884, Mar. 6	Marie Ferdinand Jacomin	Landscape: Clouds and Sunshine	34½ × 45½	2,500	
1884, Mar. 15	Jules Breton	Study for the Communicants	17¾ × 12¾		*
1884, Apr. 8	Jules Breton	2nd Study of Communicants	17¼ × 11		*
1884, June 1	Henry Guérard	Three Borders for Menus	6 × 9½	unknown	
1884, June 27	Adolphe Monticelli	Allegory	13½ × 26⅞	600	
1884, Sept. 15	Antoine-Louis Barye	Deer in the Forest	9 × 12½	unknown	
1884, Dec. 3	Antoine-Louis Barye	Cougar Devouring Deer	10½ × 13¼		*
1885, Jan. 14	Antoine-Louis Barye	Forest of Fontainebleau	8⅝ × 12¼		*
1885, Oct. 17	Adolphe Monticelli	Landscape	9⅝ × 7⅜	100	
1885, Dec. 17	Camille Pissarro	Path by River	22 × 18	300	
1886, May 1	Marie Ferdinand Jacomin	Environs of Forest St. Germain	12½ × 16⅛	2,000	
1886, June 1	Marie Ferdinand Jacomin	Forest of St. Germain	7¼ × 9½		*
1886, Aug. 23	James McNeill Whistler	Portrait of George Lucas	8⁹⁄₁₆ × 4¹⁵⁄₁₆		*
1886, Apr. 15	Francois Grison	Butcher Shop: Panel for Boissise	11¾ × 10½		*
1887, Mar. 5	Félix Bracquemond	Sketch: Portrait of a Woman	8⅛ × 7⅛		*
1887, Mar. 28	Théodore Rousseau	Oil Study	5¾ × 8½	200	
1887, Mar. 29	Georges Michel	Gathering Storm	16⅝ × 28⅝	250	
1887, Nov. 3	Félix Bracquemond	Study of Animals / Still Life Ducks	18 × 14½	15	
1887, Nov. 3	Félix Bracquemond	Study of Animals / Still Life Ducks	18⅛ × 14⅜	15	
1887, Nov. 19	Francois Nazon	Landscape	12⅛ × 18½	40	
1887, Dec. 20	Théodore Frère	Sketch: Cairo Café	10⅜ × 18		*
1888, Mar. 12	Norbert Goeneutte	Pont de l'Europe	18⅜ × 27⅛	200	
1888, May 8	Antoine-Louis Barye	Dear on a Mountainside	4⅝ × 6¾	500	
1888, May 8	Antoine-Louis Barye	Bear Walking	5½ × 7⅛	unknown	
1888, May 8	Antoine-Louis Barye	Leopard Sitting	5½ × 7	unknown	
1888, Nov. 27	Victor Vignon	View of a Village in Normandy	18 × 15	150	
1888, Nov. 27	Victor Vignon	Spring Landscape	9⅛ × 12¾	150	
1888, Dec. 14	Norbert Goeneutte	Girl in Rocking Chair / B. Lucas	18⅜ × 21⅞	unknown	

Date Acquired	Artist	Title	Size (in inches)	Price (in francs)	Gift
1889, Jan. 5	Louis Adolphe Hervier	*Village with Windmills*	16⅝ × 28⅝	450	
1889, July 21	Henry Bonnefoy	*Hall in the Barye Exposition*	23¼ × 28¾	200	
1889, Nov. 11	Jean Charles Cazin	*Early Evening*	8⅝ × 10⅛	unknown	
1890, Feb. 17	Adolphe Monticelli	*Road through the Woods*	23¾ × 15⅝	650	
1890, Feb. 17	Adolphe Monticelli	*Early Spring*	23⅝ × 15½	650	
1890, Apr. 15	Auguste Lepère	*Still Life with Pitcher*	14⅞ × 18⅛	100	
1890, Sept. 20	Hippolyte Camille Delpy	*On the Seine at Boissise*	21½ × 16¾		*
1890, Oct. 22	Norbert Goeneutte	*A Venetian Balcony*	14⅞ × 18⅛	300	
1891, Mar. 21	Leopold Flameng	*Spring Landscape*	19 × 15½	unknown	
1891, Apr. 20	Louis Adolphe Hervier	*The Windmill*	10 × 7½	unknown	
1892, Feb. 27	Alexandre-Gabriel Decamps	*At the Edge of the Forest*	18¼ × 15	550	
1893, Jan. 7	Achille Michallon	*Ruins of Theatre*	14¼ × 18¼	160	
1893, Jan. 10	Antoine Vollon	*Vase with Flowers*	18⅛ × 15⅛		*
1893, June 7	Ernest Quost	*Study: Nude and Flowers*	5 × 19		*
1894, Jan. 8	Jean-Adrien Guignet	*Landscape: Afterglow on the Banks of the Nile*	16⅝ × 28⅝	450	
1894, Jan. 22	Jean-Adrien Guignet	*Guarding the Pass*	10 × 7½	91	
1894, Feb. 7	Victor Vincelet	*Study of Flowers*	25⅝ × 21¼	175	
1894, June 20	Edme Alfred Dehodencq	*Little Gypsy*	29½ × 19⅞	136.5	
1894, Oct. 6	Charles Émile Jacque	*Red and White Flowers*	12½ × 16⅛	100	
1894, Dec. 3	Théodore Rousseau	*Landscape: Sunset*	5¾ × 8½	300	
1895, Dec. 24	John Constable	*Rugged Cliff and Drifting Clouds*	7½ × 4½	600	
1896, May 26	Victor Vincelet	*Flowers in a Vase*	18 × 12¾	50	
1896, Sept. 17	Louis Lottier	*Marine Scene*	10⅜ × 18	unknown	
1896, Sept. 17	Louis Lottier	*Turkish Scene*	17½ × 14¾	unknown	
1896, Sept. 17	Newton Fielding	*Hunting on the Moors*	6⅜ × 8⅝		*
1896, Dec. 14	Antoine-Louis Barye	*Python killing Dear*	9¼ × 13¼	350	
1899, Jan. 6	Adolphe Monticelli	*Self-portrait*	6⅛ × 4½	unknown	
1899, Mar. 5	Léon Victor Dupré	*Landscape*	3 × 4½	unknown	
1899, Aug. 21	Jean Baptiste Greuze	*The Greedy Child*	21⅝ × 15	unknown	
1899, Aug. 21	Jean Baptiste Greuze	*Chestnut Roaster*	21½ × 15	unknown	
1902, Feb. 12	Léon Victor Dupré	*Trees on Water's Edge*	23½ × 28¾	150	
1902, Apr. 1	Léon Victor Dupré	*Landscape with Trees*	26⅝ × 20⅜	150	
1903, Apr. 21	Jean Bertin	*The Mill*	15 × 18¼		*
1903, Nov. 6	Louis Mettling	*Portrait of Young Girl*	9½ × 7¼	unknown	
1903, Dec. 17	Adolphe Appian	*Lake in Ain, France*	13⅛ × 22⅛	unknown	
1903, Dec. 18	Gustave Courbet (fake)	*Waterfall*	18⅛ × 16⅛	Default on loan	
1906, May 6	Eugène Delacroix	*Lamentation over Christ*	8¼ × 12⅛		*
1906, Dec. 27	Édouard Manet (fake)	*Portrait of Marine Painter*	13½ × 10½	300	

ABBREVIATIONS

BMA	Baltimore Museum of Art
JHU	Johns Hopkins University
MHS	Maryland Historical Society
MICA	Maryland Institute College of Art
MSA	Maryland State Archives
NARA	National Archives and Records Administration
SMCA	St. Mary's College Archives
WAM	Walters Art Museum

PROLOGUE

1. For Lucas's reference to himself as a "wanderer," see Randall, *The Diary of George A. Lucas,* 2:1 (hereinafter *Lucas Diary*). In 1863, Baudelaire defined a *flâneur* in a way that might have fit Lucas: "For the perfect flâneur, for the passionate spectator, it is an immense joy to set up house in the multitude, amid the ebb and flow of movement . . . [like] the lover of pictures who lives in a magical society of dreams painted on canvas." Baudelaire, *The Painter of Modern Life.*

2. Whistler wrote to Lucas in late 1866 that Lucas had an "entrée everywhere in Paris." Mahey, "The Letters of James McNeil Whistler to George A. Lucas," 247–257.

3. See *Lucas Diary.* The fifty-one annual diaries Lucas left behind are dated from 1852 to 1908. Missing and presumably lost are the diaries for 1856 (the last full year that Lucas resided in the United States), 1857 (the first year that Lucas resided in Paris), 1860, the first five months of 1878, and 1909 (the year of his death). The diaries are located in the rare book collection of the Walters Art Museum. I am indebted to Lilian Randall for discovering, interpreting, indexing, and publishing these diaries. I also want to thank Jo Briggs, Assistant Curator of Eighteenth- and Nineteenth-Century Art at the Walters Art Museum, for recently digitizing the diaries and providing a searchable copy to me. For a discussion of the "fragmented and almost unreadable" nature of the entries but their importance in allowing scholars to understand the practice of art dealing in Paris at that time, see Francis Haskell's review of the *Lucas Diary* in *Burlington Magazine.*

4. At that time, William Lucas was the part owner and manager of the family's very profitable stationery and publishing business, which he inherited from his father, Fielding Lucas Jr. For information about Meissonier's fame at that time, see Ross King, *The Judgment of Paris,* 1–12. See also Odile Sebastiani, "Jean-Louis-Ernest Meissonier," in Philadelphia Museum of Art, *The Second Empire: Art in France under Napoleon III,* 332–333 ("It was under the Third Republic that Meissonier's glory attained its apogee").

5. On the evening of February 4, 1859, Lucas recorded in his diary: "In morning to Poissy 15 miles from Paris by rail to see Meissonier, Artist, who unfortunately was not home. Saw his wife who gave me information concerning his pictures, the price of which varied from 10 to 80,000 francs according to size & number of figures. Showed me 'the Nixe' belonging to the Queen of England & for which she paid 25,000 f." *Lucas Diary,* 2:89.

6. The art that Lucas acquired for himself or advised his clients to acquire ultimately found homes in the following museums: the Baltimore Museum of Art; the Walters Art Museum; The Metropolitan Museum of Art; and the National Gallery / Corcoran Museum of Art. For information about the American artists and patrons who resided in Paris in the second half of the nineteenth century, see Adler, Hirshler, and Weinberg, *Americans in Paris.* For information about the combined collections of William and Henry Walters, see William R. Johnston, *William and Henry Walters.* For information about the collection of Samuel P. Avery, see Beaufort, Kleinfield, and Welcher, *The Diaries 1871–1882 of Samuel P. Avery.* For a description of the collection of William Henry Vanderbilt, see Zalewski, "Art for the Public." For a description of the collection of John Taylor Johnston, see Baetjer, "Extracts from the Paris Journal of John Taylor Johnston."

7. To show his respect and admiration for Napoleon III, Lucas often attended ceremonies involving the emperor. For example, on May 17, 1858, he went to the Bois de Boulogne to see Napoleon review seven regiments of cavalry and one regiment of armory; on May 10, 1859, he went to see Napoleon depart from Paris to take command of his army in Italy in the war against Austria and noted in his diaries his thrill in seeing "the Emperor and Empress." See *Lucas Diary,* 1: 77, 94. His suggestions to his clients that they purchase portraits of Napoleon and Napoleon III serve as indicators of Lucas's

political leanings and admiration for Napoleon III. *Lucas Diary,* 2:237, 623.

8. For the style and symbolism of the clothing worn by bourgeois men in Paris during the second half of the nineteenth-century, see Thiébaut, "An Ideal of Virile Urbanity," 134–145.

9. Antony Adam-Salomon was a sculptor before turning to photography. He attempted to make his photographic portraits appear painterly by bathing the subjects in artificial light, swathing them in drapery, and retouching the photographs. The nineteenth-century critic Alphonse de Lamartine, after studying Adam-Salomon's portraits, observed that "we can no longer claim that photography is a trade—it is an art." See Newhall, *The History of Photography,* 69. In addition to retaining Adam-Salomon to photograph him, Lucas arranged for Adam-Salomon to photograph two of his important clients: John Taylor Johnston, one of the founders of the Metropolitan Museum of Art, and Samuel Avery. Lucas paid Adam-Salomon 60 F for the six photographs of him. See *Lucas Diary,* 1:46, 2:308–310, 320, 358, 372.

10. The remarks by Walters about Lucas appeared in *Antoine-Louise Barye from the French in Various Critics,* which was prepared and distributed by Walters on January 28, 1885, in connection with the unveiling in Baltimore's Mount Vernon Place of five sculptures by Barye, which Walters was giving to the city. Walter's remarks about Lucas were republished by William R. Johnston in "The Lucas Collection and the Walters Art Gallery," 4–5.

11. Fixed to the back of the painting is a note, signed by George Lucas, which states, "My portrait painted in two settings by Whistler at Boissise-la-Bertrand France 22 & 23 August 1886." I want to thank Jo Briggs for bringing this to my attention.

12. See, e.g., diary entries for July 14 and 17, Oct. 27, and Dec. 22, 1879; and Mar. 6, 10, and 14, and Apr. 21, 1883. *Lucas Diary,* 2:477, 478, 502, 511, 559, 560, 562.

13. See the Metropolitan Museum of Art, *Annual Reports of the Trustees of the Association from 1871 to 1902,* 451, 461, 510, 552, 581, 621, 629, 651, 717, 748, 851, and 852. For the reference to Lucas as an "eminent collector and generous friend," see "Membership," 54.

14. See "Mr. George Lucas," *Baltimore Sun,* Nov. 21, 1889. Lucas's reputation in America at that time is also evidenced by the observation of J. Henry Harper, who wrote that Lucas was "considered the final authority whenever any serious question has arisen as to the authenticity of one of the Barbizon school of pictures" (*The House of Harper,* 543).

15. Lucas commissioned Moreau-Vauthier to create his bust on February 12, 1890. He sat for it five times that year

and returned to inspect the work and make sure that it was cleaned, waxed, and ready for shipment to the Metropolitan Museum. See *Lucas Diary,* 2:705, 706, 708, and 711. The Metropolitan Museum's accession number for its *Bronze Bust of George A. Lucas* is 91.7. Lucas commissioned Moreau-Vauthier's son-in-law, Ernest Dragonet, to make a copy of his bust, which remained in Lucas's collection and now belongs to the Baltimore Museum of Art (BMA 1995.69). I want to thank Barbara W. File and James Moske, archivists at the Metropolitan Museum of Art, for allowing me to examine the museum's records involving this gift.

16. Toward the end of his life, Lucas carefully prepared two notebooks that listed the art in his apartment and the art in M's apartment. One notebook focused on portfolios of prints and information about the artists who made the prints, and the other notebook focused on the paintings. The inventories were not completed before Lucas's death. Both are located in the George A. Lucas Papers, BMA Archives. I thank Jay McKean Fisher and Emily Rafferty for bringing these documents to my attention.

17. The identities of all of the artists who are represented in Lucas's collection are listed in *Lucas Diary,* 1:48–51.

18. The precise number of objects in Lucas's enormous collection around the time of his death remains uncertain. There is no extant document that records this number. Although Lucas made endless fragmentary lists of his art, he never completed any comprehensive catalogue of his entire collection. The difficulty in quantifying the number of works of art also stems from the confusion over what kind of print constituted a work of art in the nineteenth century. Lucas stored his prints in portfolios that also contained hundreds of reproductions of works of art cut out from newspapers and magazines. Whether these items should be considered as works of art or ephemera is an issue that is presently under study at the BMA. The problem is further compounded by the fact that some works of art were given or taken away and others lost. According to different estimates made between 1911 and 2005, the number of prints in the collection ranged between 14,000 and 18,783.

19. On June 5, 1976, Lucas's collection of art was appraised by the Tomlinson Collection, an art appraiser. According to that appraisal, the most valuable work was the painting by Daumier, which was valued at $100,000. See letter and attached appraisal from the Tomlinson to the Maryland Institute, June 5, 1976, MICA Archives.

20. The exhibition of Lucas's collection of Barye sculpture is referred to in *Lucas Diary,* 1:26. For a thorough discussion of Lucas's relationship with Barye and his collection of Barye's

art, see Johnston and Kelly, *Untamed.* Lucas possessed over 130 prints by Whistler and approximately 75 by Manet. For an analysis and discussion of the prints by Manet that were acquired by Lucas, see Fisher, *The Prints of Edouard Manet.* For a discussion of Lucas's drawings, including the work by Daumier, see Fisher and Johnston, *The Essence of Line.* For a discussion of Pissarro's *The Versailles Road at Louveciennes* (WAM 37.1989), see Rothkopf, *Pissarro,* 98, 99.

21. John Taylor Johnston died in 1893. William T. Walters died in 1894. Samuel P. Avery died on August 11, 1904.

22. *Baltimore Sun,* Feb. 9, 1904. There is no evidence that Lucas at that time was thinking about leaving his art collection to the Maryland Institute. The first time he mentioned the Maryland Institute in his diary was more than six months after the fire on August 23, 1904.

23. See Pennell and Pennell, *Whistler's Journal,* 55, 56. After discussing the fire, Lucas showed the Pennells his portrait by Whistler and some of Whistler's etchings. The great Baltimore fire occurred on February 7 and 8, 1904, but Lucas did not learn about it until three days later, on February 11, when he received a cable from Henry Walters.

24. *Lucas Diary,* 2:926, 927.

25. See Emery, "Dornac's 'At Home' Photographs," 209–224.

26. On September 22, 1887, Lucas purchased a deluxe portfolio of etchings entitled *Exposition Ribot* from the Bernheim Gallery. *Lucas Diary,* 2:655. The etching of *The Old Beggar* was done by an engraver named Masson. Ribot had gained fame as a painter of realistic genre scenes. I want to thank Rena M. Hoisington, curator and department head of the Baltimore Museum of Art's Department of Prints, Drawings, and Photographs, for identifying this picture.

27. The *Seated Lion* and *Tiger Walking* were among the most popular works by Barye and following his death were reproduced in different sizes. Lucas's diary indicates that he acquired the *Lion* and *Tiger,* shown on and in front of his fireplace, on June 8, 1885, for 1,000 F. *Lucas Diary,* 2:610.

28. Breton won medals at the Salons of 1855, 1857, and 1861. He was awarded a first-class medal in 1861 and was named chevalier of the Legion of Honor. Cabanel was awarded the Prix de Rome in 1845; he became a leading member of the Institut de France and a professor at the École des Beaux-Arts in 1863, and was awarded the grand medal of honor at the Salons of 1865, 1867, and 1878. Courbet, one of the greatest painters of his time, was the undisputed leader of the school of realism, and in 1855 famously challenged the convention of the official Salon by erecting his own "Pavilion

of Realism." Daubigny won first-class medals at the Salons of 1853 and 1867 and the Legion of Honor in 1857. Fantin-Latour's paintings were repeatedly shown at the salons beginning in 1864. For sketches of these artists and examples of their work, see Kathryn B. Heisinger and Joseph Rishel, "Painting," in Philadelphia Museum of Art, *The Second Empire.*

29. The full title of Courbet's painting was *The Painters Studio, a Real Allegory Defining a Phase of Seven Years of My Artistic Life.* For a discussion of the significance of Courbet's decision in 1855 to mount a commercial exhibition of his paintings, see Mainardi, "Courbet's Exhibitionism." The meaning of Courbet's *The Painter's Studio* is debatable. For a review of its various interpretations, compare Fried, *Courbet's Realism,* 155–164, with Faunce, *Courbet,* 27, 28, 78.

30. *Lucas Diary,* 2:699 (Oct. 30 and 31, 1889), and 701 (Dec. 10, 1889). According to one study, Courbet painted 507 landscapes, 290 of which were painted between 1866 and 1873. For a broad study of his landscapes, the number he produced, and a reference to the paintings of dubious authenticity produced by his studio toward the end of Courbet's life, see Morton and Eyerman, *Courbet and the Modern Landscape,* 13, 14, 1/n14, and 121. For an article that tracks the reluctance of American collectors to purchase Courbet's paintings prior to the late 1880s, see Edelson, "Courbet's Reception in America Before 1900," 67–76.

31. Follower of Courbet, *Hind Forced Down in Snow* (WAM 37.2422).

32. The original painting by Courbet entitled *Biche forcée à la neige* was exhibited at the Salon of 1867. For a contemporaneous article about the Paris Exposition of 1889 which refers to Courbet's painting of the deer as one of his "principal works," see *Nation,* 49:229, 230 (Google e-book). According to Lucas's diary, on November 14, 1889, he was shown the painting by the art dealer Montaignac and arranged for it be unvarnished; on December 3, he withdrew 6,000 F from William Walters's bank account to pay for it; on December 10, he purchased a copy of Courbet's autograph; and on December 20, he paid Montaignac for the painting. *Lucas Diary,* 2:699–703. The painting remains in the collection of the Walters Art Museum (WAM 37.2422), but it is now attributed to a follower of Courbet. Courbet's *The Stream of the Black Well* is also in the Walters (WAM 37.203).

33. *Lucas Diary,* 2:906, 912, 924, 926, 927.

34. See Eik Kahng, *Courbet / Not Courbet,* exhibition catalogue, Walters Art Museum, 2006, WAM Archives. With regard to *The Waterfall* that was attributed to Courbet, a memorandum dated February 11, 1965, stated that Gaston Delestre, a connoisseur of Courbet's paintings, "was horrified

by the Lucas Waterfall . . . [and] did not think it was even by one of Courbet's three assistants but only the faintest echo of someone who had heard about Courbet, perhaps seen one of his paintings." BMA Curatorial Records.

35. When the painting was initially shown in the United States in 1911, it had no name and was simply called "Study in Oil." See the catalogue, *Exhibition of the George A. Lucas Art Collection,* item no. 54, p.16.

36. See Druick and Hoog, *Fantin-Latour,* 155–158; and Fried, *Manet's Modernism,* 10, 214, 215. Fried referred to these paintings as "féeries" and described them as possessing a "deliberate vagueness of subject and action." For paintings by Fantin-Latour that are similar in style to the sketchy painting that Lucas acquired, see *Woodland Glade* and *The Bathers* in the Manchester Art Gallery, *La Causerie* in the Leeds Museums and Galleries, and *Dusk* in the Phillips Collection.

37. The portrait of Whistler originally was part of *The Toast,* a larger painting of a group of artists that was displayed at the Salon of 1865 and highly criticized, leading Fantin-Latour to destroy the painting. Before he did so, he cut out the head of Whistler and saved it as a portrait. Lucas purchased the portrait of Whistler for Avery on February 22, 1873. *Lucas Diary,* 2:374. It was later acquired by Charles Lang Freer and is in the collection of the Freer Gallery of Art, Smithsonian Institution (06.276).

38. *Lucas Diary,* 2:375.

39. Lucas's diary indicates that he tried to sell the painting to the Lherbettes Gallery. On December 22, 1873, he "carried sketch by Fantin" to several galleries in an apparent effort to sell it, and on July 20, 1881, he offered to sell the sketch to Lherbettes Gallery for 300 F. See *Lucas Diary,* 2:386, 524.

40. See *Lucas Diary,* 2:836, 640. I want to thank Nicole Simpson for providing me with the number of Fantin-Latour's lithographs that were in the Avery and Lucas collections. Lucas's collection of Fantin-Latour's lithographs is in the collection of the BMA.

41. Lucas referred to Breton more than 150 times in his diary.

42. *Lucas Diary,* 2:219.

43. For a brief history of *The Communicante,* see Lacouture, *Jules Breton,* 194–196. The history of the painting is also discussed in Beaufort and Welcher, "Some Views of Art Buying in New York in the 1870s and 1880s," 48–55. Lucas commissioned the painting for Avery on July 13, 1881. *Lucas Diary,* 2:524.

44. Lucas's acquisition of this painting might suggest that he was a devout believer. According to his close lifelong friend Frank Frick, he was not. Frick stayed with Lucas in Paris from May 13 to May 19, 1860, and returned to Paris and stayed with Lucas again from July 21 to August 3, 1860. On July 11, 1864, Frick and his wife returned to Paris and spent more than a month with Lucas. During this period, Lucas was Frick's "daily and almost hourly companion." On Sunday, August 28, 1864, Frick spent the morning with Lucas and noted in his diary that it was a "lovely Sabbath morning but no signs of observation here." During Frick's stay in Paris, the only time he and Lucas went to a church was to hear a concert. See Frank Frick, "A Time Table Diary of Travel Abroad," vol. 1 (Aug. 28, 1864), Peabody Institute Archives, JHU. Lilian Randall described Lucas as "a lapsed Catholic who went to church only *in extremis.*" *Lucas Diary,* 1:25.

45. *Lucas Diary,* 2:583. After receiving the sketch, Lucas requested Breton to send him a "2nd study" of *The Communicante.* See *Lucas Diary,* 2:585 (Apr. 8, 1884). Both studies are in the BMA (BMA 1996.45.45, BMA 1996.45.46).

46. Avery appears to have resold the painting in 1884 to Mary Jane Morgan for $12,000 (or roughly 60,000 F), and two years later in 1884, the painting was sold at auction for $45,000, the highest price ever paid for a living artist. See Fidell-Beaufort, "The American Art Trade."

47. For a discussion of Daubigny's landscapes and their place in French landscape painting, see Marlais, "Charles-François Daubigny," 38–54.

48. *Lucas Diary,* 2:264 (Mar. 20, 1864): "At HD at Dhios sale & bought landscape Daubigny for 300 fs." Lucas retained most of his Daubigny prints, but on May 4, 1907, he sold nine of them. *Lucas Diary,* 2:951.

49. There are two versions of this famous painting. One now resides at the Musée d'Orsay and the other at the Metropolitan Museum of Art.

50. *Lucas Diary,* 2:365, 372, 374, 376, 378. The visit to Cabanel's studio led to Walters purchasing on October 26, 1873, Cabanel's beautiful painting of *Pandora* for 10,000 F. *Lucas Diary,* 2:384. The painting is in the Walters Art Museum (WAM 37.99).

51. For a list and description of the portraits of Lucas, see *Lucas Diary,* 1:46, appendix C.

52. For information about Cabanel's place in the pantheon of French mid-nineteenth-century artists and his portraits, see Amic, "Cabanel and the Portrait," 70–83; and Zalewski, "Alexandre Cabanel's Portraits."

53. Alexandre Cabanel to George Lucas, Apr. 14 and June 11, 1875, MICA Archives.

54. *Lucas Diary,* 1:46.

55. *Lucas Diary,* 2:952, 953.

56. *Lucas Diary,* 2:935.

57. For an excellent discussion and survey of the great private collections in Paris in the late eighteenth and early nineteenth centuries, see Boime, "Entrepreneurial Patronage in Nineteenth-Century France." In his survey of the great collectors in Paris at that time, the author does not mention George Lucas.

58. See Tompkins, *Merchants and Masterpieces,* 238. The trustees of the Metropolitan Museum of Art turned down Avery's gift of his print collection because at that time they did not view prints as fine art and saw no reason to collect them.

CHAPTER 1. THE CULTIVATION OF LUCAS

1. The portrait of Fielding Lucas Jr. was painted in 1808. The companion portrait of his wife was painted in 1810, the year of their wedding. Both paintings are in the BMA.

2. Fielding Lucas Jr. was born on September 3, 1781, in Fredericksburg, Virginia. Around 1798, he moved to Philadelphia, and around 1804, to Baltimore. Biographical sketches can be found in Foster, *Fielding Lucas Jr.*; Foster, "A Baltimore Pioneer in the Arts"; Uhler, "The Oldest Stationery Store in America"; and John Earle Uhler, "Fielding Lucas Jr. and Early Baltimore," undated typewritten manuscript, MHS. In 1829, Lucas published a brief catalogue of his books, which he entitled, *Valuable Works Published by Fielding Lucas, Jr.* The catalogue is in the collection of the MHS.

3. See "The Daily Journal of Robert Mills." On February 14, 1816, Mills wrote, "Called on Mr. Lucas submitted designs for store front. Made an estimate of the costs of the same." On February 24, he wrote, "Engaged in taking dimensions and making worthy drawings of the front of Mr. Lucas's store." See also Foster, *Fielding Lucas, Jr.*

4. See Uhler, "The Oldest Stationery Store in America."

5. For an excellent article about the history and growth of Baltimore during the late eighteenth and early nineteenth centuries, see Hunter, "Baltimore in the Revolutionary Generation," 183–233. The best description of the architectural history of Baltimore during the eighteenth and nineteenth centuries is found in Hayward and Shivers, *The Architecture of Baltimore.* For another description of Baltimore in 1800, see Bernard, "A Portrait of Baltimore in 1800" 341–360. For the growth of Baltimore's economy between 1800 and 1850, see Hall, *Baltimore,* 1:63–147; and Brugger, *Maryland,* 175, 196–206. Joseph C. Cox described Baltimore in the 1840s as "one of the most exciting cities in America" but with a culture that lagged behind that of New York, Philadelphia, and Boston; see "The Origins of the Maryland Historical Society," 103–116. According to the 1850 US Census, the four most populated cities in the country that year were New York, pop.

515,000; Baltimore, 169,000; Boston, 136,000; and Philadelphia, 121,000. The elegant homes that surrounded Baltimore in the nineteenth century are exemplified by Homewood House, the beautiful Federal-period country home constructed in 1803 and now located on the campus of Johns Hopkins University. For information about Homewood House and illustrations of other villas that surrounded Baltimore at that time, see Hayward and Shivers, *Architecture of Baltimore,* 27–46.

6. The idea was introduced around the turn of the century in Baltimore by Charles Willson Peale as part of his effort to attract students to his painting studio and museum for instruction. See Katz, "The Imitative Vocation," 43, 229–231.

7. Rembrandt Peale, *Graphics,* 4, 5.

8. The three drawing books published by Lucas are Amateur [Fielding Lucas], *The Art of Drawing Landscapes; being plain and easy directions for the acquirement of this useful and elegant accomplishment* (Fielding Lucas Jr., 1820); John Varley, *A practical treatise on perspective, adapted for the study of those who draw from nature, by which the usual errors may be corrected* (Fielding Lucas Jr., 182?); and Fielding Lucas, *Progressive Drawing Book* (John D. Toy, 1827). For information about other drawing manuals popular at the time, see Katz, *The Imitative Vocation,* 187–189.

9 In his *Progressive Drawing Book,* Lucas referred to Varley as making "the best work that has yet been published in England." A large selection of Varley's work is in the Tate Britain. For information about John Hill (1770–1850), see Drepperd, "Rare American Prints," 25–28.

10. John H. B. Latrobe, while studying to pursue a career as a lawyer, was employed by Fielding Lucas to write books and to draw or paint illustrations. According to Latrobe, he wrote and prepared all of the illustrations in the *Progressive Drawing Book,* and Lucas compensated him with law books Latrobe needed for his studies. The relationship between Lucas and Latrobe grew into a close friendship. Latrobe referred to Lucas as one of his oldest, truest, and best friends. Latrobe completed drawings of the principal buildings in Baltimore that were used in a travel guide published by Lucas in 1834 and entitled *Picture of Baltimore.* The two friends joined others in founding the Maryland Institute. Latrobe was also a founder and president of the Maryland Historical Society. See John Edward Semmes, *John H. B. Latrobe and His Times,* 102–105, 184, 185, 361, 397, 412, and 419.

11. Fielding Lucas Jr., *Valuable Works,* 5. Lucas's *Progressive Drawing Book* is in the rare books collection of the Maryland Historical Society. For a discussion of the quality of the prints in the book, see Drepperd, "Rare American Prints." For

...on and analysis of the content of this book, see ...ielding Lucas, Jr., 197–201.

...2. George Lucas's extant diaries begin in 1852, when he had already reached his twenty-eighth birthday.

13. The Lucas home at the corner of St. Paul and Saratoga Streets no longer exists. It apparently was replaced by the Preston Gardens in the 1920s. George Lucas was raised in this house along with six brothers and two sisters. The older brothers were Edward Carrell (b. 1811), Fielding III (b. 1812), John Carrell (b. 1814), William Fielding (b. 1818), and Henry (b. 1822). The younger brother was Charles Zachary (b. 1830). George's older sister was Mary Louisa (b. 1820), and his younger sister was Ellen (b. 1828). His parents also had two other children, Zachariah and Francis, who died at birth or shortly thereafter. Among George Lucas's siblings, the one who shared his interests and whom he loved the most was Fielding III. As discussed in the text, Fielding's death in 1853 had a significant effect on George.

14. Hall, *Baltimore*, 1:132.

15. In addition to the portraits by Thomas Sully, Lucas acquired and displayed in his home an eclectic array of paintings, prints, and objects of art that included *A View of Baltimore*, attributed to the celebrated marine painter Fitz Hugh Lane; still-life paintings by the Dutch seventeenth-century artist Ambrosius Bosschaert; an engraving of Leonardo da Vinci's *Last Supper* by the eighteenth-century Italian engraver Raphaello Morghen; and several other portraits and painted porcelains. Some of his art was displayed at public exhibitions held in the late 1840s and 1850s at the Picture Gallery of the Maryland Historical Society. See Maryland Historical Society, *Catalogue,* which includes exhibition catalogues for 1848, 1849, 1853, and 1856.

16. Foster, "A Pioneer in the Arts," 4.

17. For a discussion of the popularity of painting rooms and drawing books in Baltimore at the turn of the nineteenth century, see Katz, "The Imitative Vocation," 118–170, 187–204. For a discussion of Francis Guy's life and art and a list of painters working in Baltimore between 1796 and 1816, see Colwill, *Francis Guy*.

18. *Federal Gazette and Baltimore Daily Advertiser,* Oct. 25, 1796, (hereinafter *Federal Gazette*).

19. For descriptions of the museums opened in Baltimore by members of the Peale family in 1796 and 1804, see Miller, *In Pursuit of Fame,* 39–45, 72–74. For the advertisements about the mammoth place in the Baltimore newspapers in 1804, see *Federal Gazette,* May 29 and 30, June 2, 5, and 6, 1804.

20. *Federal Gazette,* Aug. 15, 1814.

21. *Federal Gazette,* Jan. 6, 1815.

22. For an excellent study of the Peale Museum on Holliday Street, see Miller, "A Rendezvous for Taste: Peale's Baltimore Museum, 1813–1822," chap. 8 in *In Pursuit of Fame,* 115–128. See also Hunter, *The Story of America's Oldest Museum Building*; Scharf, *History of Baltimore City and County,* 691–94 and "The Old Baltimore Museum"; John W. Durel, "In Pursuit of a Profit," in Alderson, *Mermaids, Mummies, and Mastodons,* 41–47. For information about the Baltimore Museum at the corner of Market and Calvert Streets, see Varle, *View of Baltimore,* 41; and Katz, "The Imitative Vocation," 95, 96. For a description of the architecture of the Peale Museum on Holliday Street, see Hayward and Shivers, *Architecture of Baltimore,* 92, 93.

23. See Hunter, "Peale's Baltimore Museum," 31–36.

24. For example, in the exhibition catalogues published by the Maryland Historical Society beginning in 1848, each work of art was identified first by its title, second by its owner/proprietor, and third by its artist. See Maryland Historical Society, *Catalogue*. In 1830, the Peale Museum on Holliday Street was taken over by the city and used as Baltimore's city hall. After moving to the corner of Baltimore and Calvert Streets, the Peale Museum remained there until 1835, when it closed. For information about the Baltimore Museum at the corner of Calvert and Baltimore Streets, see Varle, *View of Baltimore,* 41; and Katz, "The Imitative Vocation," 95, 96. The lithograph of the museum on Calvert and Baltimore Streets is entitled *Baltimore Street Looking West from Calvert Street* (E. Sachse, 1850). For a discussion of the exhibition held at the Maryland Academy of Fine Arts, see Thrift, "The Maryland Academy." At the exhibition conducted in 1838, between four and five hundred works of art were displayed. For a discussion of the popular annual art exhibitions at the Maryland Institute, see Frost, *Making History / Making Art,* 48–53. Beginning in 1848 as part of the annual exhibition of art and science at the great hall of the Maryland Institute, hundreds of works of art loaned from local collectors were placed on display. For the annual exhibits conducted at the Maryland Historical Society, see Rutledge, "Early Art Exhibitions of the Maryland Historical Society," 124–136. For art exhibitions at the Peabody Art Gallery, see Schaaf, "Baltimore's Peabody Gallery."

25. *American and Commercial Daily Advisor,* Jan. 6, 1830. By 1833, the Peale Museum fell out of favor and was sold by Peale to a group of investors. For an account of the inglorious history of the museum after 1833, see Scharf, *History of Baltimore City and County,* 692–694.

26. For Sarah Peale as the country's first female professional artist, see Kort and Sonneborn, *A to Z of American*

Women in the Visual Arts, 173; and Elam, *The Peale Family,* 134. See also Joan King, introduction to *Sarah M. Peale.*

27. The portrait of Fielding Lucas attributed to Sarah Peale is in the collection of the Maryland Historical Society. See Rutledge, "Portraits Painted Before 1900," 29. See also Hunter and Mahey, *Miss Sarah Miriam Peale.*

28. George Lucas owned at one time a copy of Sarah Lucas's portrait. In October 1882, he sold it to Mary Bucklers, a Baltimorean who was also residing in Paris at that time. See *Lucas Diary,* 2:550.

29. For an extensive and scholarly description of Gilmor's life, art collection, and influence on early American culture, see Humphries, "Robert Gilmor, Jr." Humphries has concluded that most of the paintings available for the public to see were in Gilmor's Water Street home. The reference to the Louvre as Gilmor's "academy" is recorded on p. 142. The beauty of Gilmor's country estate at Beech Hill was the subject of landscape paintings by Thomas Doughty, Francis Guy, and others. For pictures of the estate, see Hayward and Shivers, *Architecture of Baltimore,* 42, 43. See also Weston, "Art and Artists in Baltimore," 213–227. Doughty's painting *View of Baltimore from Beech Hill* is in the collection of the BMA. Beech Hill was located in what today is the vicinity of Gilmor and Saratoga Streets in the inner city. See Carroll Dulaney, "Gilmor Art Will Be Revived After 90 Years," *Baltimore Sun,* June 1, 1941.

30. Levasseur, *Lafayette in America,* 174, 175.

31. Greenough, *Letters of Horatio Greenough,* 36. See Katz, "The Imitative Vocation," 33. For art collections in Maryland, including the collection of Robert Gilmor Jr., see William R. Johnston, *The Taste of Maryland.* Johnston characterizes Gilmor as "the most important American collector of his time." For another excellent article on Gilmor's collection, see Rutledge, "Robert Gilmor, Jr.," 18–39. As discussed in Rutledge's article, many of Gilmor's European paintings were discovered to be forgeries. For financial reasons, Gilmor's collection was dispersed following his death in 1848. See also Carroll Dulaney, "Gilmor Art Will Be Revived After 90 Years," *Baltimore Sun,* June 1, 1941.

32. For Gilmor's role in the planning and construction of Baltimore's Washington Monument, see Humphries, "What's in a Name?," 254, 266n6 and 10.

33. Robert Gilmor Jr. to Charles Graff, Apr., 17, 1837, Collection of Metropolitan Museum of Art. The letter is referred to in Rutledge, "Robert Gilmor, Jr."

34. Humphries states that Gilmor loaned approximately eighty works of art to exhibitions held at the Baltimore Peale Museum between 1822 and 1825, that he was the "largest contributor" at these exhibitions, and that in 1848 over forty works of art owned by Gilmor were displayed at the opening exhibition conducted by the Maryland Historical Society. See Humphries, "Robert Gilmor, Jr.," 332, 333. See also Baltimore Museum of Art, *A Century of Baltimore Collecting.* The catalogue for this exhibition referred to Gilmor as "one of the very first collectors in America," and it stated that "the stimulus which he [Gilmor] gave to art in Baltimore had far flung results." Following a discussion of Gilmor's life and his collection, the catalogue for this exhibition referred to the following collectors from Baltimore: Thomas Edmondson, George A. Lucas, Mme. Ernest De Weerth, Mary Frick Jacobs, Jacob Epstein, Claribel and Etta Cone, Saidie A. May, and William and Henry Walters.

35. The two best sources for images of buildings and monuments constructed in Baltimore during the first half of the nineteenth century are Hayward and Shivers, *Architecture of Baltimore,* 66–128; and Rice, *Maryland History in Prints.* For images of the buildings in the nineteenth century and what replaced them in the twentieth century, see Duff and Clark, *Then and Now.*

36. Latrobe arrived in the United States from England in 1795; he resided briefly in Richmond and Philadelphia before settling in Washington, DC, where the federal government employed him as the surveyor of public buildings. While residing primarily in Washington, he designed the buildings in Baltimore. He died in 1820. Godefroy left France and arrived in Baltimore in 1805 to teach at St. Mary's College. After an active career as a teacher and architect in Baltimore, he returned to France in 1819. Mills designed buildings in the mid-Atlantic states; he did not arrive in Baltimore until 1814 and left around 1820 for South Carolina and then Washington DC. For a discussion of the relationship between Latrobe, Godefroy, and Mills and their projects in Baltimore, see Davison, "Maximilian Godefroy," 175–212.

37. See Sir Banister Fletcher, *A History of Architecture,* 1213, 1214. For a lengthy discussion of the cathedral and its history in early Baltimore, see Hayward and Shivers, *Architecture of Baltimore,* 66–73.

38. For the definitive history of the Maryland Institute, see Frost, *Making History / Making Art.* For a description of the early purpose of the Maryland Institute and the role played by Fielding Lucas, see 5–17. For a discussion of Fielding Lucas's contribution to the Maryland Institute, see 16 and 17. For an early nineteenth-century description of the Maryland Institute, see Varle, *A Complete View of Baltimore,* 54, 55.

39. Baltimore was known as the Monumental City even before President Adams's comments. See Humphries, "What's

in a Name?" See also *Niles' Weekly Register* 33, no. 840 (Oct. 20, 1827); and Hunter, "Baltimore in the Revolutionary Generation," 228–233. For a flattering description of the social and cultural life of Baltimore in the 1820s, see Raphael Semmes, "Baltimore During the Time of the Old Peale Museum," 115–122.

40. The engraving was made by S. Fisher based on an earlier painting by W. H. Bartlett. The engraving is in the BMA.

41. Trollope, *Domestic Manners of the Americans,* 205.

42. For an account of Dickens's visit to Baltimore, see Wilkins, *Charles Dickens in America.* For a description of Barnum's Hotel, see Gobright, *City Rambles,* 161–165. For Dickens's opinion of Barnum's Hotel, see Hall, *Baltimore,* 1:131.

43. Lucas and Latrobe, *Picture of Baltimore.*

44. Lucas and Latrobe, *Picture of Baltimore,* 239.

45. For a summary of Fielding Lucas's contributions to the culture of Baltimore, see James W. Foster, "A Baltimore Pioneer in the Arts," *Baltimore Sun,* July 14, 1935.

46. For a discussion about the cultural links between Baltimore and France in the nineteenth century, see Cheryl K. Snay, "Mise en scène," in Fisher and Johnston, *The Essence of Line,* 1–13. The early roots of this connection are discussed in Wood, *The French Presence in Maryland.* For information about the influence of French émigrés on the social life of Baltimore in the nineteenth century, see Didier, "The Social Athens of America," 20–36. For information about Lucas's studies at St. Mary's College, see *Lucas Diary,* 1:5. For a list of the students who attended St. Mary's College during the first half of the nineteenth century, see *St. Mary's Seminary of St. Sulpice Baltimore.* For references to George Lucas and his brothers, see 105, 121, 132.

47. See Wood, *The French Presence in Maryland,* 115–117, 124, 125; see also Hall, *Baltimore,* 1:57.

48. Levasseur's description of Baltimore as observed during his trip with Lafayette in 1824 is set forth in *Lafayette in America,* 167–184.

49. *Lucas Diary,* 2:316, 324, 409, 410, 411, 511, 583, 593, 594, 597, 599, 741, 755, 762, 823, 825, 827, 834, 855, 870, 871, 873, 879, 880, and 923.

50. *Annual Report of the Trustees of the Metropolitan Museum of Art for 1893–1894,* 581.

51. For a detailed account of the founding of St. Mary's College, see James Joseph Kortendick, "The History of St. Mary's College"; and John William Ruane, *The Beginning of the Society of St. Sulpice in the United States.* I want to thank Alison M. Foley, Associate Archivist at the St. Mary's

Seminary and University in Baltimore, for bringing the dissertation and other information related to George Lucas to my attention.

52. For the French influence and history of the chapel designed by Godefroy, see Stanton, "The Quality of Delight," 6–12. The names of some of the old-line families whose sons attended St. Mary's College in the nineteenth century were Carroll, Christlif, Fisher, Frick, Harvey, Jacobs, Latrobe, McKim, Mudd, Patterson, Piper, Riggs, Shriver, Stewart, Wallis, and Wilson. See *St. Mary's Seminary of St. Sulpice.* Although the original St. Mary's College in Baltimore closed in 1852, the chapel designed by Godefroy still exists, and the grounds around it have been converted into a public park.

53. See *Lucas Diary,* 1:5. The courses that Lucas would have taken and the classical literature that he was required to read are set forth in the *Calendars for St. Mary's College* for the years 1840 to 1845, which are available in the archives of St. Mary's College. See, e.g., *The Calendar of Saint Mary's College for the Academic Year, 1843–44* (Metropolitan, 1843).

CHAPTER 2. THE WANDERING ROAD TO PARIS

1. For information about the curriculum at West Point during the first half of the nineteenth century, including the teaching of art, see Park, *A Sketch*; Morrison, *The Best School*; Ahrens, *Water Color and Drawings.*

2. See John Edward Semmes, *John H. B. Latrobe,* 91–95, 132, 133.

3. *Lucas Diary,* 2:24.

4. Letter to the secretary of war, Mar. 1844, signed by G. A. Lucas and F. Lucas Jr., for the West Point application papers for George A. Lucas, file 169 (1843), NARA.

5. See George Lucas to George Whistler, Sept. 13, 1844, "Lucas Files," MHS.

6. See "Cadets separated from Mil. Academy since Jan. of 1846," signed by W. L. Macy and dated July 6, 1846, in "Register of Cadet Applications, 1819–67" (entries 242 and 234), NARA. Lucas's academic and disciplinary record at West Point is detailed in *Lucas Diary,* 1:5, 6.

7. *Lucas Diary,* 2:1.

8. *Lucas Diary,* 2:1 (Nov. 8, 1852).

9. *Lucas Diary,* 2:4, 10. During his lifetime, Lucas commissioned fifteen paintings, drawings, or busts of himself. See *Lucas Diary,* 1:46.

10. *Lucas Diary,* 2:11 (Jan. 22, 1853).

11. *Lucas Diary,* 2:15, 26, 27.

12. Although Lucas's whereabouts between the time he left West Point and started as a civil engineer in New Haven remain obscure, he or his family apparently floated the idea

that he had attended Yale Law School. J. Henry Harper claimed in his memoir, *The House of Harper* (1912), that "George Lucas, having just graduated from Yale Law School, made his maiden trip to Europe on board a side-wheeler, with the idea of taking a vacation before he began his practice of law." See also *Lucas Diary,* 1:6. There is nothing in Lucas's diary, the school's records, or elsewhere that supports the notion that Lucas ever attended or graduated from Yale Law School. In his diary, Lucas mentioned that Yale was located in New Haven, where he was working as a civil engineer, but there is no suggestion that he attended law school there. See *Lucas Diary,* 2:1, 17.

13. The first communication with his father that Lucas recorded in his diary that year occurred on June 7, 1853, when Lucas was at home to see his dying brother. On that morning he awoke his father and "summoned him to the bedside of his finest, noblest, now dying son." On October 8, 1853, Lucas sent a letter to his father. His father replied on October 12. *Lucas Diary,* 2:17, 22.

14. *Lucas Diary,* 2:27 (Dec. 31, 1853).

15. For a survey of the classical art that captured America's attention at the beginning of the nineteenth century, see Cooper, *Classical Taste in America.* The Boston Athenæum was founded in 1807 as a privately owned library and center of intellectual cultivation. In 1822, it began its art collection with eleven plaster casts of antique sculpture. Beginning in 1827, it conducted annual exhibitions, which by the end of the 1850s included more than three hundred paintings and one hundred sculptures. For the history of the Boston Athenæum, see Hirayama, *With Eclat.* For a description of the art on display at midcentury, see "Boston Athenæum," 9.

16. For a survey of the art collected in New York, Philadelphia, Boston, Baltimore, and elsewhere in the United States prior to 1850, see Miller, *Patrons and Patriotism.* With regard to the art collected in Baltimore, its athenæum opened in 1824, it was destroyed by fire in 1835, and it reopened in 1847 as part of the Maryland Historical Society. Renamed "Picture Gallery," it began to mount yearly exhibitions of copies of old master painting, portraiture, and an array of art by local artists. See Rutledge, "Early Art Exhibitions in the Maryland Historical Society." At midcentury, the Picture Gallery in Baltimore displayed twenty-nine works in bronze and metal and twenty-nine pictures attributed to Canaletto, Hogarth, Murillo, Reynolds, Rembrandt, Ruysdael, and Rosa, among others. For a list of the pictures and sculpture displayed, see *Catalogue of Paintings, Engravings, at the Picture Gallery of the Maryland Historical Society, Fourth Exhibition* (John D. Toy, Printer, 1853), MHS Archives. For discussions about the

American Art Union and its influence on early American collecting, see Sperling, "Art Cheap and Good." See also Marie-Stéphanie Delamaire, "Woodville and the International Art World," in Heyrman, *New Eyes on America,* 51–64. Among the 142 paintings at the Wadsworth Atheneum in 1950, only three were attributed to French artists: two landscapes by Poussin and a seascape by Vernet.

17. The Goupil branch in New York initially was called Goupil, Vibert, and Company. As a result of the death of Vibert, the name of the gallery was changed in 1852 to Goupil & Cie. In 1857, the gallery was sold to Michael Knoedler, who promptly mounted a grand exhibition of over two hundred French paintings while retaining Goupil as the gallery's name.

18. "The International Art Union."

19. See Barratt, "Mapping the Venues: New York City Art Exhibitions," 63, 64. For articles about the history of the Goupil gallery, the establishment of its New York branch, and the art that it sold in New York from 1850 to the 1870s, see Fink, "French Art in the United States," 87–100 (the Goupil firm "became the single most important vendor of contemporary French art in the United States"); DeCourcy E. McIntosh, "The Origins of the Maison Goupil," 64–76; "Goupil's *Album,*" 77–84; and "New York's Favorite Pictures in the 1870s," 114–123. See also Delamaire, "American Prints in Paris," 65–81; according to Delamaire, "Knoedler and his gallery were . . . instrumental in fostering the popularity of French art in the United States." For a list of the paintings sold by Goupil in New York between 1848 and 1861, see *Goupil & Cie Stock Books,* Livre 1, 1846–1861, Getty Research Institute. Goupil's promotion of French art briefly touched Baltimore. At the exhibition of paintings held at the Maryland Historical Society in 1850, eight paintings owned by the Goupil gallery were placed on display and offered for sale. One of these paintings was *Devotion* by Ary Scheffer. See *Catalogue of Paintings, Engravings etc at the Picture Gallery of the Maryland Historical Society,* third annual exhibition (John D. Toy, 1850), MHS. Unlike in New York and Boston, the taste for French contemporary art did not take hold in Baltimore during the 1850s, and the Goupil gallery made no further effort to market its French art in Baltimore at that time.

20. For an article about Ary Scheffer and his popularity in the United States, see Noon, "A Reduced Version." For a list of Scheffer's paintings on display at the Boston Athenæum prior to 1856, see Robert F. Perkins and William J. Gavin III, *The Boston Athenæum Art Exhibition Index* (Boston Athenæum, 1980). I want to thank Mary Warnement, Head of Reader Services at the Boston Athenæum, for bringing this list of paintings to my attention.

21. For the influence of the information about the French paintings displayed in the Boston Athenaeum in the 1850s and 1860s, see Hirayama, *With Eclat,* 65, 66. For the manner in which Barbizon paintings were interpreted by Americans in the nineteenth century, see Meixner, "Popular Criticism of Jean-Francois Millet," 94–105. For a list of the six paintings by Millet at the Boston Athenæum, see Perkins and Gavin, *The Boston Athenæum Art Exhibition Index.*

22. *Lucas Diary,* 2:7. For the manner in which Scheffer's painting was described by the Boston Athenæum, see *Catalogue of Pictures Lent to the Sanitary Fair for Exhibition together with Catalogue of Paintings and Sculpture of the Athenæum Galley, Beacon Street, Boston, 1863* (Fred Rogers, Printer, 1863), painting no. 59. The catalogue is available online through the Getty Portal, portal.getty.edu.

23. *Lucas Diary,* 2:10, 15.

24. *Lucas Diary,* 2:31, 32.

25. *Lucas Diary,* 2:16.

26. See *Lucas Diary,* 2:7, 28, 29, 31, 35, 52, and 53. The artist or artists who created the engravings that Lucas purchased at the Goupil gallery and gave to his friends is unknown. Even though Lucas was raised in a family that was devoted to the arts and that displayed in the family home portraits (of Lucas's parents) by Thomas Sully, it is unlikely that he saw many original French paintings during his youth in Baltimore outside of the collection owned by Robert Gilmor. See Miller, "Baltimore: Art in a Border City," *Patrons and Patriotism,* 129–138.

27. "Introduction," *Lucas Diary,* 1:7. "Following the settlement of his father's estate, Lucas inherited an annuity averaging between twelve hundred and two thousand dollars."

28. "The Dusseldorf Gallery," *New York Times,* Mar. 13, 1860.

29. See, e.g., Lucas's diary entries on Apr. 11, May 8, June 15, June 18, and Aug. 13, regarding his rendezvous with women; May 9, 11, 14, and 16, regarding the opera; and June 17, for dinner at Delmonico's. *Lucas Diary,* 2:59, 60, 62, 64, 65.

30. He began reading these books on July 23, 1854. See *Lucas Diary,* 2:42. See Reynolds, *Discourses,* and Ruskin, *Pre-Raphaelitism.*

31. Reynolds wrote, "Poussin's eye was always fixed on the sublime . . . [and] transports us to the environs of ancient Rome, with all of the objects that a literary education makes so precious and interesting to man . . . [while] Claude Lorrain . . . conducts us to the tranquilities of Arcadia and fairy land." See Reynolds, *Discourses,* 66 and 230. For an early analysis of Reynolds's lectures, see Thompson, "The Discourses of Sir Joshua Reynolds," 339–366.

32. For Holmes's review, see "The Allston Exhibition." For Ruskin's influence on America's taste for art in the nineteenth century, see Stein, *John Ruskin,* and Parks, "John Ruskin and His Influence on American Art."

33. For the ties between Ruskin's art theories and morality and religion, and the reception of these ideas in America, see Stein, *John Ruskin,* 38–41, 79.

34. Ruskin had little interest in French contemporary art. The only French artist he liked was Édouard Frère, a painter of genre scenes. In a series of lectures that Ruskin delivered on landscape painting at Oxford in January and February 1871, he made no reference to French landscapes, and his only reference to a French artist was a comment about Gérôme, asserting that his paintings of nudes were "altogether inadmissible into the ranks of fine art." See Ruskin, *Lectures on Landscapes.*

35. The date of Lucas's resignation from his last job as a civil engineer in the United States is found in *Lucas Diary,* 1:7, 33. The source of information about the time between Lucas's return to Baltimore and his departure for France in 1857 is William F. Lucas Jr. (George Lucas's nephew). See W. F. Lucas, introduction to *Exhibition of the George A. Lucas Art Collection.*

36. There is no extant diary that details Lucas's activities in Baltimore in 1856 and 1857 before he sailed for France. However, circumstantial evidence enables us to obtain a general picture of his life during this period. The only permanent commercial "gallery" in Baltimore in 1856 and 1857, as indicated in a guidebook published that year, was a photography store called Whitehurst's that offered daguerreotypes and other quickly prepared photographic portraits to its customers. See Gobright, *City Rambles.* With regard to the question of Lucas's relationships, an apparent affair with a woman in New York in 1856 likely came to an end when he returned to Baltimore. See Randall, *Lucas Diary,* 1:3.

37. For an analysis of this economic depression in Baltimore and its culmination in the "panic" of 1834, see Browne, *Baltimore in the Nation,* 114–134.

38. For example, see the advertisements placed by the museum in the *Baltimore American Commercial and Advertiser* on January 12, 15, and 17, 1857, which advertised shows by the Bryant's Campbell Minstrels, "personators of Ethiopian eccentricities."

39. For an article about the "deplorable condition" of Baltimore's culture in the 1830s and 1840s prior to the creation of the Maryland Historical Society, see Cox, "The Origins of the Maryland Historical Society." For a study of the quick rise and fall of the Maryland Academy of the Fine Arts in 1938 and 1939, see Thrift, "The Maryland Academy."

For a thorough study of the dispersal of Robert Gilmor's art collection, see Humphries, "Robert Gilmor, Jr." For an account of the destruction of the Maryland Institute in 1835, see Frost, *Making History / Making Art,* 17.

40. The Maryland Historical Society was founded in 1844. For an excellent article about the founding of the society and its picture gallery, see Brugger, "A History," 417–421.

41. Rutledge, "Early Art Exhibitions," 124.

42. One of the most significant events held in the hall of the Maryland Institute occurred on February 3, 1857, when the leaders of the city, Enoch Pratt, and a crowd of five thousand welcomed George Peabody and thanked him for his financial support for the establishment of the Peabody Institute and its future library and art gallery. See *Baltimore American Commercial and Advertiser,* Feb. 3, 1857, 1.

43. See Frost, *Making History / Making Art,* 28–53.

44. William R. Johnston, *William and Henry Walters,* 9, 10.

Chapter 3. Lucas and Paris in a Time of Transition

1. Frick resided with Lucas for six days and nights from May 13 through May 19, 1860. See Frank Frick, "A Time Table Diary of Travel Abroad," vol. 1, Peabody Institute Archives, JHU (hereinafter Frick Diary). For the source of the quotations, see Frick Diary, May 13, 1860. The area between the Rond-Point, where Lucas then resided, and the Place de la Concorde was described at that time as a place of festivity, open cafes, music, and romance. See Hazan, *The Invention of Paris,* 119–120.

2. The Second Empire under Napoleon III began on December 2, 1852, and ended ignominiously on September 4, 1870, following the bombardment of Paris and the defeat of France by Prussia. Napoleon III went into exile in England, where he died on January 9, 1873. The changes that were initiated during his reign had a lasting effect on the direction of French art for the remainder of the century.

3. For an overview of the "spectacular" material progress in France during the Second Empire, see Guérard, *France,* 308–313. The changes in the culture of Paris in the 1850s and 1860 are also recounted in Mainardi, *Art and Politics,* and Rubin, *Impressionism,* 9–48. For the increase in wealth for the upper class in Paris at midcentury, see Blake and Frascina, "Modern Practices of Art and Modernity," 98, 99: "between 1850 and 1870 profits rose by 286%, wages by 45%, and real wages, after inflation, by only 38%." For the architecture and reconstruction of Paris under Haussmann, see Kirkland, *Paris Reborn*; Pinkney, *Napoleon III*; Olsen, *The City as a Work of Art,* 35–57; and Van Zanten, "Architecture," 35–73. For a cultural tour of Paris through the prism of history, see Hazan, *The Invention of Paris.* For a critical assessment of the reconstruction of Paris by Haussmann and its damage to the working class, see Clark, *The Painting of Modern Life,* 23–78; and Harvey, *Paris.* For a discussion of the manner in which the new rail lines connected Paris with the countryside and influenced French art, see Clark, *The Painting of Modern Life,* 148–170. For a description and pictures of the new Bois de Boulogne, see Barberie, "Marville," 171–187.

4. For an excellent introduction to the development and influence of history paintings in France, focusing on Jacque-Louis David and his students, see Eisenman, *Nineteenth Century Art,* 14–50. For a discussion of the battle between the academic and anti-academic styles of art, including the references to "ugliness," during the Second Empire, see Mainardi, "The Political Origins of Modernism," 11–17; and "Pictures to See and Pictures to Sell," chap. 1 in *The End of the Salon,* 9–36.

5. Baudelaire, *The Painter of Modern Life,* 13.

6. For an analysis of the increased popularity and acquisition of landscape paintings as compared to history paintings during this era, see White and White, *Canvases and Careers,* 35–39; and Dabrowski, *French Landscape.* For the average price of history, landscape, and genre paintings in the 1860s, see White and White, *Canvases and Careers,* 39–44; and Chagnon-Burke, "Rue Laffitte," note 8: "In the 1860s, the average price for a landscape painting by a French artist was 1,443 francs against 2,861 francs for a genre painting and 6,637 for a history painting." For an excellent discussion of the history of landscape painting in France, including its significance during the 1850s and 1860s, see Adams, *The Barbizon School,* 93–186.

7. The absence of any singular direction or movement of French painting during the Second Empire and the vast array of styles and subject matter reflected in the art of this period is discussed and illustrated in Lacambre and Richel, "Painting," 243–359. For a discussion of the political interest and promotion of realism by the government of Napoleon III, see Boime, *Art in an Age of Civil Struggle,* 577–631. For the history of the Luxembourg Museum, see Lorente, *Cathedrals of Urban Modernity,* 48–96. For a description and analysis of the events in 1855 that led to the Exposition of that year, see Mainardi, *Art and Politics.* For a critique of this Exposition, see Baudelaire, *Art in Paris,* 121–143. For an analysis of the concept of *juste milieu* and its application to the work of such artists as Whistler, Manet, and Rodin, see Jensen, *Marketing Modernism,* 138–166.

8. Two articles that discuss and place the 1863 Salon de Refusés in historical context are Wilson-Bareau, "The Salon des Refusés," 309–319; and Boime, "The Salon des Refusés," 411–26. The Salon des Refusés, which lasted from the middle of May to the middle of June, exhibited approximately 753 works of art by 447 artists: 653 paintings, 63 sculptures, and 28 engravings. However, the identity of all of the artists and the art they created remains elusive. For a selection of the criticism leveled against the art displayed at the Salon des Refusés, see Harrison, Wood, and Gaiger, *Art in Theory,* 509–513. The quote is from Maxime du Camp's review in the *Revue des deux mondes.* For a discussion of the significance of the selection of landscape painters to join the Salon Jury for paintings in 1866, see Roos, *Early Impressionism,* 37–39. The last government-sponsored Salon occurred in 1880. For an analysis of the events that led to the government's decision to abandon the Salon, see Mainardi, *The End of the Salon.* The first exhibition that featured impressionist paintings occurred in 1874.

9. The estimate of 4,450 artists working in Paris in 1863 is found in White and White, *Canvases and Careers,* 51. For the number of works accepted for display at the Salon between 1789 and 1870, see Mainardi, *The End of the Salon,* 18, 19; and Hiesinger and Rishel, "Art and Its Critics," 29–36. For a discussion of the reproduction of art in Paris through photography and prints in Paris around the middle of the nineteenth century, see Bann, *Parallel Lines.* The popularity of prints during the second half of the nineteenth century is also discussed in Renié, "The Image on the Wall." For an essay by Baudelaire written in 1862 about "the return of etching," see Baudelaire, *Art in Paris,* 218–222. For a discussion of the revival of etching in the 1860s and Manet's participation in the movement, see Fisher, *The Prints of Edouard Manet,* 15–24.

10. Lucas dealt with over two hundred Parisian dealers during his fifty-two years in Paris. For a list of these dealers, see *Lucas Diary,* 1:82.

11. For one of the earliest analyses of the changes occurring in the Parisian art market during the 1850s and 1860s, see White and White, *Canvases and Careers,* which focuses on the development of a dealer-critic system for the marketing and sale of art, and notes that by 1861 there were 104 dealers. Galenson and Jensen in *Careers and Canvases,* challenge the Whites' analysis, arguing that most of those dealers were not selling the work of living artists, that there were only twenty-three who focused on contemporary French painting, and that the Salon, not private galleries, continued to play a dominant role in supporting Parisian artists until 1880. For an excellent article on the dealers who congregated along the rue Laffitte,

see Chagnon-Burke, "Rue Laffitte." For discussions about the most influential private art gallery in Paris, the Galerie Durand-Ruel, see Assouline, *Discovering Impressionism*; and Regan, "Paul Durand-Ruel and the Market for Early Modernism." For the Goupil & Cie Gallery and its devotion to the art of Delaroche, see Whiteley, "Goupil, Delaroche, and the Private Trade." In 1876, the Durand-Ruel Gallery held a groundbreaking exhibition of 252 works of art by the impressionists, and thereafter, the other major galleries on the rue Laffitte likewise began to sell impressionist paintings.

12. For the sales of impressionist art at the Hôtel Drouot in the 1870s, see Bodelsen, "Early Impressionist Sales 1874–94." The sale of Rousseau's paintings at the Hôtel Drouot is discussed in Green's "Circuits of Production." George Lucas attended the exhibition and sale of Delacroix's art at the Hôtel Drouot and refers to it in *Lucas Diary,* 2:193.

13. For the auctions at the Hôtel Drouot and its importance in the marketplace for French art in the nineteenth century, see Green, "Dealing in Temperaments," and "Circuits of Production"; Jensen, *Marketing Modernism,* 51, 52, 58, and 60; Assouline, *Discovering Impressionism,* 46, 138–142; and Kelly, "Early Patrons of the Barbizon School."

14. Borgmeyer, *The Luxembourg Museum,* 9. The Luxembourg Museum was initially founded in 1818 and remained in existence as a museum dedicated to living artists until 1937. For a history of the museum and illustrations of three hundred paintings shown there, see Bénédite, *The Luxembourg Museum.*

15. *The Source* and *The Gleaners* are in the Musée d'Orsay. *The Cold Day* is in the Walters Art Museum. *The Source* is 64 × 31 inches, *The Gleaners* is 33 × 44 inches, and *The Cold Day* is 16 1/2 × 12 1/2 inches.

16. The picture and a description of the ancient figure of Venus is found in Kleiner, *Roman Sculpture,* 246.

17. For an account of Ingres's reputation around the time that *The Source* was painted, see Shelton, *Ingres and His Critics,* 227–238. See also Fröhlich-Bume, *Ingres,* 40. *The Source* was considered by Ingres admirers to be "superior to all of his other nude figures." For an excellent article that discusses the division between art that expresses the ideal and art that expresses the real in mid-nineteenth-century France through the art criticism of Théophile Gautier, see Stocks, "Théophile Gautier." (The reference to Ingres as the alleged "presiding deity" in the temple of French art is on 47n.26.)

18. Baudelaire, *Art in Paris,* 195.

19. For a survey of the purpose and history of Millet's paintings of peasants, see Herbert, "Millet Reconsidered." For a history of *The Gleaners,* its early struggle for public

acceptance, and its ultimate recognition as one of the master-pieces of French nineteenth-century art, see Fratello, "France Embraces Millet." The admiration for Millet's art peaked in France in 1890, eleven years after Millet's death in 1879, when *The Gleaners* entered the collection of the Louvre. For an early history of Millet's life and examples of the criticism of his paintings, see Mollett, *The Painters of Barbizon.*

20. See Weisberg, *The Realist Tradition,* 96: "By portraying dedication to hard work, the daily activity of people in modest surroundings, and a love of family, Frère underscored ideals that writers and popular printmakers were advocating for the people. If the poor and middle class followed these examples—if they instilled in their own children a knowledge of ethical traditions—then the children would develop into leaders whose knowledge and respect for past traditions and customs were assured." For a nineteenth-century review of Frère's art, see M. J. Conway, "Edouard Frere."

21. See Ruskin, "Academic Notes," 83. Ruskin's effusive description of Frère can be found in the *Encyclopedia Britannica,* vol. 11 (1911).

22. See Round, "With Frère and His Confrères"; "The Studios of Ecouen," *New York Times,* Mar. 12, 1881; Weisberg, *The Realist Tradition,* 290; and William R. Johnston, "A Family Collection," in Fisher and Johnston, *The Essence of Line,* 16–18. For a nineteenth-century description of the popularity of Ecouen art, see Bacon, *Parisian Art and Artists,* 113, 114.

23. In 1858, two paintings by Frère that were sold to Ernest Gambart were resold in New York to William Walters for $300 and $400. See William R. Johnston, *The Reticent Collectors,* 241n49. The original price of the paintings when sold in Paris to Gambart must have been significantly less than what Walters paid, probably under 1,000 F. A painting by Lemmens that Lucas acquired in November 1959 cost 100 F; a painting by Duverger acquired in June 1859 cost 500 F; a painting by Duverger acquired in October 1859 cost 500 F; and another painting acquired from Duverger in October 1859 cost 1,400 F. See *Lucas Diary,* 2:96, 100, 103.

24. The sculptor was Alexandre Falguière. *Lucas Diary,* 2:284. For an image of this sculpture, see William R. Johnston, *The Taste of Maryland,* 52.

25. *Lucas Diary,* 2:947. The attribution of the painting was ultimately downgraded to "Unknown French artist." BMA 1996.45.194.

26. During this six-month period, Lucas visited the Hôtel Drouot 155 times. For the dates on which he went there between July and December 1958, see *Lucas Diary,* 2:78–87.

27. See Filonneau, *Annuaire des Beaux-Arts.* The *Annuaire* is in the Lucas collection of books owned by the BMA.

28. Lucas purchased the voluminous Louvre catalogue for 4.75 F on June 29, 1859 (*Lucas Diary,* 2:96). His visits to the Louvre can be tracked in the index in *Lucas Diary,* 1:112.

29. After attending the Salon opening on May 1, 1874, e.g., Lucas returned there eleven more times that month. Lucas's diaries show that he regularly attended the opening day of the Salons. See *Lucas Diary,* 2:93, 114, 155–57, 177, 218, 239, 296, 323, 362, 378, 394, 412, 430, 446, 473, 496.

30. The Catalogue for the Salon of 1857 was entitled *Explication Des Ouvages De Peinture, Sculpture, Gravure, Lithographie, et Architecture Des Artistes Vivant Exposés Au Palais Des Champs-Elysées* and dated June 1867. The catalogue is in the Lucas collection of books at the BMA.

31. The Luxembourg Museum originally opened in 1818. For most of the nineteenth century, the art displayed there had previously been shown in the Salon. Most of the art was academic in nature, and it was not until the 1890s that impressionist paintings were displayed. For a history of the museum and illustrations of some of the work shown there, see Bénédite, *The Luxembourg Museum.* The quotation about "public honor" is found in this book. See also Borgmeyer, *The Luxembourg Museum.* For a list of the major artists and works on display at the Luxembourg in 1857, see *Paris Guide Par Les Principaux Écrivains et Artistes.* Lucas mentioned Barye in his diary over 385 times; Bouguereau, 160; Millet, 159; Breton, 158; Cabanel, 151; Corot, 148; Merle, 136; Meissonier, 134; and Gérôme, 85. See *Lucas Diary,* vol. 1, index.

32. According to the *Lucas Diary,* 2:84, the shelves initially were "put up" on October 26, 1858. The first reference to Lucas's library of fifteen hundred volumes is in *Exhibition of the George A. Lucas Art Collection,* 57. The long list of the bookstores that Lucas frequented can be found in *Lucas Diary,* 1:68.

33. *Lucas Diary,* 2:78–108.

34. The exchange rate between American dollars and French francs in the nineteenth century is difficult to discern precisely because of the political and economic instability in both countries. Roughly, 5 F were equivalent to $1. In 1882, as documented in Lucas's diary, $200 was equivalent to 1,036 F. See *Lucas Diary,* 2:552.

35. The paintings that survived and that are presently in the collection of the Baltimore Museum of Art are a landscape by Diaz, a landscape by Amédée Baudit, and possibly a head by Couture. The amount of money, if any, that Lucas derived from the sale of the art he collected in 1858 and 1859 remains unknown. Lucas continued to earn a living primarily as a

dealer of relatively inexpensive art by relatively obscure artists into the early 1860s. In the winter and spring of 1861, he was acquiring paintings at the Hotel Drôuot and selling most of them to a dealer by the name of Dhios. *Lucas Diary,* 2:110, 111, 113.

36. For references to Lucas's meetings with Ecouen artists in 1859, see *Lucas Diary,* 2:96, 100–107. Lucas received as a gift the painting from Signac on October 7, 1859. *Lucas Diary,* 2:102. The present whereabouts of this painting is unknown.

37. See *Frick Diary.* With regard to the bronzes by Barye that were acquired by Frick, see Johnston and Kelly, *Untamed,* 52, 64, n. 4. The paintings that Frick acquired were by Anastasi, Dargelas, Duverger, Lemmens, Schenck, Signac, and Ziem; see Frick Diary, July 28, 30, and Aug. 2, 1860.

38. Frick Diary, Aug. 3, 1860.

39. Frick Diary, Oct. 4, 1864.

40. The ship belonged to Charles Morton Stewart, who was a friend and partner of Frank Frick and who would later become one of Lucas's clients. See *Lucas Diary,* 2:110. Around 1908, Henry Walters invited Lucas to return to Baltimore to see Walters's new museum, but Lucas declined the invitation.

CHAPTER 4. LUCAS AND WHISTLER

1. Lucas's collection of Whistler's prints included the full sets of *The French Set* (12 etchings), *The Thames Set* (16 etchings), and *The Second Venice Set* (26 etchings). The six etchings that were signed by Whistler and dedicated to Lucas were: (1) *Black Lion Wharf,* 1859; (2) *Eagle Wharf,* 1859; (3) *The Lime-Burner,* 1859; (4) *Amsterdam, from the Tolhuis,* 1863; *The Large Pool,* 1880; and (6) *The Bridge Santa Marta,* 1881. I want to thank Nicole Simpson for expertly guiding me through Lucas's collection of Whistler's prints.

2. For overviews of Whistler's mercurial career, see Sweet, *James McNeill Whistler;* Anderson and Koval, *Whistler;* and Sutherland, *Whistler.* For references to Lucas's relationship with Jimmy Whistler, see Mahey, "The Letters of James McNeill Whistler to George A. Lucas"; and *Lucas Diary,* 1:9, 10, 22, 23.

3. Alexandroffsky was located near the intersection of Fremont Avenue and Baltimore Street. The mansion was demolished in the 1920s. For a description of Alexandroffsky, see Hayward and Shivers, *The Architecture of Baltimore,* 131, 132; and Jacque Kelly, "Mansion with a Curious Name Kept Baltimoreans Enthralled," *Baltimore Sun,* Feb. 25, 2011. For a sketch of the life and business of Ross Winans, see "Death of Ross Winans," *New York Times,* Apr. 11, 1877. For a sketch of the life of Thomas Winans, see "A Millionaire Inventor," *New York Times,* June 11, 1878.

4. Whistler's talent for etching far surpassed that of any of his contemporaries. It was the product of drawing lessons that he took at an early age while residing in Saint Petersburg, Russia, and the tutelage in etching that he received from Seymour Haden (who had married Whistler's older half-sister) while living in London. Whistler's father, a prominent engineer, was engaged in the early 1840s by the Russian tsar to help build a railroad and moved his family to Saint Petersburg. To escape an epidemic of cholera in 1848, Whistler's mother, Anna, took the family to London. When Whistler's father suddenly died in Russia in 1849, the family returned to the United States.

5. In November 1854, Whistler took a job with the US Coast and Geodetic Survey in Washington, DC, where he resided for three months in a cramped boarding house. He left in February and returned to Alexandroffsky. For Jimmy Whistler's relationship with Thomas Winans, see Sutherland, *Whistler,* 33–38; and Anderson and Koval, *James McNeill Whistler,* 37, 38.

6. Lucas initially met Jimmy Whistler on July 25, 1854 (*Lucas Diary,* 2:42). For references to his visits to Alexandroffsky, see *Lucas Diary,* 2:45, 46.

7. See "James Whistler power of Attorney to George W. Whistler," July 30, 1865, MacDonald, *The Correspondence of James McNeill Whistler,* no. 06670, (hereinafter *Whistler Correspondence*).

8. Pennell and Pennell, *The Whistler Journal,* 87, 88.

9. *Lucas Diary,* 2:73–84. As recorded in Lucas's diary, in 1858 he tried to visit Whistler at his last-known address on January 21, March 29, April 24, April 28, May 18, May 31, June 17, June 21, June 28, July 4, September 28 and October 28 but was successful only half of the time. The observation about Whistler's many addresses in Paris is borrowed from Kathleen Adler, "'We'll Always Have Paris': Paris as Training Ground and Proving Ground," in Adler, Hirshler, and Weinberg, *Americans in Paris,* 59.

10. The letters from Whistler to Lucas can be found in *Whistler Correspondence,* nos. 09186, 11977, 01987, 09188, 01989, and 10693; and in Mahey, "The Letters of James McNeill Whistler to George A. Lucas," 247–257.

11. See Merrill, *The Peacock Room,* 47.

12. *Lucas Diary,* 2:132 (Apr. 1, 1862); Whistler to Lucas, June 26, 1862, *Whistler Correspondence,* no. 11977.

13. *Whistler Correspondence,* no. 10693.

14. The letters from Whistler to Lucas of Mar. 23 and Nov. 5, 1867, and July 18, 1873, can be found in *Whistler Correspondence,* nos. 09191, 09193, and 09182.

15. *Whistler Correspondence,* no. 09197.

16. *Whistler Correspondence*, no. 09201.

17. *Whistler Correspondence*, no. 09188.

18. May 17, 1884, *Whistler Correspondence*, no. 09203.

19. See William R. Johnston, "A Bibliophile's Confection," 83.

20. On February 1, 1867, Lucas received from Whistler through his younger brother two photographs and three etchings "from brother Jimmy." *Lucas Diary*, 2:233. Although the diary does not specifically identify the three etchings, they likely were those that had been shown in Paris at the Galerie Martinet and later inscribed "to George Lucas": *Black Lion Wharf, Eagle Wharf,* and *The Lime-Burner.* On June 11, 1881, Lucas received five additional etchings that Whistler left at a shipping depot in exchange for Lucas's payment of a shipping bill. These likely included *Amsterdam from the Tolhuis, The Large Pool,* and *The Bridge,* which were also inscribed "To Lucas" by Whistler. All of these and over one hundred more etchings by Whistler are in the BMA. See *Lucas Diary*, 2:522.

21. Baudelaire, *Art in Paris,* 220.

22. Joseph Pennell, *Concerning the Etching of Mr. Whistler,* 9. *Black Lion Wharf* was widely exhibited, and 104 impressions were made of it. See MacDonald et al., *James McNeill Whistler.* The etchings dedicated to Lucas are in the BMA. The painting "Whistler's Mother," formally known as *Arrangement in Grey and Black No. 1,* or *Portrait of the Artist's Mother,* is in the Musée d'Orsay.

23. *Whistler Correspondence*, no. 09200.

24. *Lucas Diary*, 2:582, 583.

25. James Whistler to George Lucas, May 17, 1884, *Whistler Correspondence*, no. 09203; Lucas Archives, BMA; *Lucas Diary*, 2:588 (June 2, 1884): "Wrote Whistler that I could give him bed and board."

26. See Maud Franklin to George Lucas, Oct. 26, 1886, *Whistler Correspondence*, no. 09210; and *Lucas Diary*, 2:638 (Oct. 27, 1886).

27. For Whistler's remarks to Lucas, see *Lucas Diary*, 2:754. For Whistler's remarks about Lucas to Cassatt, see Mary Cassatt to George Lucas, July 6, 1896, "Correspondence transcribed and translated," Lucas Files, MICA Archives.

28. Maud Franklin offered to give Lucas "a few" of Whistler's etchings. See Franklin to Lucas, Oct. 23, 1886, *Whistler Correspondence*, no. 09209. Lucas received them on March 7, April 4, and April 27, 1888, and January 14 and October 11, 1889. See *Lucas Diary*, 2:665, 667, 668, 681, 698.

29. See *Lucas Diary*, 2:665–668, 682–698.

30. In 1908, Lucas gave this watercolor to Henry Walters, and it has remained in the Walters Art Museum (WAM 37.318).

31. For a description of the esteem with which Whistler was held in Paris when he returned there in 1892 and how he rejoiced upon seeing his art displayed in the Luxembourg Museum, see Sutherland, *Whistler,* 254.

32. *Lucas Diary*, 2:813, 816, 826. The purchase in October 1895 was from L. Dumont and included seven etchings and six lithographs. The etchings ranged in price from 20 to 120 F, and except for one, the lithographs cost 15 F each. See itemized invoice from L. Dumont to Monsieur Lucas, Oct. 28, 1895. The purchase in April 1896 was from J. Bouillon and included sixteen lithographs and a book with fifty-seven etchings. The book cost 211 F. See itemized bill from J. Bouillon, Apr. 17, 1896. The invoices are in the Lucas Papers, BMA Archives.

33. *Lucas Diary*, 2:842, 843, 889, 902.

34. In December 1901, Lucas edited, prepared, and bound a catalogue of Whistler's art (referred to as the "Thompson Catalogue") as a gift for his friend and client Henry Walters. Lucas included in the catalogue four different portraits of Whistler. See William R. Johnston, "A Bibliophile's Confection."

35. The etchings by Whistler that Lucas acquired are pictured and described in MacDonald et al., *James McNeill Whistler.*

36. See Pennell and Pennell, *Whistler Journal,* 277.

37. Duret, *Whistler,* 20, 110, 111. Elizabeth and Joseph Pennell also visited Lucas on February 11 and December 23, 1894; they were preparing to write their own book about Whistler. During the visit on December 23, Joseph Pennell asked Lucas if he would loan some of his prints for display at an exhibition of Whistler's art in London the following spring. In connection with one of their visits, they noted in their diary that Lucas "helped us enormously with his reminiscences of Whistler's early years both in Paris and London and who [Lucas] is now reported to be preparing a book of his own." Pennell and Pennell, *Whistler Journal,* 277.

38. Whistler to Lucas, Jan. 18, 1873, *Whistler Correspondence,* no. 09182.

39. Upon receiving these paintings, Henry Walters on October 16, 1908, wrote to Lucas that when unpacking two cases from him, he was surprised to find "Whistler's portrait of you and his portrait of the 'Model with Red Hair.'" He went on, "Am I to keep them for the Maryland Institute, or what am I to do?" Walters's letter is in the Walters Archives. Upon opening his museum in 1909, Henry Walters published a catalogue of his paintings, and he updated this catalogue in 1915 and 1922. The portrait of Lucas by Whistler was not mentioned in any of these catalogues.

1. "Fine Arts," *New York Times,* Nov. 12, 1863.

2. For the growing interest in the 1850s and 1860s of American collectors in French art, see Fink, "French Art in the United States." For Michael Knoedler's role in driving the interest of Americans in French art, see Ann Landi, "150 Years of Helping Shape a Nation's Taste," *New York Times,* Dec. 1, 1996. In 1860, William Walters purchased at least two French works of art from Knoedler. They were Rosa Bonheur's *The Conversation* and Pierre-Édouard Frère's *The Cold Day,* purchased in April and June, respectively. Both are in the Walters Art Museum.

3. Mass, *Gambart.*

4. See Mass, *Gambart,* 70–95; and Pamela M. Fletcher, "Creating the French Gallery." Wright sold Bonheur's *The Horse Fair* to the New York collector Alexander Stewart, whose estate sold the painting to Cornelius Vanderbilt, who gave it to the Metropolitan Museum of Art.

5. The price of Bonheur's *Horse Fair* far exceeded the prices paid for Frederic Church's *Twilight* ($1,050) and John Kensett's *Lakes of Killarney* ($950) at the sale of William Walters's paintings at the Düsseldorf Gallery in New York in 1864. See "Sale of the Walters Gallery," *Baltimore Sun,* Feb. 18, 1864. In 1858, Walters purchased Church's large painting *Morning in the Tropics* for $555. For references to the cost of this and other Hudson River school paintings in the 1850s, see William R. Johnston, *William and Henry Walters,* 14, 15; and "The Dollars and Cents of Art," 30 ("A good work by Durand, Kensett, Hicks, Huntington etc. can be had for three hundred dollars, while they command a thousand dollars for some of their more elaborate labors").

6. "Rosa Bonheur's Horse Fair," *New York Times,* Oct. 1, 1857.

7. Voorsanger and Howat, *Art and the Empire City,* 63–65. See also Fink, "French Art in the United States," 87–100.

8. Fink, "French Art in the United States," 88.

9. "Another Exhibition of French and English Paintings," *New York Times,* Sept. 10, 1859. The *Duel After the Masquerade* by Gérôme offered for sale was a version of his earlier painting commissioned by a French royal duke for the Château de Chantilly and shown with much fanfare at the Salon of 1857. A third version is in the Hermitage Museum.

10. For information about William Walters's early collection of American and French art, including the French paintings that he acquired at the exhibition in 1859 and their cost, see Johnston, *The Reticent Collectors,* 12–17, 241n49. For the historic basis for Gérôme's *The Duel After the Masquerade,*

see Parsons, "The Wintry Duel." For an article about the popularity and reproduction of Gérôme's *Duel After the Masquerade,* see Stephen Bann, "Reassessing Repetition in Nineteenth-Century Academic Painting: Delaroche, Gérôme, Ingres," in Kahng, *The Repeating Image,* 27–52.

11. For a picture and more information about Bonheur's *The Conversation* and Walters's purchase of it, see Simon Kelly, "Rosa Bonheur: *The Conversation,*" in Fisher and Johnston, *The Essence of Line,* 120, 121. For Walters's purchase of Frère's *The Cold Day,* see William R. Johnston, *The Nineteenth Century Paintings in the Walters Art Gallery,* 92.

12. Durand, *The Life and Times of Asher B. Durand,* 193–196.

13. For Lucas's service to Latrobe, Davies, and Frick, see *Lucas Diary,* 1:9, 10; 2:74–78.

14. *Lucas Diary,* 2:96.

15. *Lucas Diary,* 2:96, 97, 101. Around the same time, Lucas purchased another painting by Duverger again for 500 F for another Baltimore banker and art collector, George Buchanan Coale.

16. *Lucas Diary,* 2:128, 131, 135.

17. *Lucas Diary,* 2:104.

18. The actions undertaken by Lucas to engage Merle are set forth in *Lucas Diary,* 2:104, 106, 107, 111–113. For the relationship between Lucas and William and Henry Walters, see William R. Johnston, *The Reticent Collectors,* 18–40. For an article about Lucas's role in the acquisition of the painting of the *Scarlet Letter* by Merle, see Dawson, "Hugues Merle's *Hester et Perle* and Nathaniel Hawthorne's *The Scarlet Letter.*"

19. Hawthorne, *The Scarlet Letter,* 45. For Merle's success as an artist, especially among American collectors, see Reed, "Elizabeth Gardner." See also, Zafran, *French Salon Paintings,* 144, 145.

20. For the social confinement of bourgeois women in Paris and their apprehension of being mistaken for a prostitute during the nineteenth century, see Pollock, "Modernity and the Spaces of Femininity." The prevalence of prostitutes in Paris in the 1850 and 1860s and the influence of this phenomena on French literature and the visual arts is discussed in Clark, *The Painting of Modern Life,* 100–120. For a discussion of the efforts in the 1850s and 1860s to overcome the restrictions imposed on women, see Thomas, *The Women Incendiaries.*

21. The circumstances of William Walters's decision to leave Baltimore, settle in Paris, and then return home are discussed in William R. Johnston, *William and Henry Walters,* 22–24.

22. Lucas introduced Walters to Barye's sculpture and

drawings when visiting his studio on September 30 and October 8, 1861, and he took Mr. and Mrs. Walters to Ecouen to dine with the Frères and the Duvergers on December 14, 1861. *Lucas Diary,* 2:122, 126. For a discussion of the early relationship between Lucas, Walters, and Barye, see William R. Johnston, "Barye's American Patrons," in Johnston and Kelly, *Untamed,* 52–65.

23. *Lucas Diary,* 2:126.

24. *Lucas Diary,* 2:136. For references to Lucas's acquisition of the work of Frère and Duverger, see *Lucas Diary,* 2:134.

25. The Düsseldorf Gallery opened to the public at 548 Broadway in New York on April 18, 1849. For several years it featured paintings by German artists associated with the Düsseldorf school. In 1860, it also started to be used as a place to sell paintings. By 1862, it ceased functioning as a museum but continued as a place to mount temporary exhibitions of art that was for sale. See Stehle, "The Düsseldorf Gallery of New York." The February 1864 sale of Walters's artwork was under the auspices of Henry Leeds and Company. The art was advertised as "the property of a collector, resident of Baltimore, now in Europe and long distinguished for his taste and liberality." For a discussion of this sale, see William R. Johnston, "A Family Collection: William and Henry Walters's French Drawings," in Fisher and Johnston, *The Essence of Line,* 21. The payment to Lucas is alluded to in *Lucas Diary,* 2:172.

26. For a description of the sale, see Beaufort, Kleinfield, and Welcher, *The Diaries 1871–1882 of Samuel P. Avery,* xviii (hereinafter *Avery Diary*).

27. For the history of paintings of the Fontainebleau Forest, particularly by Corot, Rousseau, and Millet, see Simon Kelly, "The Mystery of the Forest," in *The Forest of Fontainebleau: Painters and Photographers from Corot to Monet,* 142–151, 193, 194.

28. *Lucas Diary,* 2:150, 166, 167, 170, 171.

29. *Lucas Diary,* 2:170.

30. Lucas met Gambart at Frère's home in Ecouen on November 13, 1859. See *Lucas Diary,* 2:105.

31. For Walters's visits to the Luxembourg Museum and an exhibition of Corot's paintings, see *Lucas Diary,* 2:155, 159. The date when Walters initially went to Corot's studio and saw *The Evening Star* is uncertain. William Johnston thinks it was likely February 1864. See Johnston, *The Nineteenth Century Paintings in the Walters Art Gallery,* 15. For a discussion about when the original and the replica of *The Evening Star* were painted, see Tinterow, *Corot,* 298–300; and Simon Kelly, "Strategies of Repetition: Millet/Corot," in Kahng, *The Repeating Image,* 60–65.

32. *Lucas Diary,* 2:171.

33. For example, the artist Charles Baugniet informed Lucas that the prices of his paintings were 2,500 F for one figure, 4,000 F for two, and 6,000 F for five or six. *Lucas Diary,* 2:244.

34. *Lucas Diary,* 2:171.

35. When the painting as part of the Lucas collection was displayed at the Maryland Institute in 1911, it was entitled *High Road near Ville D'Avray.* See *Exhibition of the George A. Lucas Art Collection,* no. 234. When the painting was exhibited again at the BMA in 1965, its name was changed to *Sèvres-Brimborion, View towards Paris.* See *The George A. Lucas Collection,* no. 66. See also Sona K. Johnston and William R. Johnston, *The Triumph of French Painting,* 56, 57.

36. *Lucas Diary,* 2:172, 173, 176–180, 191. *The Evening Star* was not completed and picked up until January 17, 1865.

37. *Lucas Diary,* 2:187, 189, 190.

38. *Lucas Diary,* 2:192.

39. *Lucas Diary,* 2:129, 190–192. For a description of Bida's drawing and its place in Walters's collection, see Cheryl K. Snay, "Alexandre Bida: *The Ceremony of Dosseh,*" in Fisher and Johnston, *The Essence of Line,* 112, 113. How Petit convinced Gambart to relinquish the drawing is unknown, but it is reasonable to assume that Petit offered to sell another, arguably better, drawing by Bida to Gambart at the same price. Under this arrangement, Gambart would have received a similar or better Bida that he could resell to one of his customers, Petit received a commission of 200 F, and Walters obtained the drawing he wanted.

40. *Lucas Diary,* 2:194.

41. The estimate was made by Lilian Randall and can be found in *Lucas Diary,* 1:17.

42. The letter, dated January 27, 1904, is in the archives of the Walters Art Museum. The information about the life and business of Samuel Avery is drawn primarily from *Avery Diary.*

43. Lilian Randall, *Lucas Diary,* 1:13.

44. The letter is in the "Samuel P. Avery Papers," Thomas J. Watson Library, Metropolitan Museum of Art.

45. *Lucas Diary,* 2:206, 215, 221.

46. *Lucas Diary,* 2:207. References to the art by Plassan that Avery acquired can be found in the *Avery Diary,* 25, 78, 151, 158, 172, 233, 336, 472.

47. *Lucas Diary,* 2:234–237.

48. *Whistler Correspondence,* no. 09192.

49. Avery's patronage of Whistler is summarized in "Samuel Putnam Avery, 1822–1904," *Whistler Correspondence.* I would like to express my appreciation to Nicole Simpson for providing the number of etchings and lithographs by Whistler

that were acquired by Avery. Avery's collection of Whistler's prints is included in his vast collection of over nineteen thousand prints owned by the New York Public Library.

50. *Lucas Diary,* 2:365; *Avery Diary,* 113.

51. *Whistler Correspondence,* nos. 10630 and 10629.

52. For a discussion about the significance of the International Exposition in 1867, see Zalewski, "The Golden Age."

53. See *Avery Diary,* xxii.

54. *Lucas Diary,* 2:236, 244.

55. For an analysis of the types of paintings that Lucas was seeking to acquire for American buyers, see *Avery Diary,* xli–lvii.

56. *Lucas Diary,* 2:254.

57. *Lucas Diary,* 2:238, 244, 253, 254, 256–258. Lucas kept the paintings by Bouguereau, Ziem, Couder, and Troyon, and they presently are part of the Lucas collection owned by the BMA. See table 2 in the appendix.

Chapter 6. From Ecouen to Barbizon

1. For an excellent discussion of the history of the Fontainebleau Forest and the tension that arose between tourists and artists over the forest's use, see Jones, "Landscapes. Legends, Souvenirs, Fantasies," 4–27.

2. *Lucas Diary,* 2:198.

3. The quotation is cited in Bouret, *The Barbizon School,* 222.

4. Lucas's paintings of the Fontainebleau Forest by these artists are in the BMA and were listed in the catalogue entitled *The George A. Lucas Collection of the Maryland Institute.*

5. Hippolyte Delpy, a friend of Lucas and former student of Daubigny, painted Lucas's house in Boissise twice in 1890. One painting is in the BMA, and the other in the Walters Art Museum.

6. A small notebook of Lucas's sketches is in the Peabody Institute Archives, JHU.

7. *Lucas Diary,* 2:349.

8. Dated January 18, 1873, Whistler's letter was initially published in Mahey, "The Letters of John James McNeil Whistler," 252. See also *Lucas Diary,* 1:22.

9. *Lucas Diary,* 2:328, 329.

10. *Lucas Diary,* 2:330.

11. *Lucas Diary,* 2:330.

12. For a description of the siege of Paris and the warnings to the residents, see Christianson, *Paris Babylon,* 161–266.

13. *Lucas Diary,* 1:22; 2:330, 332.

14. For an excellent description of the effect of the Franco-Prussian War and the siege of Paris on the artists of the city, especially Manet and Meissonier, see Ross King, *The Judgment of Paris,* 272–292.

15. See George Lucas, Catalogue—Eaux fortes (c. 1904), 9, Lucas Papers, BMA Archives.

16. The painting was completed by Bouguereau in 1862 and shown at the Salon of 1863. Its depressing, heavy-handed nature did not attract French buyers. On behalf of Avery, Lucas met with Bouguereau and began negotiating the price on March 30, 1870. On April 28, Bouguereau agreed to sell it for 6,000 F. On May 3, Lucas made a downpayment of 2,000 F, and he made the final payment of 4,000 F on November 2, at a time when Paris was besieged by the Prussian army. *Lucas Diary,* 2:313, 320, 322, 323, 332. For a discussion of Lucas's relationship with Bouguereau and the paintings he purchased from him, see Zafran, "William Bouguereau in America," 17–44. *The Furies* is in the Chrysler Museum of Art.

17. *Lucas Diary,* 2:339–341.

18. *Lucas Diary,* 2:382; *Avery Diary,* 2, 50.

19. *Lucas Diary,* 2:186.

20. Like Lucas, Walters belatedly became interested in Millet following the artist's death and the explosion of interest (and the prices) of his art. In the 1880s, Walters acquired seven works by Millet. Four of these were acquired with Lucas's assistance.

21. On March 26, 1875, Lucas purchased seven etchings by Millet for 200 F. However, the date on which he acquired the preparatory drawing of *The Gleaners* is debatable. There has been some speculation that he acquired the drawing when attending an exhibition of Millet's art on April 18, 1875, or when attending an auction of his work at the Hôtel Drouot on May 8, 1875. However, Lucas made no mention of this in his diary. The first known time that Lucas was involved in the acquisition of Millet's art was August 11, 1877, when he, along with Samuel Avery, acquired from the Georges Petit Gallery a painting by Meissonier for 7,000 F, a painting by Jacques for 4,500 F, and a picture by Millet for 400 F. *Lucas Diary,* 2:410, 450. Avery recorded in his diary that on August 11, 1877, he purchased the work of Meissonier and Jacque. Avery made no reference to purchasing the Millet. See *Avery Diary,* 442. Likely, the Millet purchased on August 11 was for Lucas, its relatively low price indicates that it was a drawing, not a painting, and the drawing was probably *The Gleaners,* one of the few works by Millet that Lucas ever acquired for himself.

22. *Lucas Diary,* 2:472, 512, 516, 588.

23. In 1889, Millet's *The Angelus* sold for 553,000 F, the highest price paid for a modern painting at that time. The next year, *The Gleaners* sold for 300,000 F. See Fratello, "France Embraces Millet." The high amounts that American collectors were offering for Millet's paintings around that time were discussed in "Millet's Great Work," *New York Times,* July 3,

1889. For a discussion of Lucas's drawing of *The Gleaners,* see Simon Kelly, "Jean-François Millet," in Fisher and Johnston, *The Essence of Line,* 296. The drawing of *The Gleaners* is in the BMA. Four oil paintings, two pastels, and two prints by Millet remain in the Walters Art Museum.

24. For references to some of these activities, see *Lucas Diary,* 2:592 (visit to Millet and Rousseau monument); 643 and 649 (proposed sale of Millet house to Avery); 764, 771, 778 (communications with Millet's sons); and 838 (raising money from Henry Walters for Millet monument).

Chapter 7. M, Eugène, and Maud

1. For the transcript of the one-day trial in the case of the Ministry of Justice against Gustave Flaubert, see Bregtje Hanrtendorf-Wallach, "Madame Bovary on Trial," in Flaubert, *Madame Bovary,* 313–388.

2. See Silver, "Salon, Foyer, Bureau," 847n19; Green, *The Spectacle of Nature,* 32–35; and Tombs, chap. 12, "Private Identities: Self, Gender, Family," in *France,* 215–232.

3. *Lucas Diary,* 2:73, 74.

4. *Lucas Diary,* 2:73–79, 91, 102. The purchase of the robe occurred on October 9, 1859 ("Robe M 25.00").

5. For Whistler's references to M, see Mahey, "The Letters of James McNeil Whistler to George A. Lucas." For Frick's references to M, see Frick Diary. For the references to M as "Mrs. Lucas," see Armand Charnay to George Lucas, Sept. 16, 1888, and Henri Lefort to George Lucas, June 15, 1896, Lucas Papers, BMA Archives.

6. Walters expressed this view in a letter written on March 15, 1864, from Paris to a friend in Baltimore. See William R. Johnston, *The Nineteenth Century Paintings in the Walters Art Gallery,* 13.

7. It is not clear when Lucas and M began to live together or when Lucas began to support M and her son Eugène. Two diary entries suggest that it was early in 1864. On January 14, Lucas took M and Eugène by train to Havre, where Eugène boarded a ship for Lisbon (apparently to visit his father). On January 15, Lucas and M returned to Paris. *Lucas Diary,* 2:169. The entry on July 22, 1867, states, "Wrote M that I would be home Thursday at 10 A.M." *Lucas Diary,* 2:246.

8. *Lucas Diary,* 2:503.

9. *Lucas Diary,* 2:223, 224, 265.

10. *Lucas Diary,* 2:275.

11. Between April 10, 1871, when Eugène was seventeen, and February 1, 1874, when he was twenty and departing for college in Rio De Janeiro, he visited the house in Boissise at least ten times. *Lucas Diary,* 2:389.

12. Lilian Randall initially suggested the possibility that the female figures in *Figure in Blue* and *Skating* were modeled after M. See *Lucas Diary,* 1:22. *Figure in Blue* was painted by Alfred Alboy-Rebouet and apparently was acquired by Lucas on December 23, 1872. *Skating* was painted by Charles Baugniet and acquired on April 15, 1882. The six other paintings of female figures were *Spring Maiden* by Jean Ernest Aubert (commissioned by Lucas on July 11, 1875); *Fishing,* by Pierre Paul Leon Glaize (commissioned Nov. 5, 1875); *Lady and Dog in Landscape,* by Antoine Emile Plassan (commissioned Nov. 5, 1875); *Girl Carrying a Basket of Fruit,* by Paul Signac; *Fisherwoman of Villerville,* by Alexandre Thiollet (acquired on Nov. 20, 1883); and *Girl in a Field,* by Félix Ziem. Lucas decided upon the size of most of the panels, acquired them, and took them to the artists. See *Lucas Diary,* 2:371, 416, 420, 540, 575. I thank Oliver Shell and Katy Rothkopf, of the BMA, for showing the panels to me.

13. *Lucas Diary,* 2:419.

14. The description of Lucas's apartment is based on Lilian Randall's research in Paris. See *Lucas Diary,* 1:8, 9. The location of Lucas and M's adjacent apartments was confirmed during the author's visit to this building in May 2013.

15. The exact date that Lucas rented the second apartment is unknown. However, his diary indicates that it was likely in 1876. On the first page of his annual diaries, Lucas noted his address. From 1872 to 1876, it was "41 Rue de l'Arc-de Triomphe." Beginning in 1877, he changed it to "21 Rue de l'Arc de Triomphe au coin de la rue des Acacias." The inclusion of the words "au coin de la rue des Acacias" indicated that his address extended to the corner of the street where the adjacent apartment was located.

16. For lists of the prints that were in M's apartment and where they were located, see George Lucas, Catalogue—Eaux fortes (c. 1905), Lucas Papers, BMA Archives.

17. *Lucas Diary,* 2:563.

18. See Lucas's letter to Avery, Oct. 16, 1865, in Samuel P. Avery Papers, Thomas J. Watson Library, Metropolitan Museum of Art. Vanderbilt did not like nudes, and he and Walters displayed no nudes of contemporary female figures in their collections.

19. Rousseau lived with his mistress, Elisa Gros, from 1848 until the time of his death in 1867. She became known as Madame Rousseau. Millet and his mistress Catherine Lemaire lived together from 1845 on and had four children before they married in 1853.

20. On April 21, 1882, e.g., Lucas, M, and his servant went to Boissise and found that Huntington and Angèle were already there. They remained together at Boissise for one week until April 28, 1882. *Lucas Diary,* 2:540.

21. *Lucas Diary*, 2:616–621.

22. *Lucas Diary*, 2:387.

23. *Lucas Diary*, 2:524

24. *Lucas Diary*, 2:751.

25. *Lucas Diary*, 2:714, 850, 851.

26. *Whistler Correspondence*, no. 07524.

27. *Lucas Diary*, 2:778.

CHAPTER 8. WHEN MONEY IS NO OBJECT

1. See Troyen, "Innocents Abroad." For how by 1870 French art had made "a significant entrée into the hearts and pocketbooks of *les riches Américains,*" see Fink, "French Art in the United States." For an excellent description and analysis of the political and cultural issues at stake at the Exposition of 1867 and for profiles of the French artists who won the highest awards, see Mainardi, *Art and Politics,* 128–175.

2. Jarves, *Art Thoughts,* 298.

3. *Lucas Diary*, 2:237–242, 244. For Lucas's important role in helping Avery, Johnston, and Walters acquire French paintings, see Beaufort and Welcher, "Some Views," 49–50.

4. *Avery Diary,* xxii.

5. For Avery's observations about the price of art in Paris during the early 1870s, see his letter to John Taylor Johnston, July 31, 1872, published in Beaufort and Welcher, "Some Views."

6. See "The Wolfe Collection," *New York Times,* Nov. 3, 1887, listing over sixty French artists who were represented in the Wolfe collection, including Bida, Bonnat, Bonheur, Bouguereau, Breton, Cabanel, Corot, Couture, Diaz, Dupré, Frère, Gérôme, Merle, Meissonier, Rousseau, Troyon, and Ziem, and noting that fewer than ten of these artists were previously in the Metropolitan's collection.

7. See Hirayama, *With Eclat,* which notes that while Boston collectors acquired thousands of French paintings during the second half of the nineteenth century, fewer than one hundred found a home in the Boston Athenæum, the predecessor of the Museum of Fine Arts.

8. See Fink, "French Art in the United States."

9. "John Taylor Johnston" (obituary), *New York Times,* Mar. 25, 1893; Katherine Baetjer, "Extracts from the Paris Journal of John Taylor Johnston." For a list of the art in Johnston's collection as of the date of its auction at New York's National Academy of Design in December 1876, see Somerville Art Gallery, *Catalogue, The Collection of Paintings, Drawings and Statuary, the Property of John Taylor Johnston.*

10. *Lucas Diary*, 2:278; Baetjer, "Extracts from the Paris Journal of John Taylor Johnston" (see entry for Oct. 9, 1868).

11. Baetjer, "Paris Journal of John Taylor Johnston" (Oct. 12 and 14, 1868).

12. References to the paintings that Lucas acquired for Johnston can be found in *Lucas Diary*, 2:278, 279, 280, 284, 285, 288, 289, 297–301, 308–310, 316–319.

13. *Lucas Diary*, 2:280, 284, 285, 298, 299. The *Portrait of Eva and Frances Johnston* remained in the Johnston family until May 7, 2014, when it was sold at auction by Bonhams to an undisclosed buyer. I thank Bonhams for obtaining permission for me to publish the image of this painting.

14. "Meeting of the Officers of the Metropolitan Museum of Art, " *New York Times,* Dec. 23, 1870.

15. *Lucas Diary*, 2:492, 495.

16. "Meissonier and Bonnat," *New York Times,* Sept. 1, 1880.

17. *Lucas Diary*, 2:506 (Oct. 2, 1880).

18. According to the historian Gustavus Myers, Vanderbilt "knew nothing of art, and underneath his pretensions cared less" (*History of the Great American Fortunes,* 213). W. A. Crofutt wrote that Vanderbilt had a natural love for art (*The Vanderbilts,* 169). Other historians have expressed more measured opinions about Vanderbilt's appreciation of art. See *Avery Diary,* lviii.

19. "Vanderbilt's New House," *New York Times,* Mar. 8 1882. For an excellent discussion of the private galleries that opened in the United States in the second half of the nineteenth century, with a focus on the gallery of William Henry Vanderbilt, see Leanne Zalewski, "Art for the Public." See also Edward Strahan's lavish, five-volume, illustrated *Mr. Vanderbilt's House and Collection,* which characterizes Vanderbilt's collection as "one of the notable and recognized . . . of the world." For a survey of earlier private galleries showing French art in the United States, see Fink, "French Art in the United States," 87–100.

20. *Avery Diary,* 55–61.

21. Crofutt, "The Art Gallery," chap. 19 of *The Vanderbilts.*

22. *Lucas Diary*, 2:474 (May 31, 1879).

23. See "Vanderbilt's New House," which states that Vanderbilt's pictures "were selected by Mr. Avery."

24. *Avery Diary,* 55, 56.

25. Vanderbilt was accompanied by four servants during his trips to Paris and elsewhere in Europe. See "W. H. Vanderbilt's Return," *New York Times,* Oct. 17, 1880.

26. *Lucas Diary*, 2:496, 564.

27. *Avery Diary,* 63. Consistent with the notion that Lucas worked directly for Avery, not Vanderbilt, Lucas submitted invoices for his services to Avery. Lucas submitted

no invoices to Vanderbilt, and Vanderbilt made no direct payments to Lucas for his services.

28. *Lucas Diary,* 2:474, 483, 484, 485.

29. "Meissonier."

30. For a description of Meissonier's portrait of Vanderbilt and the observation that Meissonier was Vanderbilt's favorite French artist, see "Vanderbilt a Loss to Painters," *New York Times,* December 31, 1885.

31. *Avery Diary,* 19.

32. According to Avery, Vanderbilt paid Meissonier 25,000 F for his portrait. *Avery Diary,* 32.

33. *Lucas Diary,* 2:504, 505.

34. *Lucas Diary,* 2:503, 505, 516, 556, 578.

35. According to Lucas's diary, Vanderbilt "finished" at the end of October 1881. *Lucas Diary,* 2:528.

36. The amount Avery paid to Lucas for his services to Vanderbilt cannot be precisely determined. Based on the average price of the paintings Lucas helped Vanderbilt to acquire (40,000 F) times the number of works acquired (21), one can estimate that the total cost of these paintings was around 800,000 F. Assuming that Lucas charged his standard commission of 5 percent for his services, he would have been paid approximately 40,000 F between 1878 and 1882.

37. On May 16, 1883, Lucas was informed that Vanderbilt was coming to Paris, but the next day he received a telegram that Vanderbilt was not coming. There were no further communications between them.

38. Croffut, *The Vanderbilts,* 169.

39. Strahan, *Art Treasures of America,* 81–94.

40. "Paul Delaroche's Hemicycle," 293.

41. See "Paul Delaroche's Hemicycle."

42. See Baetjer, "Extracts from the Paris Journal of John Taylor Johnston" (see entry for Oct. 19, 1868).

43. *Lucas Diary,* 2:337, 341, 345, 346, 348.

44. *Lucas Diary,* 2:496, 553–555. For a discussion of the importance of this painting and the history of its purchase, see Kelly, "Théodore Rousseau's *Le Givre,*" 69–78. Lucas to Walters, April 30, 1880, WAM Archives.

45. *Lucas Diary,* 2:561, 563–566, 569, 571.

46. *Lucas Diary,* 2:567–570, 573.

47. Walters also had a large and distinguished collection of Asian art.

48. For a contemporaneous description of Walters's gallery of paintings, see "Fine Art in Baltimore: The Walters Gallery Collection of Paintings," *Baltimore Sun,* May 20, 1885.

49. See Zalewski, "Art for the Public." The cut-up Vanderbilt catalogues are in the WAM Archives.

50. For a description of the opening and the manner in which Walters borrowed parts of Vanderbilt's catalogue, see William R. Johnston, *William and Henry Walters,* 89–95.

51. See "Rich Treasures of Art: Mr. W.T. Walters Galleries Viewed by a Distinguished Throng," *Baltimore Sun,* Feb. 27, 1884.

52. "Mr. Walters Collection of Pictures and Ceramics," *Baltimore Sun,* Feb. 8, 1884.

53. "A Baltimore Art Collection," *New York Sun,* Feb. 27, 1884. The publisher and editor of the *New York Sun* at this time was William Laffan, a close friend of Walters. This relationship casts doubt on the article's objectivity but reinforces that Walters was interested in having his collection compared favorably with Vanderbilt's.

54. *Lucas Diary,* 2:623. The specific date on which Walters actually acquired this sketch is unknown. For a discussion of this portrait, see Zalewski, "Alexandre Cabanel's Portraits."

55. *Lucas Diary,* 2:630–633; William R. Johnston, *William and Henry Walters,* 95.

56. For two reviews that highlight Walters's best paintings, see "Fine Arts in Baltimore: The Walters Collection—Gallery of Paintings," *Baltimore Sun,* May 20, 1885," which refers to Rousseau's *Winter Solitude (Le Givre)* and Breton's *Close of the Day* as "supremely beautiful," and "The Walters Art Collection; Recent Additions—Barye, Millet, Bonnat," *Baltimore Sun,* Feb. 1, 1886, which refers to and praises the portfolio of watercolors by Bonvin as "the most interesting" new addition to the collection.

57. *Lucas Diary,* 2:357.

58. For a definitive study of Barye and his connection to Walters and Lucas, see Johnston and Kelly, *Untamed,* esp. the chapter entitled "Barye's American Patrons," 52–65.

59. *Lucas Diary,* 2:588.

60. "Mr. Walters's Reception—The Barye Gallery Opened," *Baltimore Sun,* Jan. 29, 1885.

61. William T. Walters, *Antoine-Louis Barye From the French of Various Critics* (1885), WAM Archives.

62. In June 1885, Lucas arranged for Cabanel to paint the portrait of Mary Frick Garrett, then the wife of Robert Garrett. Following Garrett's death, she married Henry Barton Jacobs, and upon her death, her portrait, along with her outstanding collection of old master paintings, was given to the BMA (BMA 1938.238). See *Lucas Diary,* 2:609.

Chapter 9. The Lucas Collection

1. For a bibliography and description of many of the most significant books and journals in Lucas's collection, see Lillian Maria Burgunder, *Master List: Contents of George A. Lucas's Personal Library,* Lucas Papers, BMA Archives.

2. See Cheryl K. Snay, "Norbert Goeneutte," in Fisher and Johnston, *The Essence of Line,* 252.

3. *Lucas Diary,* 2:563, 589, 666, 669, 894.

4. Lucas's dependence on M to care for his collection is shown by his July 1, 1902, diary entry, in which he recorded that while out of town he had written to M to inform her that the American painter Ogden Wood and his friends would be coming to their house and that she should "show my Corots." *Lucas Diary,* 2:901. For Lucas's note about the prints "prepared for pasting" and other references to the duties performed by M and Eugène, see Lucas's notes and his notebook entitled "Catalogue—Eaux fortes," boxes 15 and 16, Lucas Papers, BMA Archives. For references to M's assistance in opening mail, see *Lucas Diary,* 2:232 (Jan. 12, 1867) and 247 (July 30, 1867).

5. Lucas's Catalogue—Eaux fortes, box 15, Lucas Papers, BMA Archives.

6. Lucas's collection of Daubigny's art and information about all aspects of his life was supplemented on March 30, 1894, when he acquired a series of thirty etchings by Léonide Bourges of Daubigny's hometown, house, and boat. *Lucas Diary,* 2:786.

7. For Lucas's notes and records pertaining to the organization and storage of his art collection, see box 15, Lucas Papers, BMA Archives.

8. The lists are in box 16, Lucas Papers, BMA Archives.

9. For references to the hanging of his paintings on August 16, August 29, September 5, and October 2, 1898, and August 1, 1899, see *Lucas Diary,* 2:866, 867, 880.

10. The painting by Constant was featured in the landmark exhibition of the Lucas collection at the BMA in 1965 and featured again in a 1995 exhibition, "Parallels and Precedents," held at the BMA, during which it was compared to a Matisse odalisque. See John Dorsey, "A New Show from the Lucas Collection Illustrates Its Importance to Baltimore: Exhibit A," *Baltimore Sun,* Aug. 23, 1995.

11. Lucas prepared a list of the paintings in his Salon sometime after 1904. Fifteen of the paintings were landscapes; thirteen were images of single figures, heads, or portraits; three appeared to be still lifes, and two were genre paintings. The list is in box 16, Lucas Papers, BMA Archives.

12. For an essay about the emerging popularity of realistic landscapes in mid-nineteenth-century France, see Gary Tinterow, "The Realistic Landscape," in Tinterow and Loyrette, *Origins of Impressionism,* 55–93.

13. Lucas acquired the painting that is now called *Thatched Village* on February 8, 1864, for 300 F and referred to it in his diary as "small landscape near Amiens." He bought

Sévres-Brimborion, View towards Paris, on April 10, 1864, for 400 F and referred to it as "Landscape Road at Ville d'Avray with Paris in Distance." *Lucas Diary,* 2:171, 176.

14. *Lucas Diary,* 2:647, 658, 660, 666, 683, 686, 704, 745, 817.

15. The precise date on which Lucas acquired this painting is not known. Thiollet prepared a small, watercolor study for this painting around 1873 (see BMA 1996.48.3236), and it is likely that the painting was done and acquired by Lucas shortly thereafter.

16. *Lucas Diary,* 2:666.

17. *Lucas Diary,* 2:926.

18. See Duret, *Manet.*

19. Pennell and Pennell, *The Whistler Journal,* 55. This description of Lucas's Salon was not published until 1921.

20. As evidenced by his diary, there were only two occasions when Lucas offered to show his collection to outsiders. On July 3, 1889, he invited the American art collector Cyrus Lawrence "to my house to see my collection," and on February 4, 1906, he permitted the American artist Ogden Wood and two of his friends to see his collection of etchings. *Lucas Diary,* 2:692, 937. In 1911, following Lucas's death, his nephew William F. Lucas Jr. praised him for "the assistance and guidance he delighted to give to the art student." See *Exhibition of the George A. Lucas Art Collection,* 4. There is, however, no evidence that supports this assertion. The word *student* does not appear in Lucas's diary; nor is there any mention there or elsewhere that Lucas assisted or guided any students.

21. According to Lucas's diary, the only persons other than M and Eugène who spent a significant amount of time in his apartment and probably saw a substantial part of his art collection were (1) the artist William Baird, (2) the journalist William Huntington, (3) the journalist and celebrated columnist for *Harpers Magazine* Theodore Child, (4) Lucas's lifelong friend Frank Frick, (5) Whistler's ex-mistress Maud Franklin, and (6) Lucas's niece Bertha Lucas. Baird, Huntington, and Child were American expatriates who resided in Paris and over the course of many years often dined and socialized with Lucas in his apartment. Maud Franklin became an intimate friend and repeatedly had dinner and sometimes breakfast with Lucas and M at Lucas's apartment, and she assisted them in arranging pictures and prints. See *Lucas Diary,* 2:689, 690.

22. Lucas met Child in October 1880, and they remained close friends until Child's death in 1892. Child's only known references to Lucas were "Art Gossip from Paris," which mentions that Lucas helped William Walters and William

Corcoran assemble their collections of Barye sculpture, and "The Barye Memorial in Baltimore," which notes that Lucas had an "important collection" of Barye's art.

23. Among the hundreds of artists in Lucas's collection, only fourteen appeared to attract any visitors to see Lucas's collection. They were Barye, Bonvin, Corot, Daubigny, Daumier, Diaz, Gérôme, Goeneutte, Greuze, Isabey, Leprince, Maris, Monticelli and Whistler. See *Lucas Diary*, vol. 2, throughout.

24. See Johnston and Kelly, *Untamed*, 52–65.

25. *Lucas Diary*, 2:691 (May 20, 1889) and 702 (Jan. 3, 1890).

26. See note 22.

27. See "Mr. George A. Lucas Dead," *Baltimore Sun*, Dec. 18, 1909.

28. The 176 artists are identified in the "Paintings" section of *The George A. Lucas Collection of the Maryland Institute*. According to the biographical information about these artists collected by Lucas, 89 had won medals or awards. See *Exhibition of the George A. Lucas Art Collection*.

29. The list of paintings in Lucas's sleeping room is in box 16 of the Lucas Papers, BMA Archives. Lucas acquired the "oil study" attributed to Rousseau on March 28, 1887, for the price of 200 F. See *Lucas Diary*, 2:647. The very low price of the painting and Lucas's decision not to show it in his Salon suggest that he had his doubts about its pedigree and quality. With regard to Goubie's gift of a small painting of a dog, Lucas had previously purchased three paintings from him for Samuel Avery at a cost of 3,500 F, 10,500 F, and 7,000 F. *Lucas Diary*, 503, 515, and 517.

30. *Lucas Diary*, 2:360 (April 8, 1872).

31. In December 1983, Meissonier's painting was lost by the BMA during the renovation of the museum, and the Maryland Institute was notified. Because the painting was not considered to be of any art-historical value, nothing was done to replace it. See Brenda Richardson to Fred Lazarus, Dec. 14, 1863, Records of the Registrar, BMA.

32. For the paintings that cost 100 F or less, see appendix table 2. Lucas purchased only four paintings that cost 1,000 F or more. They were *The Lodge*, by Daumier; the *Study of a Head* (female nude), by Couture; and two landscapes by Jacomin.

33. For the way landscape and still-life paintings were treated at the time of the Salon of 1877, see Mainardi, *The End of The Salon*, 20. On March 21, 1862, Lucas met with three artists to learn the cost of their paintings. Jean Fauvelet said that the price of a painting with a single figure was 500 F and a canvas with two figures was 800 F; Monfalet charged

150 F for a single figure and 300 F for two or more; and the more prominent artist Emile Plassan asked for 1,200 F for a single figure, while two figures cost 2,000 F. *Lucas Diary*, 2:131.

34. Between 1857, when Lucas arrived in Paris, and 1870, the number of works of art shown at each of the annual and biennial Salons ranged from 2,745 to 5,434. For the number of works at each of the official French Salons in the nineteenth century, see Mainardi, *The End of the Salon*, 19.

35. For the average prices of history and genre paintings by French contemporary artists around 1857, see White and White, *Canvases and Careers*.

36. Lucas referred in his diary to any painting that was shown at the Salon and purchased for his clients or himself as a "Salon" painting. The notes in his diary indicate that he acquired around 125 "Salon" paintings for his clients, but the number likely exceeded that. The only "Salon" paintings that he purchased for himself were Jacomin landscapes that he acquired in 1882, 1884, and 1886 at a cost 2,000, 2,500, and 2,200 F, respectively. He also received as a gift a small sketch by Adolphe Weisz that apparently was shown at the Salon. *Lucas Diary*, 2:428, 543, 582, 628.

37. For example, while shopping for paintings for his clients in the Salon in the spring of 1869, Lucas noted the prices of the following paintings. Herbsthoffer, 8,000 F; Duverger, 2,000 F; Detaille, 10,000 F; Plassan, 10,000 F for a large painting and 1,000 F for a small; and van Marcke, a small painting for 1,500 F. *Lucas Diary*, 2:287, 290, 294, 295, 298, 308, 310.

38. *Lucas Diary*, 2: 582 (March 6, 1884) and 628 (May 1, 1886). For the medals won by Jacomin for this painting, see *Exhibition of the George A. Lucas Art Collection*, 94.

39. On May 16, 1866, Lucas purchased a landscape by Jules Héreau from Goupil for 500 F. *Lucas Diary*, 2:219.

40. In his memoirs, Paul Durand-Ruel listed the important collectors with whom he dealt. William Walters was referred to as having a "world-famous collection." Lucas was not mentioned. See Durand-Ruel and Durand-Ruel, *Paul Durand-Ruel*, 186.

41. See *Lucas Diary*, 2:166, 189, 191, 197–199, 203–205, 207, 214, 268, 276, 311, 314, 326. In addition to obtaining gifts in the form of paintings from Plassan, Lucas apparently received a handsome commission from Plassan for influencing Walters to purchase one of Plassan's expensive Salon paintings. See *Lucas Diary*, 2: 310 (Dec. 15, 1869: "At Plassans and got measure of his salon picture price 10,000 fs with commission for me of 10 per ct."), and 311 ("Rec'd from Plassan 1510 fs"). The present whereabouts of the portrait of Walters's daughter,

the expensive Salon painting sold to Walters, and the portrait of Lucas are unknown.

42. On May 14, 1897, Lucas informed Avery that he was retiring at the end of the year. *Lucas Diary,* 2:846.

43. These numbers are based on the approximate acquisition dates of 248 oil paintings. See appendix table 2. The acquisition dates of approximately sixty additional paintings are unknown.

44. *Lucas Diary,* 2:289, 296, 313. The painting is in the Walters Art Museum (WAM 37. 1989).

45. Rothkopf, *Pissarro,* 98.

46. The term *impressionist* was not coined until the first group show of Manet, Degas, Renoir, Sisley, Pissarro, and others in 1874. See John Rewald, "The First Group Exhibition (1874) and the Origin of the Word 'Impressionism,'" in *The History of Impressionism,* 309–340.

47. The misspelling is found on a list written by Lucas of paintings in M's Salon Bleu, Lucas Papers, BMA. The information that Lucas placed on the backs of paintings was used in the catalogue of the art exhibition held at the Maryland Institute in 1911. For the reference to Pissarro as a pupil of Corot, see *Exhibition of the George A. Lucas Art Collection,* 11, item no. 28.

48. *Lucas Diary,* 2:214, 237.

49. See Kelly, "Durand-Ruel and 'La Belle Ecole' of 1830," 56–75. See also Keppel, *The Men of 1830.*

50. See Durand-Ruel and Durand-Ruel, *Paul Durand-Ruel,* 20, 21, 94, 131.

51. For a discussion of Boudin's movement from paintings about ships to paintings about people on a beach, see Tinterow and Loyrette, *Origins of Impressionism,* 340, 341.

52. For Lucas's reference to Boudin, see *Exhibition of the George A. Lucas Collection,* 56.

53. The price of impressionist paintings in the mid-1870s is reflected by sales at the Durand-Ruel Gallery and the Hôtel Drouot. In 1875, Durand-Ruel sold seventeen paintings by Renoir that started at 60 F and capped at 300 F, and eighteen paintings by Monet that started at 180 F and capped at 325 F. See Durand-Ruel and Durand-Ruel, *Paul Durand-Ruel,* 118, 119.

54. For an excellent survey of the paintings displayed at each of the exhibits of impressionist paintings and the response of the leading critics, see Moffett, *The New Painting.*

55. *Lucas Diary,* 2:155, 373, 445, 495, 496, 601, 629, 746, 755, 787.

56. Émile Zola's *L'Oeuvre* was published in 1885. It was renamed *The Masterpiece* in subsequent English publications.

For how this novel was construed, see D'Souza, "Paul Cézanne, Charles Lantier, and Artistic Impotence." Lucas purchased an illustrated version of the book in July 1894 for 400 F. See *Lucas Diary,* 2:792.

57. See *Avery Diary,* xxxii.

58. *Lucas Diary,* 2:620, 621.

59. See *Exposition International Universelle De 1900: Catalogue Général Officiel, Oeuvres D'Art* (Imprimeries Lermercier, Paris), The Getty Internet Archives.

60. *Lucas Diary,* 2:904. *Olympia* entered the Luxembourg in 1890, and the impressionists were admitted in 1896. See "The Avant-garde at the Musée du Luxembourg: From Realism to Impressionism," *Musée d'Orsay: Painting,* www.musee-orsay.

61. See Mathews, *Mary Cassatt.*

62. *Portrait of a Woman (Estelle Musson Balfour),* by Degas, and *Springtime,* by Monet are in the Walters Art Museum (WAM 37.179 and 37.11).

63. *Lucas Diary,* 2:913.

64. In 1903, Durand-Ruel sold a painting by Manet to Havemeyer for $17,000, or 85,000 F. See Durand-Ruel and Durand-Ruel, *Paul Durand-Ruel,* 88. In 1909, Henry Walters purchased Manet's *At the Cafe* from the Durand-Ruel Gallery for $25,000, or 125,000 F.

65. *Lucas Diary,* 2:872, 944, 947. According to the BMA records, in 1953 the painting attributed to Manet was examined by the French art historian Michel Florisoone, who advised the museum that it was not by Manet. The attribution was subsequently changed to "unknown artist."

66. Baudelaire, "Painters and Etchers," (1862), in *Art in Paris,* 222.

67. See Leipnik, *A History of French Etching,* 105–137; and Lang and Lang, *Etched in Memory,* 29–34.

68. *Lucas Diary,* 2:167.

69. The only comparable American collection of French nineteenth-century prints belonged to Lucas's client Samuel Putnam Avery. See Samuel Putnam Avery Collection, New York Public Library. Lucas and Avery were both collecting prints by many of the same artists and amassed collections that were similar in quality and size. Avery seems to have taken the lead in acquiring prints by Cassatt, Manet, and the other modernists. Otherwise, it is debatable whether Lucas or Avery served as the guiding light in building their similar collections and whether one is better than the other.

70. *The Progressive Drawing Book* contained four landscapes, each of which was referred to as a "soft ground etching," etched by J. Cone and derived from a specified plate. They

collectively were referred to as "original views of American scenery," and they became collectors' items. See Drepperd, "Rare American Prints."

71. *Lucas Diary,* 2:31, 41.

72. *Lucas Diary,* 2:85.

73. See *Lucas Diary,* 2:85 (Nov. 19, 1858).

74. MacDonald, *The Correspondence of James McNeil Whistler.*

75. Lucas acquired the treatise on January 27, 1870. *Lucas Diary,* 2:314. For a discussion of Lalanne's treatise and its importance in the history of etching, see Fisher, introduction to Lalanne, *The Technique of Etching.*

76. *Lucas Diary,* 2:315 ("At Rocron and left list of old etchings wanted."), 803 ("To examine Jacque [etchings]—found myself without my notes").

77. See Elizabeth Helsinger and Anna Arnar, "Seduced by the Etcher's Needle: French Writers and the Graphic Arts in Nineteenth-Century France," in Helsinger et al., *The Writing of Modern Life,* 39–55.

78. Klitzke, introduction to *George A. Lucas Collection Selected Prints.*

79. *Lucas Diary,* 2:254.

80. Lucas began collecting etchings and other types of prints by Manet in the 1890s. It is not clear when he acquired the etchings of *Olympia,* but it was likely on March 5, 1894, when he purchased a set of Manet's etchings for 300 F. *Lucas Diary,* 2:785. Lucas acquired virtually a complete representation of Manet's prints. His two etchings of *Olympia* have been characterized as "failed efforts" to reproduce his painting, and they demonstrate that Manet was far from a master in this field. See Fisher, *The Prints of Edouard Manet,* 24, 75, 76.

81. The BMA presently is engaged in a scholarly effort to distinguish the art from the ephemera in the Lucas collection of prints. I want to thank Nicole Simpson, who was in charge of this project, and Jay Fisher, the BMA's chief curator, for providing me with a rough estimate of the number of pictures that might be characterized as ephemera.

82. The prints by Whistler acquired in 1895 were from the printer L. Dumont; the prints purchased in 1896 were from J. Bouillon. The invoices for these purchases are in the Lucas Papers, BMA Archives.

83. Keppel, "The Print Collector," 74; and *Golden Age of Engraving,* 107–110.

84. For Jacque's place in the history of French etching, see Leipnik, *A History of French Etching,* 76–78 (referring to his infatuation with pigs); Bouret, *The Barbizon School,* 149

(referring to his infatuation with sheep); and Taormina, "Charles-Emile Jacque."

85. See Cicerone, "Private Galleries," 31,32; Hart, "Public and Private Collections," 294–299. Avery began purchasing etchings by Jacque in 1871 and over the years accumulated hundreds of his etchings that in number were second only to Lucas's collection. See *Avery Diary,* 33 (July 20, 1871).

86. *Lucas Diary,* 2:409, 410.

87. *Lucas Diary,* 2:410 (Mar. 20, 1875: 4 for 5 F); 420 (Nov. 4, 1875: .75 F); 483 (Oct. 12, 1879: ordered new set of etchings for 200 F with 25 percent off).

88. *Lucas Diary,* 2:889.

89. *Lucas Diary,* 2:924.

90. See Leipnik, *A History of French Etchings,* 78. According to Leipnik, Jacque's "later etchings lack the charming poetry of his good period; they portray the boredom of a wearied spirit."

91. In 1924, René Gimpel, whose gallery had once sold a significant amount of Jacque's art, characterized Jacque as a "fourth-rate painter." See Gimpel, *Diary of an Art Dealer.*

Chapter 10. The Final Years

1. The last time that Lucas and M visited Boissise together was on July 9, 1897. They stayed there until September 2. Lucas returned to Boissise only one time after that—on September 28, 1897. *Lucas Diary,* 2:848, 851. The only times that M's name appears after 1903 in Lucas's diaries are in January and February 1908, when she was in constant need of a doctor. (The diaries for 1905 and 1909 have been lost.) *Lucas Diary,* 2:958, 959.

2. "Notes Diverses," in small financial record book, WAM Archives.

3. See *Lucas Diary,* 1:41 (1905).

4. An example of these instructions is found on a slip of paper to "EUGENE," entitled "Davios" (reminders), Lucas Papers, BMA Archives.

5. *Lucas Diary,* 2:930. Eugène resided in Boissise until the time of his death in 1928. The property remained in the hands of his children until the house was sold in 1947. *Lucas Diary,* 1:23.

6. The earliest reference to any communications between Walters and Lucas about the Maryland Institute occurred on August 23, 1904. *Lucas Diary,* 2:931. Walters's reference to Jenkins's and Frick's support of the idea is found in his March 19, 1905, letter to Lucas. This and other correspondence between them is in the WAM Archives. For Jenkins's gift of land, see "Mr. Michael Jenkins Makes Splendid Gift to

Maryland Institute," *Baltimore Sun,* Jan. 10, 1905. For an excellent historical discussion of the public support and reconstruction of the Maryland Institute, see Frost, *Making History / Making Art,* 99–119.

7. See W. F. Lucas Jr., "George Aloysius Lucas," 3, 4.

8. See *Lucas Diary,* 2:931 (Aug. 23, 1904).

9. See letters from Henry Walters to George Lucas in the WAM Archives.

10. For references to the presents that Lucas sent to Walters, see Henry Walters to George Lucas, July 15 and Oct. 16, 1908, WAM Archives. See also Walters Art Gallery Catalogues published in 1909, 1915, and 1922.

11. Frick went to Paris and met with Lucas in 1860, 1864, 1867, 1884, 1891, 1898, 1901, 1902, 1904, 1905, 1906, 1907, and 1909. See Frank Frick, "A Time Table of Travel Abroad," Peabody Institute Archives, JHU.

12. See "Frank Frick," in Hall, *Baltimore,* 2:116–119; "The New Hall Project," *Baltimore Sun,* Nov. 28, 1891; "Frick Funeral Today," *Baltimore Sun,* Dec. 28, 1910. Frick resided in Bolton Hill at 1514 Park Avenue. It was five blocks away from where the Maryland Institute was built.

13. Henry Walters to George Lucas, Mar. 19, 1905, WAM Archives.

14. Mark S. Watson, "Adventures in Art Collecting," *Baltimore Sun,* Jan. 25, 1931.

15. See William R. Johnston, *William and Henry Walters,* 126.

16. "The Massarenti Collection," *New York Times,* May 11, 1902. See Mazaroff, *Henry Walters and Bernard Berenson.*

17. As recorded in Lucas's diary, Walters visited him on June 1, 3, 21, and 23, 1904; May 12, 14, 16, and June 6 and 7, 1906: August 9, 10, 12, and 27, 1907; and April 29 and May 22, 1908.

18. "Miss Lucas in the Levant: A Baltimorean's Impression of Constantinople," *Baltimore Sun,* May 5, 1907. See also "Her Social World," *Baltimore Sun,* Feb. 11, 1896; and "A Wanderer in Europe," *Baltimore Sun,* Dec. 23, 1906.

19. See *Lucas Diary,* 2:827–829, 888, 890, 916, 921.

20. Norbert Goeneutte, *Young Woman in a Rocking Chair,* BMA 1996.45.117. See also Goeneutte to George Lucas, Jan. 16, 1889, regarding payment for "niece's portrait," Lucas Papers, BMA Archives.

21. *Lucas Diary,* 2:933 (Oct. 29, 1904).

22. See Bertha Lucas's memory of George Lucas's effort to surround himself with his art while bedridden in Mark S. Watson, "New Glory in the Museum of Art," *Baltimore Sun,* July 23, 1933.

23. Frick, "A Time Table of Travel Abroad," vol. 5, Sept. 11 and 15, 1907.

24. As of December 31, 1908, Lucas had a balance of 131,684 F in his ever-growing Paris bank account. It generated 5,140 F in interest per annum. Lucas also owned bonds in seven major US railroads. The bonds were held by Union Trust Company in Baltimore and generated annual dividends and interest of approximately $4,000 each year. Lucas's account in Baltimore was managed by W. T. Walters & Son, which mailed checks to him in the amount of 10,000 F each January and July. For Lucas's financial records from 1900 to the time of his death in 1909, see "GL Records Relating to Finances, Stocks," WAM Archives.

25. Frick, "A Time Table of Travel Abroad," vol. 5, Oct. 1, 1907.

26. Henry Walters to George Lucas, Jan. 31, 1908, WAM Archives.

27. "In Palace of Marble, Maryland Institute Opens," *Baltimore Sun,* Oct. 2, 1907.

28. Henry Walters to George Lucas, Oct. 8, 1907, WAM Archives.

29. The notes are in the Lucas Papers, BMA Archives.

30. For references to Lucas's will, see *Lucas Diary,* 2:203 (Sept. 26, 1865) and 210 (Jan. 2, 1866). Although the specific terms of that will remain unknown, the circumstances of Lucas's life at that time establish that M was the only person whom he loved and cared for and the obvious person whom he would designate as his beneficiary. Lucas's parents were dead, he had become alienated from his brothers, and he had never met any of their children. Any notion that he might have named the Maryland Institute as his beneficiary is farfetched. Lucas never attended the Institute, and he never mentioned its name in his diary until 1904, when Henry Walters embarked on his plan to convince Lucas to leave his collection there. *Lucas Diary,* 2:931.

31. See, e.g., Henri Lefort to George Lucas, June 15, 1896: "My cordial thanks to you my dear Mr. Lucas and my best respects to Mrs. Lucas." See also Armand Charnay to George Lucas, Sept. 18, 1888: "Please thank Mrs. Lucas for her kind remembrance." Lucas Papers, BMA Archives.

32. Frick, "A Time Table of Travel Abroad," vol. 6, Aug. 24, 1909. In the subsequent correspondence between Lucas and Walters, there is no suggestion that any of the art was damaged in the fire.

33. Frick, "A Time Table of Travel Abroad," vol. 6, Aug. 24, 1909.

34. Walters to Lucas, Nov. 23, 1909, WAM Archives.

35. Lucas to Walters, Oct. 22, 1909, WAM Archives.

36. Walters to Lucas, Nov. 23, 1909, WAM Archives. The whereabouts of Lucas's earlier wills, assuming they still exist, is unknown.

37. Lucas to Walters, Oct. 26, 1909, WAM Archives. In his letter, Lucas refers to "the new will."

38. Thomas Moss, "The Beggar's Petition" (1769). The poem was popularized by Théodore Gericault's lithograph, published in 1822, which carried the title "Pity the Sorrows of a Poor Old Man" and a profusion of prints that followed. The lithograph is in the collection of the Metropolitan Museum of Art.

39. Lucas to Walters, Oct. 26, 1909, WAM Archives.

Chapter 11. The Terms of Lucas's Will

1. Lucas's financial records from near the time of his death are in the WAM Archives. For an estimate of his wealth at that time, see *Lucas Diary,* 1:20.

2. The court records regarding the probate of Lucas's will are in the Lucas Papers, BMA Archives. For Walters's statement to Lucas about keeping his prior wills in his safe-deposit box, see Walters to Lucas, Nov. 23, 1909, WAM Archives.

3. *Baltimore Sun,* Mar. 9, 1910.

4. "Late George A. Lucas Leaves Collection to Mr. Henry Walters," *Baltimore Sun,* Dec. 23, 1909; "French Will to Stand," *Baltimore Sun,* Mar. 9, 1910.

5. See Mazaroff, *Henry Walters and Bernard Berenson,* 87 and 88.

6. *Lucas Diary,* 2:787.

7. Jenkins's letter is in the MICA Archives.

8. Carter's letter of acceptance is in the MICA Archives.

9. "Lucas Art Gift Duly Announced," *Baltimore American,* May 10, 1910.

10. "Artists and Their Work, Lucas Collection Expected to Go to Maryland Institute," *Baltimore Sun,* May 9, 1910.

11. See "Late George A. Lucas Leaves Collection to Mr. Henry Walters," *Baltimore Sun,* Dec. 23, 1909; "Will Place Lucas Gift," *Baltimore Sun,* May 10, 1910.

12. "Mr. George A. Lucas Dead," *Baltimore Sun,* Dec. 18, 1909. In 1911, a somewhat more accurate portrayal of Lucas's life was written by William F. Lucas Jr., Lucas's nephew, and published by the Maryland Institute in *Exhibition of the George A. Lucas Art Collection.*

13. See "Funeral of Mr. G. A. Lucas," *Baltimore Sun,* Feb. 22, 1910. For the words on Lucas's death certificate, see *Lucas Diary,* 1:32.

Chapter 12. A Collection in Search of a Home

1. See Bertha Lucas to John Carter, July 28, Sept. 27, and Nov. 29, 1910; John Carter to Bertha Lucas, Aug. 11, 1910; William Lucas Jr. to John Carter, Oct. 17, 1910; and John Carter to William Lucas, Dec. 9, 1910, and accompanying lists of objects, MICA Archives.

2. Henry Walters to John. M. Carter, Sept. 16, 1910, WAM Archives.

3. See John Carter to Faris Pitt, Oct. 29, 1910, and "Memo of helpful Statements from Mr. Pitt," MICA Archives. Pitt was the owner of Baltimore's prominent art gallery, the general manager of the Municipal Art Society, and an expert on ancient art. Having played a leading role in the installation of Walters's art in his new gallery, Pitt was requested to provide similar guidance to the Institute.

4. John Carter to Henry Walters, Jan. 30, 1911, MICA Archives.

5. W. F. Lucas Jr., "George Aloysius Lucas," 3, 4.

6. *Exhibition of the George A. Lucas Collection,* 112.

7. "Lucas Art Gems Seen," *Baltimore Sun,* Feb. 19, 1911. See also "Lucas Collection Popular," *Baltimore Sun,* Feb. 22, 1911; and "Palettes Used by Famous Artists," *Baltimore Sun,* Mar. 19, 1911.

8. See "Complete Inventory of the Lucas Collection of Paintings," prepared by Irene Cook, Custodian of the Gallery, July 1931, MICA Archives.

9. See Hans Schuler, "Sketches in the Lucas Collection," *Vistas and Perspectives* (Maryland Institute, Mar. 1932), 3.

10. See catalogue *An Exhibition of the Work of James A. McNeill Whistler Contained in the George A. Lucas Collection* (March 31–April 11, 1927, Maryland Institute), MICA Archives.

11. For a fuller description of the contents of the cluttered room where some of the Lucas collection was stored, see "Contents of Lucas Room, 1912," BMA Lucas Litigation Files. See also Eugene M. Leake, memo, Sept. 28, 1973, "The Lucas Collection," MICA Archives. According to Leake, the Institute was not "well equipped to store and to exhibit the collection."

12. For information about the effect of the Depression on the Maryland Institute, see Frost, *Making History / Making Art,* 150.

13. See Mazaroff, *Henry Walters and Bernard Berenson,* 133–135. Henry Walters died in New York on November 30, 1931, at the age of eighty-three. He left his museum and collection of art to the city of Baltimore.

14. See "Garrett Prints Loaned to Museum," *Baltimore Sun,* Aug. 7, 1930.

15. See "Breeskin, Adelyn Dohme," *Dictionary of Art Historians.*

16. See "Art: The Museum's Notable Print Collection," *Baltimore Sun,* Oct. 16, 1935. The BMA's acquisition of the Lucas collection of prints "followed a subtle and diplomatic offer by Mrs. Breeskin to catalog the prints."

17. For two early histories of the BMA, see Blanchard Randall, "The Baltimore Museum of Art," 59–68; and Greenfield, "The Museum."

18. Mark S. Watson, "New Glory in the Museum of Art," *Baltimore Sun,* July 23, 1933.

19. The first major step occurred in 1976 with the completion by Margaret G. Klitzke of an arduous two-year effort to identify each print and record by hand its title, artist, date, state of the print, and size on 3 × 5 index cards. Her accomplishment was celebrated in an exhibition of prints at the BMA in the summer of 1976. See Barbara Gold, "Cataloguing of 15,000 Lucas Prints," *Baltimore Sun,* July 18, 1976. In 2014, the BMA returned to the task by retaining Nicole Simpson to locate each print, provide it with an accession number, update the information about it, and create a digital record of the entire print collection, which ultimately should enable scholars and the interested public to have access to it.

20. See "Art Museum Holds Lucas Collection: To Have Custody of 1,400 Prints Gathered by Former Baltimorean," *Baltimore Sun,* July 10, 1933. The Maryland Institute's Resolution is in the Lucas Papers, BMA Archives.

21. See catalogue *Exhibition of Whistleriana.*

22. Breeskin, "Whistler Prints Lure Art Lovers," *Baltimore Sun,* June 26, 1934; "New Show Forces Extension of Hours at Museum," *Baltimore Sun,* Jan. 14, 1934.

23. "Lucas Paintings on View for the First Time," *Baltimore Sun,* Oct. 14, 1934. The Pissarro painting, renamed *The Versailles Road at Louveciennes (Snow)* was transferred from the BMA to the Walters Art Gallery in 1944 and is now owned by the Walters Art Museum. For an excellent discussion of this painting and Pissarro's influence, see Rothkopf, *Pissarro,* 98, 99. In 2007, Pissarro was celebrated in an exhibit at the BMA entitled, *Pissarro: Creating the Impressionist Landscape.* See Glenn McNatt, "Pissarro First Impressions, " *Baltimore Sun,* Feb. 11, 2007.

24. For an article about Emmart's career, see Jan Brady, "Books and Authors," *Baltimore Sun,* Feb. 20, 1972.

25. A. D. Emmart, "Art: Lucas Collection of Paintings on View," *Baltimore Sun,* June 16, 1935.

26. See Baltimore Museum of Art, *A Century of Baltimore Collecting,* 110. The only attention the press gave to Lucas's art and objects in this exhibition involved his correspondence

with Whistler. See Carroll Bateman, "Virtuosos of Old Baltimore," *Baltimore Sun,* June 1, 1941. See also "The Museum Show in Honor of Baltimore Art Collectors," *Baltimore Sun,* May 31, 1941, which mentions Lucas but says nothing about his collection.

27. Among the thirty-one works of art were oil paintings by Corot, Boudin, Couture, Gérôme, Goeneutte, and Pissarro, as well as the *Waterfall* attributed to Courbet; and watercolors and drawings by Barye, Daumier, Gavarni, and Millet.

28. Breeskin, *From Ingres to Gauguin.*

29. Bernard B. Pearlman, "The Growth of the Museum," *Baltimore Sun,* Dec. 13, 1961.

30. Greenfield, "The Museum." See also "The Baltimore Museum of Art: Half Century of History," *Baltimore Sun,* Feb. 16, 1968.

31. See Greenfield, "The Museum," 30.

32. "Exhibition of Paintings to be Opened Today," *Baltimore Sun,* Nov. 25, 1941. See also Greenfield, "The Museum," 44, 45. With regard to Pollock's *Blue Poles,* see Adelyn Breeskin interview by Paula Roberts, June 4, 1975, Oral History Office, MHS.

33. Cherrill Anson, "Museum's 50 Years as Cultural Center," *Baltimore Sun,* Dec. 20, 1964.

34. See Barbara Gold, "Cataloguing of 15,000 Lucas Prints," *Baltimore Sun,* July 18, 1976.

35. Prints and lithographs by Daumier were briefly displayed in the museum's print room in 1943, 1946, 1949, 1956 and 1960; and prints by Manet were briefly displayed in 1949 and 1958. Announcements about these exhibitions in the *Baltimore Sun* did not mention Lucas, although they did refer to other collectors. See "Art Notes: Prints by Daumier and Manet," *Baltimore Sun,* July 17, 1949; "Art Museum to Show Daumier Lithographs," *Baltimore Sun,* Oct. 29, 1956.

36. As part of its public relations campaign against the sale, the BMA in 1991 prepared a list of dozens of exhibitions that featured art from the Lucas collection, including sixteen exhibitions that allegedly occurred between 1941 and 1965. These exhibitions were not well publicized, and it is hard to assess their significance. The list was compiled as an appendix to a reply to the Klitzke report. Lucas Papers, BMA Archives.

37. "Lucas Brought Corot Works," *Baltimore Sun,* Aug. 31, 1952.

38. William L. Marbury to the Maryland Institute, May 17, 1963, MICA Archives.

39. See memo from David McIntyre, the BMA's assistant director of administration, to Gertrude Rosenthal, Chief Curator, and Charles Parkhurst, Director, May 21, 1963,

Lucas Papers, BMA Archives; see also deposition of Brenda Richardson, Jan. 10, 1996, Exhibit 14, MSA Lucas Litigation File.

40. For a list of the artists whose prints were involved in the sale and the titles and conditions of some of the prints, see Theodore Klitzke, "The Collection of George A. Lucas," Feb. 28, 1990, MICA Archives. With regard to the sale of the Whistlers by Breeskin, see Breeskin interview, 19 and 20. The duplicates of the Whistler prints were in the Garrett and Lucas collections. Breeskin stated that the sale of the prints was something that "you just didn't talk about."

41. Holly Selby, "Walters Sleuth Finds Illumination in the Details," *Baltimore Sun,* Apr. 9, 1995.

42. Gertrude Rosenthal referred to the Peabody's custody of Lucas's diaries in "Two Paintings by Corot," *News,* Baltimore Museum of Art, Oct. 1948, 1n2.

43. See J. Wynn Rousuck, "Of Art and Love Affairs," *Baltimore Sun,* Jan. 28, 1979. I thank Lilian Randall for answering my questions and sharing with me information about her life and her groundbreaking scholarship about George Lucas and his collection of art.

44. See Gertrude Rosenthal to Charles Parkhurst, memo, "Mr. Leake's Call Concerning the Lucas Collection," May 22, 1963, MSA Lucas Litigation File.

45. For two biographical sketches of Rosenthal's life, see Lowell E. Sunderland, "At Home in the World of Art," *Baltimore Sun,* Nov. 1, 1965; and "The Early and Late Rosenthal," *Baltimore Sun,* Oct. 20, 1968.

46. Rosenthal, "The Collector and his Collection."

47. See Cherrill Anson, "On Banks of Seine with a Bon Vivant," *Baltimore Sun,* Oct. 10, 1965.

48. Randall's *The Diary of George A. Lucas* encompasses two volumes. The first provides an insightful history, written by Randall, of Lucas's life and his relationships with artists and clients. The second volume, which is 965 pages long, provides a transcription of the diaries. For a glowing review, see Fink, "The Diary of George A. Lucas": "scholars will turn in eager anticipation [to Randall's book] in making their own discoveries."

49. William R. Johnston, *The Nineteenth Century Paintings.*

50. See exhibition catalogue, *A Baltimorean in Paris— George A. Lucas Art Agent, 1860–1909,* with Randall's introduction, "Paris for Sale: The Diary of George A. Lucas." Documents showing the layout of the exhibition and the wall labels are in the Walters Archives.

51. Elizabeth Stevens, "Lucas Show Valuable as History, Not as Art," *Baltimore Sun,* Feb. 4, 1979.

CHAPTER 13. THE SHOT ACROSS THE BOW

1. See "Maryland Institute Gets New Chief," *Baltimore Sun,* July 12, 1974.

2. Half of the costs of refurbishing the building were to come from a matching state grant of approximately $450,000. See "Cannon Shoe to become Md. Institute Studio," *Baltimore Sun,* Mar. 16, 1976.

3. The appraisal was prepared by the Tomlinson Collection, a well-respected local appraiser. The initial appraisal, dated June 5, 1976, focused on the paintings and was supplemented by appraisals in January 1977 of the prints, drawings, and sculpture. At that time, the entire collection was valued at $2,229,165 (paintings and sculpture, $1,377,100; prints and drawings, $712,390; and Barye bronzes, $139,765). See letters and appraisals from the Tomlinson Collection to MICA, June 5, 1976, Jan. and 28, 1977, MICA Archives. For Finn's goal of raising $300,000 by selling part of the collection, see William Finn's "Memorandum on the State of the Lucas Collection," June 17, 1976, MICA Archives.

4. See John Dorsey, "Art for the Sake of Money," *Baltimore Sun,* Mar. 14, 1976. See also Elizabeth Stevens, "Peabody Art Collection Has Been Slipping Away in Last 30 Years," *Baltimore Sun,* Sept. 30, 1979.

5. See correspondence between Leake and Rosenthal about the sale of Barye bronzes dated April 13 and April 21, 1966. The bronzes were sold on June 3, 1966, for $3,600. The papers pertaining to these matters are in the MSA Lucas Litigation File, 154–163.

6. See Ralph and Terry Kovel, "Know Your Antiques— Barye Once Bankrupt," *Baltimore Sun,* Dec. 19, 1971; and Lita Solis-Cohen, "Antiques—Animalier Bronzes Regaining Value," *Baltimore Sun,* Sept. 16, 1979.

7. Barbara Gold, "Sculptor Who Never Found a Public," *Baltimore Sun,* Aug. 24, 1975.

8. See J. Wynn Rousuck, "Barye's Heritage in Bronze," *Baltimore Sun,* Mar. 14, 1976.

9. Johnston and Kelly, *Untamed,* 55.

10. Richard Randall to William Finn, June 24, 1976, MICA Archives.

11. See *George A. Lucas Collection Selected Prints.*

12. See interview of Tom Freudenheim by Paula Rome, Nov. 8, 1976, Maryland Historical Society Oral History, MHS Archives.

13. See Thomas Freudenheim, "Memo of Record Re: Maryland Institute and Lucas Collection," July 19, 1976, MSA Lucas Litigation File.

14. See Finn, "Memorandum on the State of the Lucas Collection," MICA Archives.

15. See William Finn to the directors of twenty-six museums in the United States, July 9, 1976, MICA Archives.

16. For loving descriptions of Murnaghan's character and lifelong accomplishments, see *In Memoriam, Honorable Francis D. Murnaghan, Jr.* (United States Court of Appeals for the Fourth Circuit, December 6, 2000), Francis Murnaghan Papers, Special Collections, Sheridan Libraries, JHU. For Judge Wilkinson's observation, see page xxxii.

17. Francis Murnaghan to Edwin A. (Ned) Daniels, July 16, 1976, MICA Archives.

18. Murnaghan to Daniels, July 16, 1976.

19. Gertrude Rosenthal to Tom Freudenheim, July 26, 1976, MICA Archives.

20. Rosenthal to Freudenheim and the BMA curators' "Memorandum of Record" sent to Finn are in the MICA Archives.

21. An unsigned typewritten record of this meeting is in the MICA Archives. Two of the attendees, William Johnston and Jay Fisher, have recalled how Murnaghan raised his voice and intimidated Finn. I thank them for sharing this information.

22. The letters from Rosenthal, Johnson, and Weisberg are in the MICA Archives. For the article by Lincoln Johnson, see "George Lucas in Paris, 1858–1909, Collection at Museum of Art," *Baltimore Sun,* Aug. 31, 1972.

23. See Finn's script for the meeting of Sept. 21, 1976, MICA Archives.

24. Finn, meeting script, Sept. 21, 1976.

25. For the contents of the letters that Daniels sent to MICA supporters announcing the decision to not sell the collection of Baryes and representing that MICA intended to "work out a plan" for the use of the Lucas collection "that is mutually acceptable to the Baltimore Museum and the Walters," see Daniels to R. Robinson Baker, Sept. 21, 1976, MICA Archives. The exchange of notes between Frost and Freudenheim and the letter from Murnaghan about the Walters board's acceptance of the three-point plan are also in the MICA Archives. Prior to the meeting on September 21, 1975, Murnaghan was informed by MICA that it had revised its position and that any proceeds from the sale of any part of the Lucas collection would be placed in a special fund to maintain and enhance the collection. Murnaghan reported this change to the Walters board of trustees on September 14, 1976. See Minutes of the Walters Board of Trustees, Sept. 14, 1976, WAM Archives.

26. The minutes of the MICA Board meeting on October 28, 1976, is in the Lucas Papers, BMA Archives. The minutes state that Daniels "presented an agreement which had been worked out with the parties from both museums. After lengthy discussion, Mr. Johnson moved that the action on the proposal be deferred and that the Executive Committee be authorized to call a special meeting of the Board at which time the whole matter could be discussed thoroughly. . . . The motion passed unanimously." Lucas Papers, BMA Archives.

27. See Edwin Daniels to Jesse Slingluff, Nov. 1, 1976, MICA Archives.

28. Edwin Daniels to Francis Murnaghan, Nov. 5, 1976, "Lucas Collection," Lucas Papers, BMA Archives.

29. On August 1, 1991, Jay M. Wilson, president of the Walters Art Gallery, wrote a letter to Fred Lazarus, president of MICA, stating that for fifteen years, the leaders of the Walters had good reason to believe that the MICA board found considerable merit in the proposal made by Daniels in 1976 to the BMA and the Walters and had decided to honor it. The letter is in Lucas Papers, BMA Archives.

Chapter 14. The Glorification of Lucas

1. See Steve Purchase, "Museum Has Art for Everyone: A Variety of Treasures Fill Galleries," *Baltimore Sun,* Apr. 7, 1984.

2. See Deposition of Arnold L. Lehman, Jan. 22, 1996, pp. 12, 13, 123, 126, BMA Lucas Litigation Files.

3. In an interview recorded by the Smithsonian Institution in 2011, Richardson recalled that she was so distressed by most of the art that she initially found at the BMA that she would sit in the Matisse gallery and "weep and try to make myself feel better." See Oral History Interview with Brenda Richardson, July 29–30, 2011, Archives of American Art, Smithsonian Institution, aaa.si.edu.

4. Richardson's indifferent attitude about the art in the Lucas collection changed dramatically in 1995 when she became the BMA's spokesperson in opposing the sale of the collection and immersed herself in the life of George Lucas and the art he collected. Brenda Richardson, "Curator's Message," *BMA Friends of Modern Art Newsletter* 2, no 1 (Jan.–Apr. 1996). For articles about Richardson's career at the BMA, see A. M. Chaplin, "Baltimore Museum's Brenda Richardson: She Fits No Mold," *Baltimore Sun,* June 15, 1986; and Holly Selby and John Dorsey, "BMA's Deputy Director is Leaving: Curator of the Vaunted Cone Collection Was Vision Behind the Museum's West Wing," *Baltimore Sun,* Jan. 29, 1998. Paul Richard, "Museum Curator Ousted," *Washington Post,* Jan. 30, 1998. For Richardson's interest in Warhol, see Lewis, "Fifteen Minutes and Counting."

5. See Elizabeth Stevens, "Floridian Named Director of City Art Museum," *Baltimore Sun,* Sept. 26, 1979; and Nora

Frekiel, "Art, in Lehman's Terms," *Baltimore Sun,* Feb. 16, 1986.

6. Linell Smith, "The Baltimore Museum of Art Spreading its Wings," *Baltimore Sun,* Oct. 2, 1994.

7. A "little show" of drawings and watercolors from the Lucas collection was mounted in 1983. See John Dorsey, "Lucas Show Lets Us Peek over the Artists' Shoulders," *Baltimore Sun,* July 28, 1983.

8. John Dorsey, "French Realism at the BMA: Lucas Exhibit Shows Traditional Art," *Baltimore Sun,* Mar. 10, 1987.

9. See John Dorsey, "Baltimore Museum of Art to Open Exhibit from Lucas Collection," *Baltimore Sun,* Mar. 8, 1987; John Dorsey, "Art Capsules," *Baltimore Sun,* Apr. 17, 1987.

10. See M. William Salganik, "Lazarus Is Made President in Ceremony at the Maryland Institute, College of Art," *Baltimore Sun,* Oct. 27, 1978.

11. For conditions at the Institute when Lazarus was hired and his early achievements, see Weiss, "Paint by Numbers." For the reference to Lazarus as the "right man," see the Maryland Institute, *Contact* (special ed. 1978).

12. For a description of the Institute's reasons for selling the Lucas collection, see Robert Shelton to Francis Murnaghan, May 30, 1995, Murnaghan Papers, Milton S. Eisenhower Library Special Collections, JHU.

13. Memorandum to Alan Hoblitzell from Fred Lucas, re: "Lucas Collection," Dec. 15, 1981, Lazarus Deposition Ex. 16, Feb. 9, 1996, MSA Lucas Litigation File.

14. For Lazarus's reasons for tabling the decision to sell the Lucas collection, see Deposition of Fred Lazarus, Feb. 9, 1996, pp. 11, 12, 14–17, 98, 99, BMA Lucas Litigation Files.

15. The years in which they served as board chair were as follows: Sheila K. Riggs, 1985–1990; LeRoy E. Hoffberger, 1990–1993; and Robert A. Shelton 1993–1998.

16. See" Minutes of the Board of Trustees Retreat," Jan. 30, 1988, MSA Lucas Litigation File.

17. See Frederick Rasmussen, "Theodore Klitzke," *Baltimore Sun,* Jan. 9, 2008. For an article about Klitzke's collection of prints, see Scott Ponemone, "Print Collector, Living with an Artist's Vision," *Baltimore Sun,* June 26, 1978.

18. See Margaret G. Klitzke, *The George A. Lucas Collection: Selected Prints* (Baltimore Museum of Art, 1976). See also Barbara Gold, "Cataloging of 15,000 Lucas Prints," *Baltimore Sun,* July 18, 1976.

19. See Theodore E. Klitzke, "The Collection of George A. Lucas," Feb. 28, 1990; and "A Report on the Lucas Collection" from Ted Klitzke to Fred Lazarus and the Board of Trustees dated Feb. 28, 1990, MICA Archives (hereinafter "Klitzke report").

20. Klitzke report, 8–12.

21. Klitzke report, 22, 14, 15.

22. Memo from Ted Klitzke to Fred Lazarus and the board of trustees, Feb. 28, 1990 (four pages), MICA Archives.

23. The other members of the Art Assets Committee were Ned Daniels, Neil Meyerhoff, George Dalsheimer, Anne Perkins, LeRoy Hoffberger, and Sheila Riggs. I want to thank Katherine Cowan, Senior Reference Librarian of the Maryland Institute's Decker Library, for bringing this information to my attention.

24. "Housing Counsel," *Baltimore Sun,* Jan. 17, 1964.

25. Richard W. Emory to the Maryland Institute, Oct. 8, 1990, MICA Archives.

26. Author's interview with Anne Scarlett Perkins, Feb. 23, 2015.

27. Richard W. Emory to the Maryland Institute, Oct. 8, 1990, MICA Archives.

28. Weiss, "Paint by the Numbers."

29. See memo from Jay Fisher to Arnold Lehman, Brenda Richardson, and Sona Johnston, June 12, 1989, Lucas Papers, BMA Archives.

30. The Maryland Institute's minutes for board meeting, Oct. 28, 1976, MSA Lucas Litigation File.

31. At his deposition, BMA director Arnold Lehman summarized the reasons why the BMA believed that the Lucas collection was secure and would not be sold. See deposition of Arnold J. Lehman, Jan. 22, 1996, pp. 21–26, BMA Lucas Litigation Files.

32. Fisher, *Théodore Chassériau*; *Félix Buhot*; and *The Prints of Edouard Manet.*

33. The course, "Utilizing the Lucas Collection," envisioned twenty-eight lectures (two per week) during the first semester and hands-on classes during the second semester involving the creation of a comprehensive exhibition of Lucas's art. The outline of this course is in the Lucas Papers, BMA Archives. Unfortunately, the course never advanced beyond the planning stage.

34. See John Dorsey, "Baltimore Mounts Own Tribute to Manet, " *Baltimore Sun,* Oct. 2, 1983. Fisher, *The Prints of Edouard Manet.* For articles about the career and work of Fisher, see John Dorsey, "A Wizard of Prints Emerges from Shadows," *Baltimore Sun,* July 10, 1983; Earl Arnell, "Etchings and a Matter of Love," *Baltimore Sun,* Nov. 9, 1979; and Scott Ponemone, "He Is the Keeper of the Prints," *Baltimore Sun,* July 8, 1978. For a glowing review of his exhibition "Two Centuries of Lithography: 1800–1986," see John Dorsey, "BMA Lithography Exhibition Makes a Grand Impression," *Baltimore Sun,* Sept. 9, 1987.

35. See Mary Carole McCauley, "Sona Johnston: In a Subtle Light," *Baltimore Sun,* Nov. 3, 2004.

36. In 1991, Johnston informed Brenda Richardson, "I have not written on George Lucas for publication." See memo from Sona Johnston to Richardson, Mar. 26, 1991, Lucas Papers, BMA Archives. Nine years later Johnston coauthored with her husband William Johnston *The Triumph of French Painting,* which contains a brief description of Lucas's collection (pp. 14–15).

37. Fisher to Lehman, Richardson, and Sona Johnston, memo, June 12, 1989, Lucas Papers, BMA Archives. For his invitation to the Institute to see the Lucas collection, see Fisher to Fred Lazarus, July 31, 1990, Lucas Papers, BMA Archives.

38. See Gertrude Rosenthal to Charles Parkhurst, memo, May 22, 1963, MSA Lucas Litigation File.

39. See confidential memo from Arnold Lehman to Brenda Richardson and Jay Fisher, Feb. 7, 1990, Lucas Papers, BMA Archives. Years later, Lehman expressed regret about the acrimonious battle over the Lucas collection. He reportedly characterized it as the "low point" in his eighteen years as BMA director. See Keiger, "What's All the Fuss."

40. Jay Fisher to Theodore Klitzke, July 28, 1989, Lucas Papers, BMA Archives.

41. See Jay Fisher to Fred Lazarus, July 31, 1990, Lucas Papers, BMA Archives.

42. John Dorsey, "Watercolors and Drawings," *Baltimore Sun,* July 28, 1983.

43. Robert Shelton shared his memory of this tour and the impression it left on him and other attendees during an interview with the author on September 25, 2014.

44. See John Dorsey, "Lucas Collection Report Raises Concern that Some—or All—of It Will Leave City," *Baltimore Sun,* Jan. 31, 1991.

45. The BMA's plan to aggressively respond to the Klitzke report was reflected in a memo from Connie Caplan, who would become chair of the BMA's board of trustees, to Brenda Richardson, Feb. 1, 1991, Lucas Papers, BMA Archives.

46. The BMA also formed an "Ad Hoc Lucas Committee" composed of six trustees: chairman Dennis Shaughnessy, Janet Dunn, Louise Hoblitzell, Charles Newhall, Harry Shapiro, and Louis Thalheimer and two curators, Jay Fisher and Sona Johnston, to assist Richardson. Lucas Papers, BMA Archives.

47. See Richardson, "George A. Lucas and Contemporary Art."

48. Brenda Richardson to Sona Johnston, memo re: "Lucas Publicity," Mar. 24, 1991, Lucas Papers, BMA Archives.

49. See memoranda, Mar. 18, 24, and 26, 1991, between Brenda Richardson and Sona Johnston regarding the solicitation and ghostwriting of articles about Lucas, Lucas Papers, BMA Archives. In the March 24 memo, Richardson asked Johnston whether she knew "the right person for whom you can ghost and they will sign their name (maybe in exchange for a comparable article, in reverse, on an occasion when they need it, so that both parties don't feel too slimy)."

50. Susan Baer, "J. Carter Brown: A Life in Art," *Baltimore Sun,* Mar. 17, 1991.

51. Arnold Lehman to Louis B. Thalheimer, memo, Mar. 22, 1991, Lucas Papers, BMA Archives.

52. Michael Kimmelman, "J. Carter Brown, 67, Is Dead; Transformed Museum World," *New York Times,* June 19, 2002.

53. J. Carter Brown to Arnold Lehman, Apr. 12, 1991; Lehman to Brown, Apr. 30, 1991; and memo to Robert Bergman re: "Carter Brown / Lucas Collection," May 9, 1991, Lucas Papers, BMA Archives. See also Lehman Deposition, 61–65, BMA Lucas Litigation Files.

54. Johnston to Richardson, memo re: "Lucas Report for Carter Brown Signature," with handwritten notes by Lehman, May 28, 1991, Lucas Papers, BMA Archives.

55. See American Association of Museums Curators Committee, "I. About Curatorial Work," *A Code of Ethics for Curators,* 2009; see also International Council of Museums (ICOM), *ICOM Code of Ethics for Museums,* 2013.

56. Hoving, *Making the Mummies Dance.*

57. For Johnston's description, see memo to Brenda Richardson, Feb. 7, 1990, Lucas Papers, BMA Archives.

58. For the BMA's and the Walters's adoption of the word *treasure* and other superlatives used in describing the Lucas collection, see Samuel K. Himmelrich Jr. (chair, Walters board of trustees) to Sheila Riggs (chair, Maryland Institute board), Jan. 12, 1990, and enclosing the Walters board's resolution using the word "treasure"; and Louise P. Hoblitzell (president, BMA board) to Sheila Riggs and Fred Lazarus, Mar. 29, 1990, Lucas Papers, BMA Archives.

59. Sona Johnston to Faith Holland, June 7, 1991, Lucas Papers, BMA Archives.

60. Drafts of Holland's thirty-page report are in the Lucas Papers, BMA Archives.

61. The specific roles that Holland, Johnston, and Richardson played in preparing the letter that was signed by J. Carter Brown are not clear. Lehman, Richardson, and Johnston testified about this during their depositions in the case of the Maryland Institute v. The Baltimore Museum of Art and the Walters Art Gallery. Lehman testified that "Faith Holland authored the draft for Carter Brown." Deposition of

Arnold Lehman, Jan. 22, 1996, p. 68. Richardson disagreed. She testified that Holland's draft was not used for Brown's letter because its tone and character were determined to be inappropriate. Richardson testified that the "primary author" of the letter was Sona Johnston but that she (Richardson) "keyboarded the final report." Deposition of Brenda Richardson, Feb. 6, 1996, pp. 324–326. Johnston testified that she prepared an overview of the Lucas collection and her ideas were borrowed by others but that she did not write the letter signed by Brown. See deposition of Sona Johnston, Feb. 5, 1996, pp. 64–66. The depositions are in the BMA Lucas Litigation Files.

62. "An Open Letter to the Citizens of Maryland" signed by J. Carter Brown is in the Lucas Papers, BMA Archives.

63. For the most recent survey of the history of the BMA's various collections, see Carla Brenner, "A Great Museum for a Great City," in *The Baltimore Museum of Art.*

64. The Cone sisters were not mentioned in Lucas's diary or any of his papers. For histories about the Cone sisters, how they acquired their collection, and why they gave it to the BMA, see Richardson, *Dr. Claribel and Miss Etta,* 14–17; and Levitov, *Collecting Matisse and Modern Masters,* 23, 24.

65. In response to questions about why she decided to join the BMA and become its principal curator of contemporary art, Richardson did not mention the Lucas collection. See Oral History Interview with Brenda Richardson. According to Richardson, she was not inspired to learn about the contents of the Lucas collection and really get to know it until the Maryland Institute in the 1990s threatened to sell it. See Richardson, "George A. Lucas and Contemporary Art."

66. See Jay W. Wilson and Louis B. Thalheimer to LeRoy Hoffberger, Dec. 10, 1991, Lucas Papers, BMA Archives.

67. John Dorsey, "Art Museum and Walters Take Strong Stand Against Any Lucas Collection Sale," *Baltimore Sun,* Dec. 13, 1991.

68. Carol Vogel, "Maryland Collection to Be Sold," *New York Times,* Feb. 10, 1995.

69. Arnold Lehman, memo to "All Members of the Association of Art Museum Directors," dated February 2, 1995, Lucas Papers, BMA Archives.

70. John Dorsey, "The Lucas Collection: What Would its Loss Mean?," *Baltimore Sun,* Oct. 14, 1990.

71. Eugene Leake, letter to the editor, *Baltimore Sun,* Apr. 30, 1991.

72. The report is in the Lucas Papers, BMA Archives.

73. Deposition of Sona Johnston, Feb. 5, 1996, p. 30, BMA Lucas Litigation Files.

74. Rosenthal, "The Collector and His Collection," 18.

75. See John Dorsey, "Exhibit A: A New Show from the Lucas Collection Illustrates Its Importance to Baltimore," *Baltimore Sun,* Aug. 23, 1995.

76. For information about the BMA's sale, see John Dorsey, "Art Museum's Sale of Works Expected to Bring Millions," *Baltimore Sun,* Jan. 31, 1990. For information about the Walters's sale, see Sotheby's, "Antiquities and Islamic Art."

77. Riggs's note to Lazarus about the BMA's and the Walters's auctions was dated March 26, 1992. I want to thank her for bringing this to my attention and providing me with a copy. See also Sheila Riggs, memo to Fred Lazarus, Roy Hoffberger, and Bob Shelton, Sept. 23, 1992, and Jackson, Jackson, and Wagner's "Analysis of Strategic Options Available to Maryland Institute College of Art Regarding the Lucas Collection," Feb. 18, 1993 MICA Archives. For the BMA's concern about appearing to be "hypocrites" as a result of its own sale of art, see Jay Fisher, memo to Brenda Richardson, Feb. 11, 1990, Lucas Papers, BMA Archives.

78. See Nancy Haragan and Chris Hartman, memo to Fred Lazarus, Aug. 23, 1995, MICA Archives.

79. Friedlander's views on selling the Lucas collection were set forth in an op-ed piece that he submitted to the *Baltimore Sun* in September 1995 and shared with the author during an interview on October 28, 2014.

CHAPTER 15. IN JUDGE KAPLAN'S COURT

1. Author's interview with Robert Shelton, Sept. 25, 2014.

2. All of the pleadings in the case of The Maryland Institute v. the Baltimore Museum of Art and the Walters Art Gallery, In the Circuit Court for Baltimore City (Civil No. 95030001/CL191657) are in the official court file, MSA Lucas Litigation File.

3. The BMA's and the Walters's response to the complaint appears to have been based in large measure on the legal advice of Judge Francis Murnaghan, who on February 3, 1995, sent a letter to the chairperson of the Walters Art Gallery in which he proposed an answer to the complaint. See Francis Murnaghan to Adena Testa, Feb. 3, 1995, Francis Murnaghan Papers, Milton S. Eisenhower Library Special Collections, JHU. For a more complete and articulate description of the BMA's strategy, see Max Lauten (Andy Graham's partner who was also serving as counsel to the BMA) to Harry Shapiro (a member of the BMA board who was serving as inside counsel), Mar. 6, 1995. I want to thank Harry Shapiro for bringing this letter to my attention and providing a copy to me.

4. Deposition of Stephen E. Weil, Apr. 29, 1996, pp. 82, 83, MSA Lucas Litigation File. For over twenty years, Weil had been employed as a chief operating officer at the Whitney

and Hirshhorn museums and coauthored *Art Works: Law, Policy and Practice* (Little Brown, 1986). The BMA's expert, Evan Hopkins Turner, offered a similar opinion. After obtaining his doctorate in art history in 1953, Turner initially worked as a curator at the Fogg Museum at Harvard, the Frick Museum, and the Wadsworth Atheneum and then became the director of the Cleveland Museum of Art. When asked at his deposition whether "in all of your years of experience in the museum world, have you ever heard of that position being taken by a borrower of the works, that the lender should pay for the increase in value, after the fact," Turner replied, "I am not aware of one." Deposition of Evan Hopkins Turner, Apr. 4, 1996, pp. 35, 61, MSA Lucas Litigation File.

5. Grimm, "The Best Judge."

6. Author's telephone interview with Judge Kaplan on July 24, 2012.

7. Arnold Lehman to Connie Caplan, memo, Jan. 30, 1995, Lucas Papers, BMA Archives.

8. Statement from Fred Lazarus IV, Aug. 21, 1995, in the form of a news release from the Maryland Institute, MICA Archives. Maryland Institute board members began to publicly express the same idea—if the BMA wants to keep the Lucas collection, it should buy it. See Bunting, "Pleased, but Displeased."

9. Mayor Kurt Schmoke to Sylvia Williams, president of the Association of Art Museum Directors, Mar. 15, 1995, Lucas Papers, BMA Archives.

10. I want to thank Andy Graham for providing me with a contemporaneous handwritten account of the hearing. It is not known whether Rosenberg's comments about providing the mayor with a reason to get involved had any influence on the court's decision.

11. Francis D. Murnaghan to Melvin Sykes, Oct. 13, 1995, Murnaghan Papers, Milton S. Eisenhower Library Special Collections, JHU.

12. Holly Selby, "Institute Can Sell the Lucas Collection," *Baltimore Sun,* Sept. 29, 1995.

13. The Walters Art Gallery, which had borrowed only five works of art from the Maryland Institute, dropped its counterclaim for unjust enrichment, and the BMA pursued this claim just for itself.

14. Sotheby's to Benjamin Rosenberg, Dec. 21, 1995, and enclosed "Summary of Auction Estimate Listing" for the Lucas collection, Lucas Papers, BMA Archives.

15. Christie's to Ben Rosenberg, Dec. 21, 1995, and enclosed "Estimates," Lucas Papers, BMA Archives.

16. Robert Shelton to Edward Dunn, Dec. 22, 1995, Lucas Papers, BMA Archives.

17. The BMA's three approaches to establishing the monetary value of the benefits it conferred upon the Lucas collection are discussed in "The Baltimore Museum of Art's Opposition to the Maryland Institute's Motion for Summary Judgment," Mar. 29, 1996, pp. 13–17, MSA Lucas Litigation File.

18. For the factors on which the costs were based, see the BMA's exhibit "BMA/Lucas: Overview of Direct Expenses," MSA Lucas Litigation File.

19. Richardson testified at her deposition that it was her "conviction" that the BMA would be entitled to the "full value" of the Lucas collection if it were sold at that time. Upon further questioning, she testified that 75 percent of its current value was attributable to the efforts of the BMA. When asked about the factual basis for this number, Richardson provided no facts and stated instead that it was based on her experience as an art historian. Richardson deposition, Jan. 11, 1996, vol. 3, pp. 156–161, BMA Lucas Litigation Files.

20. Turner deposition, 65, 66, BMA Lucas Litigation Files.

21. Turner deposition, 145, 146.

22. Jay Fisher, memo to Arnold Lehman and Brenda Richardson, Aug. 12, 1992, and deposition of Jay Fisher, Feb. 6, 1996, pp. 43–59, BMA Lucas Litigation Files.

23. See interview with Tom Freudenheim, Dec. 20, 1995. I want to thank Andy Graham for providing me with records in which this document was located.

24. Deposition of Robert Kashey, Apr. 12, 1996, pp. 65, 66, BMA Lucas Litigation Files.

25. Holly Selby, "Ruling Lets BMA Press Part of Its Lucas Suit," *Baltimore Sun,* Apr. 25, 1996.

26. See the Court's Opinion and Order, Apr. 24, 1996, p. 6, MSA Lucas Litigation File.

CHAPTER 16. LUCAS SAVED

1. Szanton, *Baltimore 2000*; Philip Moeller, "The Rot Beneath the Glitter in the New Baltimore," *Baltimore Sun,* Jan. 28, 1987.

2. *Baltimore Sun,* Sept. 29, 1992.

3. Boyer, *Building Community.*

4. I thank Janet Dunn for providing me with the information about her role in this matter.

5. Author's interview of Robert Shelton, Sept. 25, 2014. Shelton credits Lazarus with the idea of getting the Baltimore Community Foundation involved and contacting Dunn.

6. Lorraine Mirabella, "Armbruster Head of Goldseker Foundation for 34 Years to Step Down," *Baltimore Sun,* Sept. 5, 2012.

7. Zibel, "Behind a Private Family."

8. Author's interview of Calman "Buddy" Zamoiski, Nov. 18, 2014.

9. Zamoiski interview.

10. For the terms of this plan, see paragraph 5 of Brenda Richardson's notes entitled "Arnold/Brenda Telephone Conversation with Eddie Dunn: Lucas, dated 4/16/96," BMA Lucas Litigation Files. I thank Tim Armbruster for informing me about his role in devising this plan during an interview on Oct. 8, 2014.

11. Zamoiski interview.

12. Author's interview with Frances Glendening, Mar. 27, 2015.

13. Glendening interview; Armbruster interview.

14. See Brenda Richardson, memo, "Summary of Connie Caplan's call to Brenda Richardson, 2/20/96"; and memo to Adena Testa, Mar. 13, 1996, together with six-page memo opposing state ownership of the Lucas collection, BMA Lucas Litigation Files.

15. Robert Shelton to Edward Dunn, Apr. 30, 1996, MICA Archives.

16. See Holly Selby, "Lucas Judge Took 'the Bull by the Horns,'" *Baltimore Sun,* June 11, 1996.

17. See report to Brenda Richardson and Arnold Lehman about the pretrial conference, captioned "Good morning, Brenda and Arnold," May 6, 1996, BMA Lucas Litigation Files.

18. See report to Brenda Richardson and Arnold Lehman, May 6, 1996, and the notes of Max Lauten, captioned "P.T.C. 5/6/96." I thank Andy Graham for providing these notes to me.

19. See Georgeanna Linthicum Bishop to Arnold Lehman and Brenda Richardson, May 8, 1996, BMA Lucas Litigation Files.

20. See Bishop to Lehman and Richardson, May 8, 1996; author's interview with Connie Caplan, Oct. 24, 2014.

21. Author's interview with Fred Lazarus, July 23, 2013, and Caplan interview.

22. Shelton interview.

23. The reference to Zamoiski's plan to save the entire collection is in the notes of Brenda Richardson, BMA Lucas Litigation Files. For the significant role that Puddester played in this matter, see Michael Dresser, "Bean Counter Rises to Center of Power: State Budget Chief Shuns Publicity," *Baltimore Sun,* June 24, 1996: "Puddester was the key player in putting together the $4.25 million deal that kept the famous Lucas art collection in Baltimore."

24. Judge Kaplan's remarks were noted by Fred Lazarus in his notebook. I thank Lazarus for sharing his notebook and its information with me. His notebook is in the MICA Archives.

25. Shelton interview.

26. As a result of the settlement, the Walters was obligated to pay the Maryland Institute $850,000, half of which was to be paid by the state. After further conversations with the BMA, the Walters's portion of the settlement amounted to $403,830. See Minutes of the Walters Board of Directors, Sept. 10 and Oct. 16, 1996. I thank Adena Testa and Joy Heyrman for providing this information and these minutes to me.

27. The Memorandum of Agreement is in the BMA Lucas Litigation Files.

28. Richardson, memo, June 5, 1996, BMA Lucas Litigation Files.

29. From the Editor, "Saving the Lucas Collection," *Warfield's,* June 17, 1996.

30. The *Baltimore Sun* articles about the settlement and the saving of the Lucas collection appeared on June 5, 7, and 11, 1996.

31. See "The George A. Lucas Collection—A Celebration of the Arts in Maryland," with "A Message from Frances Hughes Glendening" (Maryland House, Jan. 6–Apr. 21, 1997), Lucas Papers, BMA Archives.

POSTSCRIPT

1. See Ken Johnston, "So Potent, They Were Fated to Be Smashed," *New York Times,* May 30, 2014.

2. For recent articles about the decline of "old" art, see Robin Pogrebin, "Contemporary Casualties: Art by Old Masters Appears to Struggle as Newer Works Become the Rage Among Collectors, Viewers and Donors," *New York Times,* Aug. 29, 2016; Ken Johnson, "A Little Piece of a Lost Legacy," *New York Times,* Jan. 21, 2016; Holland Cotter, "Under Threat: The Shock of the Old," *New York Times,* Apr. 14, 2011; Jason Farrago, "The Unheralded Impressionist," *New York Times,* Feb. 3, 2017; and Caroline Corbeau-Parsons, "Forgotten Faces," *Tate,* Apr. 7, 2014.

3. One of the most striking, twentieth-century examples of the dismissal of earlier forms of art is Clement Greenberg's claim that all prior academic art was "kitsch." See "Avant Garde and Kitsch."

4. See Holland Cotter, "The Met Needs to Connect Art to Life," *New York Times,* Mar. 2, 2017.

5. Temkin, "The Museum Revisited," 312, 313, 380.

6. See Patricia Cohen, "Museums Grapple With the Strings Attached to Gifts," *New York Times,* Feb. 4, 2013; O'Hare, "Museum's Can Change."

7. AAMD, *Professional Practices in Art Museums,* section 7.17 (Collections), 2011. For an excellent treatise on the subject of the obligations of art museums to carefully dispose of art that is not of high quality and rarely shown to the public, see Ferdinando, "A Juggling Act."

8. See Metropolitan Museum of Art, Collections Management Policy, Section IV C, Sept. 8, 2015: "The Museum generally does not accept restrictions on gifts; any exceptions require the approval of the Board of Trustees." See also Collection Management Policy, the Museum of Modern Art, "Acquisitions," Oct. 5, 2010: "As a general rule, the Museum does not accept gifts that carry restrictions." These policies are available online. Robert R. Janes, "The Most Sacred Cow," in *Museums in a Troubled World,* 88–92, describes museums' promises to keep art collections forever as "nonsensical."

9. The terms of the BMA's agreement to acquire and preserve in perpetuity the Lucas collection was codified into law by the Maryland General Assembly's grant of state funds to help pay for the collection. See Miscellaneous Grant Programs (D), Maryland General Assembly Session laws, 1997, vol. 795, p. 3823. "Lucas Art Collection," Archives of Maryland, Session Laws, Archives of Maryland Online, msa.maryland.gov.

10. The two rooms are in the Jacobs Wing of the BMA. For a history of the art previously displayed in these rooms, see "To Exhibit Eisenberg Collection," *Baltimore Sun,* May 26, 1929; and "Eisenberg Collection On View," *Baltimore Sun,* Oct. 1, 1967.

11. The plaque to Lucas was installed in this space in 2003 following the restoration of the Jacobs Wing and in conjunction with the exhibition *A Grand Legacy: Five Centuries of European Art.* See Glenn McNatt, "A Grand Vision," *Baltimore Sun,* Jan. 12, 2003.

12. Glenn McNatt, "At BMA, an Exquisite French Feast," *Baltimore Sun,* Mar. 12, 2000.

13. Bill Glauber, "Burnishing a City's Image," *Baltimore Sun,* June 28, 2001.

14. Frances Hughes Glendening, "Introduction," *Nature Revealed, Landscapes and Still Lifes From the George A. Lucas Collection,* November 2000–January 2001.

15. Glenn McNatt, "The Line Kings," *Baltimore Sun,* June 19, 2005.

16. Deborah McLeod, "George Lucas' Extensive Collection Gets Feted in All of its Idiosyncratic Glory," *City Paper,* Nov. 1, 2006.

17. Kennedy, "BMA Stages a New Exhibit."

18. Blake Gopnik, "Lucas' Oblique 'View of Paris,'" *Washington Post,* Dec. 17, 2006.

19. The only article in Baltimore Sun between January 1, 2007, and December 31, 2016, that mentioned the Lucas collection involved the Barye sculpture. See Glenn McNatt, "Barye and the Beasts," *Baltimore Sun,* Feb. 11, 2007. In contrast, during the eighteen months between January 1995 and July 1996, *Baltimore Sun* published forty-two articles that praised the collection.

20. Lewis, "Art All Around."

21. In an effort to make the prints more accessible, the BMA in 2014 retained Nicole Simpson, an expert in French nineteenth-century prints, to study, inventory, and digitally catalogue the collection. The work is scheduled to be completed in 2018. See Hoisington, "Nicole Simpson"; and Cogswell, "George Aloysius Lucas."

22. See Richardson, "Curator's Message." According to Richardson, Lucas's dedication to the contemporary art of his time made him "one of us." The importance of Lucas himself, as a major collector, in any evaluation of his collection was emphasized in an affidavit signed and submitted to the Circuit Court of Baltimore City by Lilian M. C. Randall, Aug. 22, 1995, in which she indicated that the greatest cultural value and significance of the Lucas collection was not the quality of the art but the "uniquely detailed picture of American taste for French art from the post–Civil War period into the first decade of the twentieth century."

23. Pennell and Pennell, *The Whistler Journal,* 55. See also chapter 9.

24. For a description of an exhibition at the BMA that sought to recreate Lucas's world through the display of his prints and ephemera, see Lincoln F. Johnston, " 'George Lucas In Paris, 1858–1909': Collection at Museum of Art," *Baltimore Sun,* Aug. 31, 1972.

ARCHIVES
Baltimore Museum of Art
 Archives and Manuscripts Collection
 George A. Lucas Papers
 Lucas Collection Litigation Files
Johns Hopkins University, Baltimore
 Peabody Institute Archives
 Milton S. Eisenhower Library Special Collections
Maryland Historical Society, Baltimore
Maryland Institute College of Art, Baltimore
Maryland State Archives, Annapolis
Metropolitan Museum of Art, New York, NY
 Thomas J. Watson Library
National Archives and Records Administration, Washington, DC
Smithsonian Archive of American Art, Washington, DC
St. Mary's College Archives, Baltimore
Walters Art Museum, Baltimore

NEWSPAPERS
American and Commercial Daily Advisor
Baltimore American Commercial and Advertiser
Baltimore Sun
Federal Gazette and Baltimore Daily Advertiser
New York Sun
New York Times
Niles' Weekly Register
Washington Post

BOOKS
Adams, Steven. *The Barbizon School and the Origins of Impressionism.* Phaidon, 1994.

Adler, Kathleen, Erica E. Hirshler, and H. Barbara Weinberg. *Americans in Paris, 1860–1900.* National Gallery, 2006.

Ahrens, Kent. *Water Color and Drawings by Brevet Major General Truman Seymour USMA 1846.* Exhibit catalogue. United States Military Academy Library, 1974.

Alderson, William T. *Mermaids, Mummies, and Mastodons: The Emergence of the American Museum.* American Association of Museums, 1992.

American Association of Museum Directors (AAMD). Section 7.17 (Collections), 2011.

American Association of Museums Curators Committee. *A Code of Ethics For Curators.* 2009.

Anderson, Ronald, and Anne Koval. *Whistler: Beyond the Myth.* Carroll and Graf, 1994.

Assouline, Pierre. *Discovering Impressionism: The Life of Paul Durand-Ruel.* Vendome, 2004.

Bacon, Henry. *Parisian Art and Artists.* Scribner, 1880.

Baltimore Museum of Art. *A Century of Baltimore Collecting, 1840–1940.* Exhibition catalogue. Baltimore Museum of Art, 1941.

———. *Whistleriana Catalogue, Containing a List of Etchings, Lithographs and Drawings.* Reese, 1934.

Bann, Stephen. *Parallel Lines: Printmakers, Painters, and Photographers in Nineteenth-Century France.* Yale University Press, 2001.

Baudelaire, Charles, *Art in Paris, 1845–1862.* Translated and edited by Jonathan Mayne. Phaidon, 1965.

———. *The Painter of Modern Life and Other Essays.* Translated and edited by Jonathan Mayne. Phaidon, 1964.

Beaufort, Madeleine, Henry L. Kleinfield, and Jeanne K. Welcher, eds. *The Diaries 1871–1882 of Samuel P. Avery, Art Dealer.* Arno, 1979.

Bénédite, Léonce. *The Luxembourg Museum: Its Paintings.* Paris, H. Laurens, 1913.

Blühm, Andreas. *Alexandre Cabanel: The Tradition of Beauty.* Hirmer, 2010.

Boime, Albert. *Art in an Age of Civil Struggle, 1848–1871.* University of Chicago Press, 2007.

Borgmeyer, Charles Louis. *The Luxembourg Museum and Its Treasures.* The Fine Arts Journal, c. 1890.

Bouret, Jean. *The Barbizon School and 19th Century French Landscape Painting.* Thames and Hudson, 1973.

Boyer, Ernest L. *Building Community: The Arts and Baltimore Together.* Baltimore Community Foundation, 1992.

Breeskin, Adelyn. *From Ingres to Gauguin: French Nineteenth Century Paintings Owned in Maryland.* Baltimore Museum of Art. December 1951.

Brenner, Carla. *The Baltimore Museum of Art: Celebrating a Museum.* Baltimore Museum of Art, 2014.

Browne, Gary Lawson. *Baltimore in the Nation, 1789–1861.* University of North Carolina Press, 1980.

Brugger, Robert J. *Maryland: A Middle Temperament, 1634–1980.* Johns Hopkins University Press, 1988.

Champa, Kermit Swiler, Fronia Wissman, Deborah Johnson, and Richard Brettell. *The Rise of Landscape Painting in France: Corot to Monet.* Currier Gallery of Art, 1991.

Christianson, Rupert. *Paris Babylon.* Penguin, 1994.

Clark, T. J. *The Painting of Modern Life: Paris in the Art of Manet and His Followers.* Princeton University Press, 1999.

Clement, Carla Erskine, and Laurence Hutton. *Artists of the Nineteenth Century and Their Works.* Houghton, Mifflin, 1879.

Colwill, Stiles Tuttle. *Francis Guy, 1760–1820.* Maryland Historical Society, 1981.

Cooper, Wendy A. *Classical Taste in America, 1800–1840.* Baltimore Museum of Art and Abbeville, 1993.

Croffut, W. A. *The Vanderbilts and the Story of Their Fortune.* Belford, Clarke, 1886.

Dabrowski, Magdalena, ed. *French Landscape: The Modern Version, 1880–1920.* Museum of Modern Art and Harry N. Abrams, 2000.

Druick, Douglas, and Michel Hoog. *Fantin-Latour.* National Gallery of Canada, 1983.

Duff, Charles, and Tracey Clark. *Then and Now: Baltimore Architecture.* Arcadia, 2006.

Durand, John. *The Life and Times of Asher B. Durand.* Charles Scribner and Sons, 1894. Reprint, Black Dome, 2007.

Durand-Ruel, Paul-Louis, and Flavie Durand-Ruel. *Paul Durand-Ruel, Memoirs of the First Impressionist Art Dealer, 1831–1922.* Flammarion, 2014.

Duranty, Edmond. *The New Painting.* 1876.

Duret, Théodore. *Manet and the French Impressionists.* Translated by John Ernest Crawford Flitch. J. B. Lippincott, 1910.

———. *Whistler.* Translated by Frank Rutter. J. B. Lippincott, 1917.

Elam, Charles H. *The Peale Family: Three Generations of American Artists.* Detroit Institute of Art, 1967.

Eisenman, Stephen E. *Nineteenth Century Art: A Critical History.* Thames and Hudson, 1994.

Exhibition of the George A. Lucas Art Collection. Maryland Institute College of Art, 1911.

Faunce, Sarah. *Courbet.* Harry N. Abrams, 1993.

Fidell-Beaufort, Madeleine, and Janine Bailly-Herzberg. *Daubigny.* Geoffroy-Dechaume, 1975.

Filonneau, Ernest. *Annuaire des Beaux-Arts: 1861–1862.* Jules Tardiew, 1862.

Fisher, Jay McKean. *Félix Buhot: Peintre-Graveur, Prints, Drawings, and Paintings.* Baltimore Museum of Art, 1983.

———. *The Prints of Edouard Manet.* International Exhibition Foundation, 1985.

———. *Théodore Chassériau: Illustrations for Othello.* Baltimore Museum of Art, 1980.

Fisher, Jay McKean, and William R. Johnston. *The Essence of Line: French Drawings from Ingres to Degas.* Baltimore Museum of Art, Walters Art Museum, and Pennsylvania State University Press, 2006.

Flaubert, Gustave. *Madame Bovary.* 2nd ed. Edited by Margaret Cohen. W. W. Norton, 2005.

Fletcher, Sir Banister. *A History of Architecture.* Edited by Dan Cruickshank. Architectural Press, 2001.

Foster, James. *Fielding Lucas, Jr., Early 19th Century Publisher of Fine Books and Maps.* Proceedings of the American Antiquarian Society, 1956.

Fried, Michael. *Manet's Modernism, or, The Face of Painting in the 1860s.* University of Chicago Press, 1996.

Fröhlich-Bume, L. *Ingres: His Life and Art.* William Heinemare, 1926.

Frost, Douglas L. *Making History / Making Art / MICA.* Maryland Institute College of Art, 2010.

Gay, Peter. *Schnitzler's Century: The Making of Middle Class Culture, 1815–1914.* W. W. Norton, 2002.

The George A. Lucas Collection of the Maryland Institute. Gertrude Rosenthal, Chief Curator. Baltimore Museum of Art, 1965.

Gimpel, René. *Diary of an Art Dealer, 1918–1939.* Universe Books, 1987.

Gobright, John C. *City Rambles, or, Baltimore as it is.* J. Woods, 1857.

Goldstein, Malcolm. *Landscape with Figures: A History of Art Dealing in the United States.* Oxford University Press, 2000.

Goupil & Cie Stock Books. Livre 1, 1846–1861. Getty Research Institute.

Green, Nicholas. *The Spectacle of Nature: Landscape and Bourgeois Culture in Nineteenth-Century France.* Manchester University Press, 1990.

Greenough, Frances Boot. *Letters of Horatio Greenough to his brother Henry Greenough.* Ticknor, 1887.

Gruelle, R. B. *Notes Critical and Biographical.* (With inserted letters to George Lucas from artists.) Collection of W. T. Walters (now in WAM Archives). J. M. Bowles, editor and publisher. Carlon and Hollenbeck, 1895.

Guérard, Albert. *France: A Modern History.* New ed. University of Michigan Press, 1969.

Hall, Clayton Coleman. *Baltimore: Its History and Its People.* 3 vols. Lewis Historical, 1912.

Harper, J. Henry. *The House of Harper: A Century of Publishing in Franklin Square.* Harper and Brothers, 1912.

Harrison, Charles, Paul Wood, and Jason Gaiger, eds. *Art in Theory, 1815–1900: An Anthology of Changing Ideas.* Blackwell, 1998.

Harvey, David. *Paris, Capital of Modernity.* Routledge, 2003.

Hawthorne, Nathaniel. *The Scarlet Letter.* 2nd ed. W. W. Norton, 1961.

Hayward, Mary Ellen, and Frank R. Shivers Jr. *The Architecture of Baltimore: An Illustrated History.* Johns Hopkins University Press, 2004.

Hazan, Eric. *The Invention of Paris: A History in Footsteps.* Verso, 2011.

Helsinger, Elizabeth, et al. *The Writing of Modern Life: The Etching Revival in France, Britain, and the U.S., 1850–1940.* Smart Museum of Art, University of Chicago, 2008.

Henley, William Ernest. *Jean-François Millet.* Scribner and Welford, 1881.

Heyrman, Joy Peterson. *New Eyes on America: The Genius of Richard Caton Woodville.* Walters Art Museum, 2013.

Hirayama, Hina. *"With Eclat": The Boston Athenaeum and the Origins of the Museum of Fine Arts, Boston.* Boston Athenaeum, 2013.

Hoving, Thomas. *Making the Mummies Dance.* Simon and Schuster, 1993.

Hunter, Wilbur Harvey. *The Story of America's Oldest Museum Building.* Peale Museum, 1952.

Hunter, Wilbur H., and Mahey, John. *Miss Sarah Miriam Peale, 1800–1885: Portraits and Still Life.* Peale Museum, 1967.

International Council of Museums. *ICOM Code of Ethics for Museums.* ICOM, 2013.

Janes, Robert R. *Museums in a Troubled World: Renewal, Irrelevance, or Collapse?* Routledge, 2009.

Jarves, James Jackson. *Art Thoughts: The Experience and Observations of an American Amateur in Europe.* Hurd and Hudson, 1871.

Jensen, Robert. *Marketing Modernism in Fin-de-Siècle Europe.* Princeton University Press, 1994.

Johnston, Sona K., and William R. Johnston. *The Triumph of French Painting: Masterpieces from Ingres to Matisse.* Baltimore Museum of Art and Walters Art Gallery in association with Scala, 2000.

Johnston, William R. *Nineteenth Century Art: From Romanticism to Art Nouveau.* Walters Art Gallery, 2000.

———. *The Nineteenth Century Paintings in the Walters Art Gallery.* Trustees of the Walters Art Gallery, 1982.

———. *The Taste of Maryland: Art Collecting in Maryland, 1800–1934.* Trustees of the Walters Art Gallery, 1984.

———. *William and Henry Walters: The Reticent Collectors.* Johns Hopkins University Press, 1999.

Johnston, William R., and Simon Kelly. *Untamed: The Art of Antoine-Louis Barye.* Walters Art Museum, 2006.

Jones, Kimberly. *In the Forest of Fontainebleau: Painters and Photographers from Corot to Monet.* National Gallery of Art in association with Yale University Press, 2008.

Kahng, Eik, ed. *The Repeating Image: Multiples in French Painting from David to Matisse.* Walters Art Museum, 2007.

Keppel, Frederick. *The Golden Age of Engraving.* Baker and Taylor, 1910.

———. *Catalogue of an Exhibition of Etchings by "The Men of 1830."* Frederick Keppel, 1909–1910.

King, Joan. *Sarah M. Peale: America's First Woman Artist.* Branden, 1987.

King, Ross. *The Judgment of Paris.* Walker, 2006.

Kirkland, Stephane. *Paris Reborn: Napoléon III, Baron Haussmann, and the Quest to Build a Modern City.* St. Martin's Press, 2013.

Kleiner, Diana E. *Roman Sculpture.* Yale University Press, 1992.

Kort, Carol, and Liz Sonneborn. *A to Z of American Women in the Visual Arts.* Infobase, 2002.

Lacouture, Annette-Bourrut. *Jules Breton: Painter of Peasant Life.* Yale University Press, 2002.

Lalanne, Maxime. *The Technique of Etching: A Reprint of the Classic Work "A Treatise on Etching."* Edited by Jay Fisher and translated by S. R. Koehler. Dover, 1982.

Lang, Gladys Engel, and Kurt Lang. *Etched in Memory: The Building and Survival of Artistic Reputation.* University of North Carolina Press, 1990.

Latrobe, John H. B. *Picture of Baltimore.* F. Lucas Jr., 1832.

Leipnik, F. L. *A History of French Etching from the Sixteenth Century to the Present Day.* John Lane the Bodley Head, 1924.

Levasseur, Auguste. *Lafayette in America in 1824 and 1825: Journal of a Voyage to the United States.* 1829. Translated by Alan R. Hoffman. Lafayette Press, 2006.

Levitov, Karen. *Collecting Matisse and Modern Masters: The Cone Sisters of Baltimore.* The Jewish Museum, New York, and Yale University Press, 2011.

Lorente, J. Pedro. *Cathedrals of Urban Modernity.* Ashgate, 1998.

Lucas, Fielding, Jr. *The Progressive Drawing Book*. John D. Toy, 1827.

———. *Valuable Works*. Fielding Lucas Jr., 1829.

MacDonald, Margaret F., Patricia de Montfort, and Nigel Thorp, eds. *The Correspondence of James McNeill Whistler, 1855–1880*. University of Glasgow, 2003–2010. www.whistler.arts.gla.ac.uk/correspondence.

MacDonald, Margaret F., Grischka Petri, Meg Hausberg, and Joanna Meacock. *James McNeill Whistler: The Etchings, a Catalogue Raisonné*. University of Glasgow, 2012. http://etchings.arts.gla.ac.uk.

Mainardi, Patricia. *Art and Politics of the Second Empire: The Universal Expositions of 1855 and 1867*. Yale University Press, 1989.

———. *The End of the Salon: Art and the State in the Early Third Republic*. Cambridge University Press, 1994.

Maryland Historical Society. *Catalogue of Paintings, Engravings, &c. at the Picture Gallery of the Maryland Historical Society, 1848–1908*. John D. Toy, 1908.

Maryland Institute. *An Exhibition of the Work of James A McNeill Whistler Contained in the George A. Lucas Collection*. Maryland Institute, 1927.

Mass, Jeremy. *Gambart: Prince of the Victorian Art World*. Barrie and Jenkins, 1975.

Mathews, Nancy Mowll. *Mary Cassatt: A Life*. Villard Books, 1994.

Mazaroff, Stanley. *Henry Walters and Bernard Berenson: Collector and Connoisseur*. Johns Hopkins University Press, 2010.

Melot, Michel. *The Impressionist Print*. Yale University Press, 1996.

Merrill, Linda. *The Peacock Room: A Cultural Biography*. Freer Art Gallery and Yale University Press, 1998.

Metropolitan Museum of Art. *Annual Reports of the Trustees of the Association from 1871 to 1902*. No. 24 (1893).

Miller, Lillian B. *In Pursuit of Fame: Rembrandt Peale, 1778–1860*. National Portrait Gallery, Smithsonian Institute, 1992.

———. *Patrons and Patriotism: The Encouragement of the Fine Arts in the United States, 1790–1860*. University of Chicago Press, 1966.

Moffett, Charles S. *The New Painting: Impressionism, 1874–1886*. Burton, 1986.

Mollett, John W. *The Painters of Barbizon: Millet, Rousseau, Diaz*. Scribner and Welford, 1890.

Morrison, James L., Jr. *The Best School: West Point, 1833–1866*. Kent State University Press, 1998.

Morton, Mary, and Charlotte Eyerman. *Courbet and the Modern Landscape*. J. Paul Getty Trust, 2006.

Myers, Gustavus. *History of the Great American Fortunes*. Vol. 2. Charles H. Kerr, 1910.

Newhall, Beaumont. *The History of Photography*. Museum of Modern Art, 1982.

Olsen, Donald J. *The City as a Work of Art: London, Paris, Vienna*. Yale University Press, 1986.

Park, Rowell. *A Sketch of the History and Topography of West Point and the Topography of the U.S. Military Academy*. Henry Perkins, 1840.

Paris-Guide Par Les Principaux Écrivains et Artistes de la France. A. Laccroix, Verboechbouen, et Cie, Editeurs, 1867.

Peale Museum. *Rendezvous for Taste: Peale's Baltimore Museum, 1814 to 1830*. Peale Museum, 1956.

Peale, Rembrandt. *Graphics: A Manual of Drawing and Writing, for the Use of Schools and Families*. J. P. Peaslee, 1835.

Peck, James F. *In the Studios of Paris: William Bouguereau and His American Students*. Philbrook Museum of Art and Yale University Press, 2006.

Pennell, E. R., and J. Pennell. *The Life of James McNeill Whistler*. 5th ed. J. B. Lippincott, 1921.

———. *The Whistler Journal*. J. B. Lippincott, 1921.

Pennell, Joseph. *Concerning the Etching of Mr. Whistler*. Frederick Keppel, 1904.

Perkins, Robert F., and William J. Gavin III. *The Boston Athenæum Art Exhibition Index*. Boston Athenæum, 1980.

Peterson, Peter B. *The Great Baltimore Fire*. The Press at the Maryland Historical Society, 2004.

Philadelphia Museum of Art. *The Second Empire: Art in France under Napoleon III*. Philadelphia Museum of Art, 1978.

Pinkney, David H. *Napoleon III and the Rebuilding of Paris*. Princeton University Press, 1958.

Prendergast, Christopher. *Paris and the Nineteenth Century*. Blackwell, 1992.

Price, Roger. *People and Politics in France, 1848–1870*. Cambridge University Press, 2004.

Randall, Lilian, M. C. *The Diary of George A. Lucas: An American Art Agent in Paris, 1857–1909*. Princeton University Press, 1979.

Reff, Theodore. *Manet and Modern Paris: One Hundred Paintings, Drawings, Prints, and Photographs by Manet and His Contemporaries*. National Gallery of Art, 1982.

Reynolds, Sir. Joshua, *The Discourses of Sir Joshua Reynolds.* J. Carpenter, 1842.

Rewald, John. *The History of Impressionism.* Museum of Modern Art, 1973.

Rice, Laura. *Maryland History in Prints, 1743–1900.* Maryland Historical Society, 2002.

Richardson, Brenda. *Dr. Claribel and Miss Etta: The Cone Collection of the Baltimore Museum of Art.* Baltimore Museum of Art, 1985.

Roos, Jane Mayo. *Early Impressionism and the French State, 1866–1874.* Cambridge University Press, 1996.

Rothkopf, Katherine. *Pissarro: Creating the Impressionist Landscape.* Baltimore Museum of Art and Philip Wilson, 2007.

Ruane, Joseph William, *The Beginnings of the Society of St. Sulpice in the United States, 1791–1829.* The Catholic University of America, 1935.

Rubin, James H. *Impressionism.* Phaidon, 1999.

Ruskin, John. *Lectures on Landscapes.* National Library Association. Project Gutenberg E-Book #20019. Dec. 4, 2006.

——. *Pre-Raphaelitism: Lectures on Architecture and Painting.* 1854. Everyman's Library, Richard Clay and Sons, 1906.

Scharf, J. Thomas. *History of Baltimore City and County, from the Earliest Period to the Present Day.* Louis H. Everts, 1881.

Semmes, John Edward. *John H. B. Latrobe and His Times.* Norman, Remington, 1917.

Shelton, Andrew Carrington. *Ingres and His Critics.* Cambridge University Press, 2005.

Sloane, Joseph C. *French Painting Between the Past and the Present.* Princeton University Press, 1951.

Somerville Art Gallery. *The Collection of Paintings, Drawings and Statuary, the Property of John Taylor Johnston, Esq,. to be Sold at Auction.* Somerville Art Gallery, 1876.

Stein, Roger B. *John Ruskin and Aesthetic Thought in America, 1840–1900.* Harvard University Press, 1967.

St. Mary's Seminary of St. Sulpice Baltimore, 1791–1891. John Murphy, 1891.

Strahan, Edward [Shinn, Earl]. *The Art Treasures of America: Being the Choicest Works of Art in the Public and Private Collections of North America.* George Barrie, 1881.

——. *Mr. Vanderbilt's House and Collection.* G. Barrie, 1883–84.

Sutherland, Daniel E. *Whistler: A Life for Art's Sake.* Yale University Press, 2014.

Sweet, Frederick A. *James McNeill Whistler.* Exhibition catalogue. The Art Institute of Chicago, 1968.

Thomas, Edith. *The Women Incendiaries.* George Braziller, 1966.

Tinterow, Gary. *Corot.* Metropolitan Museum of Art, 1996.

Tinterow, Gary, and Henri Loyrette. *Origins of Impressionism.* Metropolitan Museum of Art, 1994.

Tombs, Robert. *France, 1814–1914.* Pearson Education, 1996.

Tompkins, Calvin. *Merchants and Masterpieces: The Story of the Metropolitan Museum of Art.* E. P. Dutton, 1970.

Trollope, Frances. *Domestic Manners of the Americans.* 1832. New ed. Edited by Donald Smalley. Alfred A. Knopf, 1945.

Varle, Charles. *A Complete View of Baltimore.* Samuel Young, 1836.

Voorsanger, Catherine Hoover, and John K. Howat, eds. *Art and the Empire City: New York, 1825–1861.* The Metropolitan Museum of Art and Yale University Press, 2000.

Walters, William T. *Antoine-Louis Barye, from the French of Various Critics.* Press of Isaac Friedenwald, 1885.

Weisberg, Gabriel P. *The Realist Tradition: French Painting and Drawing, 1830–1900.* Cleveland Museum of Art, 1981.

White, Harrison C., and Cynthia A. White. *Canvases and Careers: Institutional Change in the French Painting World.* University of Chicago Press, 1993.

Wilkins, W. Glyde. *Charles Dickens in America.* Chapman and Hall, 1911.

Wood, Gregory A. *The French Presence in Maryland, 1524–1800.* Gateway, 1978.

Zafran, Eric M. *French Salon Paintings from Southern Collections.* The High Museum of Art, 1982.

Zeldin, Theodore. *France, 1848–1945.* Oxford Clarendon, 1973.

Zola, Émile. *The Masterpiece.* Oxford University Press, 2008.

ARTICLES

Amic, Sylvain. "Cabanel and the Portrait." In *Alexandre Cabanel: The Tradition of Beauty.* Hirmer, edited by Andreas Blühm, 2010.

Baetjer, Katharine. "Extracts from the Paris Journal of John Taylor Johnston, First President of the Metropolitan Museum." *Apollo* 114 (Dec. 1981): 410–417.

Barberie, Peter. "Marville in the Bois de Boulogne." In *Charles Marville: Photographer of Paris,* by Anne de Mondenard et al., 171–187. National Gallery of Art, Washington, 2013.

Barratt, Carrie Rebora. "Mapping the Venues: New York City Art Exhibitions." *Art and the Empire City: New York, 1825–1861.* Metropolitan Museum of Art and Yale University Press, 2000.

Beaufort, Madeleine, and Jeanne K. Welcher. "Some Views of Art Buying in New York in the 1870s and 1880s." *Oxford Art Journal* 5, no. 1. (1982): 48–55.

Bernard, Richard M. "A Portrait of Baltimore in 1800: Economic and Occupational Patterns in an Early American City." *Maryland Historical Magazine* 69, no. 4 (Winter 1974): 341–360.

Blake, Nigel, and Francis Frascina. "Modern Practices of Art and Modernity." In *Modernity and Modernism: French Painting in the Nineteenth Century.* Yale University Press, 1993.

Bodelsen, Merete. "Early Impressionist Sales 1874–94 in Light of Some Unpublished 'Procés-verbaux.' " *Burlington Magazine* 110, no. 783 (June 1968): 330–349.

Boime, Albert. "Entrepreneurial Patronage in Nineteenth-Century France." In *Enterprise and Entrepreneurs in Nineteenth- and Twentieth-Century France,* edited by Edward C. Carter II, Robert Forster, and Joseph N. Moody. Johns Hopkins University Press, 1976.

———. "The Salon des Refusés and the Evolution of Modern Art." *Art Quarterly* 32 (1969): 411–26.

———. "Thomas Couture and the Evolution of Painting in the Nineteenth Century." *Art Bulletin* 51, no. 1 (Mar. 1969).

"Boston Athenæum." *Bulletin of the New England Art Union,* no. 1 (1852): 9.

Brugger, Robert J. "A History of the Maryland Historical Society, 1844–2006." *Maryland Historical Magazine* 101, no. 4 (Winter 2006).

Bunting, George L., Jr. "Pleased, but Displeased." Letter to the editor. *Warfields,* Sept. 25, 1995.

Chagnon-Burke, Véronique. "Rue Lafitte: Looking and Buying Contemporary Art in Mid- Nineteenth-Century Paris." *Nineteenth-Century Art Worldwide* 11, no. 2 (Summer 2012).

Chalkey, Tom, and Craig Hankin. "Use It or Lose It, Baltimore's Art Establishment Agonizes Over the Fate of the Lucas Collection." *City Paper* 15, no. 39 (Sept. 27–Oct. 4, 1991).

Child, Theodore. "Art Gossip from Paris." *Art Amateur* 18, no. 3 (Feb. 1888).

———. "The Barye Memorial in Baltimore." *Decorator and Furnisher* 5, no. 4 (Jan. 1885).

Chu, Petra. Review of *The Essence of Line, French Drawings from Ingres to Degas. Nineteenth-Century Art Worldwide* 5, no. 1 (Spring 2006).

Cicerone. "Private Galleries: Ex-Judge Henry Hilton." *Art Amateur* 2 (Jan. 1880): 31, 32.

Cogswell, Evelyn. "George Aloysius Lucas: A Baltimorean in Paris." *Newsletter: The Print, Drawing and Photography Society of the Baltimore Museum of Art* 35, no 1 (Spring 2016).

Conway, M. D. "Edouard Frere and the Sympathetic Art in France." *Harpers New Monthly Magazine* 43 (Nov. 1871): 801–815.

Cox, Joseph W. "The Origins of the Maryland Historical Society: A Case Study in Cultural Philanthropy." *Maryland Historical Magazine* 74, no. 2 (June 1979): 103–116.

Davison, Caroline V. "Maximilian Godefroy." *Maryland Historical Magazine* 24, no. 3 (Sept. 1934): 175–212.

Dawson, Hugh J. "Hugues Merle's *Hester et Perle* and Nathaniel Hawthorne's *The Scarlet Letter.*" *Journal of the Walters Art Gallery* 44 (1986): 123–127.

Delamaire, Marie-Stéphanie. "American Prints in Paris, Or the House of Goupil in New York, 1848–1857. In *With a French Accent: American Lithography to 1860,* edited by George B. Barnhill, 65–82. American Antiquarian Society, 2012.

Didier, Eugene L. "The Social Athens of America." *Harpers Magazine* 65 (June 1882): 20–36.

"The Dollars and Cents of Art." *Cosmopolitan Art Journal,* Mar. 1860.

Drepperd, Carl W. "Rare American Prints [*Lucas' Progressive Drawing Book*]." *Antiques.* July 1929. 25–28.

D'Souza, Aruna. "Paul Cézanne, Claude Lantier, and Artistic Impotence. *Nineteenth-Century Art Worldwide* 3, no. 2 (Autumn 2004).

Edelson, Douglas E. "Courbet's Reception in America Before 1900." In *Courbet Reconsidered.* Brooklyn Museum, 1988.

Emery, Elizabeth. "Dornac's 'At Home' Photographs, Relics of French History." *Proceedings of the Western Society of French History* 36 (2008): 209–224.

Fidell-Beaufort, Madeleine. "The American Art Trade and French Painting at the End of the 19th Century." *Van Gogh Museum Journal* (2000): 100–107.

Fink, Lois Marie. "The Diary of George A. Lucas." *RACAR* 7, no. 12 (1980): 129–131.

———. "French Art in the United States, 1850–1870: Three Dealers and Collectors." *Gazette Des Beaux-Arts,* Sept. 1978, 87–100.

Fisher, Jay. "What Would It Mean to Lose the Lucas Collec-

tion." *Newsletter of the Print and Drawing Society of the Baltimore Museum of Art* 12, no. 2 (Apr. 1995).

Fletcher, Pamela M. "Creating the French Gallery: Ernest Gambart and the Rise of the Commercial Art Gallery in Mid-Victorian London." *Nineteenth-Century Art Worldwide* 6, no. 1 (Spring 2007).

Fratello, Bradley. "France Embraces Millet: The Intertwined Fates of the Gleaners and the Angelus." *Art Bulletin* 85, no. 4 (Dec. 2003): 685–701.

Galenson, David W., and Robert Jensen. "Careers and Canvases: The Rise of the Market For Modern Art in the Nineteenth Century." National Bureau of Economic Research, Sept. 2002. Working paper 9123. www.nber .org/papers/w9123.

Glendening, Frances Hughes. *Nature Revealed: Landscapes and Still Lifes from the George A. Lucas Collection.* November 2000–January 2001. Exhibition catalogue. Baltimore Museum of Art, 2000.

Green, Nicholas. "Circuits of Production, Circuits of Consumption: The Case of Mid-Nineteenth-Century French Art Dealing." *Art Journal* 48, no. 1 (Spring 1989): 29–34.

———. "Dealing in Temperaments: Economic Transformations of the Artistic Field in France During the Second Half of the Nineteenth Century." *Art History* 10, no. 1 (Mar. 1987): 59–78.

Greenberg, Clement. "Avant Garde and Kitsch." *Partisan Review* 6, no. 5 (1939): 34–49.

Greenfield, Kent Roberts. "The Museum: Its First Half Century." *Annual of the Baltimore Museum of Art* 1 (1966): 5–103.

Grimm, Paul B. "The Best Judge You Never Heard Of: Joseph H. H. Kaplan." *Storied Third Branch,* Mar. 2014.

Hart, Charles Henry. "Public and Private Collections of the United States." *American Art Review* 1, no. 7 (May 1880): 294–299.

Haskell, Francis. Review of *The Diaries of Samuel P. Avery, Art Dealer* and *The Diary of George A. Lucas. Burlington Magazine* 123, no. 937 (Apr. 1981): 234–244.

Herbert, Robert L. "Millet Reconsidered." *Art Institute of Chicago Museum Studies* 1 (1966): 28–65.

Hiesinger, Kathryn B., and Joseph Rishel. "Art and Its Critics: A Crisis of Principle" and "Painting." In Philadelphia Museum of Art, *The Second Empire.*

Hoisington, Rena M. "Nicole Simpson: A New Project Cataloguer for the George A. Lucas Collection." *Newsletter: The Print, Drawing and Photography Society of the Baltimore Museum of Art* 32, no. 1 (Spring 2014).

Holmes, Oliver Wendell. "The Allston Exhibition." *North American Review,* Apr. 1840.

Humphries, Lance. "What's in a Name? Baltimore—'The Monumental City.'" *Maryland Historical Magazine* 110, no. 2, (Summer 2015): 253–270.

Hunter, Wilbur H., Jr. "Baltimore in the Revolutionary Generation." In *Maryland Heritage: Five Baltimore Institutions Celebrate the American Bicentennial.* Maryland Historical Society, 1976.

———. "Peale's Baltimore Museum." *College Art Association* 12, no. 1 (July 1952): 31–36.

"The International Art Union." *Bulletin of the American Art Union* 2, no. 8 (Nov. 1849).

Johnston, William R. "A Bibliophile's Confection." *Journal of the Walters Art Museum* 66, no. 77 (2008–2009): 69–86.

———. "The Lucas Collection and the Walters Art Gallery." *Walters Monthly Bulletin* 48, no. 5 (May 1995): 4–5.

———. "A Monument to Antoine Louis Barye." *Magazine Antiques.* Oct. 2006.

Keiger, Dale "What's All the Fuss." *Johns Hopkins Magazine* 53, no. 3 (June 2001).

Kennedy, Patrick. "BMA Stages a New Exhibit on 19th Century French Art." *Johns Hopkins News-Letter,* Oct. 6, 2006.

Kelly, Simon. "Durand-Ruel and 'La Belle Ecole' of 1830." In *Inventing Impressionism: Paul-Durand and the Modern Art Market,* edited by Sylvie Patry, 56–75. National Gallery Company, London, 2015.

———. "Early Patrons of the Barbizon School," *Journal of the History of Collections* 16, no. 2 (2004).

———. "Théodore Rousseau's *Le Givre.*" *Journal of the Walters Art Museum* 70–71 (2012–2013): 69–78.

Keppel, Frederick. "The Print Collector." *Art Amateur* 3, no. 4 (Sept. 1880).

Klitzke, Margaret, G. Introduction to *George A. Lucas Collection: Selected Prints.* Baltimore Museum of Art. 1976.

Lacambre, Geneviève, and Joseph Richel. "Painting." In Philadelphia Museum of Art, *The Second Empire: Art in France under Napoleon III.*

Latrobe, John H. B. "Reminiscences of Baltimore in 1824." Speech delivered to MHS in 1880. *Maryland Historical Magazine* 1, no. 2 (June 1906).

Lewis, John. "Art All Around." *Baltimore Magazine,* Oct. 2011.

———. "Fifteen Minutes and Counting." *Baltimore Magazine,* Oct. 2010.

Lucas, W. F., Jr. "George Aloysius Lucas." *Exhibition of the George A. Lucas Art Collection.* Maryland Institute, 1911.

Macdonald, Margaret F. "Maud Franklin." *Studies in the History of Art* 19, Symposium Papers 6: *James McNeill Whistler: A Reexamination* (1987): 13–26.

Mahey, John A. "The Letters of James McNeill Whistler to George A. Lucas." *Art Bulletin* 43, no. 3 (Sept. 1967): 247–257.

Mainardi, Patricia. "Courbet's Exhibitionism." *Gazette des beaux-Arts* 118 (Dec. 1991): 253–266.

———. "The Political Origins of Modernism." *Art Journal* 45, no. 1 (Spring 1985): 11–17.

Marlais, Michael. "Charles-François Daubigny and the Tradition of French Landscape Painting." In *Valenciennes, Daubigny, and the Origins of French Landscape Painting,* by Michael Marlais, John Varriano, and Wendy M. Watson. Mount Holyoke College Art Museum, 2004.

McCauley, Anne. "Caricature and Photography in Second Empire Paris." *Art Journal* 43, no. 4 (Winter 1983): 355–360.

McIntosh, DeCourcy E. "New York's Favorite Pictures in the 1870s." *Antiques* 165, no. 4 (Apr. 2004): 114–23.

———. "Goupil's *Album*: Marketing Salon Painting in the Late Nineteenth Century." In *Twenty-First Century Perspectives on Nineteenth-Century Art,* edited by Petra ten-Doesschate Chu and Laurinda S. Dixon. University of Delaware Press, 2008.

———. "The Origins of the Maison Goupil in the Age of Romanticism." *British Art Journal* 5, no. 1 (Spring/Summer 2004): 64–76.

"Meissonier." *Art Amateur* 1, no. 6 (Nov. 1879).

Meixner, Laura L. "Popular Criticism of Jean-Francois Millet in Nineteenth-Century America." *Art Bulletin* 65, no. 1 (Mar. 1983): 94–105.

"Membership." *Bulletin of the Metropolitan Museum of Art* 5, no. 3 (Mar. 1910): 54.

Mills, Robert. "The Daily Journal of Robert Mills: Baltimore 1816," edited by Richard Xavier Evans. *Maryland Historical Magazine* 30 (Sept. 1935): 257–270.

Noon, Patrick. "A Reduced Version of Ary Scheffer's *Christ Consolator.*" *Nineteenth-Century Art Worldwide* 8, no. 2 (Aug. 2009).

O'Hare, Michael. "Museums Can Change—Will They?" *Democracy: A Journal of Ideas,* no. 36 (Spring 2015).

Parker, Franklin. "George Peabody and Maryland." *Peabody Journal of Education* 37, no. 3 (Nov. 1959): 150–157.

Parks, John A. "John Ruskin and His Influence on American Art." *American Artist,* Oct. 15, 2007.

Parsons, Coleman A. "The Wintry Duel: A Victorian Import." *Victorian Studies* 2, no. 4 (June 1959): 317–324.

"Paul Delaroche's Hemicycle." *Crayon,* Mar. 7, 1855.

Pollock, Griselda. "Modernity and the Spaces of Femininity." In *The Expanding Discourse: Feminism and Art History,* edited by Norma Broude and Mary D. Garrard, 244–267. Icon Editions, 1992.

Quynn, Dorothy Mackay. "Maximilian and Eliza Godefroy." *Maryland Historical Magazine* 52, no. 1 (Mar. 1957).

Randall, Blanchard. "The Baltimore Museum of Art: An Historical Sketch." *Report of the Baltimore Museum of Art* (1931).

Randall, Lilian. "Paris for Sale: The Diary of George A. Lucas, 1824–1909." *Walters Art Gallery Bulletin* 31, no. 5 (Feb. 1979).

Reed, Timothy M. "Elizabeth Gardner: Passion, Pragmatism, and the Parisian Art Market." *Women's Art Journal* 20, no. 2 (Autumn 1999): 7–30.

Renié, Pierre-Lin. "The Image on the Wall: Prints as Decoration in Nineteenth-Century Interiors." *Nineteenth-Century Art Worldwide* 5, no. 2 (Autumn 2006).

Richardson, Brenda. "Curator's Message." (Retitled "George A. Lucas and Contemporary Art.") *Friends of Modern Art Newsletter* 2, no 1 (Jan.–Apr. 1996).

———. "Mr. Lucas and Me." *Baltimore Museum of Art Newsletter* 12, no. 2 (Apr. 1995).

Riopelle, Christopher. "French 19th-Century History Painting Now Unblushingly Struts Its Stuff," *Art Newspaper,* no. 265 (Feb. 2015).

Rosenthal, Gertrude. "The Collector and His Collection." In *The George A. Lucas Collection of the Maryland Institute.*

———. "Two Paintings by Corot." *News.* Baltimore Museum of Art, Oct. 1948.

Round, W. P. F. "With Frère and His Confrères." *Art Journal* 2 (1876): 340–342.

Ruskin, John. "Academic Notes, 1856—The French Exhibit." In *The Works of John Ruskin,* edited by E. T. Cook and A. Wedderburn. Library ed. George Allen, 1904.

Rutledge, Anna Wells. "Early Art Exhibitions of the Maryland Historical Society." *Maryland Historical Magazine* 42, no. 2 (June 1947).

———. "Portraits Painted Before 1900 in the Collection of the Maryland Historical Society." *Maryland Historical Magazine* 41 (1946): 29.

———. "Robert Gilmor Jr., Baltimore Collector." *Journal of the Walters Art Gallery* 12 (1949): 18–39.

"Saving the Lucas Collection." *Warfield's,* June 17, 1996.

Schaaf, Elizabeth. "Baltimore Peabody Art Gallery." *Archives of American Art Journal* 24, no. 4 (1984).

Schneider, Rona. "The American Etching Revival: Its French

Sources and Early Years." *American Art Journal* 14, no. 4 (Autumn 1982).

Schuler, Hans. "Sketches in the Lucas Collection." *Maryland Institute Vistas and Perspectives* 1, no. 13 (Mar. 1932).

Semmes, Raphael. "Baltimore During the Time of the Old Peale Museum." *Maryland Historical Magazine* 27 (1932): 115–122.

Silver, Catherine Bodard. "Salon, Foyer, Bureau: Women and the Profession in France." *American Journal of Sociology* 78, no. 4 (Jan. 1973): 836–851.

Sotheby's. "Antiquities and Islamic Art," *Sotheby's.* New York, Dec. 12, 13, 1991.

Sperling, Joy. "Art, Cheap and Good: The Art Union in England and the United States, 1840–1860." *Nineteenth-Century Art Worldwide* 1, no. 1 (Spring 2002).

Stanton, Phoebe B. "The Quality of Delight." *Voice of St. Mary's Seminary* 45 (Summer 1968): 6–12.

Stehle, R. L. "The Düsseldorf Gallery of New York." *New-York Historical Society Quarterly* 58, no. 4 (Oct. 1974): 305–314.

Stocks, Lynette. "Théophile Gautier: Advocate of 'Art for Art's Sake' or Champion of Realism." *French History and Civilization: Papers of the George Rudé Seminar* 2 (2006): 41–60.

Szanton, Peter L. *Baltimore 2000: A Choice of Futures.* Goldseker Foundation, 1987.

Temkin, Ann. "The Museum Revisited." *Artforum* (Summer 2010).

Thiébaut, Philippe. "An Ideal of Virile Urbanity." In *Impressionism, Fashion, and Modernity,* edited by Gloria Lynn Groom. Art Institute of Chicago, 2012.

Thompson, Elbert N. S. "The Discourses of Sir Joshua Reynolds." *Modern Language Association* 32, no. 3 (1917): 339–366.

Troyen, Carol. "Innocents Abroad: American Painters at the 1867 Exposition Universelle, Paris." *American Art Journal* 16, no. 4 (Autumn 1984): 2–29.

Uhler, John Earle. "The Oldest Stationery Store in America." *Baltimore.* Apr. 1931.

Van Zanten, David. "Architecture." In Philadelphia Museum of Art, *The Second Empire.*

Weisberg, Gabriel P. "Philippe Burty: A Notable Critic of the Nineteenth Century." *Apollo Magazine.* Apr. 1970.

Weiss, Elaine E. "Paint by the Numbers: The Fine Art of Redefining the Maryland Institute." *Warfield's.* June 1989.

Weston, Latrobe. "Art and Artists in Baltimore." *Maryland Historical Magazine* 33, no. 3 (Sept. 1938): 213–227.

Whiteley, Linda. "Goupil, Delaroche, and the Print Trade." *Van Gogh Museum Journal* (2000).

Wilmerding, John. "The First Half of the Nineteenth-Century." In *The Genius of American Painting.* William Morrow, 1973.

Wilson-Bareau, Juliet. "The Salon des Refusés of 1863: A New View." *Burlington Magazine* 149, no. 1250 (May 2007): 309–319.

Zafran, Eric M. "William Bouguereau in America." In *In the Studios of Paris, William Bouguereau and His American Students,* edited by James E. Peck. The Philbook Museum of Art, 2006.

Zalewski, Leanne. "Alexandre Cabanel's Portraits of the American Aristocracy of the Early Gilded Age." *Nineteenth-Century Art Worldwide* 4, no. 1 (Spring 2005).

———. "Art for the Public: William Henry Vanderbilt's Cultural Legacy." *Nineteenth-Century Art Worldwide* 11, no. 2 (Summer 2012).

Zibel, Alan. "Behind a Private Family, Comes a Legacy of Public Gifts." *Baltimore Business Journal,* Oct. 21, 2004.

THESES AND DISSERTATIONS

Ferdinando, Nicole A. "A Juggling Act: Balancing Institutional Needs and Donor Restrictions in Art Museums." MA thesis, Seton Hall University, 2011.

Humphries, Lance Lee. "Robert Gilmor, Jr.: Baltimore Collector and American Art Patron." PhD diss., University of Virginia, 1998.

Katz, Francis Ross. "The Imitative Vocation: Painters, Draughtsmen, Teachers, and the Possibilities for Visual Expression in Early Nineteenth-Century Baltimore, 1800–1830." EdD diss., Columbia University Teachers College, 1986.

Kortendick, James Joseph. "The History of St. Mary's College, Baltimore, 1799–1852." Catholic University of America, 1942.

Regan, Marci. "Paul Durand-Ruel and the Market for Early Modernism." MA thesis, Louisiana State University, 2004.

Taormina, John Joseph. "Charles-Emile Jacque and Printmaking in the Nineteenth Century." MA thesis, George Washington University, 1983.

Thrift, Linda Ann. "The Maryland Academy of the Fine Arts and the Promotion of the Arts in Baltimore, 1838–1839." MA thesis, University of Maryland, 1996.

Zalewski, Leanne. "The Golden Age of French Academic Painting in America, 1867–1893." PhD diss., City University of New York, 2009.